:::::PART ONE:::::::::::::::::::::::

DIGITAL PHOTOGRAPHY

Philip Andrews

CONTENTS

PART ONE

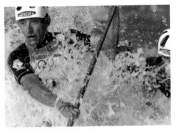

FOREWORD

It wasn't long ago that my fascination with digital photography began. At that time I was impressed with the potential the new medium offered photographers though I was also awed by the learning curve it presented those that cared to take it on.

Naturally the birth of consumer digital photography created a sense of impending doom and despair among the more conservative camera clubs and photo associations. Judges and members alike cried "foul" and "unfair advantage" as a overabundance of ghastly digital collages and composites hit the exhibition stands around the country. Unfair it was, but more so to the infant medium of digital photography than to those that felt most threatened.

As with the birth of any medium, the early days are its most unstable, and in the case of digital photography this proved especially so. At that time digital cameras were little more than expensive, pixel-poor toys. The computers on which their images were manipulated performed slower than the proverbial "wet weekend" and the imaging software on offer was complex and unnecessarily expensive. I don't even want to think about the quality of the printed output on offer, it was that bad …

But that was five years ago, a long time in digital imaging. Now we can enjoy affordable pixel-rich digital cameras capable of producing A4-sized images impossible to pick from film originals. We also have access to powerful and easy-to-use computer systems plus software manipulation programs that suit every conceivable budget and skills level. Best news of all is that we can also buy economical printers that output photo-realistic images of a quality to die for!

What does this all mean for the emerging digital photographer? Unfortunately, for such a jump in economy and quality, there's not been an equivalent shift in the level of understanding. Digital technology has not really improved the quality of our output. In fact it might have dragged it backwards a few notches as we tend to pay more attention to its bells and whistles than the creative aspects of image making.

Even though digital photography is well out of its infancy, there' still a staggering amount of new ground to be covered across all aspects of the craft. Great technology is simply not enough any more and that's where publications like this come into their own. *The Digital Photography Manual*. A handbook such as this, with clean and no-nonsense text and simple, clear illustrations is worth ten times its weight in software CD-ROMs or instructional video downloads. And, though the technology will undoubtably have advanced further still by the time you read this book, it's the theory and technique that remains its greatest asset.

Read this book. Learn the principles and techniques explained between its covers and your image making will ultimately benefit, regardless of the technology you acquire.

Robin Nichols
EDITOR
Digital Photograph & Design Magazine
Sydney, Australia

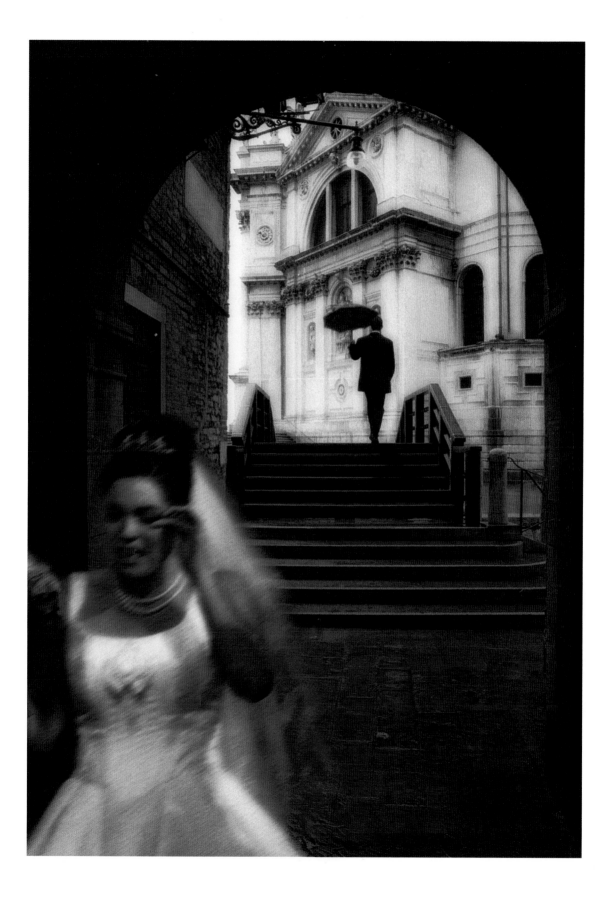

WHY DIGITAL?

WHY DIGITAL?

I believe that in the heart of all good photographers is the desire to make great images – images that communicate ideas or feelings, images that document times past or give us a glimpse of societies, people and places that we never knew existed.

Right from the very infancy of the medium, photographic image makers have embraced whatever technology was available to them to help satisfy this desire. The history of photography is as much the story of the technological changes in the medium as it is about famous people, images and events.

In France in 1826, Joseph Nicéphore Niepce produced the first photographic image the world had ever

Fig 2 – I'm sure that Talbot would not only have been interested in digital imaging, but would have embraced the technology wholeheartedly.

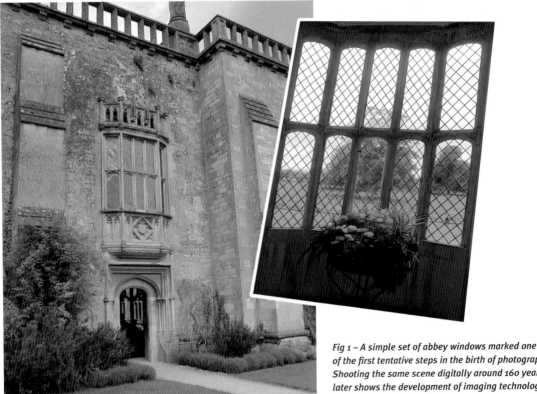

Fig 1 – A simple set of abbey windows marked one of the first tentative steps in the birth of photography. Shooting the same scene digitally around 160 years later shows the development of imaging technology.

Fig 3 – Good images are made by photographers whose skills are independent of the equipment they use. The most important skills that you have will easily transfer to the digital environment.

seen. Over the Channel, an equally simple, small and fuzzy picture – of a set of windows from an abbey just north of London – produced by William Henry Fox Talbot signalled a similar beginning to what has been a continual progression of technological advancements in the world of mechanical image-making. For the last 175 years, people like Niepce and Talbot have been constantly striving to produce materials, processes and equipment that will allow us to capture images of our world more easily, quickly and with better quality than ever before.

On a recent trip to Lacock Abbey in Wiltshire, I wondered what Talbot would have thought of me photographing the exact same window he used in his experiments with the very latest in photographic technology, a digital camera (see fig 1). I get the feeling that he would have been amazed and excited. The man was fervent, some might say zealous, in his pursuit of the ways and means to record the world around him. With this in mind, I feel that it would not be too much of a stretch of imagination to see him striding around the grounds, digital camera in one hand and laptop in the other.

NO NEED TO BE TECHNOPHOBIC

I start this book by referring back to the past because there is still an element in the photographic community that heralds all that is digital as a rejection of the craft of our imaging heritage. I believe that in reality the

advent of digital photography and the huge uptake of both the new equipment and its associated processes are entirely in line with our history (see fig 2).

Photographers have always pushed the technological boundaries of their medium. You have only to look at modern film-based camera systems to know that we will eagerly embrace changes in the way we do things if we feel that it will improve our ability to take great shots. In their latest incarnations, both Canon and Nikon have produced professional 35mm systems that have a vast array of functions and computer-based controls. Such advancements are readily accepted as great aids to making better images and there are very few photographers who would be prepared to argue that such cameras deny the craft of our common heritage.

Sadly, in some quarters, digital photography still doesn't receive the same acceptance. Traditionalists fear that these new tools will render useless the skills that they have developed over years of careful practice. Nothing could be further from the truth.

REUSE YOUR SKILLS IN A NEW WAY (fig 3)

The most important assets of great photographers are not their ability to manipulating their equipment or materials, but rather the skills that are not only transferable to the digital world but are essential to all photography. To be able to "see" will never be replaced by new technology. This might seem like a strange statement to be coming from someone who is writing a book about new technology, but it is important to understand that the ability to "see" is fundamental in all image-making endeavours.

This skill, which for most of you has probably been learnt over many years of looking at the world through a viewfinder, is the very basis of all great image-making. It is not dependent on the camera or film you use – if that were true then only those working with particular equipment and material combinations would produce successful shots. It is not something that is new – the great masters from the last century made fantastically memorable photographs because of their ability to see, not because of their place in history. And it is not a skill that will be lost in the digital world – on the contrary, digital photography is crying out for practitioners who are able to "see" and who have the skills to manipulate the tools and processes of this new area.

QUALITY (OR PRICE) IS NOT AN EXCUSE (fig 4)

OK, I admit that when I first saw the new digital technology in all its glory, six or seven years ago, I was not all that impressed. The equipment was big, bulky and heavy. The images didn't appear sharp and for me to change to digital would have required me to sell not only my house but possible several members of my family as well.

But even in those early days there was a hint of the revolution that was to come. The following years have seen the advancement of camera and printer technology to such an extent that now entry-level equipment can produce near-photographic quality images with comparative ease. The quality of image that even the cheapest digital cameras of today produce rivals that of the first professional models of the early nineties.

With such quality readily available, the last few years have seen a change in the way in which digital work is viewed. Before this period, most photographers played the "I can see pixels" game when confronted by a digital print. Along with this comment came the argument that as long as you could tell that the image's origin was digital then it should not be regarded as truly photographic. Now even the most basic digital kit can produce images that look and feel like traditional prints. This fact alone should encourage those of you who are still sceptical to give digital a try.

JUST ANOTHER TOOL IN YOUR KITBAG (fig 5)

In my photographic training I was taught to use a range of different cameras, film formats and stock types. No one combination was emphasized as more important or essentially any better than any other. Each camera type or film format had a purpose, advantages and disadvantages. When we were given a photographic task to complete, we would discuss which system would be appropriate for the job. Some days I would use 5 x 4 inch sheet film cameras, other days 35mm SLR equipment. After graduation I took this way of working into my professional life.

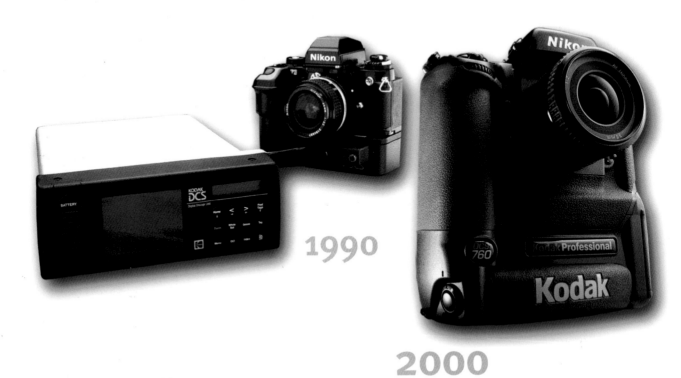

1990

2000

Fig 4 – The last decade has seen a massive increase in the quality of the images that digital cameras can produce. Kodak is one of the companies leading this technological race.

Fig 5 – Digital is yet one more choice for the working photographer. Don't be fooled into thinking that the technology is suitable for all shooting scenarios. Understanding the limitations and the advantages of the system is the key to knowing when, and for what jobs, you should choose pixel-based imaging over silver.

When digital came along I saw it as no different to any other system. It became another tool in my kitbag. Now, when asked to shoot images, I not only have to make decisions about format and film stock but I also have to choose whether to shoot film at all. seeing digital in this way frees it from being the "new messiah" for all that is photographic. It allows the technology to be used for those tasks for which it is best suited and not used in areas where film is a better choice.

THE PROFESSIONALS ARE USING IT (fig 6)

As the technology increases in sophistication and quality, digital photography is being used for more and more shooting scenarios. Initially two groups of photographers saw the potential for digital in their spheres of image-making. Press photographers realized that not having to process or scan their images would see a faster turnaround time. Commercial shooters, on the other hand, used digital photography techniques to manufacture high-quality advertising images, replacing manual retouching and splicing techniques with faster digital versions.

A quick look at any photographic association's yearly show will demonstrate just how

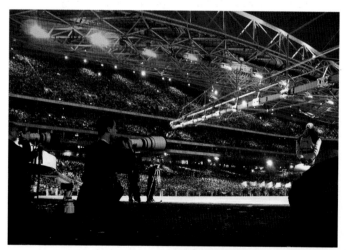

SHOOTING IN THE OLYMPIC STADIUM

WIRELESS TRANSMISSION

Fig 6 – Press and sports photographers were two of the first sectors of the industry to take up the digital challenge.

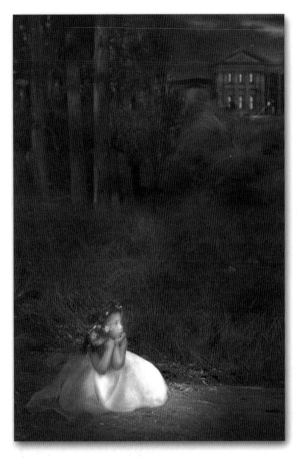

Fig 7 – Not to be outdone, wedding and portrait photographers are now diving headlong into the new technology.

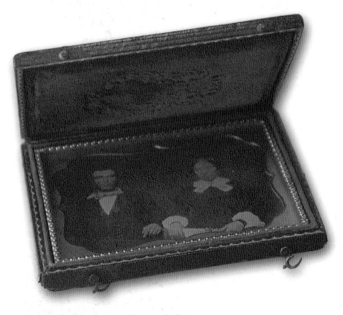

Fig 8 – The daguerreotype is an enduring reminder of photography's beginnings.

many of the hundreds of images displayed owe part, if not all, of their existence to the new technology. Professionals are taking up the digital challenge in their thousands. As a result the inner workings of the industry is changing forever (see fig 7).

The Sydney Olympics was the first in modern history where major press agencies chose to shoot no film. Of the 1200 professional press photographers present, at least eighty-five per cent chose to shoot pixel-based images. With this kind of statistic, it's easy to see why newspaper and magazine photographers see digital not as a passing fad but as their current reality. Round-the-clock processing facilities at big papers or major sporting events not longer exist. No sooner are the images shot and saved to disk inside the camera than they are being transported by modem or mobile phone to picture desks or press centres all over the world.

SOME THINGS ARE BETTER DONE DIGITALLY

Where speed is a major consideration, digital is now firmly entrenched as the only way to stay ahead of the game. In areas like current events and sports, more and more photographers, and their agencies, are working exclusively with pixel-based images. Tight deadlines means that digital is the only viable option, especially if the photographer is working on the other side of the world.

In other sectors of the industry, such as editorial or illustrative photography, all retouching and montage work is now being completed digitally. A few years ago, images that were made up of two or three photographs combined together would have taken four or five days of careful masking and airbrushing to produce. Today such a montage can be completed digitally in minutes rather than days.

In fact, not only can digital work methods produce results more quickly than traditional ones, they are also capable of effects and fine-tuning that was never possible before.

Sophisticated colour correction is one such case. Using an image editor like Photoshop it is possible to alter the colour casts of the midtones, shadows or highlights independently within an image. This level of control was never a practical reality with traditional photographic printing.

IT WON'T GO AWAY, SO BE TRUE TO YOUR HERITAGE

So just as Niepce and Talbot embraced the very latest in technology to help them in their drive to record the images that surrounded them, you too can take up the challenge of digital photography and move boldly into a new era of image-making.

This book will help you get started with guidance on equipment, software and techniques, but always keep in mind that these things are only part of the story. Great photography is always a combination of technique, materials, processes and "seeing".

A HISTORICAL PERSPECTIVE – HOW PHOTOGRAPHY HAS EMBRACED TECHNOLOGY THROUGHOUT HISTORY

1826: Heliograph – The first photographic image ever created. The process was invented by Joseph Nicéphore Niepce and used a special type of bitumen that hardened when it was exposed to light. The plate was then washed with lavender oil to remove the areas of soft bitumen.

1838: Daguerreotype – Invented by Louis Jacques Mande Daguerre, the process used a highly polished surface of silver that was sensitized over the vapours of iodine crystals. After exposure the plate was developed using the fumes from heated mercury and fixed ready for viewing in light (see fig 8).

Fig 9 – Talbot's process was the first to introduce a positive/negative system to the photographic equation.

Fig 10 – The glass plate produced images of wonderful clarity and detail as most prints were made from contacting the negative rather than enlarging it.

1839: Calotype – William Henry Fox Talbot announced a process based on a negative/positive system that is the forerunner of modern film-based photography. A paper negative was made of sensitized paper that was exposed, developed and fixed. This image was then placed in contact with another piece of sensitized paper, exposed and processed for the positive print (see fig 9).

1851: Collodion Wet-Plate – Combined the detail of the daguerreotype with the reproducibility of the calotype process. The system involved the use of glass plates which had been coated with a sensitizing emulsion and then exposed and developed whilst still wet (see fig 10).

1880s: Roll Film – George Eastman is credited as the man responsible for popularizing photography by providing a roll film and simple camera system that did away with the heavy plates of the collodion process (see fig 11).

1935: Kodachrome and Agfacolour – The introduction of these two films made it possible to produce high-quality colour images easily and comparatively quickly.

1963: First Basic Digital Camera – D. Gregg from Stanford University invented a videodisk type digital camera which was capable of capturing and storing images for a few minutes.

1986: Megapixel CCD Sensor – Kodak designed and created a sensor that contained 1.4 million pixels.

1990s: First Commercial Digital Cameras – Starting with black-and-white only and then moving into full-colour, Kodak provided digital solutions for the working professional (see fig 12).

"STARE. IT IS THE WAY....TO EDUCATE YOUR EYE"

Walker Evans (1903–1975)

Fig 11 – Roll film made photography affordable for the masses.

DIGITAL COMMANDMENTS

Seven things not to believe when it comes to digital imaging:

1. A bad photograph can be saved using the digital process. The best way to ensure good images is to take them in the first place.

2. The digital way of working is suitable for all image-making. This line of thinking is only purported by salesmen and the ill-informed.

3. You have to be rich to get into digital photography. Entry-level equipment is a lot more affordable than it used to be.

4. Digital imaging can never achieve the quality of traditional photography. This is definitely not true. In fact some high-end digital systems are able to record a far broader range of brightness than was ever possible with traditional films.

5. Digital will mean the death of traditional photographic skills. Sure you will need to learn about some new equipment and processes to take full advantage of the new technology, but your composition and "seeing" skills will always be invaluable and more importantly, transferable.

6. You will have to be a computer technician to be able to get involved in digital photography. This is no more true than saying that you will need to be a mechanic to drive a car. It is true that you will need to familiarize yourself with a new way of working, but your job is to concentrate on making the images not the technology.

7. Because digital photography makes it so easy to manipulate images convincingly no one will be able to believe that photographs are true any more. Photographs have always been manipulated and changed so that they no longer resemble reality. It's only with the advent of mass-appeal image-editing programs that the general population now realizes just how easy it is to change images.

Fig 12 – The continued development of electronic sensors is the cornerstone of the modern digital system.

DIGITAL VERSUS TRADITIONAL PHOTOGRAPHY

DIGITAL VERSUS TRADITIONAL PHOTOGRAPHY

A good way to start looking at the new technology is to compare it with what most of us already know and understand. In this section I will introduce the concepts of digital photography using ideas that will be familiar to anyone who has used an ordinary film camera.

THE CAMERA

Look at most modern digital cameras and you will see little difference from their film-based counterparts. Sure, most models have a tell-tale small viewing screen on the back of the body but, apart from this, most look and feel very familiar. If you describe a camera in its simplest terms it is a box with a lens, viewfinder, shutter, aperture and a place to hold the film (see fig 1).

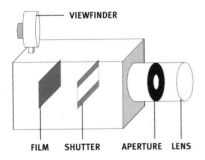

Fig 1 – All cameras are basically a light tight box with a lens, viewfinder, shutter, aperture and a place to put the film.

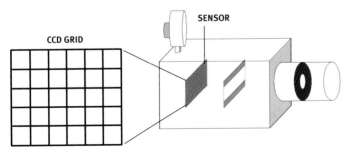

Fig 2 – Digital cameras are very similar to film cameras in most areas except that the film is replace with an electronic sensor.

All cameras, no matter how basic or sophisticated, follow this simple design. The photographer frames the image using the viewfinder. When the composition is judged to be just right, the shutter is released. Light passes through the lens and the aperture and is focused on to the film. The shutter is closed at the point when enough light has reached the film to form an image.

The digital camera adheres to this basic design in most ways except that the image is recorded onto a digital sensor rather than film (see fig 2). All the other elements of the camera work in much the same fashion for both traditional and digital image capture. If you are proficient with your film camera then you will be able to transfer a lot of your skills to new digital equipment.

DIGITAL FILM

The heart of a digital camera is the sensor. This usually takes the form of a grid of Charge Coupled Devices, or CCDs, each designed to measure the amount of light hitting it. When coloured filters are placed over the top of each CCD, each sensor can determine the colour of the light as well as the quantity. The filters are set in a pattern across the grid alternating between red (R), green (G) and blue (B) (see fig 3). Using just these three colours it is possible to make up the majority of the hues present in a typical scene.

Colour film and filtered sensors

The idea that all the colours that we see can be made up of three basic or primary colours might seem a little strange, but this system has been used in colour photography from the time that it was first invented. In fact the modern colour film has more in common with its digital sensor counterpart than you might first realize.

Almost eighty years ago it was discovered that you could capture the colour detail of a scene by shooting it

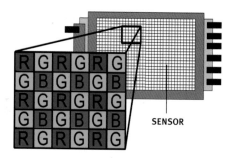

Fig 3 – A pattern of filters on a grid or matrix of CCD cells forms the heart of most digital cameras.

on black-and-white film through red, blue and green filters. If these images were then projected together through the same filters, the colour scene could be recreated. Since those early days colour film has developed in sophistication but this basic separation idea remains the same – the colours of a scene are separated and recorded individually and then recombined as a print or transparency (see fig 4).

Once it was found that CCDs could only record black and white (the brightness of a scene), it was a comparatively small jump to impose a similar separation idea onto a grid of CCDs. The result is that the majority of sensors in cameras now use this system. The files they produce are called RGB as they contain the colour information for the scene in three separate black-and-white channels relating to each colour, red, green and blue. When we view the file on screen or print it the three separations are recombined to form a full-colour image (see fig 5).

The new grain

With traditional film the details of a scene are recorded via an intricate structure of light-sensitive grains. Each grain changes in response to the light that hits it. These grains can be visible on the final print or transparency, most noticeable in large prints, or if you have been using a fast film designed for low-light photography.

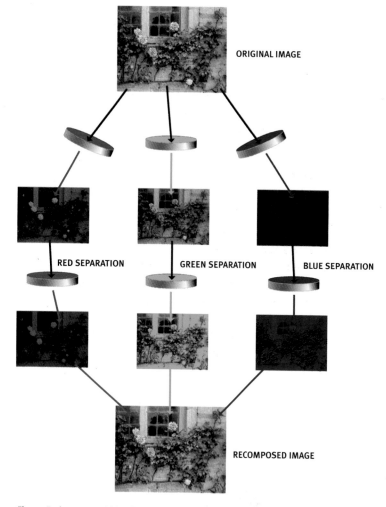

ORIGINAL IMAGE

RED SEPARATION GREEN SEPARATION BLUE SEPARATION

RECOMPOSED IMAGE

Fig 4 – Red, green and blue filters are used to separate the colours of a typical scene into three greyscale images. These pictures are then tinted and recombined to form a colour version of the original scene.

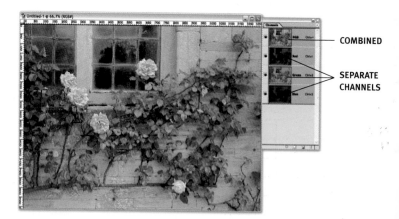

COMBINED

SEPARATE CHANNELS

Fig 5 – Colour digital files are made up of red, green and blue channels which are stored separately and are then recombined when printed or viewed on screen.

Fig 6 – Pixel grids seen from a distance appear as though they are a continuous tone photograph.

The digital equivalent of grain is a picture element, or pixel as it is usually called. Your digital photograph is made up of a grid of pixels. When seen at a distance these rectangles of colour blend together to give the appearance of a continuous tone photograph (see fig 6). Each pixel is the result of a CCD sensor recording the colour and brightness of a part of a scene. The more sensors you have on your camera chip the more pixels will result in your digital file. Just as the grain from traditional negatives is more noticeable as you make larger prints, pixels also become more apparent as you make bigger pictures.

THE DIGITAL PROCESS

The process used for capturing images the traditional way is so familiar for most of us that it is almost second nature. Shoot your images onto film, have the film processed and your negatives enlarged and then sit back and enjoy your images. When it comes to the digital equivalent it can be a little more confusing (see fig 7).

Essentially we still have three main stages – a shooting (capturing) phase, a processing (manipulation) phase, and a printing (outputting) phase. However what happens in each stage is a little different (see fig 8).

SHOOTING **PROCESSING** **PRINTING**

Fig 7 – The traditional photographic production cycle with its three basic stages.

CAPTURING **MANIPULATION** **OUTPUTTING**

Fig 8 – The digital production cycle still has three distinct phases but after the familiar shooting phase the way the content is processed is quite different.

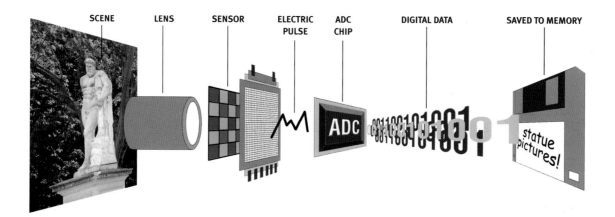

Fig 9 – Shooting skills are very similar with film and digital cameras. The difference is that the digital camera captures the image using a grid of electronic sensors rather than a piece of film.

Shooting (capturing) (fig 9)

1. The image is composed and focused and the shutter is released. Here the concerns are the same whether you are shooting on film or with a digital camera.

2. Light hits the sensors. Varying amounts of light are reflected from the scene focused by the lens onto the sensor. Each sensor receives a slightly different amount of light.

3. In response to the light, each CCD cell produces an electrical charge. The more light, the greater the charge. Keep in mind that each sensor is filtered red, green or blue so the charge reflects the colour of the light as well as the amount.

4. All the electrical pulses are collated, converted to digital information and stored according to their position within the CCD grid or matrix. This process is sometimes called quantization and uses a special chip called an analog to digital converter or ADC.

5. The digital information is stored in the camera as picture files. The information which now represents a single digital image made up of pixels, each of which has a position within the grid, a colour and a brightness, is saved to memory within the camera. The camera is now ready to take another shot.

Processing (manipulation) (fig 10)

6. The digital files are transferred to a computer. The space within the camera is limited so at some stage it is necessary to download or transfer the image files. This is usually achieved by connecting a cable from the camera to a PC.

7. Once the image is on the computer an editing program like Photoshop can be used to enhance the image.

8. The enhanced picture is saved in the computer, usually on the hard disk.

Printing (outputting) (fig 11)

9. At this point the image is ready for outputting. Most times this means making a print using an inkjet or similar colour printer, but the digital file can also be used for web publishing or even printed (written) back to film as a slide or negative.

MORE SENSORS = HIGHER RESOLUTION = BETTER QUALITY PICTURES

In traditional photography, the film is separate from the camera so it is possible for a photographer to select the film that is suitable for a particular job. If you are shooting sport under floodlights at night you can use a fast film that is particularly sensitive to low light. If, on the other hand, you are shooting under controlled lighting conditions within a studio, you can use a slow film with fine grain and saturated colours.

The digital photographer doesn't have the luxury of being able to swap recording stock. The sensitivity and "grain" or resolution of the sensor is fixed. For this reason manufacturers continue to try to develop digital cameras with higher resolution chips that can handle a greater range of lighting conditions.

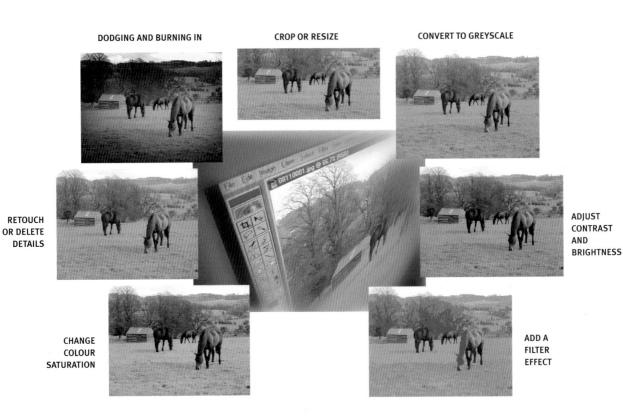

DODGING AND BURNING IN

CROP OR RESIZE

CONVERT TO GREYSCALE

RETOUCH OR DELETE DETAILS

ADJUST CONTRAST AND BRIGHTNESS

CHANGE COLOUR SATURATION

ADD A FILTER EFFECT

Fig 10 – It is during the manipulation stage of the process that we can see the power of digital photography. Here images are enhanced or changed according to the photographer's design or fancy.

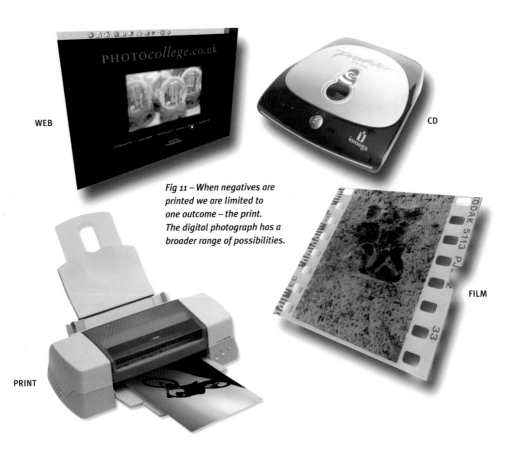

WEB

CD

Fig 11 – When negatives are printed we are limited to one outcome – the print. The digital photograph has a broader range of possibilities.

PRINT

FILM

Over the last few years we have seen digital camera resolution increase from the early days where it was measured in hundreds of thousands of pixels to today when chips are capable of upwards of 6 million pixels. Some specialist studio models are capable of 16 million pixel images but these are not your average point-and-shoot cameras. To put these figures into perspective the average 100 ISO film is estimated to have sixty million light sensitive grains within one 35mm frame. This means that the best digital SLR camera's sensors are still only capable of recording about ten per cent of the detail possible using film.

In terms of sensitivity, five years ago the average digital camera chip had an equivalent ISO rating of between 100 and 200. Now professional-level press models like the Kodak 720x can shoot up to a sensitivity of 6400 ISO (see fig 12). This effectively enables the digital press photographer the opportunity to shoot under a much wider range of lighting conditions than ever before.

THE BASICS
Lens
The function of the lens is to focus the image in front of the camera onto the film or sensor. Lenses for digital cameras are essentially the same as those for film-based cameras. In fact with some professional-level cameras the same lenses can be used on both film and digital camera backs.

Viewfinder
The viewfinder is the photographer's frame around the world. It is here that the image is composed and a moment selected for the shutter to be released. Most digital cameras have a viewfinder that is separate from the lens as well as a small colour screen that, in some modes, can act as a preview of what you are photographing.

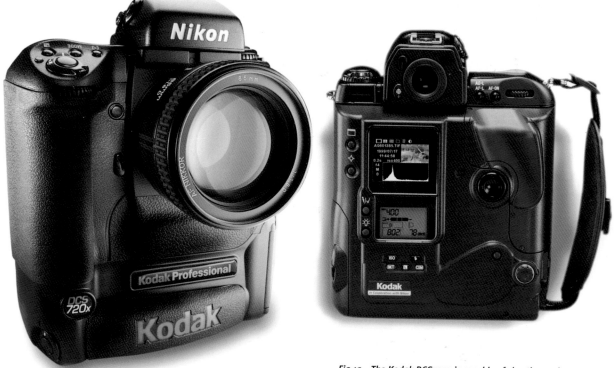

Fig 12 – The Kodak DCS720x is capable of shooting under a much wider range of lighting conditions than ever before.

400 ISO

1600 ISO

3200 ISO

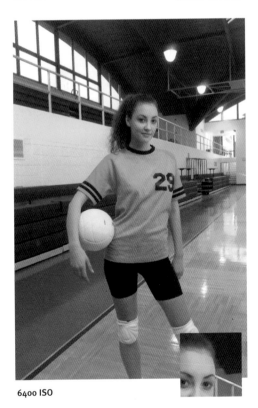

6400 ISO

Fig 13 – Unlike other cameras before it, the DCS620x and DCS720x use cyan, magenta and yellow filters to separate scenes into three greyscale channels. In doing so it has gained a full stop more sensitivity.

Fig 14 – The new CCD chip Kodak uses in its DCS620x and DCS720x is based on cyan, magenta, yellow separation of the light rather than red, green, blue.

STANDARD RGB FILTER PATTERN NEW CMYK FILTER PATTERN

Shutter

The shutter helps controls the amount of light falling on the film or sensor. In film-based cameras the shutter is usually a thin metal curtain that is raised to allow light into the camera for a specific amount of time and then lowered. Some digital cameras work in a similar manner, but others just turn the sensor on and then off again.

Aperture

The aperture is the second mechanism that controls the amount of light entering the camera. It works in a similar way to the irises in our eyes. When light levels are high the hole is made small to restrict the amount of light hitting the film. When levels are low the diameter is increased to allow more light to enter the camera.

The film

Instead of the traditional film, the digital camera captures its images using a sensor. Areas of light and dark together with information about the colour of the scene are all recorded within a fraction of a second.

EXCEPTIONS TO THE RULES
Non RGB filtered cameras (fig 13)

In 2001 Kodak released the latest version of its digital professional press camera. The DCS720x is a major step over previous models. Instead of using a CCD matrix that is filtered red, green and blue, Kodak has changed the separation filters of the sensor to cyan (C), magenta (M), and yellow (Y) (see fig 14).

In doing this Kodak have gained an extra stop of usable sensitivity as the new filters allow more light to pass to the sensor than before. This means that the camera can be used with an ISO film sensitivity setting equivalent to 6400.

For anyone familiar with colour printing techniques the step probably appears to be a fairly simple one. For years we have known that CMY colours work in a balancing act with their opposites RGB

Fig 15 – The colour diamond familiar to all you colour printers out there clearly shows the relationship between the two separation systems.

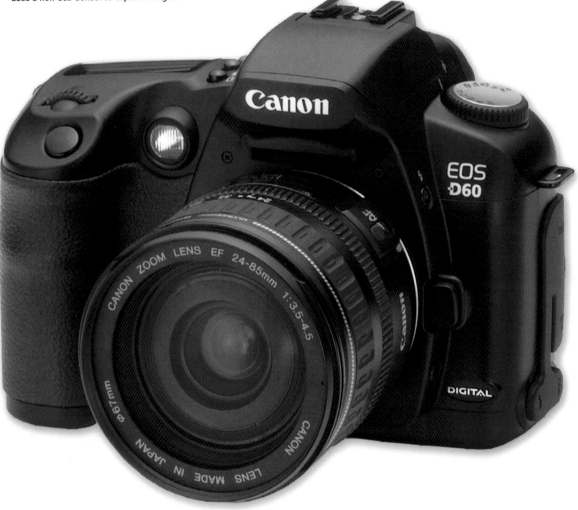

Fig 16 – The new Canon digital SLR camera uses a non CCD sensor to capture images.

colours to form white light. So it seems completely logical to swap separation filters and gain the advantage of more light hitting the sensor (see fig 15).

Non CCD sensors cameras (fig 16)

While CCDs are the main image sensor technology in town, some manufacturers are successfully pioneering image capture using other techniques. Early in 2002, Canon introduced a six-megapixel digital SLR camera based on the highly acclaimed EOS 1-N film camera. The camera makes use of a CMOS chip rather than the usual CCD matrix (see fig 17).

Canon has used CMOS sensors in some of its desktop scanners for a few years and in this camera has managed to overcome some of the engineering obstacles that stopped large sensor production in the past. The chip, measuring 22.7 x 15.1mm, consumes less power than the same size CCD and is able to be integrated more easily into image-processing circuits. Such advantages may see this type of chip assume dominance of the camera market in the future.

HOW IS A SENSOR'S RESOLUTION MEASURED ANYWAY?

A digital image is measured not in inches or centimetres but in pixels. Each pixel relates to a sample that was taken by a CCD sensor during the capturing process. Digital cameras have a set number of sensors and so the resultant file's pixel dimensions can be directly related to the chip it was made with.

The sensor's resolution is measured by quoting the number of pixels widthways by the number in height. A typical resolution might be 1200 x 1600 pixels. When these dimensions are multiplied you will have a sensor with approximately two million pixels. This is called a two-megapixel sensor.

When digital pictures are printed the pixels are spread over the paper at a specific rate per inch (or centimetre). This gives us the printing term dots per inch (DPI).

Fig 17 – Canon has successfully enlarged the CMOS sensor technology that it has been using in its scanner products to suit capture in the new camera.

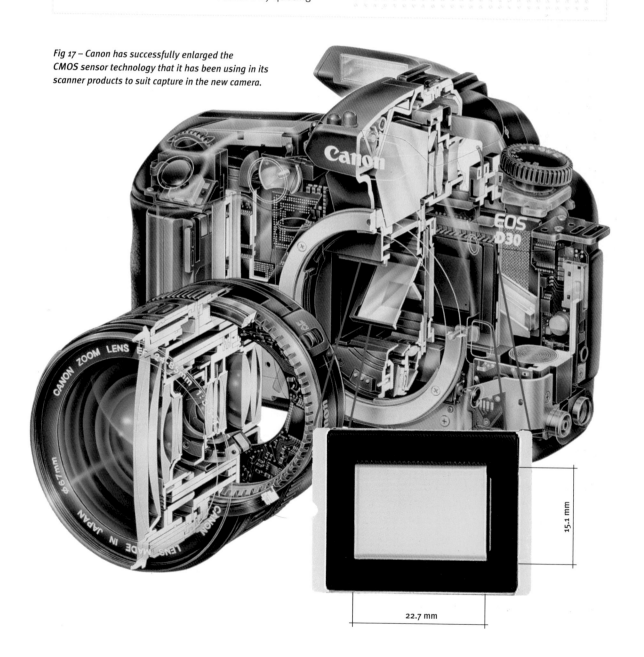

15.1 mm

22.7 mm

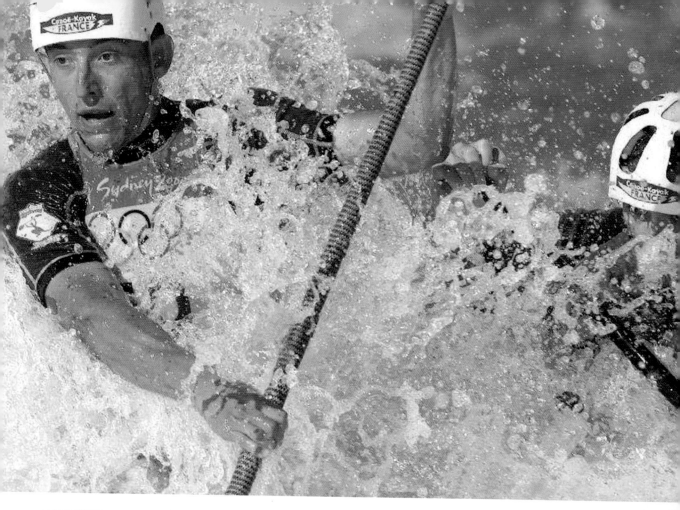

CAPTURING THE IMAGE

CAPTURING THE IMAGE

Most photographers start on their life-long image-making journey because they enjoy taking pictures. Those of us who are actively involved in using digital technology are no different.

I believe that the technology is secondary to making great images. This might seem like a funny thing for the author of this book to say, but I feel that making the images is the main job of the photographer and the technology, be it traditional or digital, plays a supporting rather than leading role in this task. Don't get me wrong, knowing your medium is a sure way to guarantee good results. But in getting to understand the characteristics of equipment and software, never lose sight of the technology's role in your photographic life. It is there to underpin your image-making, not overtake it.

For this reason, I will take the first part of this chapter to outline some basic imaging principles that could easily be used by traditional film shooters as well as their digital counterparts.

STARTING TO SHOOT (fig 1)

Photography can be a hard taskmaster. A lot of people find the whole thing a bit overwhelming when they first start taking pictures. So let's simplify things a little, I believe that when it gets down to it there are only really three things you need to understand to make great images from day one.

I call them the holy trinity of photography – no offence intended. The fact is, these three elements interact so much, it is as though they are one. Get to grips with these ideas and you will start your image-making career on a firm footing.

They are:
- Composition
- Focus
- Exposure

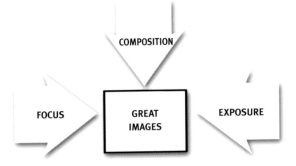

Fig 1 – Good focus, composition and exposure all combine to make great photographs.

COMPOSITION

When you look through the viewfinder of a camera you are framing the world. Just as hundreds of artists in years gone by, you are choosing what is in the frame and how each of these elements will fit together.

Some of you might say that this is overstating the activity, "All I do is point the camera at the subject and push the button". I agree, but whether you realize it consciously or not, in pushing the button, you are actually making a lot of decisions that effect the way your images look.

Making better compositions (and photos) is all about becoming actively involved in the decisions you make before exposing the film. I find it helpful to look at these choices one by one

Filtering – What to Put In and What to Leave Out! (fig 2)

Filtering is something that a lot of people do almost without thinking. Put a camera in someone's hand and immediately they are asking you to "Move that vase", or "Stand to the right so that I can see the church steeple behind you". The fact is, we all make decisions about what should be in the picture.

Keeping it simple is a great way to get control over how your images are organized. When you are looking through the viewfinder, ask yourself this question: "Is there too much in the frame?" Often some of the best images are the ones that present a single idea, or sub-

Fig 2 – Keeping the composition simple gives you a greater chance of ending up with a balanced image.

ject, without distraction. Move objects, change backgrounds and even reorganize your subject if you have to – but make sure that distractions or unwanted elements are removed from the frame.

Get to the point! My view is that photography is about communication, and as we all know, one of the quickest and best ways to communicate is to get to the point. The same can be said of making images. Again, when you are shooting ask yourself "What am I trying to say in this shot?", or "What is the point of the photograph?". Once you have narrowed your ideas down, study the image in front of you in the viewfinder and make sure that all of what you see relates to the point you are making.

If you are taking a portrait, make sure that all the other objects in the frame relate to your sitter in some way. If they don't, remove them. If your interests lie in the area of landscape photography, be selective about what you leave in or put out of the picture. Move the camera around. Make sure that what you are viewing presents a clear and consistent idea.

Remember, filtering can make or break a shot. Don't just think about what you want in the picture, think about what you don't want as well (see fig 3).

Fig 3 – Search the viewfinder to find objects that distract from the main idea of your image. Change position or angle to eliminate these things from your picture.

Framing – Learn to See as the Camera Does

Your eye is an amazing piece of imaging equipment. When you look at an object, it's possible to concentrate your vision so much that the other things in your peripheral view almost don't exist. Unfortunately the camera is not as clever, and not nearly as selective.

When viewing a scene through a camera's viewfinder, new photographers often only look at the object on which they are focusing. After all, this is the way we see and it is also a good way to start framing your picture. But concentrating on the main subject is just the beginning. Your next step should involve actively scanning the rest of the frame to see how other picture elements interact with you main point of interest.

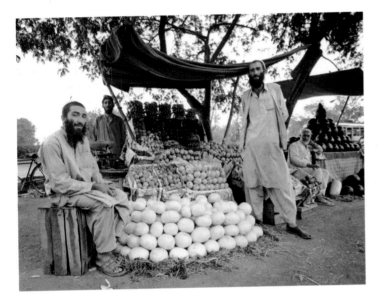

Fig 4 – Make sure you look at what is in front of, as well as behind, your subject at the time you press the button.

Have you ever had the experience of getting your images back from the processing outlet to find a few surprises in the foreground and background areas? I often hear new photographers say "I don't remember that being there". This is a sure sign that they haven't scanned the whole frame – fore, mid and background – before releasing the shutter (see fig 4).

The lesson is to learn to see as the camera sees. I know that it sounds difficult, but with a little practice it is possible to focus on the main point of interest in the frame and then quickly scan the other areas of the image to check for distractions.

Balance –The Art of Composition

Texts abound on the subject of composition and balance. Most introductory design courses contain at least one mandatory unit called "Fundamentals of Art and Design". In these classes students are presented with all sorts of rules and guidance to follow if they want to make masterpieces. I'm not about to go into depth about all these ideas but what I will do is give you some basic ideas that will get you started.

Visual Weight: Composition is all about making the elements within your frame seem balanced and "at ease with themselves". To achieve this, look at the visual weight of each element in turn. Colour, texture or brightness all determine how much attention-grabbing effect, or weight, an object has. A red flower against a deep green lawn, for instance, will attract a lot of attention – it has visual weight due to the contrast of colours.

Balancing Act: To produce a balanced composition the photographer has to adjust the position of objects within the frame according to their visual weight. If you place a bright white element on the edge of the frame, our eyes will be attracted to it, and then drawn out of the frame. Generally the result is an unbalanced picture. If the photographer changes position and the bright white element is now in the centre of the frame, our eyes will be held on the image and the whole picture will feel more balanced.

Types of Balance: The simplest balance is symmetrical. This is where the point of interest (and the element with the most visual weight) is in the middle of the frame. Asymmetrical balance, on the other hand, means that the interest points are off centre (see figs 5 & 6).

A good guide when positioning objects off centre is the rule of thirds. The frame is divided vertically, and horizontally, into thirds. To balance the picture, the elements are placed on these lines, or at their junction points.

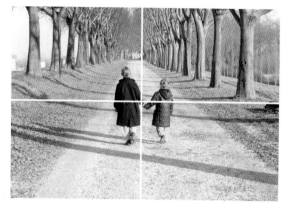

Fig 5 – Placing your main point of focus in the centre of the frame is the easiest way to balance your images.

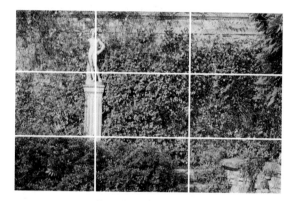

Fig 6 – Positioning objects off centre requires you to balance their visual weight with another part of the image that is equally as strong.

Rules are meant to be broken: The details above are just guides. Conforming to them will increase your chances of achieving visual balance, but won't guarantee it. And great images don't always adhere to any of these rules.

The best advice I can give is look at how other image-makers handle balance in their work and then practice, practice, practice. Once you have been shooting for a while, the basics become second nature and you will be able to refine your skills and orchestrate complex compositions with more ease than you thought possible. Just as children take years to learn to read, it will take time for you to become visually literate.

Angle of View and Perspective – Getting Right Down (or Up) to It.

Too often photographers get into the habit of always shooting their images from the same height. In most cases this is eye level or the height of your tripod. By always shooting from one level, you will be missing out on a lot of great images.

Shoot high, shoot low, but just keep shooting. I can still remember as a new photographer going to see how a real professional worked. At the time he was shooting some press images for the local paper. Once he started photographing, I recall how he moved around his subject, shooting (and talking) all the time. He changed positions constantly, making sure he had covered all the possibilities available from the location and the sitter. In his words he was "working the subject".

I learnt from this man that you need to keep searching for the great images and that even people with high levels of skills are always trying to come up with a new angle on familiar subjects.

Lenses, lenses, lenses! It is amazing the kit options that the contemporary photographer has. Nowhere is this more true than when it comes to lens choice. Even those of us who have to work to strict budgets are able to purchase either a good zoom or a set of prime lenses of differing lengths.

The digital world too is changing. The first-generation cameras had either fixed focal length lenses or very short zooms. More and more of the newer models are being released with long zooms that are at least the 35mm equivalent of 28–105mm.

The availability of these types of lenses gives the photographer a whole host of compositional options. The first, and most obvious, is the ability to zoom in or out from a subject without changing position.

Fig 7 – Wide-angle lenses increase the sense of perspective in an image and give an overall feeling of foreshortening to your photographs.

The second option is the most interesting as it deals with the change in perspective that occurs when moving between wide-angle and long lenses. Using long lenses will flatten the perspective in your images whereas wide-angle lenses will increase or steepen the effect (see figs 7 & 8).

If you don't move around your subject, or change the focal length of your lenses, you are missing opportunities and the chance to discover and shoot images that you hadn't dreamed of.

Fig 8 – Long lenses compress visual space making objects seem a lot closer in the photograph than they were in reality.

WIDE-ANGLE AND LONG LENSES (fig 9)

In 35mm terms a standard lens (50mm) has similar perspective to our own eyes. "Long" or "telephoto" lenses see a narrower angle than our eyes and can range from 85 to 600mm or greater. They are similar in effect to a telescope, allowing the photographer to get in close to a distant scene or action.

Lenses with a smaller focal length than standard are consider wide-angle. These lenses see a larger angle of view than our eyes and have a focal length of 20 to 40mm. They are often referred to as "short" or "wide" lenses. They are great for shooting landscapes, or the interiors of small spaces.

Most digital sensors are smaller than the 35mm film frame. This difference affects the perspective of different lens lengths. As the way we classify lenses as wide, standard or long is related to the frame size, a "standard" digital lens is likely to have a focal length of only 10mm. To give you some reference point, always look for the 35mm equivalent lens length. This will help guide your lens choice (see fig 10).

Most modern film and digital cameras are supplied with a zoom lens. This enables the photographer to adjust their lens length freely between two set limits. Popular zooms range from the wide (28mm) through standard (50mm) to short telephoto (105mm) (see fig 11).

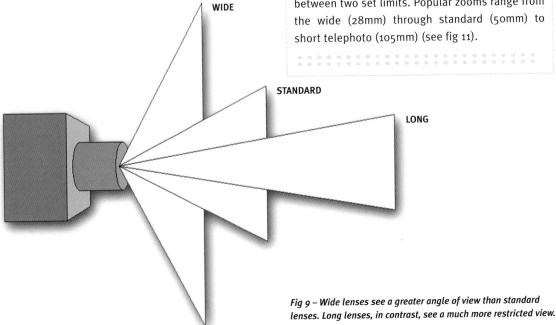

WIDE

STANDARD

LONG

Fig 9 – Wide lenses see a greater angle of view than standard lenses. Long lenses, in contrast, see a much more restricted view.

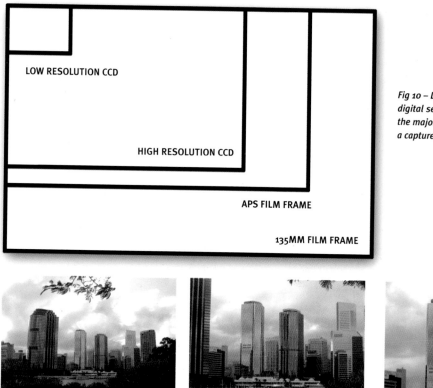

LOW RESOLUTION CCD

HIGH RESOLUTION CCD

APS FILM FRAME

135MM FILM FRAME

Fig 10 – Despite the increase in digital sensor size and resolution, the majority of cameras still have a capture area less than a 35mm frame.

Fig 11 – Zoom lenses give the user the chance to move into a subject or widen the view to shoot interiors or landscapes. The images above are (left to right) 35mm, 50 mm, and 86mm.

FOCUS

The majority of digital cameras sold today are supplied with an auto focus (AF) lens system. In the viewfinder you will see at least one, but sometimes more than one, focusing area. For the camera to focus, the subject must be in this area. Light pressure on the shutter button activates the camera and sets the focusing on the subject that is positioned here.

In most cameras the focus area is positioned in the centre of the frame (see fig 12). In professional models though, you will not only find multiple focusing areas, but you will also notice that they are distributed across the viewfinder. With the aid of a dial, or a thumb toggle, the photographer can choose which area will be used for primary focus. This enables the focusing of subjects that are off centre.

For those readers who have systems with a single central focusing zone it is still possible to focus on subjects that are off centre in the frame. Most cameras allow the user to lock focus by pressing the shutter button halfway whilst positioning the focusing area. With the focus set and without releasing the button, you can now move the camera so that the subject is off centre. Pressing the button further will release the shutter.

Fig 12 – In the centre of the viewfinder of most auto focus cameras is the focal area. The subject you want sharp must be in this area when you focus the camera.

EXTENDED SHOOTING SKILL – ZONE FOCUSING

There are a range of activities that allow the photographer the chance to predict where a moving subject will be with reasonable accuracy. In swimming for instance, the lanes and the end points of the pool are well defined. Using the zone focusing technique, the photographer would pre-focus on one point in the pool and wait for the subject to pass into this zone before pressing the shutter.

SINGLE AND CONSTANT AUTO FOCUS (fig 13)

In AF terms, two modes determine the way in which the auto focus system works on your camera. In single mode, when the button is held halfway the lens focuses on the main subject. If the user wishes to change the point of focus then they need to remove their finger and repress the button. In this mode, if the subject moves, you must refocus.

The constant or continuous focusing mode focuses on the subject when the shutter button is half pressed, but unlike the single mode, when the subject moves, the camera will adjust the focusing in order to keep the subject sharp. This is sometimes called focus tracking. Some AF SLR systems have taken this idea so far that they have "pre-emptive focusing" features that not only track the subject but analyze its movement across the frame and try to predict where it will move.

Each mode has its uses. Single focusing is handy if you wish to focus on a zone into which the subject will appear. Constant is more useful for subjects that move more randomly.

Depth of Field

What you focus on in the frame is not the only factor that determines what appears sharp in the final image. Some images, though focused on a small part of the overall picture, have sharpness from the foreground right though to the background. In other photographs

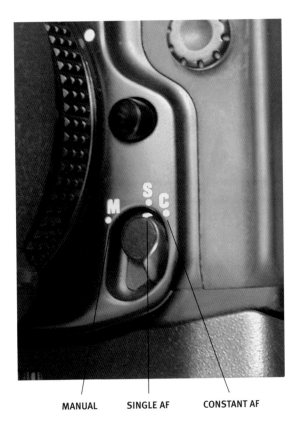

MANUAL SINGLE AF CONSTANT AF

Fig 13 – Different focusing modes gives photographers the flexibility to match the subject with the focusing method that suits it.

one small section of the image is sharp and the rest is blurred. This area of sharpness within an image is called the "depth of field of appreciable sharpness", but most photographers refer to it as "depth of field" or "DOF" (see figs 14 & 15).

Images that display sharpness from the foreground into the background are said to have large DOF. Photographs with only one area or object sharp have shallow DOF. Experienced film-based photographers are able to control not only where their images are focused but also how large the DOF effect is within their images.

Digital shooters can use similar techniques to those employed traditionally, but the small size of most sensors means that the majority of digitally sourced images will contain large depth of field characteristics. This said, careful control of aperture, focal length and subject distance will still enable photographers with pixel-based equipment to make images with a variety of sharpness ranges.

Fig 14 – In shallow depth of field images only one part of the image is sharp.

Fig 15 – Large depth of field images have sharpness from the foreground right into the distance.

DEPTH OF FIELD CONTROL TECHNIQUES (fig 16)

The area of sharpness within your photograph is controlled by three distinct factors:

Aperture: Changing the aperture, or F-stop number, is the most popular technique for controlling depth of field. When a high aperture number like F32 or F22 is used, the picture will contain a large depth of field – this means that objects in the foreground, middle ground and background of the image all appear sharp. If, instead, a low aperture number is selected (F1.8 or F2), then only a small section of the image will appear focused, producing a shallow DOF effect.

Focal Length: The focal length of the lens that you photograph with also determines the extent of the depth of field in an image. The longer the focal length (more than 50mm on a 35mm camera) the smaller the depth of field will be, the shorter the focal length (less than 50mm on a 35mm camera) the greater DOF effect.

Distance from the subject: The distance the camera is from the subject is also an important depth of field factor. Close up or macro photos have very shallow DOF, whereas landscape shots, where the main parts of the image are further away, have a greater DOF. In other words, the closer you are to the subject, despite the aperture or lens you select, the shallower the DOF will be in the photographs you take.

EXPOSURE

Contrary to popular belief, good exposure is just as critical in digital photography as traditional shooting. Bad exposure can not be "fixed in Photoshop". Under- or overexposure of the sensor leads to images in which the critical picture detail is lost forever. The creation of good-quality images always starts with the capture of as much of the image detail as possible, and the capturing process is governed by good exposure (see fig 17).

The theory is simple. To capture good images you must adjust the amount of light entering the camera so that it suits the sensitivity of the sensor. Too much light and delicate highlights are converted to white and lost, too little and shadow details become solid areas of black. The photographer alters the level of the light with two camera controls – the shutter and the aperture.

The shutter determines the length of time that the sensor is exposed to the image. The length of the period that the shutter remains open is indicated by shutter speeds. The longer the time, the more light hits the sensor and the greater the overall exposure will be. With this in mind, photographers can increase exposure by selecting long shutter speeds, or decrease exposure by using shorter ones.

Shutter speeds are represented in terms of fractions of a second, 1/125th being 1/125th of a second. The range of speeds available on most cameras is broken up into a series of numbers, each one the double, or half, of the one before (see fig 18).

Coupled with the shutter is the aperture control. Working something like the iris of our own eyes, this mechanism changes the size of the opening in the lens through which the light travels. Making the aperture, or hole, larger lets in more light giving a greater exposure, reducing the size restricts the light and produces less exposure overall.

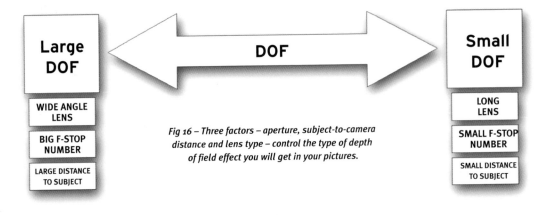

Fig 16 – Three factors – aperture, subject-to-camera distance and lens type – control the type of depth of field effect you will get in your pictures.

Fig 17 – Good exposure is the first step to making great images.

HALF THE EXPOSURE

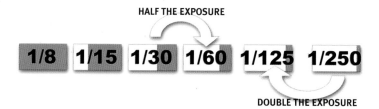

DOUBLE THE EXPOSURE

Fig 18 – Shutter speeds are arranged in a series in which each
step either doubles or halves the amount of light reaching the sensor.

HALF THE EXPOSURE

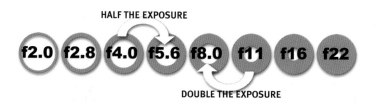

DOUBLE THE EXPOSURE

Fig 19 – The aperture series is organized in terms of F-stop numbers, each
allowing half or double the amount of light into the camera than the one before.

Again, the range of possible aperture opening sizes is represented by a number series. These are called F-stops. The numbers are organized in a halving or doubling sequence, each higher F-stop number reducing the amount of light entering the lens by half (see fig 19).

Metering (fig 20)

"All very interesting," you say, "but how do I know what F-stop and shutter settings to use to guarantee the right amount of light hits the sensor?" Good question. All digital cameras contain a metering system designed to measure the amount of light enter-

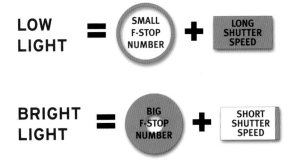

Fig 20 – In low light conditions, you will generally need to use a wide aperture and a slow shutter speed. With bright conditions you will typically use fast shutter speeds and smaller apertures.

ing the camera. In most cases the meter is linked with an auto-exposure mechanism that alters the aperture and shutter to suit the light that is available.

In low light scenarios a long shutter speed and a wide aperture would be selected to allow enough light for the sensor to record the image. In situations where light abounds, faster speeds and smaller holes would restrict the level of light to the amount required by the sensor.

In most scenarios the auto-exposure system works well, but in about five to ten per cent of all shooting occasions the meter in the camera can be fooled into providing an F-stop and shutter speed combination which produces images too dark or light to be useable. For these occasions you will need to help your camera out by intervening in the exposure process.

There are three ways to compensate for these difficult exposure circumstances:

If the camera allows the manual override of automatic settings, you can change the shutter speed (or aperture) up or down to suit the lighting.

Systems with no manual functions usually allow the locking of exposure settings. With the camera pointed at a part of the image that most reflects the exposure needed for the photograph, you can half press the shutter button to lock exposure. With your finger still on the button it is possible to recompose the image and take the picture using the stored settings.

The last method is to compensate for the exposure problem by setting the camera to purposely over or underexposure the image by one, two or even three stops worth of exposure. If you use this technique, be sure to change back to the standard settings before recommencing shooting.

HOW SENSITIVE IS MY CHIP?

The sensitivity of film to light is expressed as an ISO number. Films with a low number like fifty need a lot of light to make an exposure. Higher numbered films require less light and are usually used for night shooting or taking pictures under artificial light.

Chips don't have ISO ratings. Instead manufacturers allocate "ISO equivalent" ratings so that we all have a reference point to compare the performance of sensors and their film counterparts.

Unlike film, most chips are capable of being used with a range of ISO settings. The smallest number usually produces the best-quality image. At higher settings the resultant images are usually a little more noisy and not quite as sharp.

OCCASIONS WHEN YOUR METER MIGHT BE FOOLED
Backlit subjects (fig 21)

Problem: When your subject is backlit, for instance if they are sitting against an open window, the meter is likely to adjust the exposure settings for the light around the subject. This can lead to a silhouette effect, where, in the window example, the subject is black but the window is well exposed.

Solution 1: Move the subject so that they are being illuminated by the light.

Solution 2: Use the camera's flash system to add some more light to the subject.

Solution 3: Move close to the subject until it fills the frame. Take an exposure reading here and then reposition yourself to make the exposure using the saved settings.

At night (fig 22)

Problem: This problem is the reverse of the example above. This time the subject is surrounded by

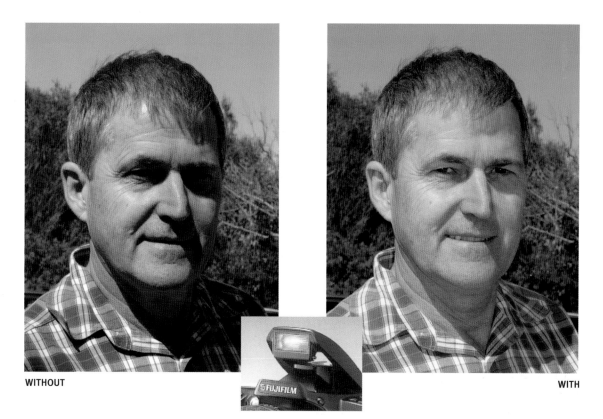

WITHOUT

WITH

Fig 21 – Strong back or side lighting can be alleviated by using some fill flash. A lot of digital cameras have a fill flash mode that uses the built-in flash to lighten dark shadow areas.

darkness. The meter sees large dark areas within the frame and over compensates for it. As a result the main subject is "blown out" or overexposed.

Solution 1: Manually compensate for the overexposure by adjusting the camera's exposure compensation mechanism so that the sensor is receiving one, two or three stops less light.

Solution 2: Move close to the subject until it fills the frame. Take an exposure reading here and then reposition yourself to take the picture using the saved settings.

Fig 22 – Overexposed subjects can be the result of the camera's meter trying to compensate for large areas of dark background.

Controlling Motion in Your Images

As well as providing the means to control the amount of light hitting the sensor, the shutter can also affect the way in which motion is captured in your images.

Most photographers are familiar with the idea that fast shutter speeds freeze the action. Sports and action publications especially show images on every page taken with high shutter speeds. They are clear and sharp, with the main subject jumping out from the background. If this is the type of image you want, there are essentially three techniques to use:

Shoot with a high shutter speed: Sounds simple enough, select a high shutter speed and fire away. However, as you know by now, there is a direct link between aperture, shutter speed, film speed and the available light. Put simply, to be able to use speeds that will freeze motion, you need a fast lens, a good sensor and good light.

Shoot with the lens wide open: That is, with the aperture set to maximum, usually F2.8 or F4 on pro lenses or F5.6 for standard zooms. This has the added bonus of giving a shallow depth of field, making the background blurry whilst the main subject remains sharp. If the action is taking place indoors, you will need to change the sensitivity of your sensor to the highest ISO possible.

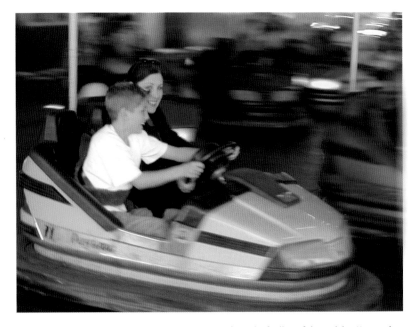

Fig 23 – Sometimes freezing the motion takes away from the feeling of the activity. Here a slow shutter speed was used whilst panning the camera to try to capture the movement of the cars.

Shoot with a fast light source: The alternative to shooting with a fast shutter speed is exposing with a light source that has a very short duration. In a lot of instances, the most suitable source will be a portable flash. The majority of on-camera flash systems output light for durations of between 1/800th and 1/30,000th of a second. It is this brief flash that freezes the motion. Don't be confused with the shutter speed that your camera uses to sync with the flash – usually between 1/125th and 1/250th of a second – the length of time that is used to expose your frame is very short and is based on the flash's duration.

Blurred Motion Techniques (fig 23)

In some instances, images where the motion is frozen don't carry the emotion or atmosphere of the original event. They seem sterile and even though we know that they are a slice of real time, something seems missing. In an attempt to solve this problem, photographers through history have played with using slower shutter speeds to capture events. The results, though blurry, do communicate more of the feeling of the motion present in the original activity.

There is no secret formula for using this technique. The shutter speed, the direction of the motion through the frame, the lens length and the speed of the subject are all factors that govern the amount of blur that will be visible in the final image. Try a range of speeds with the same subject, making notes as you go. Too fast and the motion will be frozen, too slow and the subject will be unrecognizably blurred, or worse still, not apparent at all. The results of your tests will give you a starting point that you can use next time you are shooting a similar subject.

EXTENDED MOTION TECHNIQUES

The following two techniques are an extension on those detailed above. Both require practice to perfect.

Panning: An extension of the slow shutter technique involves the photographer moving with the motion of the subject. The aim is for the photographer to keep the subject in the frame during the

exposure. When this technique is coupled with a slow shutter speed, it's possible to produce shots that have sharp subjects and blurred backgrounds. Try starting with speeds of 1/30th sec.

Flash Blur: To achieve this effect you need to set your camera on a slower than normal sync shutter speed. The short flash duration will freeze part of the action and the long shutter will provide a sense of motion. The results combine stillness and movement. Remember to make sure that the light is balanced between the flash exposure and the ambient light exposure. If you are not using a dedicated flash system this will mean ensuring that the F-stop needed for the flash exposure is the same as that suggested for the shutter speed by the camera's metering system.

SHOOTING DIGITAL AT THE OLYMPICS (fig 24)

Patrick Hamilton, a press and sports photographer based in Australia, has seen the way that he shoots change radically over the last few years. Film cameras are a thing of the past, now he shoots digital for every press job. Nowhere was the change more evident than when he was employed to photograph the kayaking and rowing events at the Sydney Olympics. For the first time in the history of the games, the majority of still photographers present shot no film.

He says, "For circumstances where speed is important there is no alternative for the press photographer than to use digital. Film still has the edge in the overall quality stakes, but the demands of the modern publishing world do not allow for the extra time needed to process and scan your negatives."

On using pixel-based cameras, he says, "Despite the fact that you can transfer a lot of your film skills to digital, the new cameras do require you to change the way that you would normally shoot."

The following are some of Patrick's tips for shooting digital action:

Exposure is critical. You have very little latitude for over- or underexposure. Use a hand-held meter if you want to double-check the exact amount of light falling on your subject.

Keep in mind that all lenses are longer on digital. Because digital sensors are smaller than the 35mm

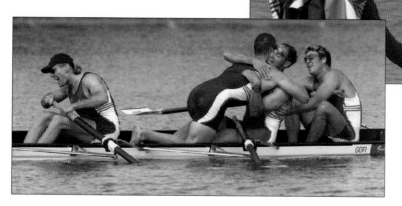

Fig 24 – The Olympics in Sydney was the first time in the history of the games that the majority of professional stills photographers shot digital rather than film.

frame, lenses used on these cameras have a comparatively longer focal length than stated. For instance, the Kodak DCS cameras have a focal length conversion factor of 1.6. This means that 20–40mm wide-angle zoom becomes a 32–64mm standard on these digital cameras.

Fill the frame. The file from a press-level digital camera is between 6 and 10mbs. This, though much better than previous cameras, gives a file that has little room for cropping in. Enlarging a section of this type of file will produce pixelated results so photographers must fill the frame.

Edit in-camera. The majority of digital cameras have the facility to view the images you have taken on a small in-built screen. This gives the photographer the opportunity to review, edit, keep or discard images whilst still on the job.

Anticipate the action. Some digital cameras have a slight time delay between the shutter button being pressed and picture being taken. With press cameras this is a comparatively short period of time, but experienced photographers still find that they have to allow for the time lag. They do this by releasing the button to coincide with the critical point of the action (see fig 25).

SHOOTING PROBLEMS AND SOLUTIONS

Problem: Main subject is not in focus (see fig 26).

Solution: This is usually caused by not having the auto-focus area on the main subject at the time of shooting. If your subject is off to one side of the frame, make sure that you lock focus on this point before recomposing and releasing the button.

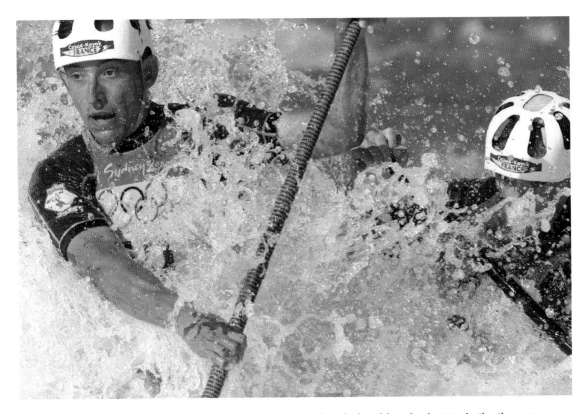

Fig 25 – Digital sports photography requires an approach in which the action point is anticipated and captured rather than seen. By the time you see the action, it will be too late to press the button.

BACKGROUND SHARP

SUBJECT UNSHARP

Fig 26 – Activating the camera's AF system with the subject not in the focusing area is usually the cause of the problem when the background of an image is sharp and the subject blurry.

Problem: Underexposure (see fig 27).

Solution: This time not enough light has entered the camera. Adjust the exposure compensation control to add more light or alternatively use a flash.

Problem: Movement: images appear blurry due to the subject, or the photographer, moving during a long exposure.

Solution: Use a tripod to reduce the risk of camera-shake and if the subject is active, try taking the picture at a point in the activity when there is less movement.

Problem: Flash off glass: the light from the flash bouncing straight back from a glass surface into the lens of the camera (see fig 28).

Solution: Using available light rather than the flash is one solution. Another is to move a little to one side so that the flash angles off the glass surface away from the camera (see fig 29).

Problem: Blown highlights.

Solution: This is caused by too much light entering the camera (overexposure). You can resolve this problem by adjusting the camera's exposure compensation control so that it automatically reduces the overall exposure by one stop. Shoot again and check the exposure. If the image is still overexposed, change the compensation to two stops. Continue this process until the exposure is acceptable.

Fig 27 – Underexposed images need to be re-exposed using either manually controlled exposure settings or one of the selections from the exposure compensation options on the camera.

Fig 28 – Shooting objects behind glass from directly in front often results in the flash being seen in the final picture.

Fig 29 – Moving to one side and shooting on an angle or turning the flash off and using available light will minimize reflections.

CAMERA TYPES AND MODELS

Digital cameras come in all shapes, sizes and price ranges. What you choose to purchase will depend on how you intend to use the images and the type of pictures you want to take. Essentially all cameras can be separated into three different groups:

Consumer

This group contains entry level cameras. These are designed for the budget-conscious user who wants to start in digital photography but has a limited amount of money to spend. The film camera equivalent is definitely the point-and-shoot variety.

Most consumer cameras have base level features, 2.0–3.0 megapixel sensors and fixed focal length lenses. These cameras use technology that we all thought was terrific a few years ago but which has been overtaken by new advances.

Prices start from as little as £100/US$140 for a very basic model and rise with functionality to about £300/US$450. The products here provide a good starting point for new digital users and for those photographers who need a simple camera with modest image-output quality (see fig 30).

Prosumer

This group contains the types of cameras designed for the serious amateur or the professional with limited needs. Here you will find advanced design and technology, high-resolution sensors and good-quality optical zoom lenses.

You will pay more for the units in this group, £300–1,000 (US$450–1,400), but what you are buying is extra levels of control for both the photographic and digital parts of the camera. Image quality in a lot of these units rivals that of the more expensive pro models.

Fig 30 – Consumer level cameras provide an economical entry point into an all-digital system.

The down side is that the designs are still proprietary, which means there is little chance of changing lenses or adding accessories already purchased for a separate film-based system. The cameras here are more than capable of producing professional photographic-quality results with technology that is definitely cutting-edge (see fig 31).

Pro cameras

These cameras are generally designed on the film-based bodies of either Nikon or Canon cameras. This means you can use the same lenses as you would on the traditional models. The target market is definitely the professional photographer and with prices that ranging up to £8,000 (US$11,000) you would have to be a very wealthy, or very serious, amateur to be able to afford one. Designed to look and feel

as much as possible like their film counterparts, the prosumer cameras are at the very forefront of digital-imaging technology. All the major companies like Kodak, Nikon, Canon and Fuji have a presence in this area of the market and, given the level of financial commitment involved in their development, this is a situation that will continue into the future (see fig 32).

Fig 31 – Prosumer level cameras often provide the image resolution of the high-end SLR units without the expense.

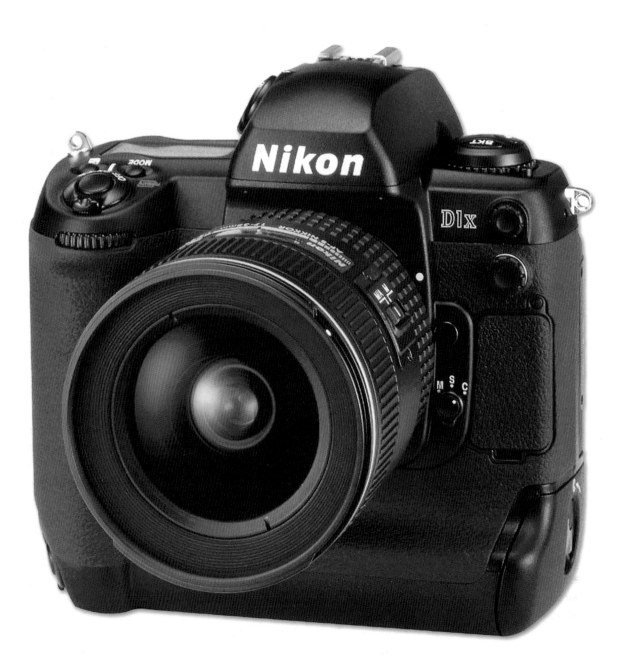

Fig 32 – Professional level cameras are designed to fit into already existing film-based systems.

BUYING YOUR FIRST DIGITAL CAMERA

With so many cameras on the market, it is important to compare features when deciding which unit to buy. Purely photographic variables like zoom length and maximum aperture are probably more familiar to you, but the digital options often cause new users more difficulties.

Below is a list of what I believe to be the most important digital features. When looking at cameras, take notes on their specifications in these areas. It will then be possible for you to compare "apples with apples" when it comes to the final choice.

Price: As a general rule of thumb, the more expensive cameras have greater resolution and a larger range of

features, both manual and automatic. This said, price can be a major deciding factor and it is important that you balance what you can afford with the limitations that come with each price bracket.

Resolution: The best cameras have chip resolution approaching 6.0 megapixels, and as you now know, the more pixels you have, the better quality the final prints will be. This said, cameras with fewer pixels still are capable of producing photographic prints of smaller sizes. The table below gives you an idea about what print sizes are possible with each resolution level.

Chip pixel dimensions	Chip resolution	Maximum photo-graphic image size at 200dpi
640 x 480	0.30 million	3.2 x 2.4 inch (81 x 61mm)
1440 x 960	1.38 million	7.4 x 4.8 inch (188 x 122mm)
1600 x 1200	1.90 million	8 x 6 inch (203 x 152mm)
1920 x 1600	3.00 million	9 x 8 inch (229 x 203mm)
2304 x 1536	3.40 million	11.5 x 7.5 inch (292 x 190mm)
2272 x 1704	4.0 million	11.4 x 8.5 inch (289.5 x 215.9mm)
2560 x 1920	4.9 million	12.8 x 9.6 inch (325 x 243.8mm)
3008 x 2000	6.1 million	15.04 x 10 inch (382 x 250.4mm)

Focus control: Fixed-focus cameras have lenses with large depths of field but no ability to focus on particular objects. These cameras are only suitable for general purpose photography. Auto-focus cameras have lenses that can focus on separate parts of the image. The number of AF steps determines how accurate the focusing will be.

Optical zoom range: Be sure to check that any information quoted on the zoom range of the camera is based on the optics of the lens rather than a digital enlargement of the picture. Enlarging the image is not a true zoom function and only serves to pixelate the image.

Aperture range: Small aperture numbers such as F2.8 mean that the camera can be used in lower light sce-

narios. If you regularly shoot in low light conditions, look for a camera with a lens which includes a range of aperture settings.

ISO equivalent range: Being able to vary the sensitivity of the chip is an advantage. You won't achieve the same quality results at higher ISO values as the base sensitivity, but having the option to shoot without a flash in low light gives you more flexibility.

Delay between shots: Cameras need time to process and store the shots you take. The size of the memory buffer will determine how much delay there will be between shots.

Flash type and functions: Most digital cameras have a built-in flash system. Check the power of the flash, which is usually quoted as a guide number. The higher the number, the more powerful the flash. Also take notice of the flash modes present in the camera. Options like red-eye reduction, fill flash and slow shutter flash sync are always useful.

Download options: Getting your images into your computer should be as easy as possible. If the camera uses a particular cable connection (USB, SCSI, serial, firewire and USB2.0) make sure your computer has the same option.

Storage capacity: The film used by digital cameras comes in the form of flash memory cards. The storage capacity of the card is measured in megabytes. The larger the card supplied with your camera, the more images can be stored before being downloaded to the computer.

Camera size and weight: The size and weight of a camera can determine how comfortable it is to use. Make sure you handle any prospective purchase before making your final decision.

Manual features: The ability to manually override or set auto functions can be a really useful, if not essential, addition to a camera's functionality. Auto everything point-and-shoot units are designed for general shooting scenarios, trying to make images outside of these typical conditions can only be achieved with a little more user control.

THE BLACK ART OF SCANNING (fig 33)

It was not too long ago that an activity like scanning was the sole responsibility of the repro house. The photographer's job was finished the moment the images were placed on the art director's desk. But as we all know, the digital revolution has changed things, and scanning is one area which will never be the same.

Desktop scanners that are capable of high resolution colour output are now so cheap that some companies will throw them in as freebies when you purchase a complete computer system. The proliferation of these devices has led to a large proportion of the photographic community now having the means to change their prints, negatives or slides into digital files. This provides a hybrid pathway for film-based photographers to generate digital files. But as all photographers know, having the equipment is only the first step to making good images.

The following steps will help you get the best out of the machinery you have to hand.

Set Up – Know Where You Are Going Before You Start the Journey

Without realizing it, when we pick up a camera, load a film and take a photograph we have made a range of decisions that will effect the quality of the final print.

By selecting the format – 35mm, 120 or 5 x 4 inch – we are deciding the degree that we can enlarge the image before we start to lose sharpness and see grain. The same can be said about our choice of film's sensitivity. Generally, low ISO stock will give you sharper and more grainless results than a faster emulsion. These things go almost without saying.

In a similar way, when we start to work digitally we have to be conscious of quality choices right from the beginning of the process. Essentially we are faced with two decisions when scanning – what resolution and what colour depth to scan with.

Resolution (fig 34)

Scanning resolution, as opposed to image or printing resolution, is determined by the number of times per inch that the scanner will sample your image. This figure will effect both the enlargement potential of the final scan and its file size. The general rule is, the higher the resolution, the bigger the file and the bigger the printed size possible before seeing pixel blocks, or digital grain.

For this reason, it is important to set your scanning resolution keeping in mind your required output size. Some scanning software will give an indication of resolution, file size and print size as part of the dialogue panel but for those of you without this facility, here is a rough guide:

Scanning Resolution	Image size to be scanned	Output size @ 300dpi	File size
4000	35mm (24mm x36mm)	20 x 13.33 inch (000 x 000mm) 6000 x 4000 pixels	22.7 mb
2438	35mm	11.5 x 7.67 inch (292 x 195mm) 3452 x 2301 pixels	22.7 mb
1219	35mm	5.74 x 3.82 inch (146 x 97mm) 1724 x 1148 pixels	5.68 mb
610	35mm	2.87 x 1.91inch (73 x 49mm) 862 x 574 pixels	1.42 mb
305	35mm	1.43 x 0.95 inch (36 x 24mm) 431 x 287 pixels	0.36 mb

Colour Depth (fig 35)

Colour depth refers to the numbers of possible colours that make up the digital file upon the completion of scanning. This is not as much of an issue as it used to be. Generally most modern computer systems can handle photographic quality colour, sometimes called 24 bit, where the image is made up of a possible 16.7 million colours. So here the decision is basically whether you want to scan in colour or greyscale (8 bit or 256 levels of grey). Be aware, though, that colour files are generally three times bigger than their greyscale equivalents. Some higher cost models have the option of working with 16bits per colour giving a total of over 65,000 levels of grey for a monochrome image and billions of colours for RGB files.

Capture Controls – If It's Not Captured, It's Gone Forever (fig 36)

With resolution and colour depth set we can now scan the image – well almost! Just as exposure is critical to making a good photograph, careful exposure is extremely important for achieving a good scan.

Fig 33 – For photographers with a sizeable financial commitment to film-based shooting, it is often a good idea to use a hybrid imaging system where film is shot and then scanned to provide digital files.

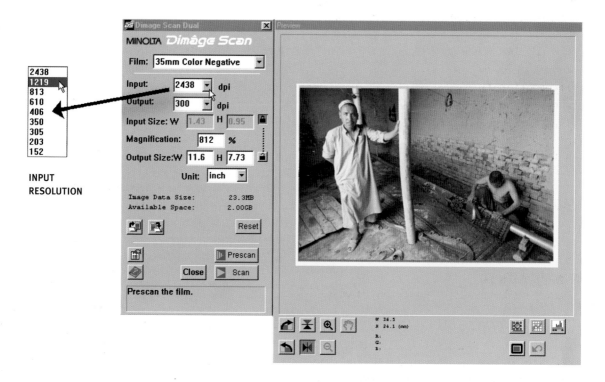

Fig 34 – You must have an idea about what the final use of the image will be before setting the resolution of the scanner.

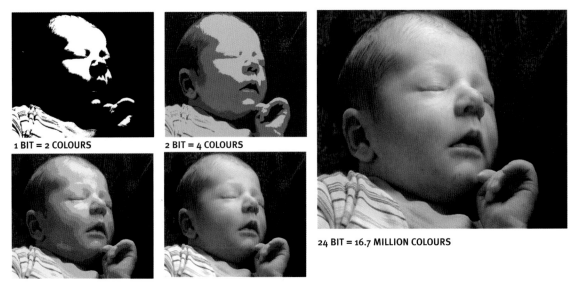

1 BIT = 2 COLOURS

2 BIT = 4 COLOURS

24 BIT = 16.7 MILLION COLOURS

4 BIT = 16 COLOURS

8 BIT = 256 COLOURS

Fig 35 – The colour depth of a file determines the numbers of colours possible in the image.

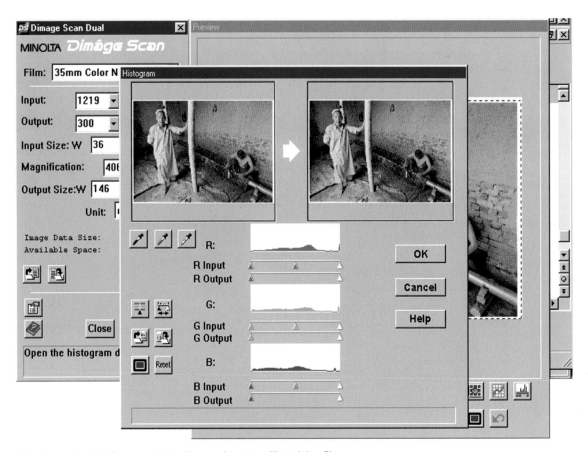

*Fig 36 – Good control of exposure during the scanning stage will result in a file
that contains as much of the information that was in the negative as possible.*

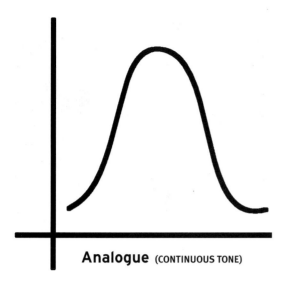
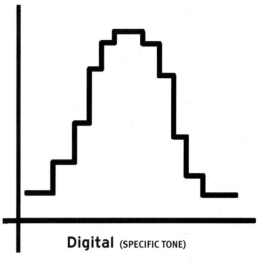

Analogue (CONTINUOUS TONE) **Digital** (SPECIFIC TONE)

Fig 37 – Scanners sample continuous tone originals at regular intervals, attributing specific numerical values for brightness, colour and position.

All but the most basic scanners allow some adjustment in this respect. Preview images are supplied to help judge exposure and contrast, but be wary of making all your decisions based a visual assessment of these often small and pixelated images. If you inadvertently make an image too contrasty, you will loose shadow and highlight detail as a result. Similarly, a scan that proves to be too light or dark will have failed to capture important information from your print or film original.

It is much better to adjust the contrast, sometimes called "gamma", and exposure settings of your scan based on more objective information. For this reason, a lot of desktop scanner companies also provide a method of assessing the darkest and lightest parts of the image to be scanned. With this information you can set the black and white points of the image to ensure that no details are lost in the scanning process.

For those readers whose scanning software doesn't contain this option, try to keep in mind that it is better to make a slightly flat scan than risk losing detail by adjusting the settings so that the results are too contrasty. The contrast can then be altered later in your image-editing package.

With all the pre-scan decisions made you can now capture your image.

ANLOGUE TO DIGITAL (fig 37)

Computers can only work with digital information, so the scanning process is designed to convert continuous tone pictures such as photographs, transparencies or negatives into digital representations of these images. The machinery samples a section of the picture and attributes to it a set of numerical values. These indicate the brightness and colour of that part of the image and its position in a grid of all the other samples taken from the photograph. In this way a digital version of the image is constructed, which can then be edited in programs like Photoshop or Paint Shop Pro.

COMMON SCANNING PROBLEMS AND SOLUTIONS

Problem: the image is too bright. The image has been scanned with settings that have resulted in an overexposed file. Highlight detail is lost and mid-

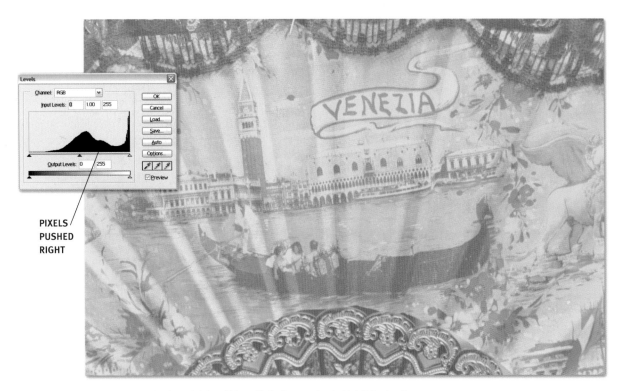

PIXELS
PUSHED
RIGHT

Fig 38 – A scan that is too bright will have limited separation in highlight details.

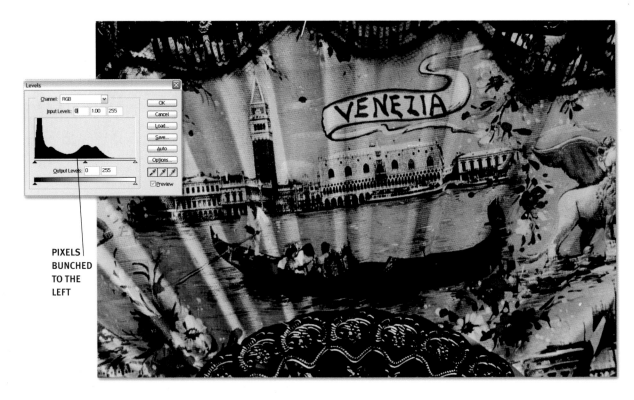

PIXELS
BUNCHED
TO THE
LEFT

Fig 39 – A dark scan will lose shadow details.

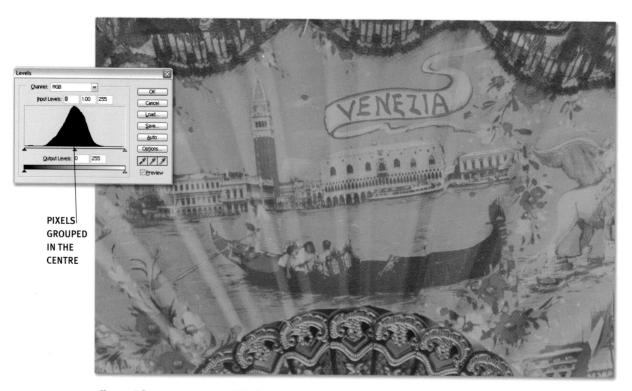

PIXELS GROUPED IN THE CENTRE

Fig 40 – A flat scan compresses all the image tones in the centre of the graph.

tone areas are too light. In the histogram the bulk of the pixels are at the right-hand end of the graph (see fig 38).

Solution: Rescan with a lower exposure setting.

Problem: The digital file shows no shadow detail. No matter what changes are made in your image-editing package, these details will not return. The histogram shows a bunching of pixels at the shadow end of the graph (see fig 39).

Solution: Rescan the image, changing either the shadow or exposure setting so that it gives these areas more exposure.

Problem: The digital file appears flat and lacking in a good spread of tones. The histogram shows a bunching of the pixels in the centre of the graph (see fig 40).

Solution: Either rescan with a higher contrast setting or use the Contrast or Levels features in your image-editing package to spread the tones across the graph.

SCANNER AS CAMERA (figs 41 & 42)

Tim Daly, UK-based illustrative photographer and author of countless digital imaging articles, users his scanner as a large camera to produce hauntingly beautiful images of everyday objects.

He says, "There is no reason why we shouldn't use all imaging devices at our disposal as ways of making great pictures. The scanner is, in effect, a large camera capable of capturing images with extremely fine detail in high resolution. The only drawback to scanner-based images is that it is not possible to 'shoot' moving objects."

*Fig 41 – It is possible to use your scanner
as a high-quality digital camera.*

*Fig 42 – Tim's process involves the scanning of
separate objects and their combining in Photoshop.*

Tim's technique for making cameraless pictures:

1. Prepare your scanner. This may mean that you need
to construct a small cardboard box, painted white on
the inside, which fits neatly over the glass surface.
2. Select the objects you wish to include in the mon-
tage using clipping paths to keep the edges sharp.
3. Scan each of the objects in turn creating separate
image files for each.
4. Open files in Photoshop and proceed to place
them into the one image as separate layers.
5. Adjust the size, colour, position and contrast
/brightness of each layer to suit the other compo-
nents in the image.
6. Selectively burn and dodge areas of the image to
add shadows to objects and direct the viewer's
attention by making some parts more apparent,
others less noticeable.

TYPES OF SCANNERS (figs 43 & 44)

There are essentially two different types of scan-
ners, those suitable for scanning prints and those
used for negatives and transparencies. Both types
sample the image at regular intervals to determine
colour and brightness, but the flatbed or print scan-
ner bounces light off the object onto the sensor,
whereas film versions scan the image via light trav-
elling through the film.

Companies like Microtek have been able to
combine both methods into their range of hybrid
scanners. With these units, the user can select
reflective- or transmission-based scanning,
depending on the original image type.

conversions of your images available. Files are saved in a variety of file sizes and resolutions, giving the user the ability to choose the level most suitable for the job at hand.

For those readers who don't want to invest in a scanner or who want file sizes greater than those available from the average desktop unit, third party scans may be the answer.

Fig 43 – Film scanners are usually more expensive than their flatbed counterparts and are capable of scanning negatives as well as slides.

Fig 44 – Print scanners are a very economical way to start making digital images from your film originals.

OTHER SOURCES OF DIGITAL FILES (fig 45)

During recent years, other options for obtaining digital versions of your silver-based images have started to be provided by high-street photo labs. It is now possible to drop your film off at the local processing business and have the negatives processed, printed, scanned and saved to CD-rom as part of the service. The quality and resolution of the scans vary from one provider to the next, so ask to see examples before committing yourself.

Putting images on CD was a process pioneered by Kodak in the mid nineties with its ProCD product. This system still provides some of the best digital

Fig 45 – High-street processing business-es are now offering the option of process-ing,printing, scanning and saving to CD in the one service.

MANIPULATING

MANIPULATING

The real power of the digital process of image making is only truly revealed in this stage of production. Just as with traditional photography there are a range of techniques and equipment designed to help turn those precious captured images into printed ones. In this section we will start with some basic techniques that have their roots firmly grounded in familiar darkroom ideas and move to some ideas that are strictly digital.

THE SOFTWARE

The main tool that photographers use when working with digital photographs is an Image Editing program. This piece of software enables the digital worker to creatively control and selectively change the images he or she has captured.

There is a range of different packages on the market (see fig 1). They fall roughly into 3 categories – entry, intermediate and professional level. Of all the groups Adobe's Photoshop is the clear leader. Despite it being a piece of software designed specifically for the professional market it has gained wide acceptance with all levels of users irrespective of their experience level. The rest of the packages have places in the market defined not so much by their cost but by how simple they are to use.

Entry Level – These packages are the easiest pieces of software to use. They offer simple approaches to common tasks and an interface that is uncomplicated and well laid out. Often they are designed so that children and new image workers can easily transfer images from camera or scanner, make a few changes and then print them out. Some even contain special "wizards" or automated step-by-step instructions for creating greeting or post cards, posters and stickers. With the upsurge of interest in the web more and more of these programs also include features that ease the process of publishing your images online.

As a first outing these products are well worth trying, especially because you will find them very competitively priced or even better, bundled free with your camera or scanner. There are, however, two sides to the simplicity coin – the very approach that makes these products easy to use also means that they can be quite limiting.

Such limitations are not obvious when you restrict yourself to activities for which the program was designed. But when you try to be a little more creative you might find yourself frustrated by not being able to change the settings of certain parts of the program. Over the last few years though these entry level packages have made major progress in terms of features and functions. So I belive that you can cut your teeth on these economically priced packages before spending the "big money" for something a little more sophisticated.

Figure 1 – Digital imaging software packages come in three different levels determined by their ease of use and sophistication more thas by their price.

Intermediate Level – The programs in this group give you more features and tools and in so doing allow you to be more creative. It's here that you will find the biggest growth area of the image editing market. Often programs that start their life with entry level features develop with maturity and sophistication to a level that meets the needs of the intermediate user. The software companies know that most digital workers want the power and the flexibility of the professional packages, but at budget prices.

To a large extent the software in this group provides what the imaging public wants. The products here contain most of the features and flexibility of the professional packages with less of the limitations of the entry level options. Of course there are differences. You would expect there to be when you can pay up to five times more for Photoshop than you do for Paintshop Pro. The feature sets of the intermediate packages can be smaller, the level of user interaction not as great, but on the whole these pieces of kit do a great job.

When you find that you are being limited by the program that came with your scanner these packages would be your next step.

Professional – This category contains the cream of editing software. It is here that you will find packages that are packed to the brim with features, functions and filters. The sheer range of options can often make these programs difficult to learn and even more difficult to master. These programs are used daily by professionals in a range of areas. The flexibility and sheer number of image editing tools means that medical, press, portrait and commercial photographers can all find a *modus operandi* with these packages that suits them.

Photoshop has always been a major player in this part of the market, but in recent years it has dominat-

ed the area, providing the model that all other packages are trying to emulate. There is no disputing that Photoshop is already a feature rich mature package. When you couple this with the fact that Adobe releases a new version of it's flagship software every 12 months or so, you can see why the others are finding it hard to play catch up. The way that Photoshop links with professional level desktop and web publishing software means that it's not just photographers who are singing the program's praises.

If you are planning to use images you create professionally then skip the first two categories and dive straight into a professional package. The learning curve will be steep to start with, but you will be rewarded with a much more powerful and comprehensive image editing environment.

MENU

TOOLBAR

DOCUMENT

WORKSPACE

DIALOGUE BOX

Figure 2 – Most packages have a method of setting up the screen work space that is similar.

THE WINDOW TO A NEW WORLD (fig 2)

The interface is the way that the software package communicates with the user. Each program has its own style but the majority contain a work space, a set of tools laid out in a tool bar and some menus. You might also encounter some other smaller windows around the edge of the screen. Commonly called dialogue boxes and palettes, these windows give you extra details and controls for tools that you are using.

Programs have become so complex that sometimes there are many different boxes menus and tools on screen that it is difficult to see your picture. Photographers solve this problem by treating themselves to bigger screens or by using two linked screens – one for tools and dialogues and one for images. Most of us don't have this luxury so it's important that right from the start you arrange the parts of the screen in a way that provides you with the best view of what is important – your image. Get into the habit of being tidy.

KNOW YOUR TOOLS (fig 3)

Over the years the tools in most image editing packages have distilled to a common set of similar icons that perform in very similar ways. The tools themselves can be divided up into several groups depending on their general function.

DRAWING TOOLS (fig 4)

Designed to allow the user to draw lines or areas of colour onto the screen, these tools are mostly used by the digital photographer to add to existing images. Those readers who are more artistically gifted will be able to use this group to generate masterpieces in their own right from blank screens.

Most software packages include basic brush, eraser, pen, and line, spray-paint and paint bucket tools. The tool draws with colours selected as and categorised as either foreground or background.

Figure 4 – Drawing tools allow you to change
and add to the pixels that make up your digital photograph.

SELECTING TOOLS (fig 5)

When starting out most new users apply functions like filters and contrast control to the whole of the image area. By using one, or more, of the selection tools, it is also possible to isolate part of the image and restrict the effect of such changes to this area only.

Figure 5 – Selection tools enable the
user to isolate a group of pixels to work on.

Figure 3 – The toolbar contains the most
often used imaging tools and functions.

Used in this way the three major selection tools – lasso, magic wand and marque – are some of the most important tools in any program. Good control of the various selection methods in a program is the basis for a lot of digital photography production techniques.

TEXT TOOLS (fig 6)

Adding and controlling the look of text within an image is becoming more important than ever. The text handling within all the major software packages has become increasingly sophisticated with each new release of the product. Effects that were only possible in text layout programs are now integral parts of the best packages.

TYPE/TYPE MASK/VERTICAL/VERTICAL MASK

*Figure 6 – Adding text or type to your images
is a comparatively simple process with most packages.*

VIEWING TOOLS (fig 7)

This group includes the now infamous magnifying glass for zooming in and out of an image and the move tool used for shifting the view of an enlarged picture.

 ZOOM MOVE

 HAND

*Figure 7 – Viewing tools help you to
navigate, and zoom in and out of, your images.*

OTHERS (fig 8)

There remains a small group of specialist tools that don't fit into the categories above. Most of them are specifically related to digital photography. In packages like Hotshots they include a "Red Eye Remover" tool specially designed to eliminate those evil-eyed

images that plague compact camera users. Photoshop on the other hand supplies both "Dodging", and "Burning-In Tool" tools.

DODGING/BURNING IN/SATURATION SPONGE

*Figure 8 – Most packages contain a host of other tools and some
even allow the user to customize the toolbar with those most used.*

SOFTWARE – WHAT ARE
SOME OF THE CHOICES?

To give you some idea of what is available the following is a summary of seven of the leading software packages on the market. Each program has its own strengths and weaknesses, and it wouldn't be possible to select any one product that would be suitable for all photographic jobs and users. When making your choice consider

- the type of activities you want to undertake,
- your current level of experience
- the type of activities you want to undertake in the future.

ROXIO PHOTOSUITE 4 PLATINUM
(figs 9 &10) *Level: Entry/intermediate*

Figure 9 – PhotoSuite is a feature full editing package that boasts a user base in the millions worldwide.

Over the past few years Roxio, previously MGI Software, has sold more than 26 million units of its top three software packages – PhotoSuite, VideoWave and Live Picture. The latest release of PhotoSuite confirms Roxio's commitment to the area and introduces a new range of functions and added features for users. Straddling the entry and intermediate levels, this package caters for most digital photographic needs.

Summary
PhotoSuite 4-Platinum Edition is the latest version of Roxio's Web and PC photo software. The new version adds more power to its photo-enhancement tools, e-sharing capabilities, and extends the boundaries of imaging beyond the desktop to the Internet with new Web features that allow home and business users to create personal websites in minutes.

FEATURES
General: PhotoSuite has a clean "look and feel" and includes thorough step-by-step guides that allow users of all experience levels to employ a vast lineup of features available for getting, preparing, composing, organizing, sharing and printing photos.

Image Editing and Enhancement Tools: Manipulation controls include cut, clone, crop, adjust colors and resize your photos. You can also remove red eye, wrinkles and blemishes or restore old, torn and faded pictures. You can choose from many special effects including warp, ripple, splatter, mirage, sepia, moonlight and more.

Image Organization Tools: Other features allow users to organize, store and retrieve photos in customized electronic albums. Fast, powerful keyword search makes it easy to find what you want. PhotoSuite comes with more than 1,500 professionally designed templates for home and business.

Recognizing that sometimes users simply want to view a photo rather than edit it, PhotoSuite 4 ships with a separate image viewer that provides users with a means of quickly viewing or browsing image content.

Best Uses:
- Home office
- School projects
- Family photos
- Image preparation for web
- Very good general purpose image editing program

EXTRA FUNCTIONS
Enhanced PhotoTapestry:
A favourite among users, PhotoTapestry replicates a photo by tiling up to 2,000 thumbnail photos in the form of the original. In this version of the program users now have the ability to create their own thumbnail collections, in addition to using any of the 30,000 thumbnails included.

Figure 10 – PhotoSuite uses a simple task orientated screen to guide users through common editing activities.

Personal Web Page Creation and Publishing:

PhotoSuite 4 includes a complete set of tools for the creation and publishing of websites. Users can select one of the pre-designed web templates included and simply add image content, or they can take complete control over design and layout. With a few simple clicks of the mouse, users can add image content, text with animation, hyperlinks, and incorporate borders and drop shadows.

Support for Web-based Email:

The package supports sending photos directly through popular web-based email services such as Hotmail and AOL Mail. Users are able to reduce and optimize file size before sending photos and can even send multiple photos as an executable file that launches a special slide-show viewer.

Web Animations:

PhotoSuite 4 includes a GIF (Graphics Interchange Format) file editor. This features allows users to turn photos into frames of an animated GIF. You have complete control over playback options, frame duration, and can even add transitions between frames.

Panoramas:

The inclusion of an enhanced stitch engine gives digital image makers the ability to stitch together as many as 48 photos, and create 360° interactive web panoramas that a web-page visitor can navigate.

Screen Saver Creator:

Also new to PhotoSuite 4 is support for MP3 files, as well as a sophisticated screen saver creator, which includes the ability to use scrolling panoramas.

Recommended Hardware Requirements:
Microsoft Windows 95, 98, ME, NT 4.0 (SP3 or higher), Windows 2000 or XP.
Internet Explorer 5 is required and included.
The recommended system required is a Pentium II – 266MHz, 32 MB of RAM recommended, SVGA Video Card, 800 x 600 screen area, 24-bit True Color 2 MB Video RAM, 200 MB Hard Drive space plus 65MB space for IE and DirectX.

Current Version: Photosuite 4 Platinum

Platform: PC

Price: US$49.99

Download Trials: No

Web Link: www.mgisoft.com
www.photosuite.com

MICROSOFT PICTURE IT! PHOTO STUDIO 2002 (Figs 11 & 12)
Level: Entry

Picture It! Photo Studio is exactly what you would you expect from the biggest software publishing company in the world. With a new web-styled start-up screen, automated correction tools, and step-by-step guided projects, it's easy for users to complete most photo-editing tasks. You can access your photos from almost any source, fix common photo problems and then share your images with everyone you know – in print or online.

Also worth noting is a publishing version of the product that combines the photo editing features of Picture It! with an easy to use desktop publishing package. Microsoft has obviously taken note of public cries for a piece of software that can go from digital camera to finished publication in the one program.

Figure 11 – Picture it! is Microsoft's entry into the imaging market. The package provides easy to use functions for most home imaging needs.

Summary

You can access your photos from a digital camera, scanner, or the Internet. The editing tools included allow you to automatically correct brightness, contrast, sharpness, and tint or colour cast. You can also fix photo problems such as red eye, remove blemishes and wrinkles from faces and use cutting-edge photo effects like emphasise and fade.

Users can then print at home with most photo and specialty papers.

FEATURES
General:
Digital camera-friendly Mini Lab works with multiple photos at the same time.

Image Editing and Enhancement Tools:
Text effects include photo, fill, bend shadow, highlight, 3D, floral, stained glass, quilt, wave, swirl, satin, and chrome. Sizing and positioning tools allow you to crop, rotate, flip, skew, align, match colour; other tools include alignment guides, rulers, edge finder, and shapes. Touchup your images with tools like brightness and contrast, tint, red eye, dust, blemish, scratch, black and white, old to new, and scratch and wrinkle removal.

Add Special effects such as shadow, transparency, blur, sharpen, distort, 3D effects, fade and clone. Illusions filters include chalk, crayon, ink, marker, pencil, sketch, watercolor, emboss, glass, glow, mosaic, metal, sepia, impressionist, sponge, fingerpaint, and burlap. A range of paint and colour effects include freehand, photo stroke, art stroke, gradient fill, and stamping. Frames include highlighted, soft, stamped, cool, photo stroke and art stroke.

Image Organization Tools:
Catalogue photos and find them easily with the Gallery feature. Search your catalogued items by

name, date, or event to find your photos quickly and easily. Make use of multiple save options, such as save for the web, save as wallpaper, send by e-mail, save to Kodak PhotoNet online.

Print features include wallet-size photo templates, specialty paper templates, print multiple, index print and print online at fujifilm.net and at Kodak PhotoNet.

Best Uses

- Home office
- School projects
- Family photos
- Very good general purpose image editing program
- Simple web page creation

EXTRA FUNCTIONS
Web:

The software allows you to create and post personal web pages, albums, and slide shows with guided set of project tools.

Email:

You can also E-mail your photos to friends and family and receive true photographic prints in the mail when you send your projects to fujifilm.net or Kodak PhotoNet online print service.

Recommended Hardware Requirements:
A multimedia PC with Pentium 166-MHz or higher processor.
The Microsoft Windows® 95 or 98, Windows ME, Windows NT, or Windows 2000 or XP operating system.
For Windows 95 or Windows 98: 64 MB of RAM
For Windows ME or Windows 2000: 64 MB of RAM
245 MB of available hard disk space
Microsoft Internet Explorer 5.5 software
Quad-speed CD ROM drive or higher.
Super VGA monitor (1 MB of VRAM).
Microsoft mouse or compatible pointing device.

Current Version:
Picture It! Photo Studio 2002
Also available: Picture It! Publishing Gold Edition

Platform: PC

Price: US$54.95

Download Trials: No

Web Link: www.microsoft.com

ULEAD PHOTOIMPACT (figs 13 & 14)
Level: Entry/Intermediate

PhotoImpact 8 is an image editor that addresses both the image editing and web page creation needs of the average digital photographer. You can manipulate your images and lay out web graphics and then optimize and output them as complete web pages.

Summary
Ulead's imaging program gives the user a range of tools, and a changing interface that is designed to support both simple and complex manipulation tasks. You can edit images and create web pages using functions such as:
- A full array of imaging & painting tools
- Vector 2D and 3D graphics
- Over 60 exclusive special effects & filters
- Visual web page layout & one-click HTML output

FEATURES
Image Editing and Enhancement Tools:
PhotoImpact includes an extensive set of creativity tools for creating and editing photographic content. Imaging Tools include:

Figure 13 – Photoimpact is a very capable entry level package that has enough functions and features to be considered as a semi-intermediate candidate.

- Special Effects
- Path Drawing Tools
- Text Tools & Effects
- Wrap & Bend
- Masking

Painting features
- 12 Paint brushes including Paintbrush, Airbrush, Crayon, Chalk
- 9 Clone brushes like Bristle, Oil Paint, Marker.
- 14 Retouch brushes such as Dodge, Burn, Smudge. Cursor shows true brush shape
- Paint and clone using object mode for improved layer control
- Paint with textures
- New Colorize Pen retouch tool

Special Effects
Lighting: Create still and animated effects using Lightning, Bulb light, Fireworks, Meteor, Comet, Halo, Spotlight, Lens flare, Laser and Flashlight

Type: Add gradient, transparency, hole, glass, metal, emboss, emboss-outline, emboss-texture, sand, concrete, lighting, fire, snow, neon and seal effects to text, selections and objects

Transform: Create still and animated effects with smudge, pinch, punch, ripple, stone, mirror, horizontal and vertical mirror, whirlpool, diffuse and horizontal squeeze

Particle: Add element-based fire, rain, clouds, snow, smoke, bubbles, fireflies and stars

Artistic Textures: Create unlimited still or animated textures using palette ramps, hue shifts and coloring control

Warping: Distort images & objects using various effects

Image Organization Tools:
The program features a customizable interface, visual "Pick-and-Apply" galleries, providing the user with simple but effect tools for editing and enhancing their images. Features include:
- EasyPalette

Figure 14 – Photoimpact makes use of the familiar toolbar and menu driven approach to its screen design.

- Quick Command Panel
- Album Management
- Screen Capture
- Digital Watermarking

Best Uses
- Home office
- School projects
- Family photos
- Image preparation for web

EXTRA FUNCTIONS
Web Toolkit
PhotoImpact 6 delivers the tools needed to create web graphics and complete HTML pages. Features include:
- Save as web page
- Component Designer
- HTML Text
- Interactive Rollovers & Buttons
- Image Optimisation
- GIF Animation
- Image Slicing

Recommended Hardware Requirements:
Intel Pentium or above compatible system.
Microsoft Windows 95/98/NT4.0 SPE
(or above) or Windows 2000 64MB of RAM or
Windows XP.
240 MB of available hard disk space. CD-ROM
Drive. True Color or High Color display and moni-
tor. Mouse or WinTab Compatible pressure-sensi-
tive graphics tablet (optional).

Current Version:
PhotoImpact 8

Platform: PC

Price: US$89.95 boxed version
US$79.95 download version

Download Trials :
Yes – 30 day from www.ulead.com

Web Link: www.ulead.com

ADOBE PHOTOSHOP ELEMENTS (figs 15 & 16)
Level: Entry/Intermediate

Adobe has finally heard the cries of the mortals and has produced an image manipulation package that has the strength of Photoshop 7.0 with a price tag more equal to most budgets. Adobe's new package gives desktop image makers top quality image editing tools that can be used for preparing pictures for desktop printing, or web work. Features like the panoramic stitching option, called Photomerge, and the File Browser palette are sure to become favourites.

Figure 15 – Photoshop Elements is Adobe's entry level product and is squarely aimed at the home market.

Thankfully the colour management and vector text and shape tools are the same robust technology that drives Photoshop itself, but Adobe has cleverly simplified the learning process by providing step-by-step interactive 'How Tos' or recipes for common image manipulation tasks. These coupled with new features like Fill Flash, Adjust Backlighting and the Red Eye Brush tool make the package a digital photographer's delight.

Summary
You can use guided activities to bring your photos into the computer organize photos, touch up, enhance, and modify images, and share your images in print, via e-mail, or on the Web

FEATURES
Organization
• Import photos from a scanner, digital camera, floppy disk, KODAK Picture CD, or the Internet.
• Store, manage, and locate photos with the built-in File Browser, which lets you create customized albums.

Editing and Enhancement
• Touch up or repair photos
• Improve brightness, contrast, and colour with the Quick Fix dialogue
• Apply dozens of special effects.
• Ensure that the colours you print match the colours on-screen with built-in colour management software.

Creativity
• Use styles to quickly add drama and pizzazz to the way that your images look
• Create personalized PDF slideshows.
• Use Photomerge to create a panorama from multiple images.

Best Uses
• Home office
• School projects
• Family photos
• Image preparation for web

EXTRA FUNCTIONS
• Create personalized wallpaper for your PhotoDeluxe screen background.
• Assemble a multimedia presentation complete with captions, music, and animations with PhotoParade

E-Sharing
Post photos and photo projects directly to your personal web community on ActiveShare.com. E-mail photos and slide shows from directly within PhotoDeluxe.

Figure 16 – A simple icon driven approach to editing activities means that this package is easy to use for all levels of users.

Hardware Requirements – Mac:
PowerPC® processor
Mac OS 9.1, 9.2.x, or Mac OS X v.10.1.3-10.1.5
128MB of RAM with virtual memory on
350MB of available hard-disk space
Colour monitor capable of displaying thousands
of colours at a resolution of 800x600 or greater
CD-ROM drive

Hardware Requirements – PC:
Intel Pentium processor
Microsoft Windows 95, Windows 98, Windows NT
4.0 with Service Pack 5 or Windows XP
128 MB of available RAM
150 MB of available hard-disk space
Colour monitor with 800x600 resolution and
thousands of colours

CD-ROM drive
32-bit TWAIN data source or Adobe Photoshop
compatible plug-in
Internet Explorer 5.0, 5.5 or 6.

Current version: 2.0 (Windows)
2.0 (Macintosh)

Platform: PC, Mac

Price: US$99.00 (either platform)

Download Trials : Yes

Web Link: www.adobe.com
www. ActiveShare.com

COREL PHOTO-PAINT 10
(figs 17 & 18)
Level: Intermediate / Professional

With its eyes firmly set on the professional market Corel over the last few years has been busy developing a substantial image editing and creating package. Photo-Paint was originally conceived as a bitmap editing add-on to Corel's now famous vector drawing package – Corel Draw. Now in version 10 this product has certainly matured way beyond these unassuming roots.

Unfortunately for much of this program's life it has lived in the shadow of Adobe's Photoshop and this has meant that a lot of photographers are still unaware of the vast array of image creation and editing features that Corel has managed to squeeze into their product.

In some ways it is a little unfair to make direct comparisons with other editing packages. Even though Photo Paint does contain an extensive range of editing tools this is only half the story. Much of the product's power is in the way that it integrates image creation features with the enhancement tools. This shouldn't be surprising giving Corel's history with vector drawing packages.

Figure 17 – Photo-Paint is an editing and image creation product designed with the professional image maker in mind.

Summary
Touted as the imaging tool to use for everything from "precision editing" to "original painting", Corel Photo-Paint is certainly a product that is worth looking at if your day to day work requires image creation as well as enhancement. Along with Photo-Paint's substantial image editing and creation tool set comes a range of add on technologies that will help streamline your imaging activities. These include
- Media asset management via the inclusion of Canto Cumulus Desktop
- Bitstream Font Navigator for font management
- Corel TEXTURE – realistic natural textures
- Corel CAPTURE – application window screen captures
- Corel SCRIPT Editor – scripting application
- Digimarc Digital Watermarking
- Human Software Squizz! To help create distortion effects. 800 TrueType and Type 1 fonts

FEATURES
Image Editing and Enhancement Tools:
Choose from over 15 Artistic Media brush types featuring hundreds of options or create your own brush types. Over 100 Effects filters, including new artistic, texture-based and creative effects. Multiple onscreen color palettes. Extensive Undo and Redo features. Support for pressure-sensitive graphics tablets.

Experiment using Live Effects, with interactive tools including Perspective Drop Shadow, Watercolor Effect, Plastic Effect, Fill, Blend, and Transparency. Apply non-destructive visual effects to any image with over 20 different lenses.

*Figure 18 –
Photo-Paint's
interface echoes
the design of the
company's major
vector editing
package – CorelDraw.*

Image Organization Tools:

Use the Ixla digital camera interface for easy download of images from over 120 camera models. Enhanced printing features – imposition layout, preflight warnings, miniature preview to verify changes and downsampling of bitmaps. Easy import and export of images with embedded ICC standard profiles – CPT, CDR, TIFF and EPS. Import, edit and export multi-layered Adobe Photoshop PSD files, Adobe Illustrator AI and EPS files, and MetaCreations Painter RIFF files

Best Uses

- Professional level photographic enhancement and editing
- Professional level bitmap image creation
- Home office
- Image preparation for web and print publishing

EXTRA FUNCTIONS
Web

Integrated web design features, including animated GIF, QuickTime(tm) VR, AVI and MPG creation, and support for GIF 89a, PNG, TGA, PCX and JPG with onscreen preview.

Hardware Requirements – PC :
Windows 95, Windows 98 or Windows NT 4 or XP
32 MB RAM (64 MB recommended)
Pentium R 133
2X CD-ROM drive
Mouse or tablet
SVGA monitor
100 MB hard disk space

Hardware Requirements – Mac:
Power Macintosh Power Macintosh G3
Mac OS 7.6.1 Mac OS 8.1, OSX or higher
32 MB RAM with Virtual Memory enabled
64 MB RAM or greater
CD-ROM drive

Current Version: PC – 10
 Mac – 10

Platform: PC, Mac

Price: US$249.00

Download Trials : No

Web Link: www.corel.com

JASC PAINTSHOP PRO (figs 19 &20)
Level: Intermediate

Jasc has cleverly positioned its product between the template driven entry level packages and comparatively expensive professional ones. Providing much of the feature set of the big products and more flexibility than the smaller ones Paint Shop Pro has always had a huge user base the world over. Now in its seventh version, this is a mature package that provides what most serious photographers demand from their editing program.

Summary
Start to use this package and you will discover what 20 million users already know – Paint Shop Pro offers the easiest, most affordable way to achieve professional image editing results.

Paint Shop Pro enables users to:
- Retouch, repair, and edit photos with high-quality, automatic photo enhancement features
- Create and optimize Web graphics with built-in Web tools and artistic drawing and text tools
- Design animations with Animation Shop 3 included free
- Save time with productivity tools: grids, guides, alignment, and grouping
- Expand your creativity with over 75 special effects
- Share photos electronically via e-mail, Web sites, and photo-sharing sites

FEATURES
Image Editing and Enhancement Tools:
Tools for Painting, Drawing, Text, Image Editing, Layers and Layer Blend Modes. Screen Capture features and Digimarc Watermarks. Special Effects Filters, Picture Tubes and Picture Frame Functions.

Automatically adjust colour balance, enhance brightness, saturation, and hue. Remove red-eye, automatically. Restore damaged photos with Scratch Removal Tool. Adjustable Histogram enhances details without loss of information. Instantly remove noise, scratches, dust, or specks and improve crispness and impact. Repeat last command feature.

Image Organization Tools:
Direct Digital Camera Support, Photo Enhancement Filters, Colour Adjustments and Adjustment Layers. Visual Browser, Multiple-level Undo/ Redo, Multiple Image Printing and Batch File Format Conversion features. Enhanced Support for nearly 50 file formats, which is more than any other product on the market.

Figure 19 – PaintShop Pro started as a highly regarded shareware product. Now in its seventh version this is an intermediate level product with a small price and its eyes set firmly on making some in roads into the pro market.

Figure 20 – Using the familiar menu and toolbar combination, there are more than a few similarities with the other major products in the professional and intermediate areas.

Best Uses

- Professional and intermediate level editing
- Home office
- School projects
- Family photos
- Image preparation for web

EXTRA FUNCTIONS

Web Development Tools

Create professional-quality GIF animations with Animation Shop 3. Speed-up downloading of web graphics with Image Slicing. Automatically create "hotspots" and embed URL links with new Image Mapping features. Create visual mouse-overs with Image Rollover effects. Preview graphics in various web file formats in up to 3 browsers. Enhanced Optimize graphics for high web performance with JPG/GIF/PNG Optimizer.

Recommended Hardware Requirements:
500 MHz or better processor
128 MB of RAM
32 bit color display adapter at
1024 x 768 resolution

Current Version: 7

Platform: PC

Price: US$99.00 USD download
US$109.00 USD boxed

Download Trials: Yes – www.jasc.com

Web Link: www.jasc.com

ADOBE PHOTOSHOP (figs 21–23)

Level: Professional

Figure 21 – Adobe's Photoshop is the premier editing product in the market today. Its feature and tool range coupled with its robustness has made it the industry favourite for several years now. With the release of version 7.0 don't think that this situation will alter too much in the future.

Now in its seventh version, Photoshop is definitely the tall poppy of the image editing market. Millions of professional users the world over have made this package the industry standard. With each new version of the product Adobe has cemented its position as the undisputed front runner.

Adobe Photoshop 7.0 software introduces the next generation of image editing with the broadest and most productive tool set available. With strong links to major web and desktop publishing packages Photoshop enables the professional user to achieve the highest quality results across all media.

Summary

Adobe Photoshop 7.0 software maximizes creative possibilities with a wealth of innovative new tools. For web designers, the combination of new vector drawing tools with powerful rollover styles allows for quick creation of buttons and other web graphics. And now users can easily create sophisticated, multi-state JavaScript rollovers by saving custom button shapes in libraries then selecting rollover styles in ImageReady 7.0 to automatically slice the buttons and apply a variety of new layer effects.

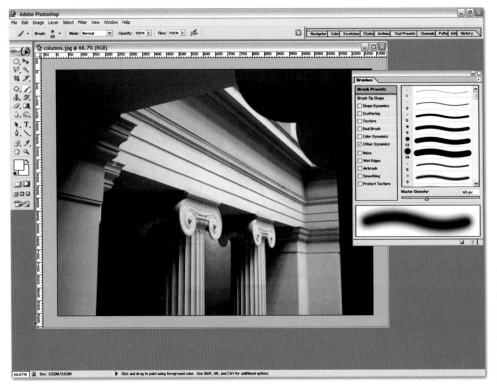

Figure 22 – Photoshop is the package that pioneered the menu/toolbar interface that a lot of the other packages now emulate.

Figure 23 – Adobe is also marketing a cut down version of its frontline product under the LE or limited edition tag. Containing the most used basic tools and functions of the fully fledged program the competitive pricing of this product does make it a viable entry into Adobe's world.

FEATURES

Image Editing and Enhancement Tools:

Photoshop includes the most flexible toolset on the market. The combination of selection, painting and enhancement tools has set the industry standard that the other programs follow. In addition to those tools we already know version 6 includes vector shape drawing with resolution-independent output and on-canvas text entry and advanced formatting.

Image Organization Tools:

Including a collection of automated tools like the much used "Contact Sheet", Photoshop provides basic robust organization tools designed for the professional user.

Best Uses

- Professional level photographic enhancement and editing
- Home office
- Image preparation for web and print publishing
- Extensive linking with professional publishing packages for web and print.

EXTRA FUNCTIONS

PDF Support:
Extensive PDF workflow including shared PDF annotations.

Web:
Streamlined web workflow with Adobe GoLive and Image Ready 7.

Print:
Streamlined web workflow with Adobe Illustrator and InDesign.

Hardware Requirements – PC:
Pentium-class processor
Microsoft Windows 98, Windows Millennium, Windows 2000, Windows NT 4.0 or XP
64 MB of available RAM
125 MB of available hard-disk space
Color monitor with 256-color (8-bit) or greater video card
Monitor resolution of 800x600 or greater
CD-ROM drive

Hardware Requirements – Mac:
PowerPC-based Macintosh computer
Mac OS Software version 8.5, 8.6, 9.0, or OSX
64 MB of available RAM (with virtual memory on)
125 MB of available hard-disk space
Color monitor with 256-color (8-bit) or greater video card
Monitor resolution of 800x600 or greater
CD-ROM drive

Current Version: 6

Platform: PC, Mac

Price: US$609 (U.S.) for all platforms

Download Trials: Yes – www.adobe.com

Web Link: www.adobe.com/products/photoshop

SIDE BY SIDE COMPARISONS

To give you a good idea about what each level of software is capable of, the techniques described in the following chapters will demonstrate how to use three different software packages to achieve similar effects. As the techniques become more complex you will notice that the simpler packages might not have the features needed to complete the task, but on the whole the differences of approach and flexibility will become obvious.

For entry level I will use Ulead PhotoImpact software. From the intermediate group I have picked the much famed Paintshop Pro, and for the professionals Photoshop will be used.

I have also included both Macintosh and Windows shortcuts for software that is available on both platforms.

WHAT EQUIPMENT DO I REALLY NEED ?

In this new photography the computer is a major part of your digital darkroom. This machine is the pivot point for image acquisition, manipulation and output. For this reason it is important to be clear about what equipment is really needed for the job.

The metal box that sits on the computer desk before you contains a variety of components that together give you access to your images. Each component plays a part in the image production cycle.

Processor (CPU) – It seems that every 6 months or so the major chip manufactures produce a new version of their front line processors. These chips are the engine of your computer and as such determine how quickly your machine will complete most tasks (see fig 24).

The processors are catagorized in terms of their cycle speed and generally speaking, the higher the number, the faster the chip. At present the best chips have a speed of about 2200mhz. Compared to the 12mhz "Turbo" chip that drove my computer in 1989 these new processors just fly. But as soon as the chip makers develop faster models, software manufacturers and creative users dream of even more complex tasks to give them. The result is no matter what speed the machine is they never seem fast enough for the job at hand.

CPU Purchase tip – The fastest and latest are also the most expensive. Buying a machine with a slightly slower chip (the fastest and latest two months ago) will provide a more economical, albeit a little slower, entry machine.

Memory (RAM) – RAM memory is where your editing program and image is kept when you are working on it. It is different to the memory of your hard drive or zip disk, as the information is lost when your computer is switched off. The amount of RAM your computer has is just as important as processor speed for graphics work. Photoshop recommend-five times the amount of RAM as the biggest image you will be working on. If you work with 20 Megabyte files regularly then your computer should have at least 128 mb of RAM memory.

RAM Purchase Tip – Buy as much memory as you can afford. The amount usually supplied with off-the-shelf systems is sufficient for most word processing and spreadsheet tasks but is usually not enough for good quality digital imaging.

Screen – The screen is the visual link to your digital file. It follows then that money spent on a good quality screen will help with the whole cycle of production. Screen size is important, as you need to have enough working space to layout tool bars, dia-

Figure 24 – The CPU is both the brains and the brawn of your desktop computer.

logue boxes and images. Screens are catagorized in terms of a diagonal measurement from corner to corner. 15- or 17-inch models are now the standard with 19 or 20 inch being the choice of imaging professionals. Look for a screen with a low dot pitch number (0.28 or less) as this helps to indicate how sharp images will appear.

Screen Purchase Tip – Make sure that you "test view" a known image on a screen before purchasing as there can be a great difference between units of similar specifications.

Video Card – The video card is the most important part of the pathway between computer and screen. This component determines not only the number of colours and the resolution that your screen will display, but also the speed at which images will be drawn. Pick a card with a fast processor and as much memory as you can afford.

Video Card Purchase Tip – Read a few tests from the big computer magazines before deciding on a card. Don't assume that good 3-D performance will also be reflected in the area of 2-D graphics. Check to see that the amount of memory you have on the card enables you to view your desktop at higher resolutions in full 24-bit colour.

Mouse or Graphics tablet – Much of the time spent working on digital images will be via the mouse or graphics tablet stylus. These devices are electronic extensions of your hand allowing you to manipulate your images in virtual space. The question of weather to use a mouse or stylus is a personal one. The stylus does provide pressure sensitive options not available with a mouse only system. Wacom, the company foremost in the production of graphics tablets for digital imaging use, has recently produced a cordless mouse and stylus combination that allows the user to select either pointer device at will (see fig 25).

Mouse or Graphics tablet Purchase Tip – My best advice is to try before you buy. The mouse, or stylus, needs to be comfortable to use and should fit your hand in a way so that your fingers are not straining to reach the buttons.

Storage –The sad fact is that digital imaging files take up a lot of space. Even in these days where standard hard disks are measured in terms of gigabytes the dedicated digital darkroom worker will have little trouble filling up the space. It won't be long before the average user will need to consider expansion options. For more details about the alternatives see the "Storage" chapter of this book.

Storage Purchase Tip – A CD writer provides the most economical way of storing large image files.

Figure 25– The tools and menus of your program are accessed by using either a mouse or stylus. Wacom produces a cordless combination package that provides the option of either system.

TIDY SCREEN TIPS (fig 26)
No matter what size screen you have it always seems that there is never enough space to arrange the various palettes and images needed for editing work. Here are a few tips that will help you make the most out of the "screen property" that you do have.

Docking – Docking is a feature that allows several palates or dialogue boxes to be positioned together in the one space. Each palette is then accessed by clicking on the appropriate tab at the top of the box.

Rollups – Most editing packages allow for large palettes to be rolled up so that the details of the box are hidden behind a thinner heading bar. The full box is rolled out only when needed.

Resizing the Work Window – If you have a small screen then it is still possible to work on fine detail within an image by zooming in to the precise area that you wish to work. For this reason it is worth learning the keyboard short cuts for "zooming in" and "out". This function is a little like viewing your enlargement under a focus scope.

Hide all the Palettes – Once you have selected a tool, it is possible with some editing programs, to hide all the palettes and dialogues to give you more room to manoeuvre. In Photoshop this is achieved by hitting the TAB key.

SAFE WORKING (see figs 27–30)

For your comfort, work efficiency and safety it is worth following a few basic guidelines when setting up your digital imaging environment. Most of the suggestions are based upon research undertaken in business environments where the computer is the central work tool and are designed to reduce muscle and eye fatigue.

Lighting – Position the screen of your computer to minimize glare from lights in the room or from any windows. Do not set your computer up in front of a

DOCKING

ROLLUPS

SCREEN RESIZE

Figure 26 – Some of the frustrations that come from having limited screen space can be alleviated by employing some basic "tidy screen" tips.

Figure 27 – Correct positioning of computer, desk and chair can help reduce fatigue and reduce the risk of injury.

window as this will effect the way that your eyes perceive contrast and colours on the screen. The top of the screen should be just below eye level when you are seated.

Seating – Use an adjustable chair that will give you good lumbar support and allow your thighs to be horizontal with your feet are flat on the floor.

Figure 28 – Proper care of floppy disks will help ensure that you can retrieve your data when you next need it.

Desk – The height of the desk should be adjusted so that your shoulders are relaxed when using the keyboard. The mouse should be at the same level as the keyboard.

Figure 29 - Despite their external appearances to the contrary Zip disks are very similar to your hard drive. Use these tips to help ensure a long life for your cartridges.

Breaks You should always take rest breaks when working on long intensive projects with the computer. This generally means getting up and moving around, focusing your eyes on distant objects regularly and resting your wrists.

Electrical Take all the same precautions with your computer setup that you would with any other electrical device. Keep away from water and any other liquids.

Figure 30 – Scratches to the written surface of a CD can mean that the information stored will not be able to be retrieved. A few simple precautions can help prevent this problem.

General precautions Your machine and any portable storage disks such as floppies, zips or CDs should always be keep away from dust, water and magnetic sources. These things can adversely effect your ability to retrieve data from these media.

MANIPULATION TECHNIQUES

MANIPULATION TECHNIQUES

STARTING YOUR JOURNEY
– OPENING YOUR IMAGES

With your images transferred from the camera or scanner, it's a simple job to open them into your image-editing package. Most programs provide you with the opportunity to view small thumbnails of each image before opening it fully (see fig 1).

PhotoImpact

1. Select File····〉Visual Open from the menu bar.

Fig 1 – You start the manipulation phase of the digital-imaging process by opening your saved images from disk.

2. Find the drive and folder that contains your image.
3. Double click the thumbnail to open your image.

Paintshop Pro

1. Select File····〉Open from the menu bar.
2. Browse the disk and folders to select your image.
3. Check Preview of image.
4. Click Open button.

Photoshop

1. Select File····〉Open from the menu bar.
2. Browse the disk and folders to select your image.
3. Check Preview of image.
4. Click Open button.

ONE: CHANGING BRIGHTNESS

One of the first things you learning when printing traditional photographic images is how to control the exposure of the print. Too much and the image is dark, not enough and the image is too light. The digital equivalent of this is the brightness control. Usually in the form of a slider, this feature allows you to increase or decrease incrementally the brightness of your images.

Make sure that when you are making your adjustments you don't lose any picture detail. Too much light-

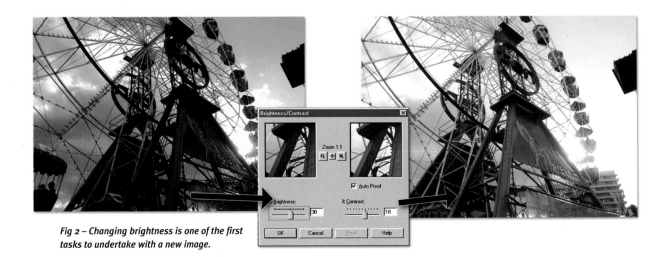

Fig 2 – Changing brightness is one of the first tasks to undertake with a new image.

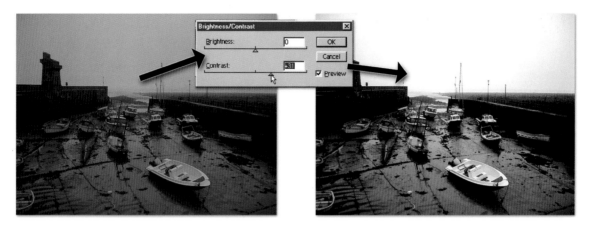

Fig 3 – Sometimes confused with brightness, contrast controls the spread of tones within your image.

ening and delicate highlights will be converted to white and lost forever. Conversely if you radically decrease the brightness of your photograph much of the shadow detail will be converted to black (see fig 2).

PhotoImpact

1. Select Format····}Brightness and Contrast from the menu bar.
2. Change the brightness level using the slider, or
3. Select the thumbnail that looks like the best spread of tones.
4. Click Preview to confirm your changes.
5. Click OK to finish or Continue to make more changes.

Paintshop Pro

1. Select Colours····}Adjust····}Brightness/Contrast from the menus.
2. Adjust Brightness slider.
3. Check preview for changes.
4. Click OK button when finished.

Photoshop

1. Select Image····} Adjustments ····} Brightness /Contrast from the menus.
2. Adjust Brightness slider.
3. Check Preview for changes.
4. Click OK button when finished.

What if I make a mistake?

First of all, don't worry! Select the Undo option from the edit menu of any of the programs. This will undo the last step that you completed. In this case it would restore your image to the original brightness before your alteration. Remember, though, Undo can only erase the last step.

TWO: ADJUSTING CONTRAST

Contrast can be easily confused with brightness, but rather than being concerned with making the image lighter or darker, this function controls the spread of image tones.

If an image is high in contrast it will typically contain bright highlights and dark shadows. Both of these areas will contain little or no detail. These images are usually taken on sunny days. Low contrast pictures are typically captured on overcast days where the difference between highlights and shadows is less extreme.

All image-editing software packages provide the user with the ability to alter the contrast of their images (see fig 3).

PhotoImpact

1. Select Format····}Brightness and Contrast from the menu bar.
2. Change contrast level using the slider, or
3. Select the thumbnail that looks like the best spread of tones.
4. Click Preview to confirm your changes.
5. Click OK to finish or Continue to make more changes.

Fig 4– Removing colour casts from images is definitely a photographic job that is more easily accomplished digitally than traditionally.

Paintshop Pro

1. Select Colours····⟩Adjust····⟩Brightness/Contrast from the menus.
2. Adjust Contrast slider.
3. Check preview for changes.
4. Click OK button when finished.

Photoshop

1. Select Image ····⟩Adjustment····⟩Brightness/Contrast from the menus.
2. Adjust Contrast slider.
3. Check Preview for changes.
4. Click OK button when finished.

AUTOMATIC CORRECTIONS

Most software packages also include ways of applying contrast and brightness automatically. These features are based on the computer assessing the image and spreading the tones according to what it perceives as being normal. In most instances, using these features results in clearer images with better overall contrast and brightness, but I would always suggest that you make the changes manually when you are manipulating important or complex pictures. Manual correction allows much finer control of the shadow and highlight areas.

PhotoImpact users can use the Auto-Process ····⟩Contrast option found under the Format menu to automatically correct contrast and brightness. Photoshop provides and Auto Levels and Auto Contrast that allows users to correct automatically and distribute their image's tones.

THREE: GETTING RID OF COLOUR CASTS

Working in colour brings with it both pleasure and pain. Sometimes what our eyes see at the time of shooting is quite different to what appears on the computer screen. Skin tones appear green, white shirts have a blue tinge or that beautiful red carnation ends up a muddy scarlet hue – whatever the circumstances, sometimes the colour in pictures seems to go astray.

In the old days, if you didn't have your own colour printing set-up you would have had to live with these problems. Now, with the flexibility of modern image-editing programs, ridding your favourite picture of an annoying cast is easily achieved (see fig 4).

PhotoImpact

1. Select Format····⟩Colour Balance from the menu bar.
2. Select the thumbnail that looks like the best colour correction.
3. Click Preview to confirm your changes.
4. Click OK to finish or Continue to make more changes.

NB: You can change the amount of difference in the colour cast of the thumbnails by altering the Thumbnail Variation slider.

Paintshop Pro

1. Select Colours····⟩Adjust····⟩Red/Green/Blue from the menus.
2. Adjust the individual colour sliders.
3. Check proof for changes.
4. Click OK button when finished.

Photoshop

1. Select Image····⟩Adjustments····⟩Variations from the menus.

2. Adjust Fine-Coarse slider.
3. Select the version of your picture that is cast free.
4. Check Current Pick for changes.
5. Click OK button when finished.

WHERE DO MY CASTS COME FROM?

Our eyes are very accommodating devices. Not only do they allow us to see objects and colours, but they also help interpret what is around us. For instance, if we view a white piece of paper under a fluorescent light, a household bulb or in the shadow of a building, it will always appear white to us. If we photographed the same sheet under similar lighting conditions the results would be quite different.

Under the fluorescent tube the paper would appear to have a green tinge, lit by the household bulb it would look yellow and in the shadow the sheet would look blue. Each light source has a slightly different colour. The professionals refer to these differences as changes in the colour temperature of the light. The sensor, or film, in our cameras records these differences as colour casts in our pictures.

Most modern digital camera have an automatic "white-balance" facility that helps the sensor record the image as if it were shot under white light. Similarly, a lot of the camera-based software programs available contain a function that accounts for different lighting conditions (see fig 5).

AUTO WHITE BALANCE

FLUORESCENT LIGHTING

Fig 5 – Automatic white balance functions on modern digital cameras help to alleviate mixed lighting problems that still plague film users.

Adding Casts to an Image

Although it might feel like a strange thing to do at first, there will be times when you want to add a cast or a dominant colour to your pictures. A good example of this is adding a tint to a black-and-white image to produce effects similar to sepia or blue-toned prints (see fig 6).

Fig 6– Toning of a black-and-white image can be achieved digitally by intentionally adding a cast to your image.

Fig 7– Israel Rivera makes good use of the enhancement features of Photoshop in his moody images.

To add colour to a black-and-white or greyscale image you will need to save the image as an RGB file even though it only contains black, white and grey information. Most programs allow you to do this by changing the colour mode of the image to RGB. You will not notice any immediate difference in the image but the file will now be able to accept colour information.

Photoshop users can then add tints to their image by selecting the Hue/Saturation option from the Image menu. Ensure that the Colorize option is checked, then change the colour of the tint via the Hue slider control and the strength by adjusting the Saturation slider.

If you use Paintshop Pro then you can achieve similar results by using the Colorize option from the Colours menu. Again moving the settings of both the saturation and hue controls will change the strength and colour of the tint.

Fig 8 – Brightness, texture and colour
are all manipulated digitally during production.

TRICKS OF THE TRADE: TINTING AT WORK (figs 7 & 8)

Israel Rivera, a landscape and documentary photographer, loves the look and feel of moodily printed and toned photographs. His latest project involved careful shooting and long hours of darkroom printing to achieve the emotion he desired in his prints.

Late in the project, Israel realized that the techniques he was using in the darkroom could be easily duplicated digitally. Cautiously at first, he started making pixel-based versions of his emotive prints. He says, "Initially I felt that the digital images might look a little gimmicky, but once I saw the results, there was no turning back. The pictures are great and the image quality speaks for itself."

FOUR: CROPPING YOUR PHOTOGRAPH

The framing of images is one skill that easily transfers between traditional and digital photography. By the careful positioning of the four edges of the image you can add impact and drama as well as improving the composition of your images.

For most of us, framing or cropping occurs twice during the image-making process – once when we compose the picture within the viewfinder and a second time when we make final adjustments before printing.

Digital cropping is a simple matter of drawing a rectangular border around the area of your photograph that you wish to keep. What is inside this selection will remain, what is outside will be discarded.

Fig 9 – Cropping your images can help to concentrate the viewer's attention on the most important aspects of your shot.

Often it is what you choose to throw away that makes an image strong. So, before making that final decision, be sure that the cropped image is more dynamic and balanced than the original (see fig 9). Remember, if you don't like the results of your crop, you can always Undo and start again.

PhotoImpact

1. Pick the Standard Selection tool from the toolbar.
2. Click and drag a selection around the part of the image you want to keep.
3. Select Edit⋯⟩Crop from the menu bar to discard the parts of the image outside the selection.

Paintshop Pro

1. Select the Cropping tool from the toolbar.
2. Draw a rectangle around the section of the image you wish to keep.
3. Adjust the selection using the "handles" in the four corners of the rectangle.
4. Double-click in the centre of the rectangle to complete the crop.

Note: If the toolbar is not visible, select the Toolbar option from the View⋯⟩Toolbars menu.

Photoshop

1. Select the Cropping tool from the toolbar.
2. Draw a rectangle around the section of the image you wish to keep.
3. Adjust the selection by clicking on the edge or corner "handles" of the rectangle and moving them to a new position.

4. Double-click in the centre of the rectangle to complete the crop.

Note: If the toolbar is not visible, select the Toolbar option from the Windows⋯⟩Tools menu. If the cropping tool is not visible, click and hold the marque tool. This will produce a "tool rollout" which will contain the cropping tool as one option.

FIVE: RETOUCHING OUT UNWANTED DETAILS

All of us are struggling to capture the perfect picture, the one image where everything comes together – composition, focus, lighting and exposure – to make a photograph that is both memorable and dramatic. How often you capture such an image depends on your experience and skills, but for every one image that you feel makes the grade, there are many that come really close. With a little digital help, these images can also become success stories.

Traditionally, retouching was the sole domain of the photographic professionals. Using fine brushes and special paints, these artists would put the finishing touches onto photographic prints. The simplest changes would involve the removal of dust and scratch marks from the print. More complex jobs could require a total fabrication or reconstruction of destroyed or unwanted parts of an image.

The advent of digital techniques has changed the retouching world forever. The professionals have traded in their paints and brushes for graphics tablets and big screens and more and more amateurs are carrying out convincing spotting jobs at home (see fig 10).

There are many methods for retouching images,

Fig 10 – Once the domain of back-room artisans, high-quality photographic retouching is within easy reach of most digital workers.

here we will concentrate on the most basic techniques that are used for removing from your photographs marks that are usually the result of dust on the negatives during scanning. Most of the programs use a cloning or rubber stamp type tool to copy a clean part of the image over the offending dust mark. The best results are achieved by careful use of the retouching tools on enlarged sections of the image.

Photoimpact

1. Select the Remove Scratch tool from the toolbar.
NB: If the tool isn't visible you can display all the retouching tools by making the Retouch Tool Panel visible by selecting View····ͻToolbars and Panels····ͻRetouch Tool Panel from the menu bar.
2. Adjust the size, edge softness and shape of the brush using the Attribute toolbar.
3. Adjust the level of the effect.
4. Position the mouse pointer over the scratch and click to retouch.

Paintshop Pro

1. Select the Clone Brush from the toolbar.
2. Select a brush size and type.
3. Move the pointer over the part of the image that you want to copy over the dust mark.
4. Hold the Shift key down and click over the area to be copied. This specifies the copy point.
5. Move the cursor to the dust mark and click and hold to start over-painting with the copied area.

Photoshop (fig 11)

1. Select the Rubber Stamp tool from the toolbox.
2. Select a brush size and type.
3. Move the pointer over the part of the image that you want to copy over the dust mark.
4. Hold the Alt key for Windows and Option key for Mactintosh and click over the area to be copied. This specifies the copy point.
5. Move the cursor to the dust mark and click and hold to start over-painting with the copied area.

TOP TIPS FOR CLONING

1. Carefully select the area to copy. This is the biggest factor in how successful your retouching will be.
2. Adjust the your brush size to suit the size of the dust mark.
3. Use a brush style that has a soft edge, this way the copied area will be less noticeable against its new background.
4. Sometimes adjusting the transparency (opacity) of the cloning brush will helps make your changes less noticeable. This will mean that you have to apply the tool several times to the dust mark to ensure coverage.

TRICKS OF THE TRADE:
BETTER RETOUCHING TECHNIQUES

Although the techniques above are more than up to the task of smartening up your images, the professionals often have their own pet methods for tweaking their photographs. Commercial photographer Florian Groehn uses a combination of Photoshop's Dust and Scratches filter and the History brush.

He says that if you use the filter by itself your whole image become soft and unsharp. "It is much better to apply the filter only in the area of the dust problems. Combining the filter and the history brush allows this." Follow the steps below to use Florian's technique (see figs 12–14).

1. Open your image into Photoshop.
2. Select the Dust and Scratches filter from the Filter····>Noise menu.
3. Highlight a typical dust mark in the preview area of the filter dialogue.
4. Adjust the Radius slider until the mark disappears. Notice that the image becomes soft and areas of colour become flat and textureless.
5. By adjusting the Threshold slider you can now reintroduce some texture (grain) back into image. High values here will bring the dust mark back so aim for a balance between texture and the elimination of marks.
6. When you are satisfied with the preview select OK to filter the image.
7. Select the step before the filter in the History palette.
8. Select the History Brush from the toolbox.
9. Change the mode for the brush to darken for light marks on a dark background and lighten for dark marks on a light background.
10. Apply the brush to the marks.

Fig 11 – Most of the entry-level packages have a "Red Eye Reduction" feature that rids your images of the effect that seem to plague compact camera users.

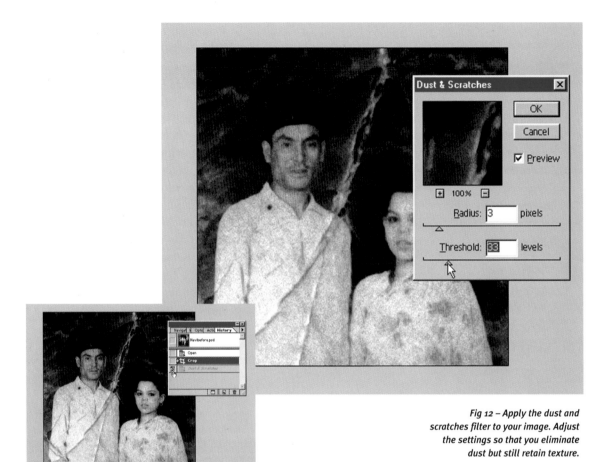

Fig 12 – Apply the dust and scratches filter to your image. Adjust the settings so that you eliminate dust but still retain texture.

Fig 13 – Using the History palette select the step before the filter was applied.

Fig 14 – Retouch the white dust spots using the History brush set to darken

SIX: ADDING BORDERS TO YOUR PRINT

There is no doubt that the quality of the image is everything. A good picture needs no tricks or frills to help make an impression. As if to prove this point, some photographers go as far as to refrain from any form of post-shooting "embellishment". They regard even the addition of borders to an image as sheer gimmickry.

This attitude ignores the fact that the edges of an image have always been important to photographers. Some shooters always include the black frame of the negative's edge as part of their image. The border does three things – contains the picture elements of the photograph, visually separates the image from its surroundings, and passes on to the viewer the composition that the photographer intended.

their audience to know that the image was shot full-frame. It was a way to show off the in-camera compositional skill of the photographer. When you saw the black edges of a print, you knew that the image had not been subjected to any cropping during the enlarging process – you were seeing exactly what the photographer saw.

To some extent this assumption is still made with black frames, but don't let this stop you experimenting. Remember that, once you have mastered the basic steps of this technique, there is no reason why you can't use a range of other border colours.

Photoshop has a function called Stroke which forms the basis of the technique I use to make black borders around my images. This command can be

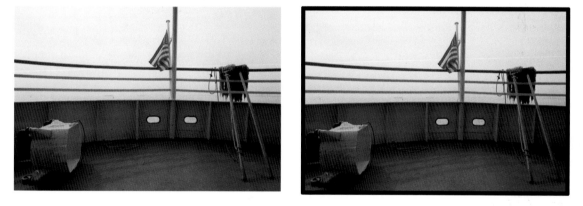

Fig 15 – A simple black border added to your image can help to contain the viewer's eye.

What is even more significant is that borders have been a part of print-making tradition for years. Whether it is the black edges of the negative's frame or the chemical overspill of a Polaroid print, many photographers have found that the edge of the image helps to define the photograph.

The world of digital imaging means that print borders in all manner of shape, size and style are readily available. Any image, no matter its origin, can be surrounded by a border easily. This technique section will show you how to make two of the most popular border types – black edge and drop shadow.

Simple Black Frame Border (fig 15)

Select a suitable image to which to apply your border. Keep in mind that traditionally this type of edge treatment was reserved for photographers who wanted

used to draw a line that follows the edge of a selection. In this example we simply select the whole image and stroke the selection with a line of a given colour and pixel width.

Paint Shop Pro, on the other hand, has a specialist Add Borders command that allows the user to place a coloured line around the whole image quickly and simply. No selection step is needed, and the lines at different edges can be of different thicknesses – a bonus for those of us who prefer a slightly thicker border on the bottom edge of the picture.

Paintshop Pro

1. Ensure the background colour is black.
2. Select Image⋯Add Borders.
3. Adjust the size of each border.

Photoshop

1. Select····>All.
2. Ensure that foreground colour is black.
3. Select Edit····>Stroke (Width = 16 pixels, Location = Inside).

Shadowed Print Edge (fig 16)

As in a lot of areas of our life, fashion exists within the realms of digital imaging. The drop shadow – a subtle blurry shadow that gives the illusion that the text or image is sitting out from the page – is one "look" that has been very popular over the last couple of years. Such is the extent of its usage that most image-editing software, including Photoshop and Paint Shop Pro, now has automated processes for creating this effect.

The example that I have detailed below adds a white border to the image first before increasing the canvas size and finally adding the shadow.

Paint Shop Pro

To make the white border:

1. Ensure the background colour is white
2. Select Image····>Add Borders.
3. Adjust the size of each border.

To make canvas big enough for the drop shadow:

4. Select····>All.
5. Select Edit····>Cut.

6. Select Image····>Canvas Size (adjust the size to account for the shadow).
7. Edit····>Paste····>as a new selection.
8. Click to stamp down when positioned (keep selected).

To make the shadow

9. Select Image····>Effects····>Drop Shadow.
10. Adjust sliders to change the style of the shadow.

Photoshop

To make the white border:

1. Select····>All.
2. Ensure that foreground colour is black.
3. Edit····>Stroke (Width = 16 pixels, Location = Inside).

To make canvas big enough for the drop shadow:

4. Select····>All.
5. Ensure background colour is white.
6. Select Edit····>Cut.
7. Select Image····>Canvas Size.
8. Adjust the size to account for the shadow.
9. Edit····>Paste.

To make the shadow:

10. Select Layer····>Layer Styles····>Drop Shadow. Adjust sliders to change style of shadow.

SPECIALIST BORDER AND EDGE EFFECTS SOFTWARE

Some software companies have devised specialist packages to help make border and edge effects on digital images. One such company is Extensis Software whose Photoframe product is now in its second version. A downloadable demo version is available from www.extensis.com (see fig 17).

The product installs easily into Photoshop and is accessible through the Filters menu. It is very simple to use. After opening your image go to Filter····⟩ Extensis····⟩PhotoFrame. A specialized dialogue box appears which then allows you to select, add and adjust borders and edge effects from a range supplied with the software. The manufacturer claims that well over one thousand different frames are possible.

The real power of the product is apparent when you see the extent to which you can control the application of the effects. With the image previewed it is possible to use the controls to change size, softness, opacity, colour, and width of the border. In addition, you can use the mouse pointer to change the size, shape, and position of the frame.

When you are happy with the results of your adjustments, click the apply button and you are returned to the Photoshop interface with the finalized version of your image.

A recent addition to the Extensis product group is an online version of Photoframe. Users can now create a variety of frame and edge effects for their images directly within their web browser, without the need to install desktop software. Photoframe Online is available free to Creativepro.com members at www.creativepro.com/photoframe/welcome.

Other Border Types (fig 18)

Sometimes a slick straight-edged neat and tidy border is not what you want for a particular image. Providing an edge that is more rough and ready photographically would mean printing through a glass carrier, or using a roughly cut mask sandwiched with the negative at the time of printing. These techniques do, however, provide borders with a unique look and feel.

Digitally speaking, it is possible to achieve a similar effect by combining a ready made "rough frame"

Fig 17 – Extensis' Photoframe product automates the frame-making process via a Photoshop plug in.

Fig 18 – Specialist frame or edge software can provide almost infinite variations to the surrounds of your image.

file with your image file. Putting both images together requires a bit of forethought though. Make sure that the images are a similar size and orientation. Check the colour mode of each file. If you want a coloured final image then both files need to be in a colour mode

Fig 19 – You can make and apply your own borders by scanning the edges of a pre-existing print or one specially made for the purpose.

before you start – this applies even if the border is just black and white.

The process is fairly simple – select the frame, copy it to memory and then paste it over the image. The tricky bit is resizing the pasted frame so that it fits the dimensions and shape of the picture. To achieve this, Photoshop workers will need to practice manipulating the image using the Free Transformation command. Those readers who prefer Paint Shop Pro will need to become familiar with the Deformation tool.

Paint Shop Pro

To select frame:

1. Open Frame and Image files
2. Ensure that the image file has enough white surround to accommodate a frame.
3. Select the white areas of the frame picture using the Magic Wand
4. Click on Selections····}Invert to select actual frame
5. Select Edit····}Copy.

To paste the frame onto the image:

6. Switch to the image file.
7. Edit····}Paste····}as a new layer
 (to paste frame onto image file).

To adjust the frame to fit the image:

8. Select the Deformation tool from the toolbar.
9. Move the corner and side nodes to re-size the frame to fit.

Photoshop

To select frame:

1. Open frame and image files.
2. Ensure that the image file has enough white surround to accommodate the frame.
3. Select the white areas of the frame picture using the Magic Wand.
4. Select····}Inverse (to select the actual frame).
5. Edit····}Copy.

To paste the frame onto the image:

6. Switch to the image file.
7. Edit····}Paste (to paste frame onto image file).

To paste the frame onto the image:

8. Select Edit····}Free Transform.
9. Move the corner and side nodes to re-size the frame to fit.

MAKING YOUR OWN BORDER FILES (fig 19)

The border used with the image above was made by scanning the edge of a black-and-white photograph printed with a glass carrier. Once converted to a digital file you can then select the image area and cut it away. The resulting border file can then be used with any other image file.

Try making your own files by scanning old prints or the edges of ones made specially for the purpose.

SEVEN: USING FILTERS

OK, hands up all of you who have a range of "Cokin"filters in your camera kit bag. If your arm is raised in timid salute then you are not alone, I too admit to buying a few of these pieces of coloured gelatine in an attempt to add drama and interest to my images. Ranging from the multi-image split prism to the keyhole mask for that all important wedding shot, these photographic "must haves" seem to be less popular now than they were in the seventies and eighties.

It's not that these handy "end of lens add-ons" are essentially bad, it's just that we have all seen too many hideous examples of their use to risk adding our own images to this infamous group. In fairness, though, I still would not leave home without a good set of colour correction filters, and I am sure that my landscape colleagues would argue strongly for the skillful use graduated filters to add theatre to a distant vistas.

As much as anything, the filter's decline in use can be attributed to changes in visual fashion and just like

Fig 20

COLOURED PENCIL

CUTOUT

FRESCO

PAINT DABS

PLASTIC WRAP

ROUGH PASTEL

those dreaded flares, the filter effects of the seventies have made a comeback, thanks to digital. This time they don't adorn the end of our lenses but are hidden from the unsuspecting user, sometimes in their hundreds, underneath the Filter Menu of their favourite image-editing program.

NEVER FORGET ... SO YOU'LL NEVER REPEAT IT!

The association with days past and images best forgotten has caused most of us to overlook, no, let's be honest, run away from, using any of the myriad of filters that are available. These memories, coupled with a host of garish and look-at-this-effect-type examples in computing magazines, have overshadowed the creative options available to any image-maker with the careful use of the digital filter.

To encourage you to get started, I have included a few examples of the multitude of filters that come free with most imaging packages. I have not covered Gaussian blur or any of the sharpening filters as most people seem to have overcome their filter phobia and made use of these to enhance their imagery, but I have tried to sample a variety that you might consider using.

If you are unimpressed with the results of your first digital filter foray, try changing some of the variables. An effect that might seem outlandish at first glance could become useable after some simple adjustments using the sliders contained in most filter dialogue boxes.

The filter examples are grouped according to their type. For ease of comparison, each of the filters have been tested using a common image.

Artistic Filters (fig 20)

Coloured Pencil: Sketchy pencil outlines on a variable paper background.
Variables: Pencil Width, Stroke Pressure, Paper Brightness.

Cutout: Graded colours reduced to flat areas much like a screen print.
Variables: Number of Levels, Edge Simplicity, Edge Fidelity.

Fresco: Black-edged painterly effect using splotches of colour.
Variables: Brush Size, Brush Detail, Texture.

Fig 21

ACCENTED EDGES

CROSS HATCH

INK OUTLINES

SUMI-E

Paint Dabs: Edges and tones defined with daubs of paint-like colour.
Variables: Brush Size, Sharpness, Brush Type.

Plastic wrap: Plastic-like wrap applied to the surface of the image area.
Variables: Highlight Strength, Detail, Smoothness.

Rough Pastel: Coarsely applied strokes of pastel-like colour.
Variables: Stroke Length, Stroke Detail, Texture, Scaling, Relief, Light Direction, Invert.

Brush Stroke Filters (fig 21)

Accented Edges: Image element edges are highlighted until they appear to glow.
Variables: Edge Width, Edge Brightness, Smoothness.

Crosshatch: Coloured sharp-ended pencil-like crosshatching to indicate edges and tones.
Variables: Stroke Length, Sharpness, Strength.

Ink Outlines: Black ink outlines and some surface texture laid over the top of the original tone and colour.
Variables: Stroke Length, Dark Intensity, Light Intensity.

Sumi-e: Black outlines with subtle changes to image tone.
Variables: Stroke Width, Stroke Pressure, Contrast.

Distort Filters (fig 22)

Pinch: Image is squeezed in or out as if it is being stretched on a rubber surface.
Variable: Amount.

Shear: Image is distorted in the middle in one direction whilst the edges remain fixed.
Variable: Undefined areas.

Twirl: Image is spun and stretched to look as if it is being sucked down a drain hole.
Variable: Angle.

Wave: Image is rippled in a wave-like motion.
Variables: Number of Generators, Type, Wavelength, Amplitude, Scale, Undefined Areas, Randomize.

Pixelate Filters (fig 23)

Colour Halftone: Creates an effect similar to a close-up of a printed colour magazine image.
Variables: Maximum Radius, Screen Angles for channels one to four.

Fig 22

PINCH

SHEAR

TWIRL

WAVE

Fig 23

COLOUR HALFTONE

MEZZOTINT

MOSAIC

POINTILLIZE

Mezzotint: Adjustable stroke types give tone to the image.
Variables: Type.

Mosaic: The image is broken into pixel-like blocks of flat colour
Variable: Cell Size.

Pointillize: Random irregular dot shapes filled with colours drawn from the original image.
Variable: Cell Size.

Sketch Filters (fig 24)

Bas Relief: Image colour is reduced with cross lighting that gives the appearance of a relief sculpture.
Variables: Detail, Smoothness, Light direction.

Chalk and Charcoal: A black-and-white version of the original colour image made with a charcoal-like texture.
Variable: Charcoal Area, Chalk Area, Stroke Pressure.

Graphic Pen: Stylish black-and-white effect made with sharp-edged pen strokes.

Variables: Stroke length, Light/dark balance, Stroke direction.

Stamp: Broad flat areas of black and white.
Variables: Light/Dark Balance, Smoothness.

Fig 24

BAS RELIEF

CHALK AND CHARCOAL

GRAPHIC PEN

STAMP

Fig 25 CRAQUELURE STAINED GLASS

Texture Filters (fig 25)

Craquelure: Cracks imposed on the surface of the original image.
Variable: Crack Spacing, Crack Depth, Crack Brightness.

Stained Glass: Image is broken up into areas of colour which are then bordered by a black line to give an effect similar to stained glass.
Variables: Cell Size, Border Thickness, Light Intensity.

THE TEN COMMANDMENTS FOR FILTER USAGE

1. Subtlety is everything. The effect should support your image not overpower it.
2. Try one filter at a time. Applying multiple filters to an image can be confusing.
3. View at full size. Make sure that you view the effect at full size when deciding on filter settings.
4. Filter a channel. For a change, try applying a filter to one channel only – red, green or blue.
5. Print to check effect. If the image is to be viewed as a print, double-check the effect when printed before making any final decisions about filter variables.
6. Fade strong effects. If the effect is too strong, try fading it. Use the Fade selection under the Filter menu.
7. Experiment. Try a range of settings before making your final selection.
8. Mask then filter. Apply a gradient mask to an image and then use the filter. In this way you can control which parts of the image are affected.
9. Different effects on different layers. If you want to combine the effects of different filters, try copying the base image to different layers and applying a different filter to each. Combine effects by adjusting the opacity of each layer.
10. Did I say that subtlety is everything?

FILTER DIY (fig 26)

Can't find exactly what you are looking for in the hundreds of filters that are supplied with your editing package or available to download from the Net? I could say that you're not really trying, but, then again, some people have a compulsion to do it themselves. If that's you, all is not lost. Photoshop provides the opportunity to create your own filtra-

tion effects by using its Filter····}Other····}Custom option.

By adding a sequence of positive/negative numbers into the twenty-five variable boxes provided, you can construct your own filter effect. Add to this the options of playing with the scale and offset of the results and I can guarantee hours of fun. Best of all, your labours can be saved to use again when your specialist customized touch is needed.

EIGHT: CHANGING SHARPNESS

Sharpness has always been an image characteristic for which photographers have striven. Shooters spend a lot of time and money on purchasing equipment and developing techniques that help ensure that their images are always pin sharp. Strangely, in recent years and in direct contrast to these ideas, just as much care and attention has been paid to intentionally blurring parts of the photograph.

A predominant picture style in the late nineties and into the new millennium has been the photograph with an ultra-small depth of field. Used to great effect in glossy food magazines, these images contain large areas that are purposely shot out of focus to contrast with a small section of the picture that is kept very sharp.

Traditional techniques for capturing these images involve the use of good-quality lenses, judicious selection of f-stop settings and, in some cases, a studio camera that is capable of changing the plane of focus. Apart from these manual techniques, a certain amount of control over sharpness is also possible within the digital field. In this section we will look at two methods that can help change the appearance of sharpness in your images.

Increasing Sharpness

At the outset, let me state clearly that an image that is taken out of focus can never be made sharp. Good focusing is the key to sharp images, and this fact is not altered by using digital techniques. The sharpening options offered by most software programs can only

Fig 26 – Photoshop provides the option to make your own filters using its Filter····}Custom function.

enhance the appearance of sharpness in an image, not make bad focusing good.

Entry level software usually offers at least one method for sharpening images. The more sophisticated image-editing programs offer a range of sharpening choices. Most of these have fixed parameters that cannot be changed or altered by the user. Some programs provide another choice – unsharp masking. This feature has a greater degree of flexibility and can be customized in order to get the best out of your images. The unsharp mask filter gives the user the most choice over his or her sharpening activities and should be used for all but the most simplistic sharpening needs.

PhotoImpact

Basic sharpening:

1. Select Format----->Focus from the menu bar.
2. Pick the thumbnail that represents the best sharpening effect, or
3. Click the Options button.
4. Adjust Sharpen/Blur slider and Levels settings.
5. Click Okay to finish.

Unsharp masking:

1. Select Effect----->Blur and Sharpen----->Unsharp Mask from the menu bar.
2. Pick the thumbnail that represents the best sharpening effect, or
3. Click the Options button.
4. Adjust Sharpen Factor and Aperture Radius sliders.
5. Click Okay to finish.

Paintshop Pro

Basic Sharpening:

1. Select Image----->Filter----->Sharpen or Sharpen More from the menu bar.

Unsharp Masking:

1. Select Image----->Filter----->Unsharp Mask from the menu bar.
2. Adjust Radius, Strength and Clipping settings. Click Okay to finish.

Photoshop

Basic Sharpening:

1. Select Filter----->Sharpen----->Sharpen, Sharpen Edges or Sharpen More from the menu bar.

Unsharp Masking:

1. Select Filter----->Sharpen----->Unsharp Mask from the menu bar.
2. Adjust Amount, Radius and Threshold settings.
3. Click Okay to finish.

WHAT IS UNSHARP MASKING?

Those of you who have a history in photography will recognize the term "unsharp masking" as a traditional film compositing technique used to sharpen the edges of an image. The sharpened edges, when seen at a distance, give the appearance of increased sharpness to the whole image. A different technique, which had the same type of results, involved developing black-and-white film in a high "Acutance" developer like Agfa's Rodinal. The developer produced an increase in the contrast between edges, giving an appearance of increased sharpness.

Photoshop and the other software programs combine the spirit of both these techniques in their Unsharp Masking filters. When the filter is applied to an edge, the contrast between two different tones is increased. This gives the appearance of increased sharpness at the edge.

Controlling Your Unsharp Mask Effects (fig 27)

In Photoshop the user can control the effects of the filter in three ways, via the slider controls in the dialogue box (other programs use similar controls with varying names):

Amount: Ranges from 0 to 500 per cent and determines the degree to which the effect is applied to the image. Start at a value of about 150 per cent.

Radius: Controls the number of pixels surrounding the edge pixels that are affected by the sharpening. To start with, try setting the radius at the resolution of your image divided by 200. For example if the resolution is 600 dpi then the radius should be set at three (600/200 = 3).

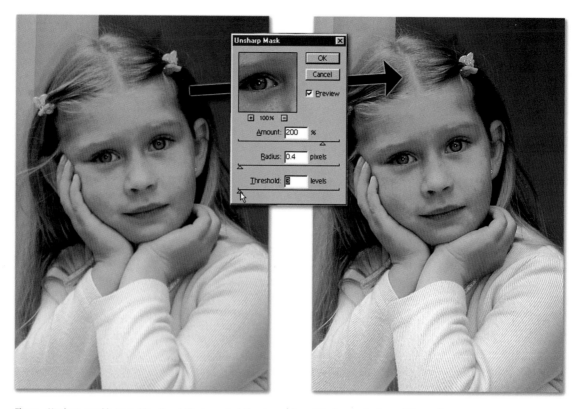

Fig 27 – Unsharp masking provides the ability to control the sharpening of the image via three slider settings. In Photoshop these are called amount, radius and threshold.

Threshold: This setting determines how different in brightness pixels need to be before the sharpening filter is applied. Although much under-used, this filter is essential for controlling which parts of your image will be affected by the sharpening. When you apply sharpening to flat areas of tone, like sky or flesh, they become very "noisy". By adjusting the threshold value you can stop the sharpening of these areas whilst maintaining sharpening everywhere else. A value of zero sharpens all the pixels in the image.

PRO'S SHARPENING TIP
Convert your image to LAB mode and apply the sharpening to the L channel only. As all the colour information is held in the other two channels, the sharpening will only affect the detail of the image, not the colour.

Intentionally Blurring Your Images (fig 28)
Although the notion of artificially introducing blur into your carefully focused images might seem a little sacrilegious, this digital technique is an important one to learn. Most photographers know that a blurred background will help to direct the viewer's eyes towards the main subject in your image. The blur functions contained within modern image-editing packages enable you to change the areas of focus within your picture and control the viewer's gaze more easily than ever before.

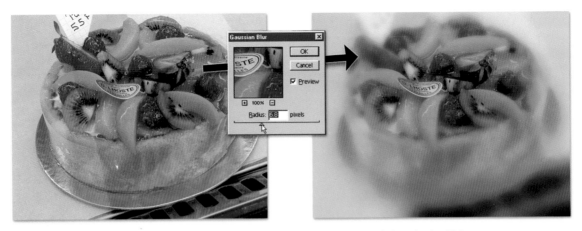

Fig 28 – Intentional blurring, or defocusing as some photographers prefer to call it, is a technique that is widely used in glossy food photography. A similar effect can be obtained by careful use of the Gaussian blur filter.

Again the more sophisticated software programs provide the greatest number of blur functions, Photoshop and Paintshop Pro giving six possibilities, but most packages include at least one blur filter. Just like the unsharp mask function, the Gaussian blur filter gives the user more control over the amount of blur applied to an image.

PhotoImpact

1. Select Effect⋯⟩Blur and Sharpen⋯⟩Blur, or
2. Select Effect⋯⟩Blur and Sharpen⋯⟩Gaussian Blur from the menu bar.
3. Pick the thumbnail that represents the best blurring effect, or
4. Click the Options button.
5. Adjust Variance sliders.
6. Click Okay to finish.

Paintshop Pro

1. Select Image⋯⟩Blur⋯⟩Blur or Soften filters from the menu bar or, for more control,
2. Select Image⋯⟩Blur⋯⟩Gaussian Blur.
3. Adjust Radius slider to the desired setting.
4. Click OK to finish.

Photoshop

1. Select Filter⋯⟩Blur⋯⟩Blur or Blur More from the menu bar or, for more variations and control,
2. Select Filter⋯⟩Blur⋯⟩Gaussian Blur, Motion Blur, Radial Blur or Smart Blur.
3. Adjust the sliders to the desired settings.
4. Click OK to finish.

TECHNIQUE NINE: ADVANCED TONAL CONTROL

The tones within a typical digital image are divided into 256 levels of red, green and blue. Each part of the image is uniquely described according to its colour, brightness and position within the grid that makes up the whole image. Apart from viewing the file as a picture, there are several other ways that the pixels can be displayed.

The Histogram and Levels Function (fig 29)

The histogram is a basic graph of the spread of pixel tones from black to white. High points in the graph indicate that there are a lot of pixels grouped around these specific tonal values. Conversely, low points mean that comparatively few parts of the image are of this brightness value. In simple terms, this graph maps the amount of pixels in the highlight, midtone and shadow areas of the image.

The histogram becomes particularly handy when used in the context of Photoshop's Levels function. Here the user can control the spread of the image tones. This means that flat or compressed tone images can be expanded to allow the display of a full range of brightnesses from black to white.

Paintshop Pro implements a similar histogram-based feature with Equalize and Stretch settings found under the Colours⋯⟩Histogram Functions selection on the menu bar.

Paintshop Pro

1. Select Colours⋯⟩Adjust⋯⟩Histogram Functions⋯⟩ Equalize or Stretch from the menu bar.

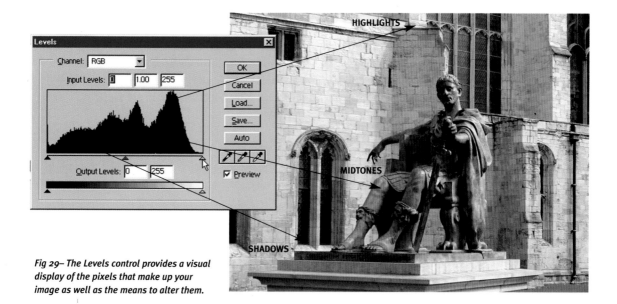

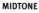

Fig 29– The Levels control provides a visual display of the pixels that make up your image as well as the means to alter them.

Photoshop

1. Select Image····>Adjustments····>Levels from the menu bar.
2. Adjust the white and black points of the graph by either dragging the left and right triangles until they meet the first pixels, or by
3. Sampling the brightest and darkest parts of the image using the eyedroppers.
4. Midtones can be adjusted by moving the middle triangle beneath the graph.
5. Click OK to finish.

Curves! What Curves? (fig 30)

Characteristic curves have long been used by photographers to describe the specific idiosyncrasies of the way that different films and papers respond to light. In both Photoshop and Paintshop Pro the curve has been used as a way of displaying and modifying an image's tonal areas.

When a user opens the curves dialogue box in Photoshop he or she is confronted with a straight-line graph at forty-five degrees. The horizontal axis represents the current brightness of the pixels in your image, or input levels, the vertical axis represents the changed values, or output levels.

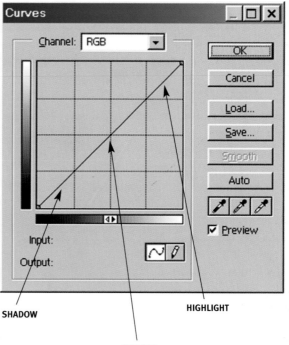

Fig 30 – The Curves function provides a way to visualize and control the tones in your image. It does this in a way that echoes the ideas used for years by photographers to illustrate how film and paper respond to light and development.

The diagonal straight line that appears by default when opening the curves dialogue box indicates that input and output levels are the same.

Changes are made to the image by moving the position of parts of the curve. When the pointer is clicked on the curve an "adjustment point" appears. When this point is clicked and dragged the pixels associated with that value will be lightened or darkened. Because the point is just part of a curve values on either side of the adjustment will also be affected. Many adjustment points can be added to the curve to anchor or change a set of pixels.

In Paintshop Pro the curve idea is used to represent image tones in the Gamma Correction function. Red, green and blue channels can be adjusted together or independently. Unlike Adobe's product, making changes in Paintshop Pro will only alter the midtones of the image. Black and white points are effectively fixed and are best altered through the contrast and brightness controls.

Paintshop Pro

1. Select Colours····⟩Adjust····⟩Gamma Correction from the menu bar.
2. Move the sliders to the left or right to change the values of the midtone areas of your image.
3. Deselect the Link option to allow independent alteration of red, green or blue channels.
4. Click OK to finish.

Photoshop

1. Select Image····⟩Adjustments····⟩Curves from the menu bar.
2. Using the mouse, move parts of the curve to adjust shadow and midtone and to highlight areas of your image.
3. Click OK to finish.

Fig 31 – Pegging parts of the curve before alteration gives the user more control over the pixels that are changed.

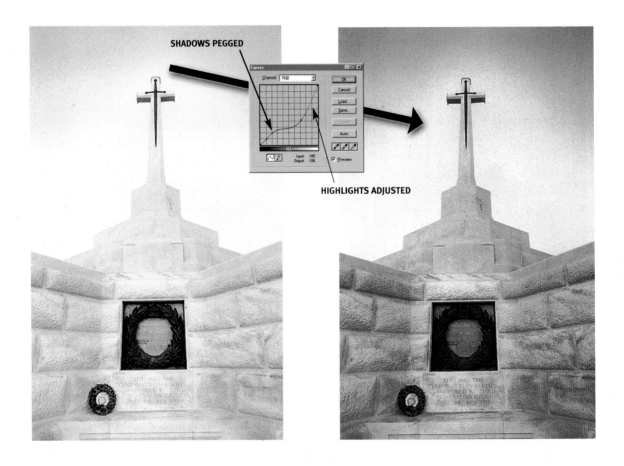

SHADOWS PEGGED

HIGHLIGHTS ADJUSTED

BLUE CHANNEL ADJUSTED ONLY

Fig 32– The curve of individual channels can be altered independently
allowing for manipulation of just one colour at a time.

**HANDY HINTS FOR
PHOTOSHOP CURVE CHANGERS**

Changes can be subtle or dramatic depending on the amount that the curve is altered from its original state. To help you with your first set of adjustments, here are a couple of helpful hints:

- Moving an adjustment point to the left will result in a lightening of these pixels,
- Conversely, a movement to the right will darken the pixels,
- A steepening of a section of the curve will result in higher contrast of the values selected, and
- A flattening of the curve will result in a lower contrast image.

If selecting and moving points is not precise enough for your needs, then you can change to the pen mode and freehand draw your own curve directly onto the graph. Those working with precise changes can note input and output value adjustments as they appear at the bottom of the box.

FINER CURVE CONTROL USING PHOTOSHOP (fig 31)

By clicking on a section of your image you can easily locate the value of that pixel and its position on the curve. This method was used to identify a specific group of highlight pixels in the Memorial Cross image. This image is made up mainly of light tones, with a small amount of shadow detail contained in the wreaths. To add some drama to the image, I located the shadow details and pegged their position on the curve. I then adjusted the highlight detail, safe in the knowledge that the shadows would remain largely unchanged. It is easy to see the changes to the resultant image, as the lighter tones have been modified to included more midtone area.

USING CHANNELS AND CURVES TOGETHER (fig 32)

At the top of the curves dialogue box is a selectable drop down menu that allows the user to select "combined" or "individual" channels. This feature provides the user with the ability to modify each individual channel that makes up your image. In the case of the Lemons image, which is an RGB file, it is possible to select and adjust one channel at a time. To demonstrate this I selected the blue channel and made the mid and shadow tone areas lighter. This adjustment made the blue background more vibrant without affecting other areas of the image.

TEN: SELECTING AREAS TO WORK ON

New and experienced users alike agree that being able to select specific areas of an image to work on is one of the most basic, but essential, skills of the digital darkroom worker. Sure, it is possible to make broad and general adjustments to pictures without such skills, but it's not too long before you will find yourself wanting to be a little more particular about which parts of the image you want to change.

With selection being such an important part of modern image-editing techniques, it is no surprise that all the main software products have a variety of methods that can be used to isolate wanted pixels.

The majority of these tools can be grouped into three major techniques:

1. Lasso- and pen-type tools that are used to draw around objects,
2. Marquee tools that, again, draw around objects, but in predefined shapes such as rectangles or ellipses, and
3. Colour selection tools, such as the magic wand, that define selection areas based on the colour of the pixels.

Added to these are selection tools designed specifically for isolating foreground objects from their digital backgrounds. The Extract function from Adobe's Photoshop and the Mask Pro plug-in from Extensis are two such products.

The Basic Tools

Not all tools are suitable for all jobs. For this reason the software companies generally provide several different selection tools that can either work in isolation or together.

Marquee (fig 33)

Out of all the standard offerings, the marque tool is the most simple. The user has a choice of a rectangular or elliptical marquees, providing the ability to make square and rectangular selections along with circular and oval shaped ones. This is appropriate for selecting regular hard-edged objects in an image and is often used in conjunction with other tools.

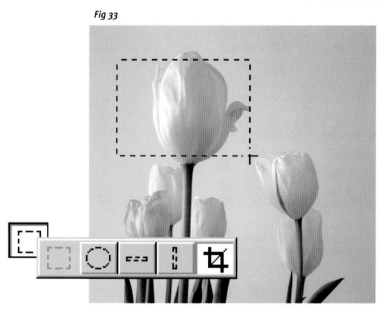

Fig 33

want to select has a dominant colour that is in contrast to others within the picture, then the magic wand is a good choice.

The precision of the colour selection can be adjusted using the Tolerance setting found in the wand's palette. The higher the number, the less fussy the tool will be about its precise selection. To get the tolerance level just right, you might need to deselect and reselect several times. If you are lucky enough to have a clean and colour-consistent object or background, this is the tool for you.

Photoshop

1. Select the magic wand tool.
2. Click on the dominant colour in the background of your image.
3. Check the resultant selection to see that all background pixels have been encompassed by the marching ants.
4. If the selection isn't quite right, deselect (ctrl+d or Select····⊱Deselect), adjust the tolerance of the wand (double click the magic wand in the tool box to reveal the palette), and select again.

Photoshop

1. Select marquee tool.
NB: Remember, to change tools you select and hold down the mouse button until the other options become available.
2. Locate the starting point of the rectangle,
 or ellipse. This is usually the upper right
 or left of the image.
 Click and drag the mouse to draw the selection.

Magic Wand (fig 34)

The magic wand makes its selections based on pixel colour, not drawn area. If the part of the image you

Fig 34

Fig 35

Lasso (fig 35)

Using the lasso tool or, for even more accuracy, the magnetic lasso which sticks to edges, the user can draw around irregular-shaped objects. An alternative to this approach is to select the parts of the image that you don't want changed and then invert the selection. Inverting swaps the selection from object to back-ground and vice versa.

Photoshop:

1. Select the lasso tool.
2. Carefully outline the objects that you want selected, or
3. Draw around the objects you don't want in the selection, and
4. Inverse the selection (Select····⟩Inverse).

Pen Tool (fig 36)

The pen tool, like the lasso, is essentially used to draw the outline of the objects to be selected. Again, with this tool you have the option of a magnetic version, which aids in drawing by sticking to the edges of objects. The pen draws a path rather than a selection. Once drawn, it has to be converted to a selection before use.

Photoshop

1. Select the pen tool.
2. Carefully outline the objects that you want selected.
3. Once completed, show paths palette (View····⟩Show Path).
4. Convert path to a selection (in the paths palette select Make Selection).
5. Delete path and leave selection (in the paths palette select Delete Path)

ADDING TO AND SUBTRACTING FROM SELECTIONS

You can add to a selection using any of the standard tools by holding down the shift key and then reusing the selection tool. You can also subtract from a selection by using the tool whilst depressing the Control key for PCs or Option key for Mac. In this way you can progressively build a complex selection that encompasses many irregular shapes, tones and colours.

ELEVEN: ADDING TEXT (fig 37)

Adding text to your images is an important next step towards digital proficiency. Traditional photographic techniques rarely gave the opportunity for shooters to add easily a few well-chosen words to their images. This is not the case with digital image-making. All of the major image-editing software packages have a range of text features. All have functions that allow the selection of font size and type and positioning within the picture. The most sophisticated packages also provide extra enhancements for the text, such as automatic "drop shadows" or "outer glows".

PhotoImpact

1. Pick the Text tool from the toolbar.
2. Position the cursor, now a text icon, in the image and click.
3. Use the Text Entry Box to enter text.
4. Use the settings to adjust font size, type and colour.
5. Click OK to finish.

Paintshop Pro

1. Pick the Text tool from the toolbar.
2. Position the cursor, now a text icon, in the image and click.

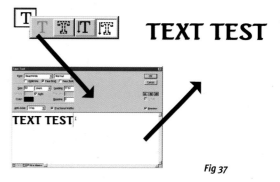

Fig 37

3. Use the Text Entry dialogue box to enter text.
4. Use the settings to adjust font size, type and colour.
5. Click OK to finish.

Photoshop

1. Pick one of the Text tools from the toolbar.
2. Position the cursor, now a text icon, in the image and click.
3. Use the Type Tool dialogue box to enter text.
4. Use the settings to adjust font size, type and colour.
5. Click OK to finish.

Fig 36

THEORY INTO PRACTICE

THEORY INTO PRACTICE

This chapter contains a series of examples of how the manipulation techniques you have just learned can be used to create exciting and refined images that communicate your ideas in ways that traditional photography cannot.

ONE: RESTORING AN OLD
BLACK-AND-WHITE PHOTOGRAPH
Difficulty level: 1
Programs: PhotoImpact, Paintshop Pro, Photoshop

Restoring an old photograph is typical of the type of jobs that the digital photographer is presented with on a regular basis. The type of skills needed to make repairs to damaged or faded images makes picture restoration a good exercise for new users.

Capturing Your Image (fig 1)
Most restoration tasks start with the carefully scan-

ning of the original image. It is this process that captures all the information you will be working with, so be sure to adjust the contrast and brightness controls within the scanner plug-in to guarantee that you don't loose delicate highlight or shadow detail.

In some cases, where the original has been torn to pieces, it is worth spending a little time making sure all the relevant sections are located and scanned. Repositioning and stitching the offending pieces together is a lot easier than trying to create complex bits of an image anew.

Even if the original is a black-and-white print, I still scan it as a colour original. This way I can capture the tint of the emulsion or toner that was used to produce the print originally. It also means that stains on the print surface can be isolated more easily (using Select ····▸Colour Range in Photoshop) and removed.

Contrast and Brightness Control (fig 2)
Once the image is captured, the first step is to adjust the contrast and brightness. This can be undertaken using the automatic controls contained within your

Fig 1– More than just the start of the restoration process, scanning captures the information that will be the basis of your completed image. Lack of care here will lose important information that is vital to the process.

Fig 2 – Adjust the spread of the tones in your image by altering its contrast and brightness.

PHOTOIMPACT

PAINTSHOP PRO

PHOTOSHOP

imaging package or by manually pegging the white and black points of the image. Apart from these general changes, I also tend to make small adjustments to the brightness of the shadow areas, so that subtle details, which tend to get lost at the printing stage, are more apparent.

<div style="border:1px dotted">

STEPS FOR SHADOW ENHANCEMENT (fig 3)

PhotoImpact
1. Select Format···⟩Tone Map from the menu bar.
2. Click on Highlight Midtone Shadow Tab at the top of the dialogue.
3. Move the Midtone slider to the right add or increase the values to lighten shadows.

Paintshop Pro
1. Select Colours···⟩Adjustments···⟩Gamma Correction from the menu bar.
2. Make sure that the Red, Green and Blue sliders are linked.
3. Move the sliders right to lighten shadow detail.

Photoshop
1. Select Image···⟩Adjustment···⟩Curves from the menu bar.
2. Carefully push the shadow area of the curve upwards so that the section from the black to this point is steeper than before.

</div>

Fig 3 – A little adjustment to the shadow area of your image will help, as it's this detail that is often lost in the printing process.

Removing Dust and Scratches
Dust and scratches are a fact of life for most of us who scan our own negatives and prints. Sure, careful cleaning of the original will produce a file with fewer of these problems, but, despite my best efforts, some marks always seem to remain. All imaging packages contain good tools for removing these annoying spots. Most are based on either blending the mark with the surrounding pixels or stamping a piece of background over the area. Time spent on this helps ensure a professional result.

Repairing Damaged Areas
Reconstructing damaged or missing areas of an image is the most skillful part of the restoration process. Most tears and major scratches can be fixed by using the Rubber Stamp tool in Photoshop, PhotoImpact's Clone-Paintbrush or the Clone Brush in Paintshop Pro. Search the picture for areas of the image that are of similar tone and texture to the damaged area to sample. The quality of your selection will determine how imperceptible the repair will be.

Large areas can be constructed quickly by selecting, copying and pasting whole chunks of the background onto vacant or missing parts of the image. Feathering the edges of the selection will make the copied areas less apparent when they are pasted. Remember, credibility is the aim in all your reconstruction efforts.

Fig 4 – To disguise the smoothing that is associated with some restoration steps, add a little texture to the image. Try to match the size and type of grain structure with that of the original.

Putting Texture Back (fig 4)

Often one of the telltale signs of extensive reconstruction work is a smoothing of the retouched areas. Even though cloning samples texture as well as colour and tone, continual stamping tends to blend the textures, producing a smoother appearance. To help unify the new area and disguise this problem, a little texture should be applied to the whole image.

This can be achieved by adding "noise" to the image. This option is situated under the Filter menu in Photoshop, the Image menu in Paintshop Pro and the Effects menu of PhotoImpact. In an enlarged view of your image (at least 1:1 or one hundred per cent) gradually adjust the noise effect until the picture has a uniform texture across the both new and old areas.

Adding Colour (see figs 5 & 6)

A lot of historical images are toned so that they are brown-and-white rather than just black, white and grey. A similar, sepia-like effect can be created digitally using the colourize options of Photoshop (Image····} Adjustment····}Hue/ Saturation), PhotoImpact (Format····} Hue/Saturation), and Paintshop Pro (Colours····} Colourize). With the colourize box ticked, you can make changes to the tint of the image by sliding the Hue selector.

Fig 5 – Adjusting the Hue/Saturation control is an easy way to add a digital tone to your print.

Fig 6 – Restoration is a common job for digital photographers and one that hones important imaging skills and techniques.

Fig 7– Deep etching is a frequently used preliminary step to adding multiple images together in a montage.

TWO: GETTING RID OF BACKGROUNDS
Difficulty level: 1
Programs: Photoshop, Mask Pro

In the old days, placing an object against a clean, white background was achieved by a process called "deep etching". This technique required a graphic designer or photographer to cut away background information by carefully slicing the image with a scalpel. Today, the job is completed in a less dramatic and more effective manner using a blunt mouse instead of a sharp knife.

Achieving this deep-etched look digitally requires the careful selection of objects and the deletion of their backgrounds. As an example, I chose an illustration containing a sign in the background. I wanted to extract the sign from the image and combine this image with a second picture (see fig 7). I could, and usually would, use one of the Photoshop's in-built tools to complete this task, and, as we have already seen, there is a variety of ways to reach the same goal.

Lasso Tool
Using the Lasso tool, or for even more accuracy, the Magnetic Lasso, I could draw round the whole sign, being careful to pick out the edges. Any overlaps could be tidied up using the eraser. I would then inverse the selection (Select⋯Inverse) and delete the background (Edit⋯Cut) (see fig 8).

Fig 8 – The Lasso is a selection tool that is based on an area drawn by the user.

Marquee Tool

The Marquee tool is not really an option here as the shape of the object to be selected is not regular. A rectangular marquee would leave a lot of the background area still to be erased (see fig 9).

Fig 9 – The Marquee tool also bases its selection on a drawn area.

Magic Wand

The Magic Wand tool makes its selections based on colour not a drawn area. For this example, it would be best to select the background colour and then adjust the tolerance (found in the Magic Wand palette) to try to encompass all the required pixels. It would then be a simple matter to delete the unwanted pixels (see fig 10).

Fig 10– The Magic Wand selects objects based on their colour.

Colour Range

In a similar way, the Colour Range tool, which is found nestled under the Selection menu in Photoshop, would allow me to select interactively the background or foreground colours, from which I could make a selection or mask (see fig 11).

Why the Need for More?

With such a variety of ways to achieve that all important selection, there would seem to be little or no need for another group of tools in this area. As the software versions of each of the leading packages have developed, so too has the sophistication of their selection tools. What more could specialist selection or masking products give the user that would warrant their use?

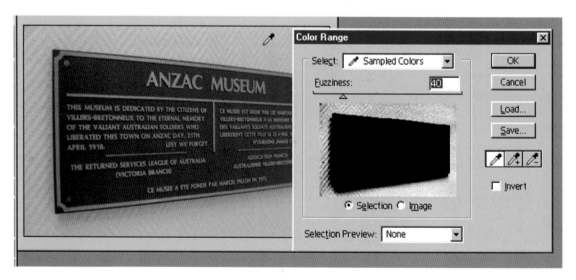

Fig 11 – Colour Range is a refined colour selection tool that allows the user to adjust and add to the colours that are selected.

The short answer is that, despite the strengths of these standard tools, for most jobs, specialist software can provide a greater level of flexibility and adjustment.

The Mask Pro Way

Extensis has obviously designed their Mask Pro plug-in around the tasks that digital workers find themselves doing most often, and has been careful to provide a range of options that, although similar to Photoshop in flavour, provide an extension to Adobe's tool set.

When you select Mask Pro from the Extensis heading under the Photoshop Filter menu, you are presented with a new working window containing the image, four palettes and the toolbox (see fig 12). Standard and Extensis versions of traditional tools like the Brush, Paint Bucket, Magic Wand and the Pen are pro-

vided (see fig 13). Use the Keep and Drop eye droppers to select the colours within the image to be saved or discarded (see fig 14). These colours will now form the basis of the selection made with any of the specialized tools.

Next, drag the Magic Wand or Magic Brush tool along the outside edge of the image that you want to isolate from the background. Mask Pro will mask the area based on the Keep and Drop colours you have selected. Once completed, the image can be returned to Photoshop with the foreground figure now free of its background (see fig 15).

Once the sign is isolated, it is a comparatively simple job to drag it from its original window to that of the new background (see fig 16). If, like me, you need some white space to the side of the background image, change the size of the canvas before combining the images.

MASK PRO TOOLBOX BRUSH AND THRESHOLD PALETTES KEEP AND DROP PALETTES WORK WINDOW

Fig 12 – Mask Pro is a dedicated selection system designed to make the job of cutting objects from their backgrounds easier and faster than ever before.

KEEP — DROP

MAGIC BRUSH — BRUSH

MAGIC FILL — BUCKET FILL

MAGIC WAND — AIRBRUSH

MAGIC PEN — PEN

HAND — ZOOM

ERASE

Fig 13– The tools in Mask Pro are customized versions of the ones available in Photoshop.

KEEP PALETTE — COLOURS TO KEEP

DROP PALETTE — COLOURS TO DROP

NEW SET NEW COLOUR BIN COLOUR

Fig 14 – The Keep and Drop palettes determine what parts of the image are saved or deleted from the image.

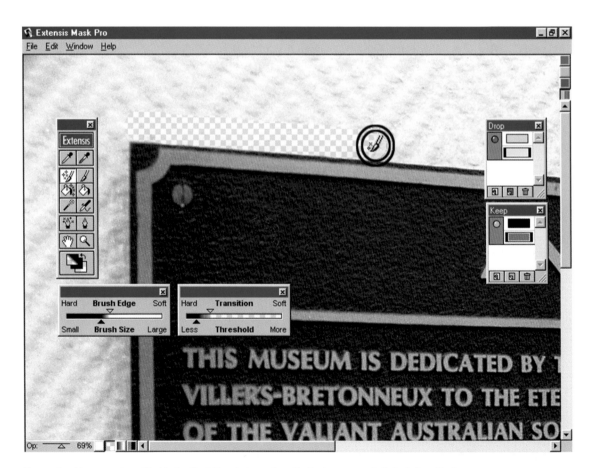

Fig 15 – Brushing around an object in the Mask Pro window automatically drops unwanted pixels from the image.

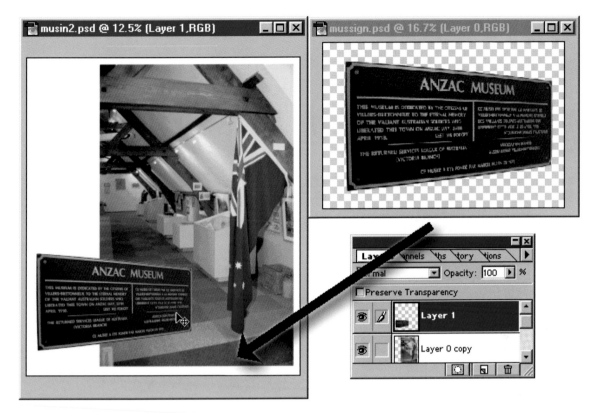

Fig 16 – Combining two separate images is as simple as dragging the image layer from one open window to the other.

MASK PRO USAGE SUMMARY

1. Crop the image if necessary.
2. Open the Mask Pro plug-in by selecting the desired mode from the Extensis selection underneath the Filters menu in Photoshop: Filters····}Extensis····}Mask····}Select or Filters····}Extensis····}Mask····}Composite.
3. Use the eye droppers to select the colours you wish to keep or drop from the image.
4. Select the areas to mask away using one of the painting or drawing tools like the Magic Wand or Magic Brush.
5. Search for the any holes and complete the mask using the Bucket Fill and Magic Fill tools.
6. Save the mask and return to Photoshop satisfied with a job well done!

Optional: Before returning to Photoshop you can apply other Mask Pro options such as:

- Using the Make Work Path to create a clipping path, or
- Using Edgeblender to reduce or eliminate halo effects.

Those of you who are Net connected can download trial versions of all the Extensis software from Error! Reference source not found.

Adobe's Extract Tool (fig 17)

Hidden away under the Image menu in Photoshop is Adobe's specialist selection tool. Revised and updated for Version 6, the concept is simple – draw around the outside of the object you want to select, making sure that the highlighter overlaps the edge between background and foreground, and then fill in the middle. The program then analyses the edge section of the object using some clever fuzzy logic to determine what should be kept and what should be discarded, and Hey Presto! the background disappears.

The tool is faster than lasso or pen tools as you don't need to be as accurate with your edge drawing, and it definitely handles wispy hair with greater finesse than most manual methods I have seen. There are several ways to refine the accuracy of the extraction process that are handy for those areas where the computer has difficulty deciding what to leave and what to throw away.

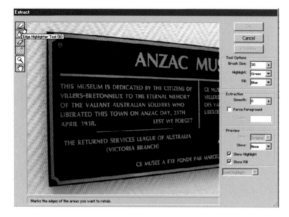

Fig 17 – Adobe's answer to advanced selection tools like Mask Pro is the Extract function.

EXTRACT USAGE SUMMARY

1. Select the layer you wish to extract.
2. Chose Image····⫽Extract from the Photoshop menus.
3. Using the Edge Highlighter tool, draw around the edges of the object you wish to extract (see fig 18).
4. Select the Fill tool and click inside the object to fill its interior (see fig 19).
5. Click Preview to check the extraction.
6. Click OK to apply the final extraction (see fig 20).

Extraction Tips:
- Make sure that the highlight slightly overlaps the object edges and its background.
- For items such as hair use a larger brush.
- Make sure that the highlight forms a complete and closed line around the object

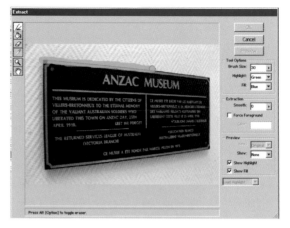

Fig 18 – The first step in the extract process is to highlight the edges of the object to be extracted.

Fig 19 – Once completed, the highlighted object can be filled.

Fig 20 – Photoshop processes the command to extract by determining which part of the object is to be kept and which is to be dropped. The result is the selected object with its background deleted.

THREE: DIGITAL DEPTH OF FIELD

Difficulty level: 2
Programs: Photoshop

Photographers have long considered control over the amount of sharpness in their images a sign of their skill and expertise. Almost all shooters display their depth of field agility regularly, whether it's by creating landscape images that are sharp from the very foreground objects through to the distant hills or the selective focus style so popular in food and catalogue shots. Everyone from the famed Ansel Adams and his mates in the F64 group to today's top fashion and commercial photographers makes use of changes in areas of focus to add drama and atmosphere to their images.

In the digital age, the photographer can add a new technique to the traditional camera-based ones used to control depth of field in images. Unlike silver-based imaging, where once the frame is exposed, the depth of sharpness is fixed, pixel-based imaging allows the selection of focused and defocused areas after the shooting stage. In short, a little Photoshop trickery can change an image which is sharp from the foreground to the background to one that displays all the characteristics normally associated with a shallow depth of field.

Basic Defocusing of the Pixels – Step by Step

1. Choose an image that has a large depth of field. This way you will have more choice when selecting which parts of the image to keep sharp and which parts to defocus. The example I have used has a large depth of field in its original form; it's sharp from the holy man in the foreground to the temple walls at the back of the frame. The picture demonstrates all the characteristics of an image made with a small aperture, such as F16 or F22. If I had shot this image with a larger aperture (F2.8 or F2), the holy man in the mid-ground would be sharp, while the foreground and background would be defocused (see fig 21).

2. Use one of Photoshop's selection tools to isolate the part of the image you want to remain sharp.

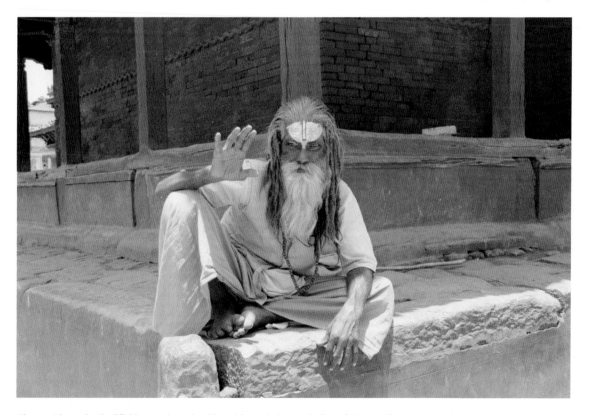

Fig 21 – A large depth of field example made with a wide-angle lens and a large f-stop number.

Fig 22 – Even with a feathered edge, a simple one-selection blur does not provide a very realistic shallow depth of field image.

I selected the whole figure of the holy man. Inverse the selection (Selection⋯⟩Inverse). In the example, the new selection included both the background and foreground information.

3. Add some feathering to the edge of the selection so that the transition points between focused and defocused picture elements is more gradual. This step can be omitted if you want sharp-edged focal points that contrasted against a blurry background.

4. Filter the selected area using the Gaussian Blur filter (Filter⋯⟩Blur⋯⟩Gaussian) set at a low setting to start with. Make sure the Preview option is selected, this way you can get an immediate idea of the strength of the effect.

5. Hide the "marching ants" that define the selection area so you can assess the defocusing effect. Use the magnifying tool to examine the transition points between sharp and blurred areas. Re-filter the selection if the effect is not obvious enough.

This technique provides a simple in-focus or out-of-focus effect (see fig 22). It reflects, in a basic way, a camera-based shallow depth of field effect and draws our attention to the holy man. However, it is not totally convincing. To achieve a result that is more realistic, the technique needs to be extended.

Producing a More Realistic Depth-of-Field Blur

If realism is our goal, it is necessary to look a little closer at how camera-based depth of field works and, more importantly, how it appears in our images.

Imagine an image shot with a long lens using a large aperture. The main subject, situated midway into the image, is pin sharp, but the depth of field is small, so other objects in the image are out of focus. Upon examination, it is possible to see that those picture elements closest to the main subject are not as blurred as those further away. The greater the distance from the point of focus, the more blurry the picture elements become. The same effect can be seen in images with large depths of field, through the depth of sharpness is greater.

This fact, simple though it is, is the key to a more realistic digital depth of field effect. The application of a simple one-step blurring process does not reflect what happens with traditional camera-based techniques.

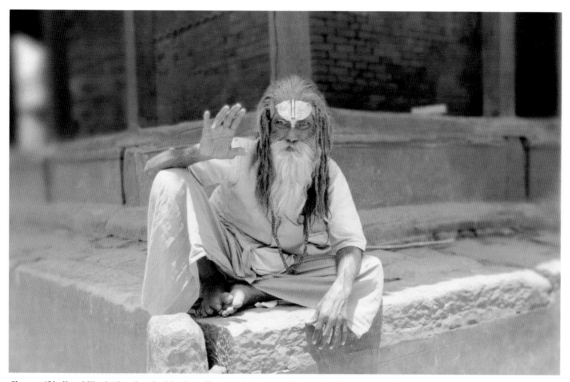

Fig 23 – If believability is the aim, the blurring effect needs to be applied gradually across the image.

More Realism – Step by Step (fig 23)

1. Using your raw scan image, repeat the first few steps of the basic defocusing process using Gaussian Blur filter settings that produce only a slight effect. A pixel radius of one is a good start. In my example, the holy man and the portion of the step beneath him was kept sharp, the rest of the image was slightly blurred.

2. Now change the selection so that those parts of the image that are just in front of the subject or just behind are not included. Apply another Gaussian Blur filter. This time, increase the pixel radius to two. In the example image more of the step in front and behind the main subject was excluded from this second application of the filter.

3. Change the selection again removing the image parts that are next furthest away from the main subject. Reapply the Gaussian Blur filter with a setting of four. Part of the temple behind the subject in the example was now removed from the selection which was then blurred again.

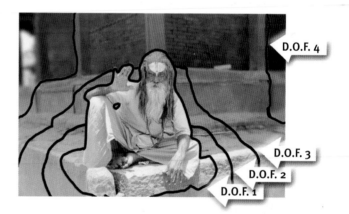

Fig 24 – A series of four selections was used to produce an image with a more realistic shallow depth of field effect.

4. This step can be repeated as many times as is needed to give a more realistic appearance to the effect. Each time, the selection is changed to exclude picture parts that are progressively further away from the subject, and each time the filter setting is doubled. In my example, four different selections were used to produce a more realistic depth of field effect (see fig 24).

If the simply created depth of field in the first example is compared with the more refined version in the second image, it is possible to see how an authentic feeling can be created by gradually increasing the amount of blur within the image.

Taking the Story Further

Using the techniques above, it is possible to replicate the depth of field effects that are obtainable through traditional means. However, if the idea is taken further, the clever digital photographer can produce images that achieve a quality and style that exceeds what is possible with camera-based manipulations.

Depth of field is based on a single plane of focus that runs through your subject. When using fixed-backed cameras, such as 35mm or medium format, the focus plane is parallel to the back of the camera or film plane. The depth of sharpness in the image then extends in front of and behind this plane. Aperture selection, lens length and subject distance all control the extent to which this sharpness extends into your picture.

Even with moving-back cameras, such as a mono-rail or 4 x 5 inch format, depth-of-field control is restricted, pivoting around a single plane, though that plane can be tilted away from the parallel.

Digital depth of field frees the image-maker from all these focus plane constraints. Areas of sharpness are controlled by the section of the image that is selected in your editing package, not by where the focus plane was at the time of shooting. Using this idea, it is possible to have areas of sharpness in the foreground and background of an image at the same time. This would not be possible using traditional means.

How to Produce Non-Focal Plane Constrained Depth of Field

To explain this idea I have selected another image of the holy man, this time shot a little closer in. The traditional depth of field displayed in the straight version of the image shows the main subject as sharp with a small amount of softness in the wall behind. As expected, the areas of sharpness revolve around a single plane that is parallel to my camera back and runs vertically through the subject (see fig 25).

A digitally manipulated version of the same image

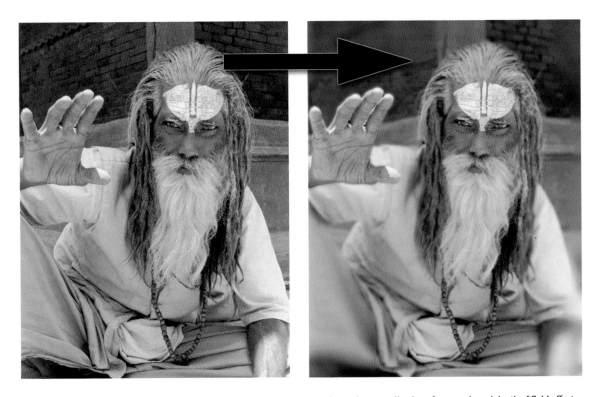

Fig 25 – An extension to the basic technique gives the user the chance to go beyond pure replication of camera-based depth of field effects.

exhibits a range of focus points that are not necessarily in the same plane. In the example I chose to keep the face, the hand and the beads sharp whilst applying a blur filter to the rest of the image. The final image

SELECTED FOCUS POINTS

Fig 26 – Several points within the image, not all on one plane, were chosen to remain sharp. It would not have been possible to produce this effect by traditional means.

shows depth of field effects that can not be achieved traditionally as the three sharp elements are not in the same plane (see fig 26).

This final technique, though not possible using camera and film, draws on a long and rich heritage of sharpness manipulation and will surely open up a new vista of visual possibilities for the digitally creative.

FOUR: DIGITAL LITH PRINTING
Difficulty level: 2
Programs: PhotoImpact, Paintshop Pro, Photoshop

The craft printing revival of the nineties introduced a new generation of monochrome enthusiasts to a range of printing techniques, both old and new, that transform the mundane to the magnificent. Lith printing is one such technique. For the uninitiated, the process involves the massive over-exposure of chloro-bromide-based papers coupled with development in a weak solution of lith chemistry. The resultant images are distinctly textured and richly coloured and their origins are unmistakable.

The process, full of quirky variables like the age and strength of the developer and the amount of over-exposure received by the paper, was unpredictable and almost impossible to repeat. In this regard at least, printers found this technique both fascinating and infuriating. This said, it's almost a decade since lith printing started to become more commonplace and there is no sign of people's interest declining.

"Long live lith," I hear you say, "but I don't have a darkroom." Well, there's no need. The digital worker, with basic skills, a good bitmap imaging program, and a reasonable colour printer, can reproduce the characteristics of lith printing without the smelly hands or the dank darkroom of the traditional technique.

Step A: Decide What Makes a Lith Print
If you ask photographers what makes a lith print special, the majority of them will tell you it's the amazing grain and the rich colours. Most lith prints have strong, distinctive and quite atmospheric grain that is a direct result of the way in which the image is processed. This is coupled with colours that are seldom seen in a black-and-white print. They range from a deep chocolate, through warm browns, to oranges and sometimes even pink tones. If our digital version is to seem convincing, the final print will need to contain all of these elements.

Step B: Get Yourself an Image
Whether you source your image from a camera or a scanner, make sure that the subject matter is conducive to a lith-type print. The composition should be strong and the image should contain a full range of tones, especially in the highlights and shadows. Good contrast will also help make a more striking print.

Fig 27– If you are starting the digital lith-printing process with a colour image, your first step is to convert the image to greyscale.

Step C: Lose the Colour (fig 27)

Unless you are scanning from a monochrome original, you will need to change the mode of your digital file from either RGB or CMYK colour to greyscale. Even though lith prints do have a distinct colour, they all start life as a standard black-and-white image.

To change colour to greyscale:

PhotoImpact – Format····▷Data Type····▷Greyscale
Paint Shop Pro – Colours····▷Grey Scale
Photoshop – Image····▷Mode····▷Grayscale

Fig 28 – After desaturation, images tend to be a little flat. This can be rectified with a small adjustment of the Contrast and/or Brightness sliders.

*Fig 29 – Grainy texture is one of the most recognizable characteristics of
lith prints, adding it to our digital image is critical if the effect is to be reproduced.*

Step D: Adjust Contrast and Brightness (fig 28)

Sometimes when a colour image is changed to
greyscale there is a noticeable flattening of the tones
– the image looks low in contrast. Using the tools in
your editing program, adjust the contrast and bright-
ness of the image to make up for any loss of contrast.
Make sure that all the tones are well spread and that
the image contains a good black and white as well as
textured shadows and highlights.

To adjust brightness:
PhotoImpact – Format····⟩Brightness/Contrast
Paint Shop Pro – Colours····⟩Adjust····⟩Brightness/Contrast
Photoshop – Image····⟩Adjust····⟩Brightness/Contrast.

Step E: Add Texture (fig 29)

There are a couple of ways to simulate the texture of the
lith print. You can filter the whole image using a film
grain filter. Most of these type of filters have slider con-
trols that adjust the size of the grain and how it is applied
to the highlights of your image. I prefer to use a Noise fil-
ter as it gives an all-over textured feel that is more suit-
ed to the lith print look. Again, variations of the intensity

of the effect can be made via the filter's dialogue box.
To add texture:
PhotoImpact – Effect····⟩Noise····⟩Add Noise.
Paint Shop Pro – Image····⟩Noise····⟩Add.
Photoshop – Filter····⟩Artistic····⟩Film Grain or
Filter····⟩Noise····⟩Add Noise.

Step F: Add Colour (fig 30)

The simplest and most effective way to add
lith-like colours to your image is to make another
change to its colour mode. For Photoshop users,
instead of reverting back to a RGB, change to a
duotone mode. This special colour mode is
designed to allow a greyscale image to be printed
with the addition of another user-selected colour.
In effect, we can select whether the digital lith
print will have a chocolate brown or pink colour
by selecting the second colour that will mix with the
grey tones of the monochrome print.

Paint Shop Pro and PhotoImpact devotees will
need to colourize a RGB file that has been reconstitut-
ed from the greyscale, and then create the lith colour
by adjusting the Hue and Saturation sliders.

Fig 30– Lith-like colours can be added to the black-and-white image using the Hue/Saturation controls.

To add colour:

PhotoImpact – Format····⟩Data Type····⟩ RGB True Colour.
Format····⟩Hue Saturation.
Check Colourize option and adjust Saturation and
then Hue sliders to add colour to the greyscale.
Paint Shop Pro – Colours····⟩Channel Combining····⟩
Combine From RGB.
Select the greyscale image for each channel source,
then Colours····⟩Colourize.
Adjust Saturation and then Hue sliders to add
colour to the greyscale.
Photoshop – Image····⟩Mode····⟩Duotone.
Change type from monochrome to duotone.
Double click the colour space in ink 2.
Select a colour from the colour swatch.

Step G: Print Your Results

Printing, the final step of the process, shouldn't be
underrated. Be sure to use the best quality settings for
your printer. This means selecting the highest resolu-
tion possible and making sure that check boxes like
Finest Detail are always ticked. Finally, use good-qual-
ity heavy-weight photo paper. Remember, most photo-
graphic paper is about 225gsm so if you want the
same feel as a photograph, make sure you use a simi-
lar weighted stock to print on.

ACTION STATIONS

Because I like texture and grain, the lith printing
effect is one I use often. The process is always the
same – de-colour, texturize and re-colour – and,
exciting as watching my colour images changing to
something altogether more atmospheric is, the
steps can become a little tedious.

Actions to the rescue! Many of you will be aware
of the macro language that allows users of
Photoshop 4 or greater to record a series of actions
and apply them, at a later date, to another image.
This facility is perfect for creating lith effect.

I simply activate the recording button, proceed
through the steps of making a colour image into a
lith one, and save the action for later use (fig 31).
Then, when the action is started, the steps are car-
ried out one by one as if I am pressing the buttons.
Not only can I apply the effect to another image
with just one button click, I can also change a whole
folder, or directory, of candidate images by using
the associated batch function.

I now possess a whole series of self-recorded
actions that carry out a range of routine tasks that

would otherwise have me chained to the desktop for longer periods than I already am. These are, in effect, my digital toolkit.

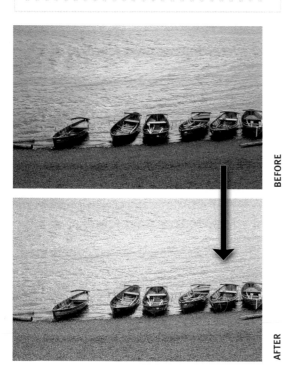

BEFORE

AFTER

Fig 31 – The steps of the digital lith process can be recorded as a Photoshop action, making the whole process a one-button-push affair.

TRICKS OF THE TRADE: STEPHEN MCALPINE'S TEXTURED MONTAGE TECHNIQUE (figs 32 & 33)

Difficulty level: 2

Programs: PhotoImpact, Paintshop Pro, Photoshop

Stephen McAlpine is a professional portrait and wedding photographer who spent the first ten years of his career creating beautiful hand-crafted black-and-white images for his clients. Long hours were spent in the darkroom moulding and shaping a visual style that is both distinctive and emotive.

The approach was a success with his clients but his best work took many hours to complete. When he started to play with digital techniques, he realized he could provide the same style of work within a time frame that suited his bottom line.

"Digital is an extension of what I was already doing in the darkroom." McAlpine explains. "The new technology provides me with a way of working that is both creatively satisfying and efficient. I can now offer clients a fully customized service that would have been prohibitively expensive if produced traditionally. What's more, with current digital RA4 printing [photographic colour printing] the image looks and feels no different than what I would have produced if I had spent hours in the darkroom."

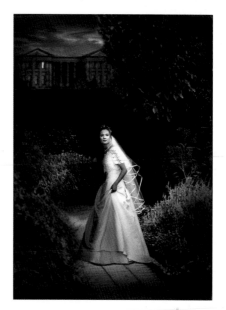

Fig 32 – Stephen McAlpine's imagery was initially produced in a darkroom-only process, now he makes use of digital techniques to create images that are both stunningly beautiful and highly emotive.

The following is a summary of the steps that McAlpine uses to create his beautiful images.

Step 1: Scan the various image parts from black-and-white original negatives.

Step 2: Adjust the contrast and brightness of the individual parts so that they have a uniform look. Double-check that the light direction and quality is consistent with all parts.

Step 3: Drag all components onto separate layers of one image. Resize and adjust edge areas to fit the parts together.

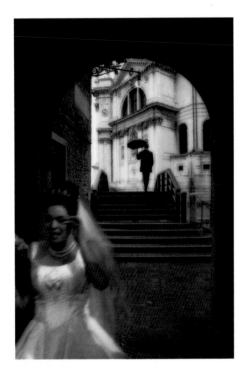

Fig 33 – The steps used by McAlpine to create his photographs are designed to unify separate image components.

Step 4: Introduce uniform grain (or noise) across all components to give the appearance that they were all sourced from one negative.

Step 5: Add drama to the image by selectively darkening and lightening areas using the Dodging and Burning-in tools. Artificially create drop shadows for foreground objects to give the appearance that they were shot in situ.

Step 6: Use the Variations filter (or Hue/Saturation control) to add toning colours to the black-and-white images.

Step 7: Output proofs to a desktop inkjet and final client images to a digital RA4 colour printer.

FIVE: DIFFUSION PRINTING
Difficulty level: 2
Programs:Paintshop Pro, Photoshop

Most photographers are obsessed with sharpness. We all strive for the ultimate quality in our images, carefully selecting good lenses, picking and choosing between film types and always, yes always, double-checking that the enlarger is focused before making that final exposure. All this so we can have sharp, well-focused images, of which we can be proud.

It seems almost a mortal sin, then, for me to be introducing you to a technique that shows you how to make your images "blurry", but, as we have seen, these days the photographic world is full of diffused images. From the food colour supplements in our weekend papers to the latest in portraiture or wedding photography, subtle, and sometimes not all that subtle, use of diffusion is a regular feature of contemporary images.

Traditionally, adding such an effect meant placing a "mist" or "fog" filter in front of the camera lens at the time of shooting. More recently, in an attempt to gain a little more control over the process, photographers have been placing the same filters below their enlarging lenses for part of the print's exposure time. This process gave a combination effect where sharpness and controlled blur happily coexisted in the final print.

The digital version of these techniques allows much more creativity and variation of the process and relies mainly on the use of layers and the Gaussian Blur filter. Both Photoshop and Paint Shop Pro have these facilities, coupled with simple interfaces that allow the user to control the application and control of the blur.

The Basics of Digital Diffusion (fig 34)
The Gaussian Blur filter, which can be found in most image-editing packages, effectively softens the sharp elements of an image when it is applied. Used by itself, this results in an image that is quite blurry and, let's be frank, not that attractive. However, when this image is carefully combined with the original sharp picture, we achieve results that contain sharpness and diffusion at the same time, and are somewhat more desirable.

Essentially we are talking about a technique that contains three distinct steps:

Firstly, make a copy of your image and place it on a second layer that sits above the original. Rename this layer "blurred layer".

With this layer selected, apply the Gaussian Blur filter. You should then have a diffused or blurred layer sitting above the sharp original (see fig 35).

(Photoshop users who don't like the look of the Gaussian diffusion, can choose to use the Diffuse filter instead. This filter is not as controllable but does achieve a different effect.)

Fig 34– Digital diffusion printing provides the user with more controllable options than are traditionally available.

Finally, change the layer blending mode and/or the opacity of the blurred layer to adjust the way in which the two layers interact as well as how much of the sharp layer shows through.

Photoshop contains fourteen, and Paint Shop Pro seventeen, different blending modes that allow the user control over how any layer interacts with any other. After testing them all, I found that the modes that worked best for the example image were normal, soft light, multiply and luminosity. Of course, other modes might work better on your images so don't just take my word for it, make sure you experiment.

Adjusting the blurred layer's opacity changes the transparency of this image. This, in turn, determines how much of the layer below can be seen. More opacity means less of the sharp layer characteristics are obvious.

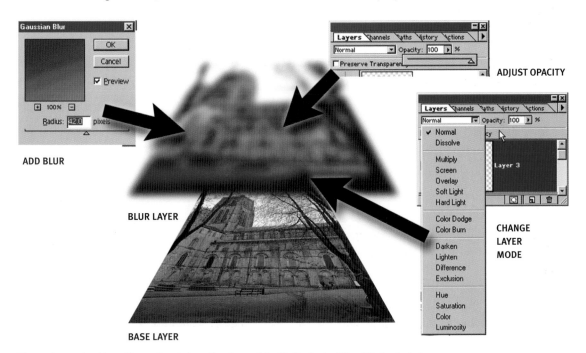

Fig 35 – A gaussian-blurred layer placed above the sharp original is the basis of the diffusion technique.

By carefully combining the choice of blending mode and the amount of opacity, the user can create infinite adjustments to a diffusion effect.

Paint Shop Pro

1. File----}Open – Select image.
2. Layers----}Duplicate.
3. Rename new layer "blurred layer".
4. Make sure this layer is selected.
5. Image----}Blur----}Gaussian Blur.
6. Adjust blending mode and opacity in layers dialogue.

Photoshop

1. File----}Open – Select image.
2. Layer----}Duplicate Layer.
3. Rename new layer "blurred layer".
4. Make sure this layer is selected.
5. Filter----}Blur----}Gaussian Blur or Filter----}Stylize----}Diffuse.
6. Adjust blending mode and opacity in layers dialogue.

One Step Further: Graduated Diffusion

In some instances, it might be preferable to keep one section of the image totally free of blur. If you use Photoshop this can be achieved by applying the Gaussian filter to your original image via a selection.

For example, I could select the gradient tool, making sure that the options were set to "foreground to transparent" and "radial gradient". I could then switch to "quick mask" mode and make a mask from the centre of the image to the outer right-hand edge of the image. When switching back to the selection mode, I would now have a graded circular selection through which I could apply the blurring filter.

If this extra step is applied to a duplicate of the original image on a separate layer, it will still be possible to use blending modes and opacity to further refine the image.

Photoshop

1. File----}Open – Select image.
2. Layer----}Duplicate Layer.
3. Rename new layer "blurred layer".
4. Make sure this layer is selected.
5. Ensure that the gradient blur tool is set to "foreground to transparent" and "radial".
6. Switch to "quick mask" mode.
7. Draw gradient.
8. Switch back to selection mode.
9. Filter----}Blur----}Gaussian Blur or Filter----}Stylize----}Diffuse.
10. Adjust blending mode and opacity in layers dialogue.

Even More Control: Erased Back Diffusion Technique (fig 36)

You can refine your control over the diffusion process even more by using the Eraser tool to selectively remove sections of the blurred layer. At its simplest, this will result in areas of blur contrasted against areas of sharpness. However, if you vary the opacity of the Eraser, you can carefully feather the transition points (see fig 37).

BEFORE AFTER

Fig 36– The erase back diffusion technique provides the user with control over which areas of the image remain sharp and which are blurred.

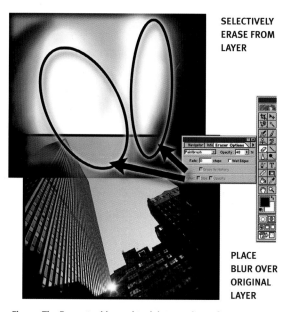

SELECTIVELY ERASE FROM LAYER

PLACE BLUR OVER ORIGINAL LAYER

Fig 37– The Eraser tool is used to delete sections of the upper blurred layer to reveal the sharp image below.

The addition of the erasing step allows much more control over the resultant image. It is possible to select and highlight the focal points of the photograph without losing the overall softness of the image.

Paint Shop Pro

1. File⋯⋗Open – Select image.
2. Layers⋯⋗Duplicate.
3. Rename new layer "blurred layer".
4. Make sure this layer is selected.
5. Select Eraser tool.
6. Adjust opacity of the tool.
7. Erase unwanted sections of the blurred layer.
8. Image⋯⋗Blur⋯⋗Gaussian Blur.
9. Adjust blending mode and opacity in layers dialogue.

Photoshop

1. File⋯⋗Open – Select image.
2. Layer⋯⋗Duplicate Layer.
3. Rename new layer "blurred layer".
4. Make sure this layer is selected.
5. Filter⋯⋗Blur⋯⋗Gaussian Blur or Filter⋯⋗Stylize⋯⋗Diffuse.
6. Select Eraser tool.
7. Adjust opacity of tool.
8. Erase unwanted sections of blurred layer.
9. Adjust blending mode and opacity in layers dialogue.

LAYER BLENDING MODES

These modes determine how layers interact together. The following modes work best with the diffusion technique examples described here and are common to both Photoshop and Paint Shop Pro, but don't limit your experimentation. Try other modes, the effect they give might be more appropriate for the images you use.

Normal : This is the default mode of any new layer and works as if you are viewing from above the group of layers. In this mode, a layer that is only partially opaque (that is, partly transparent) will allow part of the layer beneath to show through. As the opacity level drops, the layer concerned becomes more transparent.

Multiply: Multiplies the top layer colour with that of the layer directly beneath it. This always results in a darker colour.

Soft Light: Darkens or lightens the bottom layer colours, depending on the top layer colour. If the top colour is lighter than fifty per cent grey, the image is lightened, as if it were dodged. If the top colour is darker than fifty per cent grey, the image is darkened, as if it were burned in.

Luminosity: Creates a result colour with the hue and saturation of the bottom layer colour and the luminance of the top layer colour.

SIX: PANORAMIC IMAGING

Difficulty level: 1
Programs: Spin Panorama, PhotoImpact, Photosuite

All right, I admit it, I love the shape of panoramic pictures. There is just something about a long thin photograph that screams "special" to me. I have often dreamed of owning a camera capable of capturing such beauties but, alas, my bank balance always seems to be missing the amount needed to make such a purchase.

Lately the pragmatist in me has also started thinking about whether the comparatively few shots that I would take in this format would warrant the expense. I was in the midst of such thoughts when I stumbled onto a solution to my wide-vista problems.

A More Economical Approach (fig 38)

Spin Panorama is a piece of bonus software that came free with my new Epson printer. Since it's designed to generate impressive virtual reality tours from a series of individual shots, I initially thought that it would be of little use to someone interested in print-based images. I was wrong.

In the process of stitching together a series of images, the program allows the user to save the final scene as a JPEG file. As most photographers interested in digital-imaging know, this is an eminently useful format. My mind started to turn over and I realized that this could be a way for me to make panoramic pictures without having to pay for new equipment.

Field Test

A leisurely visit to a local National Trust property provided a great opportunity to test this technique for making panoramic images. Situated in a man-made landscape, the main house is fronted by a ornamental lake. To the left, a statue on its plinth rises from the water. The opposite side is just a bare stage.

Keeping in mind the recommendations of a ten to twenty per cent overlap in each successive image, I shot a series of three stills, keeping the camera at the same height and focal length throughout.

The Results

As soon as the images were processed, I scanned them into my computer and used the Spin Panorama software to match and stitch the images together (see "How to Use Spin Panorama" below). As you would expect, areas where overlapping objects were obvious and sharp-edged stitched together perfectly, but the computer had a little more difficulty with more ill-defined picture sections, such as random foliage.

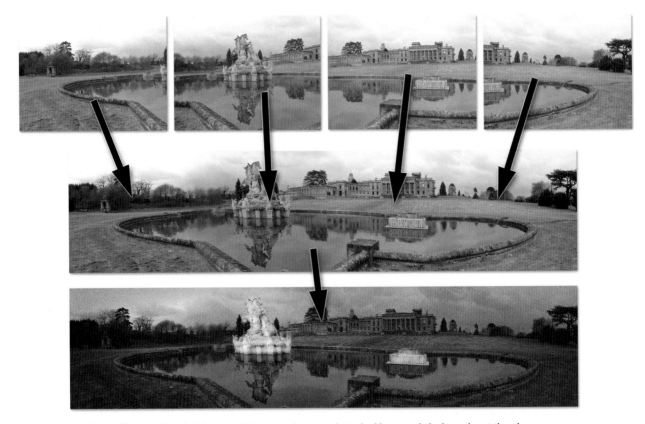

Fig 38 – It is possible to produce digital panoramic images using several standard images stitched together at the edges.

Stitching complete, I cropped the panorama to remove edge areas that would reveal its stitched nature and saved the whole project as a JPEG file.

Finishing Touches

The base work now done, I was ready to add some finishing touches in Photoshop. I felt that the nature of the scene deserved alterations that would suit the atmosphere of the environment. First I used the rubber stamp tool to eliminate the dust that appeared on the original scans. I then discarded the colour in the image by converting the mode to greyscale. Using the levels tool I was able to position precisely the blacks, whites and, more importantly, midtone greys of the image. I then used the dodging tool to lighten the statue detail in the front left of the picture. I also used a feathered selection and the Levels feature to darken the edges of the picture.

To complete the atmosphere I filtered the image using the Noise filter set to Gaussian and Monochromatic and added a lith printing-type colour via the Hue/Saturation control.

A Successful First Date

Don't tell my wife, but I think that Spin and I have just started a beautiful friendship. I feel that I can confidently shoot a series of images knowing that, when stitched together, they will produce stunning wide-angle vistas in the format that I so adore. All this for a fraction of the cost of purchasing a dedicated panoramic camera.

HOW TO USE SPIN PANORAMA

Shoot your images making sure that you have an overlap between successive images of between 20 and 40 percent. Hold the camera steady and before you start to take the photographs pan through the vista to check to see if your view point, exposure, height and position are the best for the location. For the most accurate results you should pan 'around the camera' keeping it as the centre of your pivot.

Start the Panorama Maker program choosing which format image you wish to create – Horizontal, Vertical, 360 Degree or mosaic Tile. If you know the focal length of the lens used to shoot the source images you can input that value in the Camera Lens section of the dialogue. If you are unsure then use the Automatic option. Select the output size you require and make sure that

the Automatic Exposure Correction feature is checked (see fig 40). Click Next.

Create a new Album using the New option from the drop-down menu. Add the source images from either your camera or computer to the album preview area. Drag the images from here to the story board section at the bottom of the screen. Change the order of the pictures by clicking and dragging to a new position. Alter

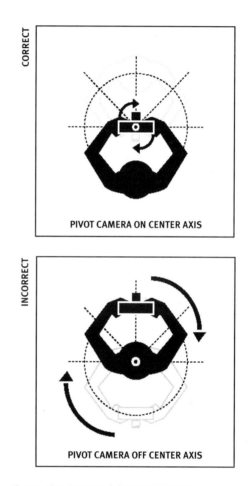

Fig 39 – Shooting around the axis of the lens will provide images that are more easily stitched.

orientation, contrast or brightness of any picture by double clicking on the thumbnail to take you to the Edit Screen (see fig41). Click Next.

The program produces an automatically stitched image. Use the magnify options to check the stitch points of overlapping picture edges. To increase the accuracy of difficult areas you can adjust the stitch

Fig 40 – After starting the Panorama Maker program choose the style of image, focal length of lens and size of final result.

Fig 41– Add the source images to the album section of the screen and then drag them to the storyboard.

points for each overlap manually by clicking on the Fine Tune button. This screen allows you to manually drag the matching stitching points for two consecutive images. Match image parts from both pictures. Sometimes it is necessary to try a range of stitching points before achieving a convincing result (see fig 42).

Click OK and then Finish to complete the panorama.

Output the final panorama. The final step in the process allows you to save the completed panorama as a picture in a variety of formats (Save button), a QuickTime movie file (Export button) or to print the wide vista photograph (Print button, see fig 43).

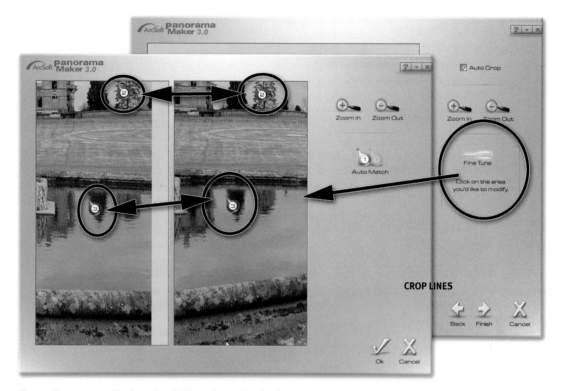

Fig 42 – You can manually place the stitching points using the Fine Tuning screen if the automatic process does not produce good results.

Fig 43– With the stitch complete you can choose between three types of output – image file, QuickTime movie or print.

Software Details

Spin Panorama is produced by Picture Works Technology, Inc. The program is available as part of the bonus software pack with new Epson printers.

PhotoImpact, Photoshop Elements and Photosuite also have dedicated stitching functions that you can use to create panoramic images.

SEVEN: RECAPTURING THE DRAMA OF YOUR IMAGES

Difficulty level: 3
Programs: Photoshop

At times it's hard to make decisions about which images to print and which to file. Like a lot of photographers, I find it difficult to judge my own work and am often disappointed with my results. The images don't reflect the atmosphere I saw and felt at the time of

Fig 45– This portrait image, though already striking, can be improved by some drama-enhancing digital techniques.

Fig 44 – Sometimes shots have the potential to be a lot more dramatic than they first appear. There are several characteristics in this image that can be improved via a little digital enhancement.

shooting. In years past, I sought to recapture this atmosphere through the use of sophisticated darkroom techniques. More recently I have found that digital manipulation provides me with a range of options, some not even possible in the darkroom, that help bring the drama back to my images. The following process combines a series of basic techniques that together will help transform your images.

As examples I selected a couple of images that, in my eyes, failed to reproduce the atmosphere that was evident to me on the day. The first is a typical beach scene, complete with deck chairs, gravel (alas, no sand) and the obligatory old pier in the background (see fig 44). The second is a portrait of a stylish young gent intent on "tanning his tatts". Both images seemed stronger in the viewfinder than the straight prints indicate, and are good candidates for me to demonstrate the techniques I use to enhance the theatrical nature of my images (see fig 45).

Step A: Defocusing, or Depth of Field (fig 46)

Photographers have long used depth of field to control what is sharp within their images. We all know that shallow depth of field, produced by a long lens or a small aperture number (or both), isolates the focused object against a blurred background. This technique has more recently be called "defocusing", indicating

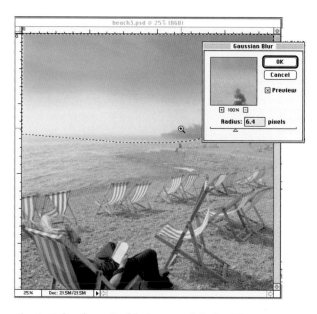

Fig 46 – Defocusing parts of the image can help direct the eyes of your audience towards the focal points you choose.

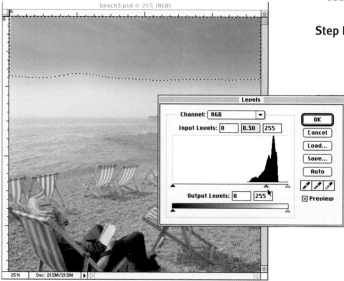

Fig 47 – The use of carefully drawn and feathered selections, together with the Levels dialogue, gives the user great control over the darkening or lightening of specific image areas.

that the photographer has made a definite decision about the sharpness of all elements in the image and that it didn't just happen by accident.

This term is handy to use for the digital version of the technique as it describes the process of blurring that occurs. Background objects, like the fence in the punk portrait, can be selected using one of the Photoshop selection tools, the edge of the selection feathered, and a Gaussian Blur applied. The contrast between the blurred and sharp parts of the image gives the appearance of a shallow depth of field. This directs the viewer's eye to the main part of the image.

In the beach scene, which has a large depth of field courtesy of a wide-angle lens and a small aperture, the areas in both the foreground and background were defocused, directing attention to the reading man. A series of selections and blur amounts were used to graduate the sharpness from the subject to the other parts of the image. This has the effect of most closely replicating the depth of field effects created by a standard camera lens and aperture.

Photoshop tools/menus used:
- Selection tools (Magic Wand, Marquee, Lasso)
- Feather (applied to the edge of the selection)
- Gaussian Blur filter.

Step B: Darkening Specific Areas (fig 47)

Dodging and burning is a traditional photographic technique that has been used for decades to help change and manipulate the tones in a photograph. Photoshop, again through the use of a series of feathered sections, allows the user to darken and lighten specific areas of an image.

Your first thought might be to use the Brightness/ Contrast control to adjust the tones in the selected area, but this type of manipulation can produce very crude results. Instead, use your Levels control. If you carefully move the grey point in the dialogue box you will find that you can

change the midtones without adversely affecting either the shadows or highlights. This solves the problems of clogged shadows, or blown highlights, that sometimes occurs when using the Brightness/Contrast control. Remember, with the selection "active", adjusting the levels will only affect the areas selected. The feathering will mean that the change in tone will happen gradually.

In the portrait, the forearms and the edge of the frame were darkened using this technique. The sky in the background, together with the foreground, were altered in the beach scene.

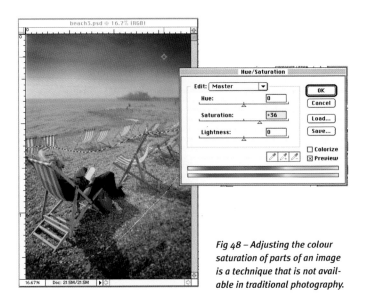

Fig 48 – Adjusting the colour saturation of parts of an image is a technique that is not available in traditional photography.

Photoshop tools/menus used:
- Selection tools (Magic Wand, Marquee, Lasso)
- Feather (applied to the edge of the selection)
- Levels dialogue box.

Step C: Saturation and Desaturation (fig 48)
This technique, unlike the previous two, does not draw easy parallels from the world of traditional photography. Again, the user selects and feathers areas of the image to work on. Making adjustments in the Hue/Saturation dialogue box will then allow a change in the saturation of the colours in the image. Desaturate, and the image will gradually turn black-and-white; saturate, and the colours will become vibrant and, if pushed to extremes, garish.

In the portrait, the background was changed to become almost monochrome. To add even more contrast, the subject was then selected and its saturation increased. Back on the beach, the deck chairs were the obvious choice to saturate. Again, fore- and backgrounds were desaturated.

Photoshop tools/menus used:
- Selection tools (Magic Wand, Marquee, Lasso)
- Feather (applied to the edge of the selection)
- Hue/Saturation dialogue box.

Step D: Eliminating Unwanted Details (fig 49)
A lot of you will probably have used the Rubber Stamp tool before. As we have seen it's great for removing scratches and dust marks in all those restoration projects that the family insist on giving you. In the beach scene, I used the Rubber

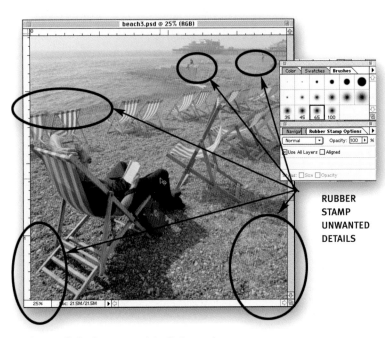

RUBBER STAMP UNWANTED DETAILS

Fig 49 – Eliminating unwanted details from an image can improve the overall composition of the photograph.

Stamp, or Cloning tool, not only to retouch dust marks but also to change whole sections of the image.

In the foreground, you will notice that the diagonal walls on the right and left sides have been replaced with more gravel. The sailing boat and countless people have been removed from the background.

When the boat and the life preserver were removed, the pier was repaired and, most significantly, the people in the mid-ground in the water, on the beach and sitting on the chairs have also been removed.

These adjustments add to the desired feeling of the isolation of the main subject, and provide an image that is now free of clutter.

Photoshop tools/menus used:
• Rubber Stamp
 or Cloning tool.

REALISM VERSUS EMOTION

I'm sure that, looking at the results, a lot of you will say to yourselves that these techniques create photographs that lie or, at least, don't reflect the truth of the scene (fig 50).

In one respect I agree with you. I have made definite changes to the images that did not occur on the day – people being removed from chairs, the sky made to appear menacing, colourful

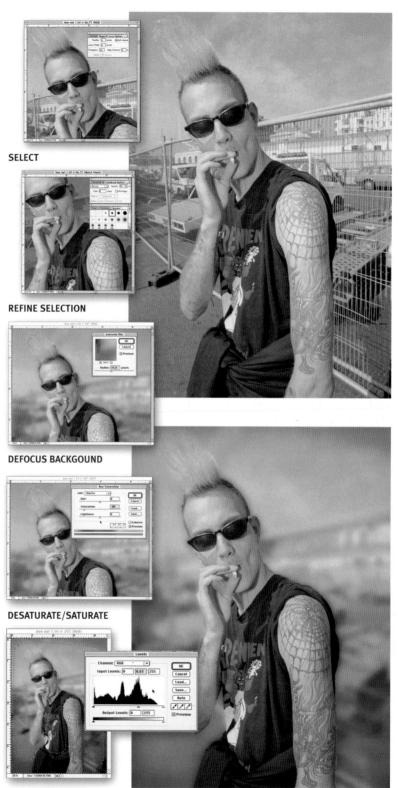

SELECT

REFINE SELECTION

DEFOCUS BACKGOUND

DESATURATE/SATURATE

DODGE AND BURN

Fig 50 – Dramatization of the portrait is a matter of five simple steps.

backgrounds turned to black and white. But remember, realism was not my aim. I was attempting to recreate the atmosphere of the image I saw through the viewfinder, and perhaps partly imagined.

The man reading the book in the deck chair seemed totally unaware of what was going on around him. He was in a world of his own. I gave life to this feeling by removing the other people from the image, saturating the area nearest to him and desaturating the background. The darkening and defocusing of the areas around him focuses attention on him and increases the sense of his isolation (see fig 51).

The punk in the portrait was standing with his friends enjoying the sun like everyone else, but his choice of personal grooming and style made him stand apart from the other beach-goers. In comparison, everything and everyone else looked a bit drab. To emphasize this, I desaturated and defocused the background. This draws the viewer's attention straight to him (see fig 52).

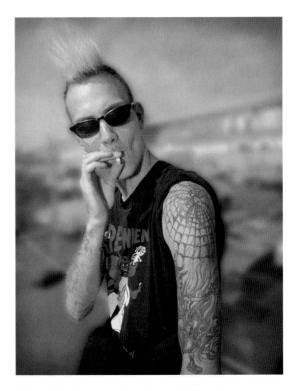

Fig 52 – The changes made to the portrait, though not objectively accurate, reflect the atmosphere of the individual at the time of shooting.

Fig 51 – The enhanced beach photograph is a lot more dramatic than it originally appeared.

TRICKS OF THE TRADE: MARTIN EVENING'S CROSS-PROCESSING EFFECTS (fig 53)
Difficulty level: 2
Programs: Photoshop

One of the most popular photographic techniques in the last few years has been the cross-processing of print and transparency films. There are two different ways of producing these distinctive images. You can process colour negative film in slide chemistry (E6) or colour slide film using the negative process (C41). Either way, you ended up with images in which the basic details remain but the tones and colours are changed.

By some careful manipulation of the colours in the image, it is possible to reproduce the results of cross-processing digitally without having to shoot or develop your film any differently than normal. Martin Evening, the undisputed guru of Photoshop

Fig 53 – *The digital version of the cross-processing effect can be made from colour negatives that were processed as recommended, scanned and then manipulated using the curves function.*

for photographers, uses a digital technique which uses the Curves function to introduce casts and compression image tones. Define the characteristics you want.

To start the process it would be helpful to describe the characteristics of a typical image that has been shot on colour negative film and then processed as if it were a transparency. Immediately obvious is the yellowing of the light tones and the presence of a strong cyan cast in the shadow and midtone areas. Add to this compression, and consequential loss of detail in the highlight areas, and you are left with an image that contains some distinctive characteristics that we can replicate digitally.

To achieve Martin Evening's cross-processing effects, uses follow these steps:

Open a high key image.
1. Adjust for brightness and contrast.
2. Change to 16bit mode.

Produce yellow highlight tones (fig 54)
3. Create a curves adjustment layer and change to the blue channel.
4. Peg a mid-point on the curve.
5. Lower the white point on the curve to introduce a yellow cast into the image.

Add more warmth.
6. Change to the green channel.
7. Again, peg the mid-point and lower the high light level – this time not to the degree of the change in the blue channel.

Make the shadows cyan.
8. Change to the red channel, peg highlight and shadow areas and then pull the midtone areas of the curve downwards to introduce a cyan cast.

Readjust the final contrast/brightness settings.
9. Return to the composite (RGB) channel and adjust the overall brightness and contrast so that it is lighter and the skin tones are more blown out.

Fig 54 – *Martin Evening's technique for replicating the cross-processing effect uses the Curves function in Photoshop to both compress tones and adjust image colours.*

Inkjet Photo Paper
(Ilford)

per - 2 in 1 / Glossy and Satin

Glossy Film - Adhesive Backed

Jet Canvas

K. Classic

285 gsm Soft Fine Art
sic)

Matte Paper - Heavyweight
(Epson)

THE ART OF DIGITAL PRINTING

THE ART OF DIGITAL PRINTING

The new wave of inkjet printers that is hitting the market means it is cheaper than ever to produce photo-quality images direct from your home PC or Mac (see fig 1). Reading through the literature that accompanies these devices has you imagining richly coloured, sharp, high-quality images flowing from the machine at the click of one simple button. Unfortunately simple is not a word that most desktop photographers use a lot when it comes to printing.

Sure, there are those sweet occasions when everything seems to come together at once. The times when a great and memorable printed version of our digital masterpiece emerges, just as we had imagined, from the jaws of our whirring inkjet. But for most of us these occasions are the exception rather than the rule. The majority of new digital enthusiasts I talk to complain that their printed output does not match their expectations.

The following techniques are designed to help you prepare your images for printing and to push your desktop output device to the very edge of its capabilities.

PRINTERS – WHAT ARE MY CHOICES?

A few years ago there was only one printing option capable of producing photographic results – Dye Sublimation. This system was based on transferring dye from donor ribbons and fusing it to a special transfer paper. The results looked and felt like continuous tone photographic images. For a long time these printers held the high ground of digital printing. The downside to the image quality produced by these machines was the high cost of each print and the machine itself.

Today, thermal wax, solid inkjet and colour laser printers are all capable of reasonable results but in the last couple of years it is the inkjet printer that has taken the desktop digital market by storm. Led by the Epson company, manufacturers have continued to improve the quality of inkjet output to a point where now most moderate- to high-priced printers are capable of producing photographic-quality images. Add to this the fact that the price per printed sheet and initial outlay for the machine is comparatively very low and you can see why so many photographers area now printing their own images.

The only drawback with inkjet technology is that the prints have a short life compared to traditional photographic images. This lack of archival quality is a problem manufacturers are now working on. The latest top of the line photographic inkjet printers use pigment inks instead of the dye based counterparts that feature in many of the home use machines. These inksets provide a much more

Fig 1 – The modern inkjet printer is capable of producing photographic-quality images right from your desktop.

stable print than their predecessors and the expected life of these images is now rivalling, and in some cases exceeding, the archival life of traditional photographically produced prints.

Though a lot of professionals still prefer to output critical work via digital versions of the standard photographic processor, many are now turning to this new ink technology as a viable alternative.

WHICH MODEL?

Image quality is everything when you are picking a printer. Sure, it makes sense to compare resolution, numbers of inks, price of the printer and its consumables but the reason you are buying the machine is to make great images. Never make a purchase without seeing printed results. If possible, take your own file to the showroom and ask to have it output via several different machines. This way you will have a means of comparing exactly what each printer is capable of.

KNOW YOUR TOOLS

There is no doubt that modern-day inkjet printers are amazing pieces of machinery. The precision with which they can lay down minute coloured droplets in patterns that simulate a continuous tone photograph is nothing short of remarkable. This said, the average printer still has its limitations, or to be fair, its own imaging characteristics. The first part of the process of making great prints is getting to know these characteristics.

TESTING YOUR PRINTER

When I start using a new printer, specialist types of inks or a different printing paper, I carry out three simple tests to help me understand how the setup works.

Tonal Testing

First I look at how the printer handles difficult tonal areas. In particular, I find it very useful to be able to predict how a specific printing setup deals with delicate highlight and shadow details. I am talking about the region of an image that lies between eighty-five per cent grey and one hundred per cent black, and fifteen per cent grey and zero per cent bright white.

The performance of each printer, ink and paper combination can vary greatly in this area. By printing a test image made up of some carefully prepared grey and colour scales, I can examine how each combination works and compare the results from a variety of setups. In particular I look for the point in the highlight area where the last printed tone is no longer distinguishable from the white of the paper. In the shadows I locate the last step in the scale where dark grey becomes black (see fig 2).

These two points are the extent of my printer's tonal capabilities. Note down the exact percentages for later use. With these values known, I can adjust the spread of the tones in my images with the assurance that delicate highlight and shadow detail will not be lost or be unprintable.

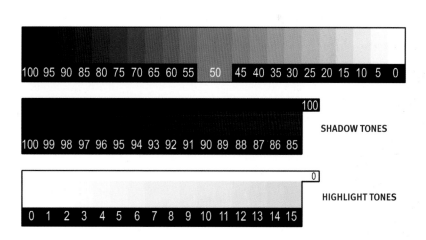

Fig 2 – Make a special greyscale image to test how your printer handles printing difficult areas like shadows and highlights. Use five per cent changes for each of the steps from zero to a hundred. Make two more scales with one per cent steps for highlights and shadows.

Colour Testing

To help with further evaluation, I also add a known image to the tonal scales. The one I use contains a mixture of skin colouring as well as a range of bright

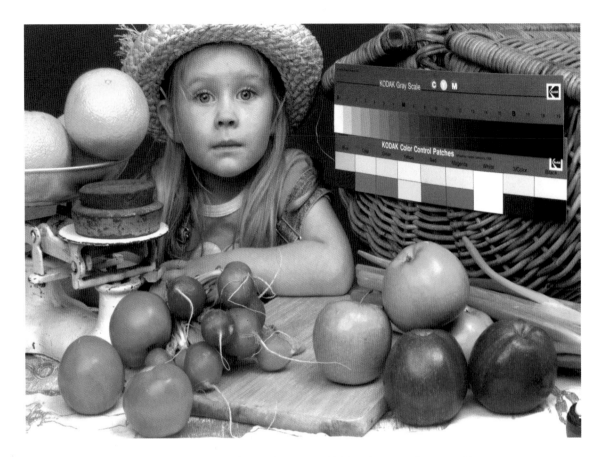

Fig 3 – Add to your tonal scales a test colour image that contains a range of bright colours as well as some skin tones.

colours. Once printed, colour cast differences due to specific ink and paper combinations become more obvious. When trying to define the colour of your cast, look to the midtones of the image as your guide. Adjustments can then be made, either in the printer setup or via the image file itself, to account for the colour variations (see fig 3).

Print Quality Testing

The modern inkjet printer is capable of amazingly fine detail. The measure of this detail is usually expressed in dots per inch (dpi). A typical photographic-quality Epson printer is able to print at 2880dpi when set on its finest settings. Logic says that if I am to make the best-quality print from this machine then I will need to make sure that my image file matches this resolution. This may be logical but it is definitely not practical. A file designed to produce a 10 x 8 inch (254 x 203mm) print @ 2880dpi would be about 1.35GB in size. Start

playing with files this size and you will find that your machine will quickly have a coronary.

The answer is to balance your need for print quality with file sizes and image resolutions that are practical to work with. To this end, I tested my printer by outputting a variety of images with resolutions ranging from 100dpi through to 800dpi, all made with the machine set on its best-quality setting (1440dpi). The results showed that big changes in print quality were noticeable to the naked eye with resolutions up to about 300 dpi. Settings higher than this resulted in very little if any change in perceivable print quality. So, to get the best from my printer, I set its resolution to the finest it is possible to produce (2880dpi) and make files that have an image resolution of between 200 and 300 dpi.

With the tests now completed we have a set of parameters that can be used to adjust the characteristics of our images prior to printing.

PREPARING FOR PRINTING – STEP BY STEP (fig 4)

I use the steps below regularly when preparing my images for print. By now I'm sure you wil be aware of, or use regularly, most of the techniques, but used together they will help push up the abilities of your printer and produce high-quality results regularly and consistently.

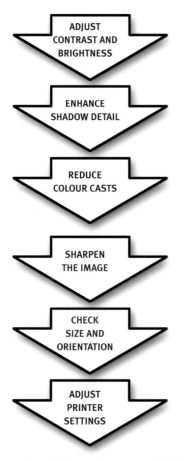

Fig 4 – Once you have finished testing your machine, it is time to implement your knowledge in a series of print preparation steps.

Step One: Adjust Contrast and Brightness

To spread the tones of your image using the results of your test information, peg your black and white points (see fig 5).

PhotoImpact

1. Select Format····҉Tone Map from the menu bar.
2. Click on the Highlight Midtone Shadow Tab at the top of the dialogue box.
3. If the shadow areas of your test prints are clogged then move the shadow slider to the right. This lightens the dark tones.
4. Take note of the shadow value.
5. If the highlight areas of the test print are blown then move the highlight slider to the left. This darkens the light tones.
6. Take note of the highlight value.
7. Reprint your test image, checking the changes. If the results are not satisfactory make further adjustments and print again.
8. Continue this process until you can print all the tones in the test image.

Paintshop Pro

1. Select Colour····҉Adjust····҉Highlight/ Midtone/ Shadow from the menu bar.
2. If the shadow areas of your test prints are clogged then move the shadow slider to the right. This lightens the dark tones.
3. Take note of the shadow value.
4. If the highlight areas of the test print are blown then move the highlight slider to the left. This darkens the light tones.

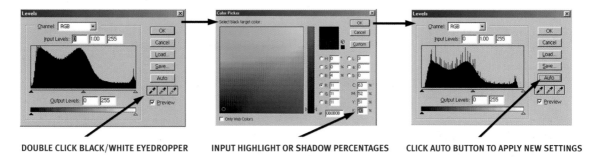

DOUBLE CLICK BLACK/WHITE EYEDROPPER INPUT HIGHLIGHT OR SHADOW PERCENTAGES CLICK AUTO BUTTON TO APPLY NEW SETTINGS

Fig 5 – Use the information about how your machine prints shadow and highlight areas to peg your black and white points in the Levels dialogue. Applying the auto function will now spread, or constrain, your image tones to the range that your printer can output.

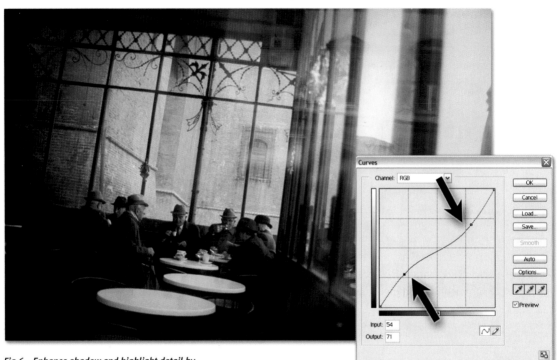

Fig 6 – Enhance shadow and highlight detail by carefully manipulating the Curves function in Photoshop.

5. Take note of the highlight value.
6. Reprint your test image, checking the changes. If the results are not satisfactory make further adjustments and print again.
7. Continue this process until you can print all the tones in the test image.

Photoshop

1. Select Image····⟩Adjustment····⟩Levels from the menu bar in Photoshop.
2. Double click the black eye dropper in the dialogue.
3. Input the percentage of the black point from your test in the "K" section of the CMYK values.
4. Click OK to set the value.
5. Repeat the procedure inputting the white point.
6. Click the Auto button in the Levels box.

Notice that the histogram of your image has changed. The shadow and highlight information has moved towards the centre, catering for the characteristics of your printing setup.

Step Two: Enhance Shadow Detail

Even with the changes made above, a lot of images need particular help in the shadow and highlight area. Enhancing the detail here can be achieved easily by some subtle manipulation (see fig 6).

PhotoImpact

1. Select Format····⟩Tone Map from the menu bar.
2. Click on the Map Tab at the top of the dialogue box.
3. Click the Show Control Points box.
4. Carefully move the shadow area point (second from the left) upwards and the highlight point (second from the right) downwards.
5. Click OK to finish.

Paintshop Pro

1. Select Colours····⟩Adjust····⟩Gamma Correction from the menu bar.
2. Make sure that the Link box is checked.
3. Move any of the sliders to the right.
4. Click OK to finish.

Photoshop

1. Select Image⸱⸱⸱⸱⸱⸱⸱⸱⸱⸱⸱⸱⸱Adjustment⸱⸱⸱⸱⸱⸱⸱⸱⸱⸱⸱⸱Curves from the menu bar in Photoshop.
2. Carefully push the curve slightly upwards in the shadow area and slightly downwards in the highlight region.
3. Click OK to finish.

These actions will increase the contrast of the shadow detail and reduce the contrast of the highlight area. When printing, both these steps will help produce images that display more detail in these difficult areas.

Step Three: Reduce Colour Casts

Photoshop has a range of techniques that you can use to reduce colour casts. Probably the simplest is the Variations control in Photoshop. Here the user can select from a variety of small thumbnails each displaying slight changes in colour (see fig 7).

PhotoImpact

1. Select Format⸱⸱⸱⸱⸱⸱⸱⸱⸱⸱⸱Colour Balance from the menu bar.
2. Select the Presets Tab from the top of the dialogue.
3. Select the thumbnail that looks the most neutral. If a cast still exists, continue to select more neutral thumbnails until you are happy with the results.
4. Click OK to finish.

Paintshop Pro

1. Select Colour⸱⸱⸱⸱⸱⸱⸱⸱⸱⸱Adjust⸱⸱⸱⸱⸱⸱⸱⸱⸱⸱Red Green Blue from the menu bar.
2. Move adjustment sliders until the image looks neutral.
3. Click OK to finish.

Photoshop

1. Select Images⸱⸱⸱⸱⸱⸱⸱⸱⸱⸱⸱⸱Adjustment⸱⸱⸱⸱⸱⸱⸱⸱⸱⸱⸱⸱Variations form the menu bar.
2. Click on the thumbnail with the least the colour cast.
3. Continue this process until the image is colour neutral.
4. Click OK to finish.

Casts that are the result of a particular paper and ink combination should be reduced by changes to the colour setup in the printer's software (see step 6).

Step Four: Sharpen the Image

Digital files captured by scanning print or film originals

Fig 7 – To reduce a prominent colour cast, select the most neutral image from the thumbnails in the Variations dialogue.

Fig 8 – Digitally generated images can often be improved by the application of a little sharpening. In this example, the Unsharp Mask filter was used as it provides the most options for the user to control the sharpening effect.

can usually benefit from a little sharpening before printing. As with most digital controls, it is important to use any sharpening filter carefully as over-application will cause a deterioration in the appearance of your image. My own preference is to use the Unsharp Mask sharpening tool as it offers the user the most control over the effects of the filter (see fig 8).

PhotoImpact

1. Select Effect···⟩Blur and Sharpen···⟩Unsharp Mask from the menu bar.
2. In thumbnail view it is a simple matter of selecting the preview with the sharpness that suits your needs. Users who want a little more control can click the Options button and adjust the Sharpen Factor and Aperture Radius sliders.
3. Click OK to finish.

Paintshop Pro

1. Select Image···⟩Sharpen···⟩Unsharp Mask from the menu bar.
2. Adjust Radius, Strength and Clipping controls until the preview is acceptable.
3. Click OK to finish.

Photoshop

1. Select Filter···⟩Sharpen···⟩Unsharp Mask from the menu bar in Photoshop.
2. Adjust Radius, Amount and Levels sliders to achieve the desired effect.
3. Click OK to finish.

Step Five: Check Print Size/Paper Orientation (fig 9)

Sometimes the scanning or camera software will save your file with image settings that are not suitable for the size of paper you are using. In these cases, you will need to change the size of your output. Photoshop has a couple of aids to help with checking that the size of your image suits that of the paper.

PhotoImpact

1. Select File···⟩Print Preview from the menu bar.
2. Using the preview screen change the position and size of your image.
3. A title may also be added here.

Paintshop Pro

1. Select File···⟩Print Preview from the menu bar.
2 The basic layout of image and page can be

checked with this dialogue.

3. If further changes are needed, select the Setup Button from the menu bar.

4. Adjust the scale and position of image before selection OK to finish.

Photoshop

1. Select Image ⋯▸Image size from the menu bar in Photoshop.

2. Input the paper size in inches or centimetres in the Image Size dialogue box.

3. Photoshop will then calculate the dpi need for the file in order to output a print of the dimensions you selected.

4. To doublecheck the settings you have chosen, move to the bottom left of the image window and, using the mouse button, click and hold next to the document info section of the bottom bar. This will provide you with a print preview pop-up that shows an outline of the image on the paper.

5. If the image resolution (or paper orientation) is not properly set, the image will show up as being too big, or small, on the paper.

6. If this occurs, either return to the image size dia-logue and adjust your print size or adjust the settings in the Page Setup selection of the File menu.

NB: Users of versiosn 6 & 7 of Photoshop will be in the envious position of now being able to interactively adjust the image size prior to printing by using the new Print Preview function (see fig 10).

Step Six: Adjust the Printer Settings

The printer's dialogue box contains an array of settings and controls that act as the last fine-tuning step in outputting your digital masterpiece. Most new users follow the automatic everything approach to help limit the chances of things going wrong. For most scenarios this type of approach will produce good-quality results, but those of you who want a little more control, will have to abandon the auto route.

There are several adjustments that can be made via the printer control: (see fig 11).

• Paper size, orientation and surface type,

• Dots per inch that the printer will shoot onto the page (printer resolution), and

• Colour and tone control.

PRINT PREVIEW

IMAGE BIGGER THAN PAPER

IMAGE SMALLER THAN PAPER

Fig 9 – Check the print size using either the Image Size dialogue or the Print Preview located at the bottom of the work area.

ADJUSTABLE HANDLES

FIT TO PAGE OPTION

Fig 10 – Photoshop 6 and 7 users benefit from an all-improved Print Options Preview system located in the edit menu.

The surface of the paper is critical to how much of the detail produced by your printer and your image preparations ends up in the final print. Paper manufacturers have spent the last few years perfecting coatings that maintain the integrity of the inkjet dots whilst producing images that simulate a traditional photograph.

Choosing a paper type in your printer settings changes the dots per inch that the inkjet head will place on the paper. Papers with finer surfaces, or better coatings, can accept finer dot quality, or higher dpi settings.

You should always check the dpi after choosing a paper type as sometimes the selection that the program determines might not suit your needs. Some Lyson papers, for instance, have a rough-textured surface that would lead you to pick a Photo Paper setting from the dialogue. This, however, would result in the print head being set at 720dpi, half of what this type of paper can handle. To get the most from both the printer and paper, you would need to change manually, or customize, the dpi to the highest quality possible.

It is also at this stage that any colour change, or cast, that results from paper and ink combination, rather than from shooting conditions, is corrected. If, after your tests, you find that your prints all exhibit a shift of hue that is not present in the screen original, then changes can be made to the colour balance within the print dialogue box.

As an example, I have found that some non-branded papers have a distinct magenta cast that is consistent throughout all prints. To correct this I add more green in the printer's dialogue box until the resultant print is neutral. I then save this setting for use with that combination of ink, paper and printer in the future. Using the printer's dialogue box to make paper- and ink-based adjustments means that I can always be assured that an image that appears neutral on screen will print that way.

SUMMING UP

Make sure that all the hard work you put into taking great pictures is reflected in their printing. Make the time to get to know your printer, paper and inks and the reward will be high-quality prints that exhibit all the care and skill used in their taking.

INKJET PAPER CHARACTERISTICS

Weight: Paper weight is measured in grams per square meter. This factor, more than any other, affects the feel of the printed image. To give you a sense of different paper weights – photocopy paper is usually 80gsm, drawing cartridge 135gsm and standard double weight photographic paper 200gsm. If your aim is to produce images that look and feel like the photographic real thing, don't underestimate the effect of paper weight. For the best effect, try to match the weight of your inkjet paper with its photographic equivalent. Weight can also be a factor in how much the paper ripples after it is printed. Heavy paper is more resistant to this effect.

PAPER TYPE

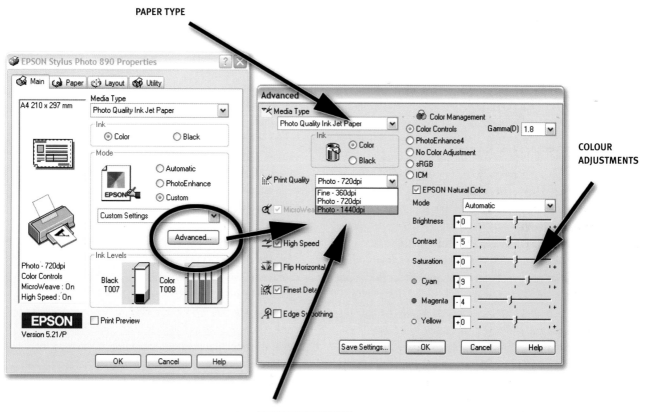

COLOUR ADJUSTMENTS

PRINTER RESOLUTION

Fig 11 – Make the final changes to how the image will print using the printer's own dialogue box. Colour casts due to specific ink and paper combinations can be illuminated here and the settings saved for later use.

Surface: Most photographers I know are particular about the surface of the photographic printing paper they use. One friend likes the surface of a specific paper so much that he imports it from the States because he says that his images just don't look the same on anything else. I'm sure that certain inkjet paper surfaces produce no less loyalty amongst the ranks of image-makers. In an attempt to woo punters, some manufacturers have even reproduced their photographic paper surfaces in their inkjet range. Kentmere is a good example. K. Tapestry and K. Classic both have their textured photographic counterparts. Using these papers, it is possible to produce a mixed series of pictures containing both digital and traditional photographic images on similar paper bases – all the images will have the same look and feel despite their different origins.

Base colour: Inkjet papers come in a variety of colours which can range from subtle neutral tones to bright and vibrant hues. The base is coloured either by adding pigment during the paper-making process, in which case the colour is present right through the paper, or when the surface of the paper is treated to receive inks in which case the colour is only on the printable side of the paper. Care should be taken when using papers with a base colour as they will cause a colour shift in the printed image. The clever printer can make allowances for the shift by adjusting the digital file to account for the paper colour prior to printing.

Paper Sizes: A3, A4, A5, and A6 as well as the traditional photographic sizes of 6 x 4 and 10 x 8 inches (152 x 102mm and 254 x 203mm) are all commonplace in the more popular paper types and surfaces. Panoramic sizes and rolls of paper are also available for the image-maker who prefers a wider format.

Price: Buying larger quantities than the normal pack of ten to twenty-five sheets will almost always get you a better price, and remember to shop around, there will always be someone who wants your custom a little more than the next guy.

PAPER TYPES (fig 12)

Glossy Photographic: Designed for the production of the best photographic-quality images. These papers are usually printed at the highest resolution that your printer is capable of and can produce either photo-realistic or highly saturated colours.

Matt/Satin Photographic: Designed for photographic images but with surfaces other than gloss. The surfaces are specially treated so that, like the gloss papers, they can retain the finest details and the best colour rendition.

Art Papers: Generally thicker papers with a heavy tooth or texture. Some in this grouping are capable of producing photographic-quality images, but all have a distinct look and feel that can add subtle interest to images with a subject matter that is conducive. Unlike other groups, this range of papers also has examples that contain coloured bases or tinted surfaces.

General Purpose: Papers that combine economy and good print quality and are designed for general usage. They are different to standard office or copy papers as they have a specially treated surface designed for inkjet inks. Not recommended for final prints but useful for proofing.

Specialty Papers: Either special in surface or function. This group contains papers that you might not use often, but it's good to know that they are available when you need them. The range is growing all the time and now includes such diverse products as magnetic paper, back light films (plastic based translucent media which are

Fig 12 – Making comparison prints on different paper stocks can help you decide which product is best for particular images or occasions.

are viewed with a light from behind) and a selection of metallic sheets.

When trying to choose what stock is best for your purposes, compare on the basis of weight, surface, colour, sizes available, number of sheets in a standard pack, price per sheet and special fea-

tures. When you have narrowed the field down, it is worth testing each with a print made using the same print settings, inks, digital file and printer. This will give you a visual comparison that will help you make the final decision.

STORAGE

STORAGE – THE DIGITAL STORY

Sometimes life just seems to get more complex. Traditionally, photographers have had little choice about the way their images will be stored. Essentially, the decision could be made by answering two questions: "What format film will I use?" and "Do I want to end up with slides or negatives?" With this sorted no more thought needed to be given to storage.

In the digital world life is not so simple. Unlike film-based images, the digital file can be stored on a variety of physical devices and using a range of file formats.

Like most people, when I started to play with digital photographs I was blissfully unaware of the array of choices and their consequences. I would scan a picture or negative, make some changes in a program like Photoshop, and then save it. The next time I started up the program I was able to retrieve the same image and continue working. I didn't give the process of storing the image a second thought.

It was only when I started to want to share my images with friends that I learned that there was a lot more to consider than I first realized.

5X7 INCH PRINT @ 300DPI = 9MB

6.4 FLOPPY DISKS

Fig 1 – Digital files take up a lot of space. The humble floppy disk drive was never meant for files this size.

10X8 INCH PRINT @ 300DPI = 20.6MB

14.7 FLOPPY DISKS

MY GOODNESS, WHAT BIG FILES YOU HAVE!

The good news about modern digital imaging is the high quality of the files produced by digital cameras and scanners. The bad news is that quality is directly linked with file size. Photographic quality means big files. Digital images are notorious for the amount of space they consume. A typical file that will print a photographic quality picture 5 x 7 inches (127 x 178mm) in size can take up as much as 9mb. A 10 x 8 inch (255 x 213mm) version can take up 20.6mb.

The storage of images this size on a hard drive is no real problem, but if you want to move them from one machine to another then you will face some difficulties. The humble floppy disk will only hold about 1.4mb of information. This is fine for word processing or spreadsheet files, but is not all that useful for good quality images (see Fig 1).

THE ALTERNATIVES TO THE HUMBLE FLOPPY

Manufacturers very quickly became aware of the need for a large capacity portable storage solution for digital photographers and other graphics professionals. A few systems have come and gone but the range of devices that we now have are bigger, faster and cheaper than ever before.

Zip disk (fig 2)

The Zip revolution started in 1995 when Iomega first released the 100mb removable cartridge and drive. Featuring a disk not much bigger than a standard 1.4mb floppy, this storage option quickly became the media of choice with photographers and graphic designers worldwide. The latest incarnation of the drive is not only smaller than its predecessor but, the new cartridge, is now capable of storing 750mb of your precious pictures. What's more, the new drive can still read the 100mb and read/write the 250mb catridges.

Capacity: 100mb, 250mb or 750 mb per cartridge

Speed:
Good, especially if being used as an internal drive or via the Usb or Scsi connections

Hardware needed:
Zip drive (parallel, Scsi, Usb and internal versions are available)

Consumables needed: Zip cartridges (available in 100mb, 250mb and 750 mb versions)

Best Uses:
Portable read and write scenarios such as work between non-networked machines, incremental backups or important work in progress

Cost: 100mb cartridge: £6.50/US$10
250mb cartridge: £7.50/US$15
750mb Usb External drive: £139.00/US$170

Value for money: £0.01/US$0.02 (cost per mb media only)

Positives:
Comparatively cheap and stable rewrite option; big user base

Negatives:
The person you are sharing your data with must also have a drive; cartridge prices

Fig 2 – The Iomega Zip drive, external version: Portable rewritable with a big user base.

DVD (fig 3)

DVD is fast becoming the storage medium of choice for the professional image maker. The technology comes in three distinct formats: DVD-R (write once), DVD-RW (re-recordable), and DVD-RAM (rewritable). These three formats each have unique applications –

• DVD-R: write-once archiving for video and data that you do not want to lose or accidentally erase

• DVD-RW: re-recordable DVD for video and data material that can be erased and reused again and again.

Capacity: 4.7Gb (4700mb)

Speed:
Good – fastest when connected via USB 2.0 or Firewire

Hardware needed:
DVD writer/rewriter drive (Firewire, Usb and internal versions available)

Consumables needed:
DVD disks

Best Uses:
Portable read and write scenarios such as collaborative work between non-networked machines, incremental back ups or important work in progress and now as camera 'food'.

Cost:
4.7gb disk: £4.50/US$6.00
USB/Firewire External drive: £350.00/US$500
Internal drive: £250.00/US$375

Value for money:
£0.0009/$US0.0012 (cost per mb media only)

Positive:
Now that drives and media have reduced in price this storage option is an extremely cheap way of storing images, text, movies and music.

Negatives:
Compatibility is increasing especially if the DVD-R format is used but some older DVD readers might have problems accessing the data on some disks.

Fig 3 – As DVD writers and media become more affordable the DVD-R format is becoming more popular as a storage medium for digital shooters.

• DVD-RAM: rewritable DVD for mission critical data needing as many as 100,000 re-write cycles

The DVD-R format is the most compatible with dvd players and should be used where ever possible. As drive and disk prices continue to fall this technology is set to replace the CD as the digital photographer's main storage medium.

CD-ROM (fig 4)

The CD is a stable and familiar format that is used universally for storing massive amounts of data cheaply. As recently as five years ago, CD readers were an expensive add-on to your computer system. Now writers, and sometimes even rewriters, are thrown in as part of system package deals. The CD has become the floppy of the millennium and unlike the Iomega and Imation storage options the majority of all current computers have a CD drive.

Drives and media are available in two formats. "Write once, read many" or Worm drives (CD-R) are the cheapest option and allow the user to write data to a disk which can then be read as often as required. Once a portion of the disk is used it cannot be overwritten.

The advanced version of this system (CD-RW) allows the disk to be rewritten many times. In this way it is similar to a hard drive, however the writing times are much longer. Rewriters and the disks they use are more expensive than the standard CD writer and disks. The more recent drives can read, write and rewrite all in one unit.

Capacity: 650mb

Speed:
Good, especially if being used as an internal drive or via the Usb or Scsi connections

Hardware needed:
Internal CD drive

Consumables needed:

CD blanks in write once or rewritable versions

Best Uses:
Storage of large files; back up of data; transport of files or complex documents

Cost:
Standard CD blanks (write once): £0.20/US$0.35
Standard CD writer drive: £100.00/US$120
CD rewritable blanks: £1.00/US$1.50

Value for money:
Standard: £0.0007/$0.0009 (cost per mb media only)/Rewritable: £0.003/$0/0018 (cost per mb media only)

Positives:
Good value accessible back up and transport option

Negatives: Slow write speeds

Fig 4 – CD Drive: Available in internal and external versions. This is still the cheapest way to store masses of image files.

Portable hard drive

A new category in portable storage is the range of portable digital hard drives available for photographers. These devices operate with mains or battery power and usually contain a media slot that accepts one or more of the memory cards used in digital cameras. The most well known of these devices is the MindStor (previously called the Digital Wallet).

Capacity: Depends on the drive used but typically 10 or 20Gb

Speed: Good – fastest when connected via USB 2.0 or Firewire

Hardware needed: Portable hard drive

Consumables needed: None

Best Uses: For downloading images from camera memory cards whilst shooting in the field. Can also be used as extra hard drive space.

Cost: £4.50/US$6.75
USB/Firewire External drive - GBP 424.00

Value for money:
£0.04/US$0.6 (cost per mb media only

Positives:
Excellent storage option for the digital photographer on the move. Combines on-the-road picture storage with the advantage of being able to be used as an extra portable hard drive.

Negatives:
Initial cost is a bit expensive.

External Hard Drives (fig 5)

With the ever increasing need for storage and the desire of many users to be able to move their image archives from one machine to another, companies like Iomega are developing more an more sophisticated external hard drive options. Their latest offerings include capacities from 20 to 120Gb and the choice of Firewire or USB connection.

Capacity: 20gb –120gb (2000mb)

Speed: fast because of the USB 2.0 and Firewire connection

Hardware needed: external drive

Consumables needed: None

Best Uses: Portable read and write scenarios such as work between non-networked machines, incremental back ups of important work and the safe keeping of whole image archives.

Cost: Internal Drive: £250/$US375
120Gb – £200/$US350
80GB: £150/$US225.00

Value for money: £0.001/US$0.03(cost per mb media only)

Positives: Fast read and write times and massive amounts of storage.

Negatives: Initial cost.

Fig 5 – External hard drives from companies such as Iomega provide a very cost efficient method of accessing and moving large archives of images.

Web storage (fig 6)

It's not a totally new idea to store data on the web, but it is only in recent years that commercial entities like bigvault.com and swapdrive.com have been making the whole notion a lot more viable. With the number of machines now connected to the net it is not unrealistic to use such a service as a virtual extension of your hard drive. Travellers especially will find this storage option a godsend, as it reduces the number of disks or Zips that you need to carry. But be warned, access times are not great.

Fig 6 – Web drive: Great for those who need access all over the world and hate to carry luggage, virtual drive space is becoming more popular, but download times are still a bit of a concern.

Capacity: Depends on the provider

Speed:
Slow read and write – but how slow depends on your modem speed, cable modem owners have it made

Hardware needed: Internet connected computer

Consumables needed: None

Best Uses:
Worldwide sharing or collaborative working on small or highly compressed images,

or as a backup option for the traveller

Cost: Depends on storage plan

Value for money: Depends on storage plan

Positives:
Nothing to carry; always available when your machine is connected; can be shared with others worldwide

Negatives:
Slow read and write access

HOW TO CHOOSE

With this amount of choice it is sometimes difficult to decide which product will best suit your needs (see fig 7). The best advice I can give is to think carefully about:
- how many images you are going to be working with,
- how large those images will be,
- what access time will you consider adequate,
- whether you want to share them with others and, most importantly,
- how much money you have to spend.

The answers to these questions will help you narrow down the solution to your storage needs.

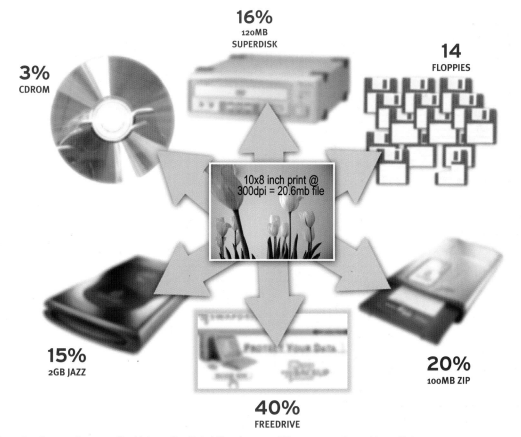

3% CDROM

16% 120MB SUPERDISK

14 FLOPPIES

10x8 inch print @ 300dpi = 20.6mb file

15% 2GB JAZZ

40% FREEDRIVE

20% 100MB ZIP

Fig 7 – Just how much space will a high-quality digital file take up on different types of portable media?

WHEN A BIG HARD DRIVE IS JUST NOT BIG ENOUGH?
(see fig 8)

It is the very nature of the digital-imaging beast that as quality increases so does the space needed to store it. It still amazes me the pace at which manufacturers produce ever bigger hard drives to fill our storage appetite.

Even more fascinating, or perhaps frustrating, is the way in which a drive I bought six months ago, and swore I could never fill, manages to run out of useable space. It seems that my hard drive storage is a bit like my income – the more I have, the more I use.

If you are like me, then here are a few tips to help conserve your drive space (and in turn, your hard-earned income):

1. Use a file format that has compression built-in. Save your files using the TIFF format with compression turned on. This format does not use a compression technique that will degrade the quality of your images and it will save you space.
2. Be disciplined about how and where you store your images. By storing your images in an organized way you will quickly see and remove any duplicate and temporary files from your drive.
3. Make images that are the size that you need. Make decisions at the time that you are creating a digital file about what size you need that file to be. If you are only going to want to print a postage stamp-size version then there is no need to have a 20mb file.
4. Be careful about using different colour modes. A RGB colour file is twenty-five per cent smaller than its CMYK equivalent. Only use the CMYK mode if you have a definite reason for doing so.

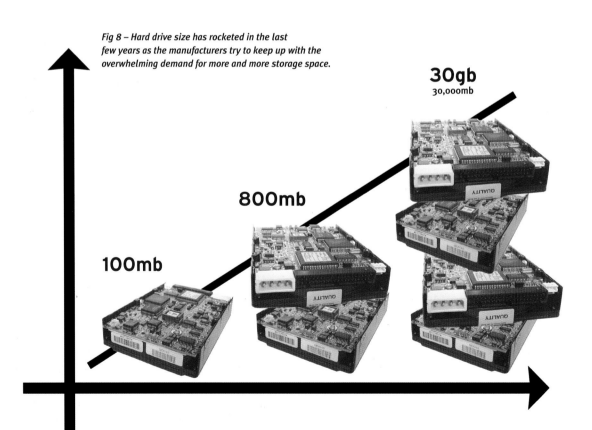

Fig 8 – Hard drive size has rocketed in the last few years as the manufacturers try to keep up with the overwhelming demand for more and more storage space.

30gb
30,000mb

800mb

100mb

WHERE DOES MY IMAGE FILE GO WHEN I SAVE IT? (fig 9)

One of the most difficult concepts for new computer users is the fact that so much of the process seems to happen inside a obscure little box. Unlike traditional photography, where you can handle the product at every stage – film, negative and print – the digital production cycle can seem a little unreal. Where your image actually goes when you store it is one of its mysteries.

PC

The devices that are used to store digital information are usually called drives. In PC terms they are labelled with letters – "A" drive is for your floppy disk drive and "C" drive your hard disk. It is possible to have a different drive for every letter of the alphabet but in reality you will generally only have a few options on your machine. If, for instance, you have a Zip and a CD drive then these might be called "D" and "E" drives.

Mac

If your platform of choice is the Macintosh system then you need not concern yourself about the letter names above. Each drive area is still labelled but a strict code is not used.

Within each drive space you can have directories (PC) or folders (MAC). These act as an extra way to organize you files. To help you understand, think of the drives as drawers within a filing cabinet and the directories as folders within the drawers. Your digital files go into these folders.

Fig 9 – How you organize your images on your drives will affect how efficiently you will use the space that is available to you.

FILE FORMATS – THE STORAGE STORY CONTINUES

The storage of your digital masterpieces is really a two-step exercise. Firstly you need to decide where the image should be saved. Secondly you have to select the file format which will be used to save the image. Having now discussed the "where" of the process, we shall dedicate some time to looking at "how" our images can be stored.

Digital imaging files can be complex things. In their simplest form they are a description of each picture element, its colour and

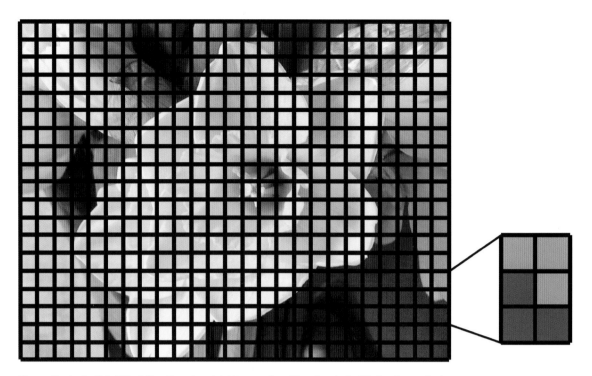

Fig 10 – The basic digital file defines the colour, brightness and position of each pixel that makes up the image.

brightness and its physical whereabouts within the image (see fig 10). With the increased sophistication of image-editing programs and our demand for complex graphics has come a range of purpose-built file formats that encompass a host of "value added" features that are beyond this basic file.

Layers vs flat files

The original image-editing programs performed all their manipulations on the basic file. At the time this didn't seen too much of a problem as we were just happy (and amazed) that we could actually change sections of an image digitally. But as designers and photographers increased their understanding of the new medium they also increased the complexity of the manipulations they wished to perform.

Working with a flat file became more and more restricting. Eventually the software developers incorporated the way that graphic designers had been working for years into image-editing programs. They took the idea that if you separate parts of an image onto transparent layers then you can manipulate each part without affecting the rest of the image. If the

image is then viewed from the front, all the layers appear merged and the picture looks flat – just as if it were a basic file (see fig 11).

As the image files of the time were all flat, the software developers also developed formats that would allow the storage of the separate layers. With the integrity of each layer intact it was then possible to return to work on a specific element of an image at a later date.

The Photoshop file format, or PSD, is an example of a format that will save editable layers separately. Each layer can be manipulated individually. Groups of layers can be linked and moved or merged to form a new single layer with all the elements of the group. Text layers remain editable even when saved and in the latest version of the software, special effects, such as drop shadows, can be applied to each layer automatically (see fig 12).

This extra flexibility does come at a cost. Layered files are bigger than their flat equivalents. With the size of modern hard drives this is not really something to be worried about. A second consideration is that formats like PSD are proprietary, that is they only work

with the programs that they originated from. This only becomes a problem if you want to share files with another piece of software and maintain the layers. No common layer formats have emerged yet, each software manufacturer preferring to stick with their own file types.

Compression

Imaging files are huge. This is especially noticeable when you compare them with other digital files such as word processing files. A document that may be a hundred pages long could easily be less than one per cent of the size of a single 10 x 8 inch (255 x 213mm) digital photograph. With files this large it soon became obvious to the industry that some form of compression was needed to help alleviate the need for us photographers to be continuously buying bigger and bigger hard drives.

A couple of different ways to compress your images have emerged over the last few years. Each enables you to squeeze large image files into smaller spaces but one system does this with no loss of picture quality – lossless compression – whereas the other enables greater space saving with the price of losing some of your image's detail – lossy compression.

Initially you might think that any system that degrades your image is not worth using and, in most circumstances, I would have to agree with you. But

LAYER 1 LAYER 2 LAYER 3

Fig 11 – A layered file appears to be similar to a flat file except that parts of the image are separated on individual layers. Each layer can be edited and changed separately from the other parts of the image.

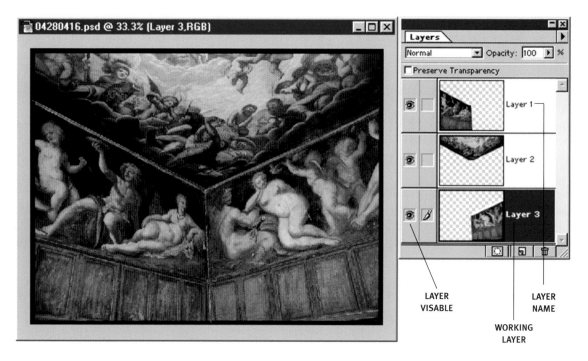

Fig 12 – Photoshop uses a layers dialogue box to control the positioning and features of each layer in the image.

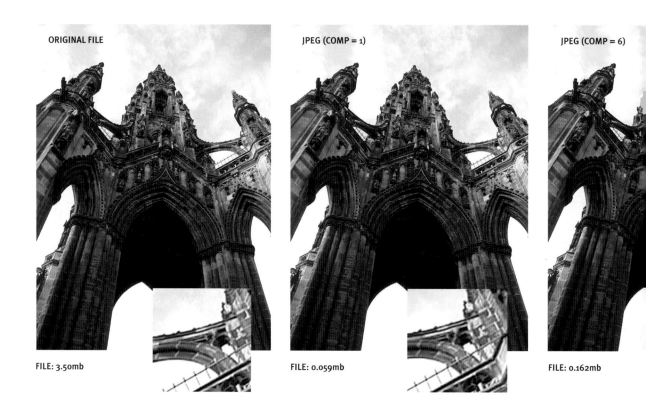

sometimes the image quality and the file size have to be balanced. In the case of images on the web they need to be incredibly small so that they can be transmitted quickly over slow telephone lines. Here some loss in quality is preferable to images that take four or five minutes to appear on the page. This said, I always store images in a lossless format on my own computer and only use a lossy format when it is absolutely crucial to do so.

The main compression formats that are used the world over are JPEG (Joint Photographer's Experts Group) and TIFF (Tagged Image File Format) (see fig 13). JPEG uses a lossy algorithm to attain high compression ratios. By using a sliding scale from one to twelve you can control the amount of compression used to save your image. The more compression you use the more noticeable the effects (artefacts) of the process will be (see fig 14). TIFF on the other hand uses a totally different system, which results in no loss of image quality after compression.

For these reasons TIFF is a format used for archiving or sharing of work of the highest quality. Most press houses use TIFF as their preferred format. JPEG is used almost exclusively in the world of image transmission and the web. In this realm file size is critical and the loss of quality is more acceptable. This is especially true if the image is to be viewed on screen where some artefacts are less noticeable than when printed.

Web features

The Internet in its original form was text based. Now the web is very definitely a visual, some might say a multimedia, medium. When you view a web page for the first time all the information on that page has to be transported from the computer where it is stored down the phone line to your machine. The pictures, animations and text that make up the page might be coming from almost anywhere in the world. It's a simple fact that the larger the file sizes of these components, the

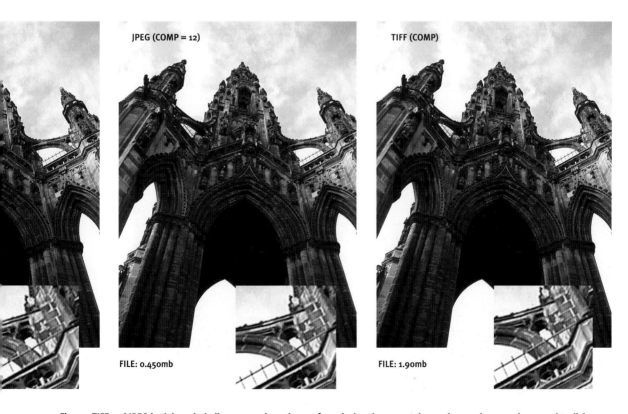

JPEG (COMP = 12)

TIFF (COMP)

FILE: 0.450mb

FILE: 1.90mb

Fig 13 – TIFF and JPEG both have in-built compression schemes for reducing the space taken up by your images when saved to disk.

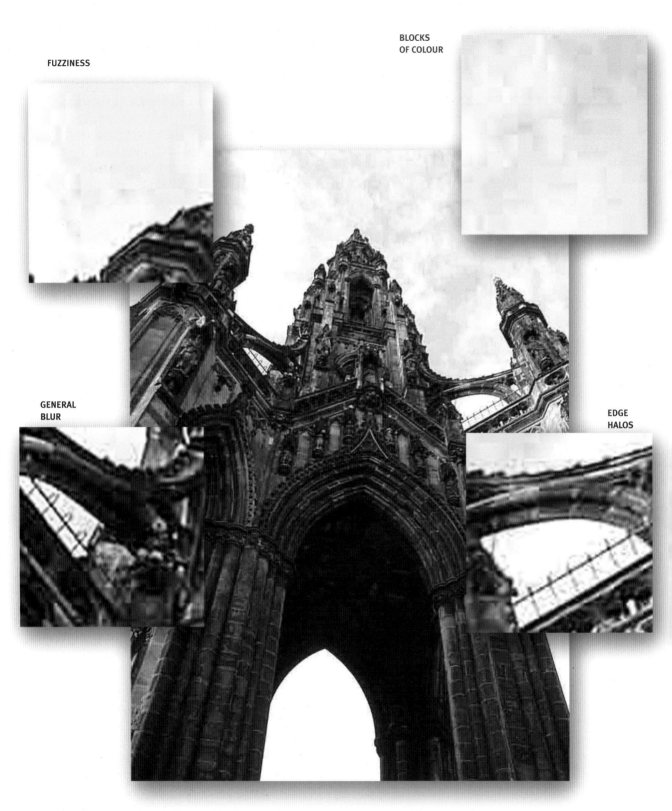

FUZZINESS

BLOCKS OF COLOUR

GENERAL BLUR

EDGE HALOS

Fig 14 – To reduce the size of images, JPEG uses a compression system that loses detail from your image.
High levels of this type of compression will cause your image to degrade and display a variety of artefacts.

longer it will take to download and display the page on your machine.

For this reason there are several file formats of choice for web work. Each is suited to specific types of image files. There is no one format that can be used for all the visual parts of your pages.

JPEG is best used for continuous tone photographs. GIF is designed for images with a limited number of flat colours and works best with logos and animated banner ads. PNG is a fairly new file format which has a wider colour range than GIF and better handling of transparency as well. This is a great format for users of Version 4 browsers or higher.

SVG and JPEG 2000 are two extremely new formats that offer improvements over the web formats we currently use. SVG is a vector-based system that provides not only smaller file sizes but also sharp images at any screen size. JPEG 2000 is a complete tune-up for the millennium of the old compression system. It features new user-controlled flexibility, less apparent artefacts and better compression to boot.

Customizing images for the web is so important these days that all the major image editing packages have sophisticated functions or wizards that will help you squeeze your images down to size without losing too much quality (see "Save for Web Option in Photoshop" page 181).

file format that can be used by both systems equally. I stick to TIFF, JPEG and PSD, as these formats are useable on both platforms (see "Top Tips for Cross-platform Saving" page 181).

Annotations

Some file types allow the user to attach text information to the main image file. This feature allows press agencies and picture libraries the chance to store captions, bylines, dates and background information all in the one format. This extra information is hidden from view when you first open the file in an image-editing program, but can usually be read and edited via an information window somewhere in the program.

Fig 15 – With some formats it is possible to include some text along with the image data in one file.

Cross-platform concerns

The two major computer systems used by photographers the world over are the Macintosh and the IBM clone. Each system has its advantages and drawbacks and I'm not prepared to debate those here and now. I use both on a regular basis and there is no gain in trying to promote one over the other.

What is important to understand, though, is the basic fact that not all the people you will want to share images with will be using the same hardware as you. If you know this to be the case then you must select a

Photoshop gives such access through highlighting the File·····>File Info selection. Here you can view and edit entries for captions, keywords, categories, credits and origins. Some third-party image browsers can also search the captions and keyword entries. These categories are part of an information standard developed by the Newspaper Association of America (NAA) and the International Press Telecommunications Council (IPTC) to identify transmitted text and images. File information can be added in the following formats PSD, TIFF, JPEG, EPS and PDF (see fig 15).

"BUT WHAT FORMAT SHOULD I USE?"

It's great to have such a choice of image file formats but the big question is what format should you use. There is no simple answer to this. The best way to decide is to be clear about what you intend to use the image for. Knowing the "end use" will help determine what file format is best for your purposes (see fig 16).

At scanning or image-capture stage I tend to favour keeping my files in a TIFF format. This way I don't have to be concerned about loss of image quality but I still get the advantage of good compression and I can use the files on both Mac and IBM platforms.

When manipulating or adjusting images I always use the PSD or Photoshop format, as this allows me the most flexibility. I can use, and maintain, a load of different layers which can be edited and saved separately. Even when I share my work, I regularly supply the original PSD file so that last-minute editing or fine-tuning can continue right up to going to press. If, on the other hand, I don't want my work to be easily edited, I supply the final image in an IBM TIFF format with all the layers flattened.

If the final image is to be used for the web, I save it as a GIF, PNG or JPEG file, depending on the numbers of colours in the original and whether any parts of the

image contain transparency. There is no firm rule here. Size is what is important so I will try each format and see which provides the best mix of image quality and small file.

Fig 19 – Raster and Vector files are completely different ways of describing a digital image. All photographic images are stored in Raster or Bitmapped format.

VECTOR VS RASTER (fig 19)

The digital graphics world uses two main ways to describe images – one is Raster or Bitmapped and the other is Vector.

Raster images are made up of a grid system that breaks the image down into tiny parts or picture elements (pixels). At each point on the grid, the position, colour and brightness of each pixel is recorded. All digital photographs are stored in this format. Programs like Photoshop and Paint Shop

File Type	Compression	Colour Modes	Layers	Additional Text	Uses
Photoshop (.psd)	✘	RGB, CMYK, Greyscale, Indexed colour	✔	✔	DTP, Internet, Publishing, Photographic
GIF (.gif)	✔	Indexed Colour	✘	✘	Internet
JPEG (.jpg)	✔	RGB, CMYK, Greyscale	✘	✔	DTP, Internet, Photographic
TIFF (.tif)	✔	RGB, CMYK, Greyscale, Indexed colour	✘	✔	DTP, Publishing, Photographic
PNG (.png)	✔	RGB, Greyscale, Indexed colour	✘	✘	Internet

Fig 16 – Different file formats are suitable for different applications and have a variety of in-built features.

Pro work exclusively with this type of image.

Vector images are very different. They work by mathematically describing the shape of flatly coloured objects within a space. Logos, sophisticated text manipulations and CAD drawings are all examples of vector graphics. Programs like Illustrator, Corel Draw and Freehand create images that are stored as vector graphics.

THE MAJOR RASTER FORMATS
JPEG – Joint Photographic Experts Group (fig 17)

This format provides the most dramatic compression option for photographic images. A 20mb digital file which is quite capable of producing a 10 x 8 inch (225 x213mm) high-quality print can be compressed as a

image as a standard baseline or progressive image. This selection determines how the image will be drawn to screen when it is requested as part of a web page. The baseline image will draw one pixel line at a time, from top to bottom. The progressive image will show a fuzzy image to start with and then progressively sharpen this image as more information about the image comes down the line.

This is a great format to use when space is at a premium or when you need very small file sizes.

TIFF – Tagged Image File Format (see fig 18)

This is one of the most common and useful file fomats. Images in this format can be saved uncompressed or using a compression algorithm called LZW, which is lossless. In other words, the image that you "put into" the compression process is the same as the one you receive "out". There is no degradation of quality.

When you save you can choose to include a preview thumbnail of the image, turn compression on and off and select which platform you are working with. Most agencies and bureaus accept this format but nearly all stipulate that you supply work in an uncompressed state. Opening a compressed image takes a lot longer than opening one that is saved without compression.

Use this format when you want to maintain the highest quality possible.

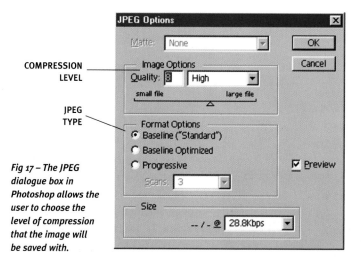

COMPRESSION LEVEL

JPEG TYPE

Fig 17 – The JPEG dialogue box in Photoshop allows the user to choose the level of compression that the image will be saved with.

JPEG file so that it will fit onto a standard floppy disk. To achieve this the format uses a lossy compression system, which means that some of the image information is lost during the compression process.

The amount of compression is governed by a slider control in the dialog box. The lower the number, the smaller the file, the higher the compression and more of the image will be lost in the process.

You can also choose to save the

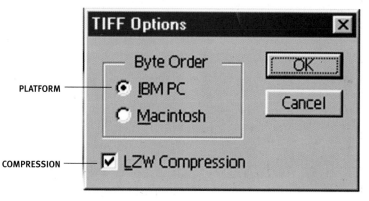

PLATFORM

COMPRESSION

Fig 18 – The TIFF dialogue box in Photoshop gives the user the choice of which platform to save for and whether compression is used.

GIF – Graphics Interchange Format

This format is used for logos and images with a small number of colours and is very popular with web professionals. It is capable of storing up to 256 colours, animation and areas of transparency. It is not generally used for photographic images.

PNG – Portable Network Graphics

A comparatively new web graphics format that has a lot of great features that will see it used more and more on websites the world over. Like TIFF and GIF the format uses a lossless compression algorithm that ensures what you put in is what you get out. It also supports partial transparency (unlike GIF's transparency off/on system) and colour depths up to 64bit. Add to this the built-in colour and gamma correction features and you start to see why this format will be used more often.

The only drawback is that it only works with browsers that are Version 4 or newer. As time goes by this will become less and less of a problem and you should see PNG emerge as a major file format.

PSD – Photoshop's native format

This file type is capable of supporting layers, editable text and millions of colours. You should choose this format for all manipulation of your photographic images. The format contains no compression features but still should be used to archive complex images with multiple layers and sophisticated selections or paths. The extra space needed for storage is compensated by the ease of future editing tasks.

EPS – Encapsulate PostScript

Originally designed for complex desktop publishing work, EPS is still the format of choice for page layout professionals. It is not generally used for storing photographic images but worth knowing about.

THE FUTURE IS HERE

As our imaging needs increase, so too does the format technology used to store our pictures. In the last year or so two new formats have been developed, both particularly suited for web production. By the time you read this, you will be seeing, and hopefully using, commercial versions of software that use these formats.

ORIGINAL

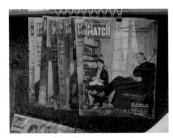

STANDARD JPG 40:1

JPG2000 100:1

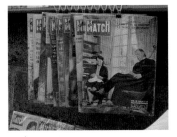

JPG2000 40:1

Fig 20 – JPEG2000 is a new improved version of the JPEG compression system. It is capable of much higher compression ratios and more user control.

JPEG2000 (see fig 20)

The original JPEG format is a decade old and despite its continued popularity it is beginning to show its age. Since August 1998 a group of dedicated imaging professionals (the Digital Imaging Group – DIG) have been developing a new version of the format. Dubbed JPEG2000, it provides twenty per cent better compression, less image degradation than JPEG, full colour management profile support and the ability to save the file with no compression at all.

With its eyes firmly fixed on the ever-increasing demand for transmittable high-quality images, JPEG 2000 will undoubtedly become the default standard for web and press work.

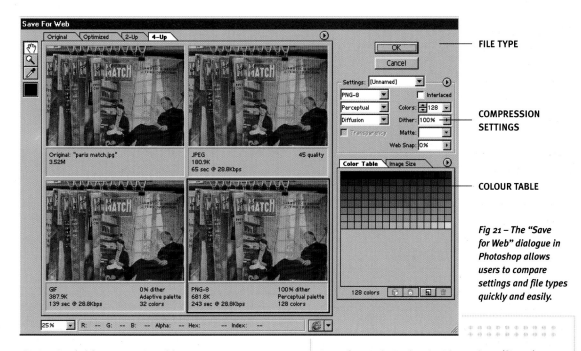

FILE TYPE

COMPRESSION SETTINGS

COLOUR TABLE

Fig 21 – The "Save for Web" dialogue in Photoshop allows users to compare settings and file types quickly and easily.

SVG – Scalable Vector Graphics

Unlike the two most popular web formats today – JPEG and GIF – SVG is a vector-based file format. In addition to faster download speeds, SVG also comes with many other benefits such as high-resolution printing, high-performance zooming and panning inside of graphics and animation.

This format will challenge the current dominant position of GIF as the premier format for flat graphic images on the web.

Save for Web Option in Photoshop (fig 21)

The latest version of Photoshop has a "Save for Web" function that enables direct comparison of an image being saved in a range of different web formats. This gives web professionals a quick and easy way to test particular compression settings and to balance file size with image quality. GIF, JPEG and PNG formats can all be selected and the compressed results compared to the original image.

TOP TIPS FOR CROSS-PLATFORM SAVING

1. Make sure that you always append your file names. This means add the three letter abbreviation of the file format you are using after the name. So if you were saving a file named "Image 1" as a TIFF, the saved file would be "Image1.tif", a JPEG version would be "Image1.jpg" and a Photoshop file would be "Image1.psd". Photoshop users can force the program to "Always Append" by selecting this option in the "Saving Files" section of preferences.

2. Mac users: save TIFF files in the IBM version. When saving TIFF files you are prompted to choose which platform you prefer to work with, choose IBM if you want to share files. Mac machines can generally read IBM tiffs but the same is not true the other way around.

3. Mac user: save images to be shared on IBM formatted disks. If you are sharing images on a portable storage disk, such as a Zip, always use media that is formatted for IBM. Mac drives can usually read the IBM disk but IBM machines can't read the Mac versions.

4. Try to keep file names to eight characters or less. Older IBM machines have difficulty reading file names longer than eight characters. So, just in case you happen to be trying to share with a cantankerous old machine, get into the habit of using short names ... and always appended, of course.

JARGON BUSTER

A

ADC or Analogue to Digital Converter: Part of every digital camera and scanner that converts analogue or continuous tone images to digital information.

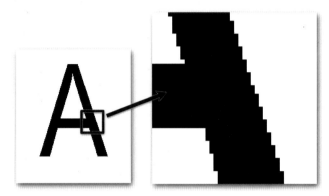

Fig 1 – Aliasing is most noticeable on the edges of text and objects.

Aliasing: The jaggy edges that appear in bitmap images with curves or lines at forty-five degrees. There are anti-aliasing functions in most image-editing packages that use softening around the edges of images to help make the problem less noticeable (see fig 1).

Aspect Ratio: The relationship between the width and height of a picture. The maintaining of an image's aspect ratio means that this relationship will remain the same even when the image is enlarged or reduced. The aspect ratio can usually found in dialogue boxes concerned with changes of image size (see fig 2).

Fig 2 – Maintaining the aspect ratio of your photographs when you enlarge or reduce their size will guarantee that all the picture elements remain in proportion.

B

Background Printing: A printing method that allows the user to continue working while an image or document is being printed.

Batch Processing: The application of a function or a series of commands to several files at one time. This function is useful for making the same changes to a folder full of images (see fig 3).

Bit or Binary Digit: the smallest part of information that makes up a digital file. It has only a value of 0 or 1. Eight of these bits makes up one byte of data.

Bitmap: The form in which digital images are stored, made up of a matrix of pixels.

Brightness Range: The range of brightnesses between shadow and highlight areas of an image.

Fig 3 – The batch mode in most image editing products helps apply a collection of commands to several images automatically.

Byte: The standard unit of digital storage. One byte is made up of 8 bits and can have any value between 0 and 255. 1024 bytes is equal to 1 kilobyte. 1024 kilobytes is equal to 1 megabyte. 1024 megabytes is equal to 1 gigabyte.

C

CCD or Charge Coupled Device: The device which, placed in a large quantity in a grid format, comprises the sensor of most modern digital cameras (see fig 4).

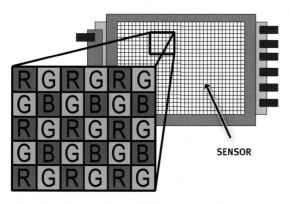

Fig 4 – The CCD sensor is the digital equivalent of film.

Colour mode: The way that an image represents the colours that it contains. Different colour modes include RGB, CMYK and greyscale.

CMYK

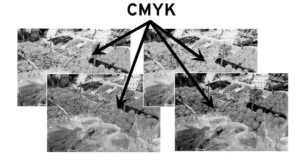

Fig 5 – CMYK separations are traditionally used for printing images using the lithographic process.

CMYK: A colour mode in which all the colours in an image are made up of a mixture of Cyan, Magenta, Yellow and Black (K). CMYK is the most common mode in the printing industry and is used by most high-quality digital printers (see fig 5).

Compression: The process in which digital files are made smaller to save on storage space or transmission time. Compression is available in two types – lossy, where parts of the original image are lost at the compression stage, and lossless, where the integrity of the file is maintained during the compression process.

D

Digitization: This is the process by which analogue images or signals are sampled and changed into digital form.

DPI: Dots per inch, a term used to indicate the resolution of a scanner or printer (see fig 6).

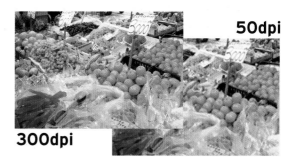

Fig 6 – The DPI is a measurement of the resolution of the image.

Duotone: A greyscale base image with the addition of another single colour other than black. Based on a printing method in which two plates, one black and one a second colour, were prepared to print a single image (see fig 7).

Dynamic Range: The measure of the range of brightness levels that can be recorded by a sensor.

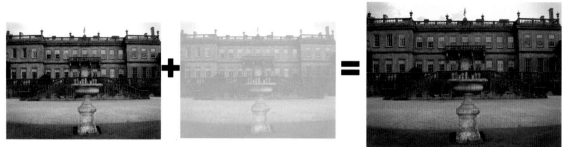

INK COLOUR 1 INK COLOUR 2

DUOTONE IMAGE

Fig 7 – Duotone images are made up of two versions of the same image printed using different coloured inks in registration.

E

Enhancement: Changes in brightness, colour and contrast designed to improve the overall look of an image.

F

File Format: The way in which a digital image is stored. Different formats have different characteristics. Some are cross-platform, others have in-built compression capabilities. See Chapter Eight for more details.

Filter: In digital terms, a filter is a way of applying a set of image characteristics to the whole or part of an image. Most image-editing programs contain a range of filters that can be used for creating special effects.

G

Gamma: The contrast of the midtone areas of a digital image.

Greyscale: A monochrome image containing 256 tones ranging from white through a range of greys to black.

Gaussian Blur: A filter which, applied to an image or a selection, softens or blurs the image.

Gamut: The range of colours or hues that can be printed or displayed by particular devices.

H

Histogram: A graph that represents the spread of pixels within a digital image (see fig 8).

Hue: The colour of the light as distinct from the how light or dark it is.

Fig 8 – The Histogram is a visual representation of the pixels that make up your digital image.

I

Interpolation: The process used by image-editing programs to increase the resolution of a digital image. Using fuzzy logic, the program makes up the extra pixels that are placed between those generated at the time of scanning.

Image Layers: Images in both Photoshop and Paint Shop Pro can be made up of many layers. Each layer will contain part of the image. When viewed together,

the layers appear to make up a single image. Special effects and filters can be applied to layers individually (see fig 9).

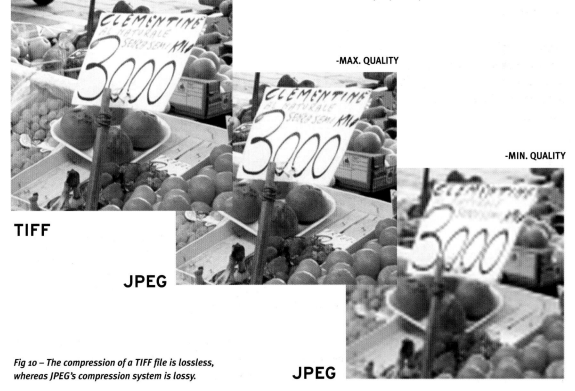

Fig 9 – Layers help keep separate different parts of a complex image.

J

JPEG: A file format designed by the Joint Photographic Experts Group that has in-built lossy compression, enabling a massive reduction in file sizes for digital images. Used extensively on the Web and by press professionals for transmitting images back newsdesks worldwide (see fig 10).

JPEG2000: The latest, more flexible, release of the JPEG format.

L

Layer Opacity: The opacity or transparency of each layer of a layered image. Depending on the level of opacity of the layer, parts of the layer beneath will be more or less visible. You can change the opacity of each layer individually by moving the opacity slider in the Layers palette.

LCD or Liquid Crystal Display: A type of display screen used in preview screens on the back of digital cameras and in most laptop computers.

TIFF

JPEG

-MAX. QUALITY

-MIN. QUALITY

Fig 10 – The compression of a TIFF file is lossless, whereas JPEG's compression system is lossy.

JPEG

M

Megapixel: One million pixels. Used to describe the resolution of digital camera sensors.

O

Optical Resolution: The resolution at which a scanner actually samples the original image. This is often different from the highest resolution quoted for the scanner as this is scaled up by interpolating the optically scanned file.

Fig 11 – Palettes are a good way for image-editing software to provide a range of user options.

P

Palette: A type of menu within image-editing programs that allows the user to select changes in colour or brightness. (See fig 11.)

Pixel: The smallest image part of a digital photograph, short for picture element (see fig 12).

Q

Quantization: The allocation of a numerical value to a sample of an analogue image. Part of the digitizing process.

Fig 12 – The pixel is the digital equivalent of film grain.

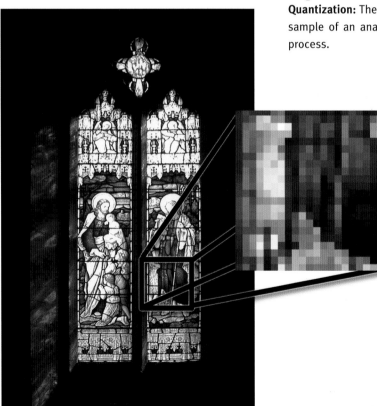

R

RGB: A colour mode in which all the colours in the image are made up of a mixture of Red, Green and Blue. This is the typical mode used for desktop scanners, bitmap programs and digital cameras (see fig 13).

S

Stock: A printing term referring to the type of paper or card that the image or text is to be printed on.

RGB

Fig 13 – Digital photographs are typically made up of three components – one for the red parts of the image, one for the green and one for the blue.

T

Thumbnail: A low resolution preview version of a larger image file used to check before opening the full version (see fig 14).

Fig 14 – Browsing software often makes use of thumbnails to preview quickly the contents of a file.

TIFF or Tagged Image File Format: Is a file format that is widely used by imaging professionals. The format can be used across both Macintosh and PC platforms and has a lossless compression system built in (see fig 10).

PHOTOGRAPHY CREDITS AND CONTACT DETAILS

Tim Daly
UK-based illustrative photographer, author of countless digital imaging articles and co-director of the online photography and imaging college – Photocollege.co.uk.
Email: tim@photocollege.co.uk
Web: www.photocollege.co.uk

Patrick Hamilton
A press and sports photographer based in Australia, currently working for .
Email:

Stephen McAlpine
Wedding and portrait photographer based in Australia.
Email: sbmcalpine@bigpond.com.au

Martin Evening
UK fashion photographer, undisputed champion of digital photography and author of Photoshop 6 for Photographers, Focal press.
Email: martin@evening.demon.co.uk

...PART TWO...

DIGITAL VIDEO

Robert Hull and Jamie Ewbank

Part 2 Contents

Introduction

Videomaking should always be an adventure, whether you are an experienced producer of your own movies or whether you just press the big red record button on special occasions. Every time you put the viewfinder to your eye, or gaze at the LCD screen on your camcorder, you are about to embark on a marvellous journey, which even with the best planning, will take you to places and put you in situations you might perhaps only have dreamed about.

We hope that by the end of this book you will be prepared to make even more journeys into the unknown with your camcorder, because seeing what you have recorded, in any capacity -whether it be at home on your TV, at a camcorder club screening, or even in competition with other videos - will give you an enormous buzz. Even experienced videomakers still get goosebumps when they see an amazing shot or a sequence they have created. It might have come by chance, it might have taken an age to plan and shoot, but, whatever it is, it is the outcome that matters. And you will soon discover, if you talk to anyone involved in film or videomaking, these are the moments they live for.

With the best will in the world, reading a book is not going to make you a videomaker. Both of us know this, but we also know, occasionally from harsh experience, that having the basics locked away somewhere in the little grey cells can be a godsend. So, with that in mind, we set to

the task of developing this book. Ultimately, we decided that the basics, quite frankly, were not going to be enough (and it would make this a pamphlet, not a book!). Instead, we thought it best to give you a taste of the whole shooting match, from the basics to the downright complicated - and yes, we thought it only right to include computer jargon as well!

The growth of digital technology, predominantly in the last seven years, has been enormous. I say the last seven years because that is how long it has been since Sony launched the first digital camcorder. Now, as we continue to edge into the twenty-first century, the range of equipment, and its capabilities, available to videomakers with all sorts of budgets is bewildering. Not only is it possible to pick up a high-quality DV camcorder for a reasonable price, but with the advent of computer-based, non-linear editing it is no exaggeration to state that professional-quality editing is possible from the PC in the living room or bedroom. The hours of faffing around with an edit VCR have now been replaced by the hours of faffing around with a PC or an Apple Mac!

It is also important to remember that even within the digital realm technology is changing. Camcorder manufacturers have already tried to vary the digital mix, with a MiniDisc camcorder from Sony and an MPEG camcorder being introduced by Hitachi. Neither of these really caught consumer imagination, but then, in 2001, Hitachi launched the first camcorder to record onto DVD. Digital tape is still likely to be with us for some time, but DVD points to one of the many routes forward. Heck, by the time you are reading this there might even be a camcorder that records onto its own internal hard disk rather than onto a tape!

Amid all this exciting new technology one point shines out like a beacon: no matter what camcorder you use, you are only as good as the shots you take, and so, with that, we suggest that you read on. . .

1

Getting Started

Getting Started

A BRIEF HISTORY OF CAMCORDERS

Although digital technology is undoubtedly the future of video-making, it is worth knowing a little about the camcorder's past. According to myth and legend – well actually according to Sony – the first consumer camcorder was launched way back in 1980. However it wasn't until 1985 that a real battleground emerged with Sony launching the 8mm recording format, while JVC introduced its compact version of the VHS format, in VHS-C. Consumers now had access to machines which were both a CAMera and a reCORDER, hence camera and recorder, whereas previously they had been seen wandering around with two separate boxes, one for taking the images, the other for recording them.

EARLY DAYS

These first machines used analogue recording methods and as such the quality of the pictures was somewhat below that seen on a TV screen. The United Kingdom, Australia, New Zealand and parts of Western Europe use the **PAL** (Phase Alternating Line) TV colour standard, which builds a television picture through 625 horizontal lines. France uses the **Secam** standard (again 625 lines), while the USA and Japan use the **NTSC** standard (525 horizontal lines). While not all these lines are used for creating the images – some are simply used for providing information – the fact that both the 8mm and VHS-C formats were capable of a line resolution of around 240 lines, gives you some indication as to the picture quality on offer. Alternatively you could always just check out a home video bloopers show and when the really ropey looking stuff comes on . . . that'll be analogue camcorders!

However, despite the somewhat duff picture quality, camcorders became a desirable product throughout the late 1980s and early 1990s as household after household fell for the novelty value of seeing yourself and your friends on video. Camcorder sales peaked in the early 1990s due to the success of manufacturers providing smaller camcorders with increased features, at more affordable prices. It has also helped that some of the most popular television programmes worldwide (such as Britain's *You've Been Framed* and *America's Funniest Home Videos)* are devoted to home movies.

A NEW BREED

Every dog has its day, however, and though still popular in the mid-1990s, the camcorder's moment in the spotlight was ebbing away. The arrival of new technology: home cinema, DVD, mobile phones, gaming technology and the Internet, meant consumers' attention was divided even further, and consequently video-making lost out.

Fortunately, the major electronics manufacturers had a trick up their sleeves that would make videomaking vital again. In 1995 Sony produced the world's first digital camcorder, the DCR-VX1000. This large, not especially attractive, camcorder recorded onto small digital cassettes using the Mini DV (Digital Video) format. Images were crisp, clear and full of detail, the camcorder had several important manual controls and high-quality digital sound. It was also possible to add an external microphone.

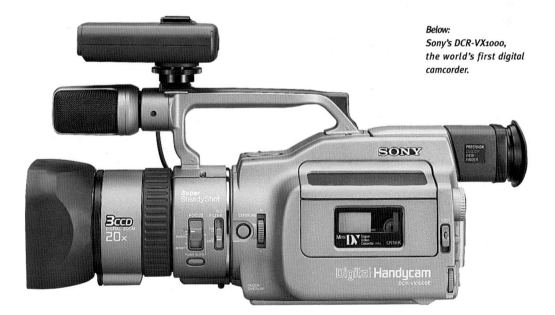

Below:
Sony's DCR-VX1000,
the world's first digital
camcorder.

Although hardly aimed at the general or casual user, it provided a tantalizing taster of what was to come. The term "Broadcast Quality", often the barometer of whether footage was good enough to be shown on TV or the cinema screen, was about to take a battering. Context became the important issue.

Quick to spot the benefits of the VX1000 the BBC soon bought a plentiful supply. To its cameramen and women, used to lugging around larger format film and video cameras, the VX1000 was not a large camera. In fact it allowed them to take camcorders into previously undiscovered areas. The era of the fly-on-the-wall, "docusoap" and reality TV show was upon us.

BIGGER IS NOT ALWAYS BETTER

Following the launch of the VX1000, JVC, Panasonic and Canon soon followed with their own DV models and a contest of miniaturization began. Every quarter, as launches were made,

there would be a new claim for the world's smallest camcorder. The range of designs on the market became bewildering: you could have an upright or "book"-style DV camcorder, a rectangular-styled palmcorder, a camcorder that looked like an SLR camera, or, if simplicity was your bag, a square camcorder.

As the list of digital camcorders grew towards the end of the 1990s, so did the amount of features available to the consumer. Digital effects and zooms increased, video lights were added, batteries were made smaller, LCD screens were made bigger. Soon it became possible to take digital snaps with your camcorder and decide whether you wanted to store them on tape or on a supplied storage card. You could, therefore, have the best of both worlds – a way of taking both moving and still images. Yet, despite this rush, some seasoned videomakers felt the new camcorders were selling them short.

In the early days, camcorder controls were large and easy to operate, and control over focus, exposure, zoom, white balance and shutter speeds was manual. With the increasing miniaturization, these features were being sacrificed for functions that made it easier for a salesmen to "sell" the camcorder. A camcorder with a 500x digital zoom is virtually unusable, as the camcorder needs to be completely steady or either the shot will be lost, or the amount of **pixellation** (distortion) of the image will be so high as to make the image unintelligible.

SOMETHING FOR EVERYONE

To this end the camcorder market now divides into three distinct sections: budget, entry-level and enthusiast. There are consumer DV camcorders available for both under £/US$ 500 and over £/US$ 3,000, and at many price points in

Below:
Small is beautiful:
Modern camcorders are
light and portable.

between. What is more, the level of design is now sophisticated enough to be able to distinguish between the different needs of the variety of customers. Enthusiast camcorders have more manual control over sound and video, have less digital and picture effects – in general, less gimmicks. They tend to be slightly larger and more complicated to use than their counterparts in the budget and entry-level sectors. Here you will find a real dogfight for your money. Feature counts will be high, but corners might have been cut in terms of build quality, as well as image and sound quality.

However, as video-making continues its dash into the twenty-first century, the range of products on offer to consumers has never been greater, nor has the performance rating of camcorders been higher. With digital videomaking now more affordable, there is now virtually no limit on what can be achieved, whether it be from the comfort of your living room, or as part of a semi-professional set-up. Digital videomaking now dovetails beautifully with the power of desktop video. Computers and camcorders can now meet and, within a few hours, videos can be stitched together with basic cuts and transitions, or, for the more ambitious, with previously very expensive special effects.

CHANGING THE OLD ORDER

Even film-makers have had to take note of the power of digital video, as traditionalists used to cutting on film now make way for the power of

the pixel and the PC. Hollywood is increasingly utilizing the flexibility and time-saving aspects of digital video. Initially, this was in the post-production houses famous for adding the "special" bit to film effects, but now this can even include shooting feature films on digital video cameras.

Above:
The Panasonic NV-MX300, a definite enthusiast's camcorder.

Camcorders can now record onto DVD disks, or in the case of Sony's MICROMV format, using MPEG2 compression, onto cassettes smaller than a book of matches.

It is easy to be blinded by the speed of technology, but through this tremendously accelerated journey it is worth bearing in mind that, ultimately, though technology will help you make your ideas a reality, you have got to be able to point the camera in the right direction and know which button to press before you can do it. You can't put a price on basic video-making know-how!

FROM ANALOGUE TO DIGITAL – A CAMCORDER TIMELINE

1980 Sony introduces first consumer camcorder in Japan.

1985 Sony launches 8mm recording format. JVC counters with the introduction of the VHS-C format, a compact version of its VHS technology.

1988 JVC ups the ante with arrival of Super VHS (S-VHS) format.

1989 Touché! Sony reacts with the Hi8 format, offering video-makers increased picture quality, and eventually stereo sound.

1995 First Mini DV (Digital Video) camcorder arrives in the UK. It is the Sony DCR-VX1000, and though it costs significantly more than analogue consumer camcorders it is soon adopted by TV companies, production companies and semi-professional videomakers due to its exceptional picture quality.

1996 JVC and Panasonic launch DV camcorders into the UK market. JVC's GR-DV1 is the first example of a palmcorder, so called because it is so small it fits neatly into the user's hand.

1997 An omen of things to come? DVD players having been on sale in Japan for a year, are now available in the USA. Hitachi tries to change the camcorder market, unveiling its MP-EG1A camcorder towards the end of the year. This is the first tapeless camcorder, using MPEG compression to record digital images onto an internal hard disk. Image quality is unimpressive and price seems too high for consumers – it flops.

Right:
Sony's Hi8 Handycam.

1999 Sony introduces the Digital8 format. These new camcorders allow the user to record digital images onto analogue 8mm/Hi8 tape. Backwards compatibility means you can replay your existing 8mm/Hi8 tapes in the new machines!

2000 Hitachi and Sony announce plans for new camcorders. Hitachi's plans include a DVD camcorder, while Sony unleashes a MiniDisc camcorder.

2001 Hitachi's DZ-MV100 DVD RAM camcorder goes on sale for around £1,800. Sony hits back, however, with a brand-new format MICROMV Recording onto tapes smaller than Mini DV cassettes and using MPEG2 compression.

WHY CHOOSE DIGITAL?

Inevitably with the rise of digital technology the cost of analogue equipment has fallen. It is now possible to buy a basic "point-and-shoot" analogue model for under £/US$300. So why, you might ask, do you need to buy digital, when you

can save money on analogue equipment? It is an intriguing question because as any experienced videomaker will tell you, making movies – even amateur ones – can be an expensive business. Fortunately for us there are many answers to this conundrum.

Chiefly, digital image and audio quality is superior to that from analogue machines. Even digital camcorders at the budget end of the market will provide far better picture quality than that seen from 8mm, VHS-C, S-VHS-C or Hi8 formats. In terms of horizontal line resolution, a basic DV camcorder will resolve around 400 lines, colours will be reproduced more accurately than on analogue formats and there will be a sharpness and detail to the images that is unavailable on other formats.

Sound

Audio, on the other hand, has always been something of a troubling matter for camcorders. The microphones included on all but the most expensive (and high end) camcorders are generally one of the cheapest components used. Consequently sound quality does not always match the clarity of the images recorded. Even with digital technology there is a disparity between the quality of the images and audio. As a rule, most DV camcorders use **PCM** (Pulse Code Modulation) stereo sound. This is audio that has been digitized. It is available in two settings 16-bit (48kHz, two channels) and 12-bit (32kHz, two from four channels). The first setting provides the highest-quality sound recording, often claimed to be slightly better than CD quality, though in reality slightly worse! The second setting does not produce as dynamic or fully rounded sound, but as it only records onto two, out of four, channels, a further two channels are left open for adding

narration or soundtrack dialogue/music at a later date.

In reality, the audio performance of DV camcorders is acceptable rather than inspiring, but it is still an improvement on the recording methods of analogue camcorders, if only because of the flexibility it offers.

Non-Linear Editing

Aside from the improved performance criteria, digital camcorders have also helped support the growth in computer-based editing. This is commonly known as non-linear editing (NLE), as footage can be chopped, changed and moved around at will, rather than being edited in a linear fashion. Computer hardware and software is necessary for this, and footage is often displayed on the computer monitor in a form known as a "timeline". This shows video and audio information which can then be re-ordered and have titles, transitions and effects added to it.

All digital camcorders incorporate a **Firewire** socket among their terminals. This is a connection protocol developed by Sony, which allows for data communication at very high transfer rates. It can often be referred to by its technical name, IEEE-1394, but is more commonly known as Firewire.

A camcorder can be connected to either a PC or a Mac computer through a Firewire cable. The Firewire socket on a camcorder is a four-pin affair while on most computers the socket is six-pin. Therefore, the cable that connects the camcorder and the computer has one six-pin and one four-pin connection. Using the cable it is then possible to transmit the data from the DV tape in the camcorder onto the hard drive of the computer. From here, provided you have the right hardware and software, you can run amok with your footage, adding bits, trimming clips,

changing the running order – as well as at a later date creating your own Video CDs, Internet movies and ultimately DVDs.

Facing the Future

And what about the future? Well, if picture, sound quality and computer-based editing weren't enough to convince you, then try the fact that within the next couple of years you might not be able to buy a new analogue camcorder at all!

Below and Right: The introduction of Mini DV and Digital 8 camcorders have revolutionized video-making.

Sony has introduced its MICROMV format, and Hitachi has launched several DVD camcorders, these are still just forays into new ways of recording images. Mini DV, due to its lightweight camcorders, affordable tapes and computer compatibility, is almost certain to remain the most popular and convenient mass market way of creating and distributing video.

Sony has already ceased production of its 8mm camcorders, and while its Hi8 still remains popular, who knows how long it has left, considering the success of Sony's backwards compatible Digital8 format. JVC, the architects of VHS and once committed to the format, have also confessed to seeing a time without analogue camcorders, and have been one of the busiest manufacturers in addressing the budget end of the digital camcorder market.

Yet, by its very nature, the electronics industry is subject to fast-paced change. So what of the future of digital video. Although

Choose digital because of:
- Picture quality.
- PCM stereo sound.
- Opportunity for non-linear (computer) editing.
- Compatibility with other technologies: digital cameras, DVD, Internet and email applications.
- Death of analogue camcorders.
- Cost.

BUYING THE RIGHT
DIGITAL CAMCORDER

The most common question asked of anyone "in the know" about camcorders is usually, which one should I buy? It is not that it is an impossible question to answer, it is just that once consumers realize the potential number of answers, their buying decision seems to become more complicated.

Cost is the most important consideration when buying a camcorder. The range of camcorders on offer is huge, and because of canny marketing there is a model that will appeal to everyone, but consumers need to know how much they can spend, in order that they can be advised properly. As we mentioned previously, the camcorder market is divided into three sections: budget, entry-level and enthusiast. Obviously prices change rapidly and there is no way of keeping track of them during the lifetime of a book, so you should keep your eyes trained on the videomaking press and price comparison sites on the Internet. However, as a rough guide, the three sections break down this way.

Budget: prices generally sub £/$US500 to around £/$US800.
Entry-level: prices generally £/$US800 to around £/$US1,200.
Enthusiast: price generally upwards of £/$US1,200.

What you get for your money is vastly different. Enthusiast camcorders are usually larger than their counterparts, have a wide selection of manual controls, have advanced level of socketry including Firewire in and out, analogue inputs and outputs, and will require an invest-

Above:
One of the most popular uses for camcorders is to create lasting memories of idyllic holidays.

Right:
Camcorders are getting
smaller and far easier to
take with you . . .
anywhere.

Mini DV, Digitals, DVD-RAM and MICROMV The first two are by far the most popular and prevalent and unless your needs *are* very specific you should look here first.

Mini DV

The most popular DV format. Tapes are smaller than a box of matches, affordable and are capable of producing high quality images and audio. Tape lengths vary but are available in 30, 60- and 90-minute options. There are in excess of 80 camcorders on offer using this format, and they are noted for their compact, lightweight design.

ment of your time to learn how to use them effectively. Camcorders in the other two sections will mix and match features and functions, with an increasing number of digital and picture effects becoming available, while manual features – the favourites of any experienced video-maker as it allows them to control how the footage is recorded – will take a back seat. Budget camcorders are designed to be very easy to use, and to provide reasonable results "for the money", but they won't have the flexibility or control of more expensive models.

Once you decide which user you want to be your choice becomes easier. If you want an easy-to-use camcorder for recording the odd family event, there is no point shelling out £/$US1,500 on a model with all the features a semi-pro would want. And likewise, if you want to edit videos on your home computer, while also digitizing existing analogue footage, you will be left wanting if you are tempted by the sub-£/$US500 price tag of a budget DV model.

Digital Formats

In order to buy the right camcorder you should first decide on the right format. There are currently four consumer digital video formats:

Digital8

Around ten models of Digital8 camcorder are available. Predominantly from Sony, the inventors of the format, although Hitachi also have a model available.

Camcorders are similar in design to Hi8 models in that they are large, fairly bulky and decidedly heavy in comparison to their pure DV counterparts. The benefit of the format is that the camcorders use 8mm and Hi8 tapes but record images of a digital quality, while they can also play back your existing 8mm and Hi8 tapes.

DVD-RAM

Only Hitachi has so far entered this market in the UK – though Panasonic has sold a DVD camcorder in Japan. The camcorder records digital images, sound and stills, using MPEG2 compression, onto an 8cm rewritable DVD disk, housed in a caddy that fits into the left-hand side of the camcorder. On the first UK model, the DZ-MV100, the disk had 1.4 gigabyte (GB) capacity on each side and provided a maximum recording time of 60 minutes (30 minutes per side). Image quality was not quite up to DV standard, and you could not play the DVD in a conventional DVD player. New models in 2002 have addressed some of the initial problems, but Hitachi stands alone in promoting this format.

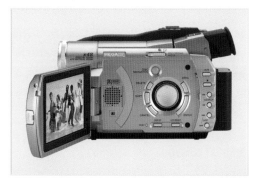

MICROMV

This format was introduced by Sony in the summer of 2001. Tapes are smaller than Mini DV and images are recorded using MPEG2 compression. Picture quality is around the same as Mini

DV, but there are problems on playback, with a slight pause being apparent at the end of each recorded segment.

Two models are available at time of publication: the DCR-IP7 and DCR-IP5. The former boasts Bluetooth wireless technology, which allows the camcorder to surf the Internet, and both send and receive emails.

Once you have selected your DV format, it is time to move on to the main features which will try and separate you from your hard earned cash. Some of these features are about as much use as a chocolate fireguard, but there are plenty that will help you distinguish just what sort of camcorder user you are.

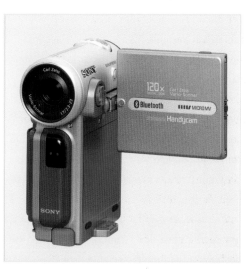

Left:
The next step. Is DVD-RAM or MICROMV the future of digital video?

FIREWIRE (DV-IN-AND-OUT)

Firewire sockets allow the DV signal to transfer between suitably equipped devices, the most common cases being a digital camcorder and a computer. All digital camcorders have a Firewire socket, but only a small percentage of them allow the digital signal to be sent and received. Hence you will see plenty of camcorders referred to as DV-out, but few as DV-in-and-out.

DV-out only means you can transfer your DV footage to the computer for editing, but once there you cannot transfer it back to a blank DV tape waiting in your camcorder – and so complete a fully digital video. The reason for the lack of DV-in-and-out camcorders has long been a moot point. Manufacturers claim that in the eyes of Customs and Excise a DV camcorder capable of recording a signal from another source is also a VCR (Video Cassette Recorder) and liable to more duty. Therefore, the price of a DV-in-and-out model is usually more than that of a DV-out only. In their wisdom, camcorder manufacturers took it upon themselves to claim that consumers would not be willing to pay the extra for DV-in-and-out, even when, as we have pointed out, it is necessary to get the full benefit from digital video and computer editing.

What is frustrating for UK users is that all digital camcorders can actually send and receive via Firewire, but because of the Customs problem, camcorders coming to the UK are deliberately neutered to disable their DV-inputs. Camcorder manufacturers have increased the number of DV-in-and-out models, usually by including at least one of them in a new range, and there is also a burgeoning market in products called Widgets, as well as software hacks, that allow consumers to reactivate the DV-in socketry on their camcorders – at the cost of invalidating the camcorder's warranty!

If non-linear editing figures highly in your criteria for buying a digital camcorder, make sure you consider the DV-in-and-out question.

Analogue Inputs

Generally found on enthusiast models, analogue inputs allow an analogue source i.e. a camcorder or VCR to be connected to the digital camcorder. It is then possible to record the analogue material onto digital tape. For users moving from analogue to digital, this is a useful way of archiving material in a digital format, or should you wish to edit on a computer you can now incorporate analogue footage.

Manual Controls

A must if you want to take videomaking seriously and take control of your productions. All but the most basic DV camcorders will allow you to take manual control over focus, but you will have to check specifications carefully if you want manual exposure, shutter speeds, iris or white balance controls.

Left:
Camcorders can be used
as a digital stills camera
and have removable
storage media.

On enthusiast models the manual controls tend to involve larger buttons, and potentially a manual focus ring around the lens, rather than a small thumbwheel on the side or back of the camcorder.

Zoom

It's an easy adage to remember: optical zoom = good, digital zoom = bad!

One of the easiest videomaking mistakes to make is to overuse the zoom. Check out your favourite films and TV shows and see how little the professionals use it, and when they do, why it is often purely stylistic. If you want to see something closer, move closer to it!

Optical zooms can run up to 25x magnification, a perfectly adequate number, which creates no picture degradation. Digital zooms can run up to 700x magnification and increase pixellation (picture noise) on your images, while also causing you to use a tripod in order to keep the camcorder steady enough to see anything. If you are still interested in digital zoom perhaps it is worth asking yourself: is the best way to record your favourite image by standing ten miles away from it?

Image stabilization

Two image stabilization systems have grown up over the years. Optical and Digital (Electronic). Video purists have often hankered solely after the optical system, as it does not electronically alter the image in order to keep it steady, and therefore your footage will not suffer from any picture noise. However, optical systems increase the size of a camcorder and in the age of miniaturization, the digital system has become more prevalent. This system, sensing camcorder shake, electronically enlarges a 70 per cent portion of your image and stores this to tape instead. The camcorder then compares each image with the last and moves this enlarged

Left:
An optical zoom in of
up to 25x magnification
is more than adequate
for most video-making.

portion up and down in order to keep the key elements in the same position.

Initially digital stabilization was prone to increasing picture noise, but recent systems have shown a marked improvement.

However, the best form of image stabilization known to videomakers is still a tripod!

Sockets

Small things, but things that are often overlooked, the inclusion of key sockets on your camcorder can often make the difference between a polished production and a gremlin-encrusted nightmare. The two most important, after DV-in-and-out, are an external microphone socket and a headphone jack. The first allows you to bypass the basic microphone on your camcorder and invest in a far more subtle and sophisticated version, which is likely to give you a fuller, more directional sound.

The headphone jack is important for enabling you to hear what your camcorder is recording in the audio department. This is useful for picking up fluffed lines, over-flying aircraft, squeaks, buzzes and other noises you might not necessarily want on your footage.

Viewfinder/LCD

Digital camcorders invariably feature both optical viewfinders and LCD screens. They can both be used for framing images, but the LCD screen does place extra draw on the camcorder battery. LCD screens range in size from around 1.8 inches to 3.5 inches and are always colour.

They are best used for reviewing footage, and as most camcorders have built-in speakers, you can watch and listen to footage taken only seconds ago. The larger the LCD screen the more money you will pay, but be warned: LCD screens hate bright sunlight, and can often be rendered useless by it.

Viewfinders are now predominantly colour, though traditionalists have always preferred black-and-white viewfinders for the exposure and contrast "hints" they give. Sadly, even high-end, enthusiast camcorders now use colour view-finders, though you can find accessories for some of these camcorders, such as Canon's DM-XL-1 or DM-XL1S, which include black-and-white viewfinders.

Right:
Sock-et to 'em:
Analogue, Firewire
and PC connections.

Again miniaturization has caused viewfinders to be reduced in size, so, if only from a comfort point of view, be sure to check the eyepiece you might be gazing down for hours on end is comfortable.

Audio

If you want flexibility in the audio department, look out for camcorders which feature audio dub – most camcorders utilizing 16-bit and 12-bit PCM stereo sound feature it, but not all. Audio mix is also another useful function, as it allows you to balance the level of sound coming from the different stereo channels.

Digital Stills Storage

Do you want your camcorder to be your camera as well? If so, virtually every camcorder from budget models to enthusiast camcorders can oblige. Previously restricted to storing snaps to Mini DV tape, digital camcorders now record high-quality stills to multimedia cards. Images can be printed out via computer or sent as email attachments. The number of still images that can be stored depends on the MegaByte (MB) capacity of the storage card. Image quality has improved to a point where some enthusiast camcorders are capable of stills approaching the quality of 35mm film.

CHOOSING THE
RIGHT COMPUTER

One of the reasons why DV has become so popular, aside from its high quality, is the ease with which it can be imported and altered using a computer. Computer programs are a digital environment and, as such, are happy to work with digital video, exploiting the massive range of software and hardware available and allowing you to edit your videos, add special effects, create video emails, compress films for broadcast over the Internet and even author your own DVD videos and Video CDs. All of this is done without having to alter or compress the information on tape, meaning that you will suffer no loss of quality in your footage.

You can buy what are known as "one-box" systems for video editing that contain all the components and software you need to edit video, but these can be expensive and, unlike a computer, can only be used for video editing. Additionally, should you not like the particular software on a one-box system, or find that you require features it does not possess, then you have wasted a lot of money. Computers, on the other hand, can be turned to many more uses and can be easily upgraded, which is why we

Below:
The Apple Mac has a dedicated following among computer users.

would always recommend a trip to the PC store over a one-box editor.

That is not to say that you have to turn your front room into Industrial Light and Magic simply to enjoy using your camcorder, but it is worth bearing in mind that the DV format opens up such a wealth of possibilities that it would be wrong not to consider what benefits a good computer with well-chosen software can bring to your videomaking.

Your camcorder will have a DV-out socket at the very least, and hopefully a two-way DV in-out socket if you were paying attention during the last section. It should also have come with a DV cable for transferring the information via the camcorder's DV socket to one located on your computer.

DV.cable goes under a variety of different names – Apple, who own the copyright, call it Firewire, Sony refer to it as iLink, most of the PC world knows it by the rather long-winded IEEE1394. In essence it is a cable and socket system that draws its power from the devices it is attached to and allows the high-speed transfer of information between your camcorder and computer.

The type of computer you'll choose to use for DV editing will depend on your personal tastes and the generosity of your bank manager (put him on your Christmas card list now.)

The first question to think about is whether you chose Apple Mac or PC. PC essentially means Personal Computer and, as such, technically refers to Macs as well. Over the years, however, PC has come to be used as a generic term for a computer with an Intel or AMD processor that runs Microsoft's Windows operating system. Macs, on the other hand, use processors known as G3s or G4s and an operating system known as the Mac OS.

These operating systems are likely to be the point that demand the most consideration when choosing a computer. The Windows system, in one of its many forms (95, 98, 98SE, NT, Millennium Edition, 2000 or the latest XP) is used on around 90 per cent of the world's computers

Left:
An iMac running OS X provides stability, built-in sockets and basic editing software.

and is likely to be instantly familiar to anyone who has so much as glanced at a computer.

Whereas Windows can be found on computers made by a massive variety of manufacturers, the Mac OS is found exclusively on machines manufactured by Apple Macintosh. Both systems have their respective strong and weak points.

The Mac OS is stable, that is it does not crash very often, intuitive, versatile and stylish. Windows, on the other hand, is less stable, less stylish and, for videomakers, quite restrictive. On the other hand, it does have the massive advantage of ubiquity – Windows machines are everywhere, which makes them the priority market for software developers and means that there is a much wider range of software and accessories available for Windows machines. Additionally, the familiarity of the Windows operating system makes it easy for beginners to learn and communication between different computers is rarely a problem as the likelihood is that they will both be using the same system.

Mac and PC users have a tendency to be clannishly devoted to their machines and you will be able to tell them apart by looking at their eyes – Mac users will have a melancholy look brought on by staring wistfully at adverts for wondrous software that isn't designed to work on their machine, whereas Windows users will have bloodshot eyes, having spent several nights awake trying to rescue the huge amounts of data lost when their computer last crashed.

Most users will invariably choose the operating system that they are most familiar with – be it the one from work, college, or an existing home PC. There is absolutely nothing wrong with sticking with what you know, but, just for the record, we would recommend that you have a look at both Macs and PCs and try and work out which system suits you best, bearing in mind that a computer is a big investment and that you will probably want to use it for more than just video-related work.

Left:
Socketry on an iMac provides 2DV inputs as well as a host of other connections.

One thing to think about is that Apple Macs (the iMac, iBook, Powerbook and G4) all feature firewire sockets and iMovie2, a very basic piece of video editing software. Many PCs, on the other hand, will need to you to install a capture card (a device with a DV socket) and your choice of editing software separately. This is not necessarily a bad thing because many capture cards feature onboard video-specific processors which will help lighten the load on your computer's processor. As manufacturers become more aware of the needs of videomakers, more and more PCs are being made with the relevant sockets and software built in.

Another point to bear in mind is that older versions of the Windows operating system, such as 95, 98 and 98 SE impose a limit of 4GB on the size of information files. This sounds like a lot, but in truth it is only about 18 minutes of video, meaning that projects longer than that will need to be split into several smaller files.

Having decided whether to go for a Mac or PC you then need to look at the hardware itself –

Right:
When it comes to PCs,
Dell have a well-deserved
reputation for quality.

most importantly the processor and the memory.

The processor is the brain of your computer, the part that does all the "thinking". When you give your computer a command it is the processor that works out what that command means and what effect it will have upon the work you are doing. A fast processor is essential, as video editing will often require your processor to execute a staggering number of commands and you really don't want to be waiting around for your processor to carry them out.

A common method of assessing the power or speed of a processor is by looking at its clock speed – the number quoted in MegaHertz. As a very rough guide, a 700MHz processor can execute about 700,000,000 commands in a second. However, the actual design of the processor (essentially a microchip with millions of tiny transistors and a basic understanding of the words yes and no) can have a massive effect on its performance. Hence a Pentium 4 processor

is likely to be more efficient than a Pentium 3, even if they have the same clock speed, whilst a 733MHz G4 processor in a Mac is considered by Mac users to be the equivalent performer to a 1.7 GigaHertz processor on a PC!

While you won't necessarily require a top-of-the-line, fastest-on-the-market processor for video editing, a good processor will make a lot of difference, and, considering that it is much harder to upgrade your processor than it is to increase RAM or HDD capacity, it is worth looking for the fastest (and hence, most future proof) processor your budget will run to. Think Pentium 4, G4 and AMD Athlon/Athlon XP, and look for a nice high clockspeed, then phone your bank manager and ask him if he liked his Christmas card.

Memory comes in two forms – the information stored on your hard disk and the information stored in the Random Access Memory (RAM). RAM holds the information your

computer is working with at any given time and is used by the processor when executing commands. Anything stored in RAM will disappear when the computer is turned off, whereas the Hard Disk is used to store the information permanently. A common (and accurate) cliche is that the Hard Disk is the equivalent of long-term memory, whilst RAM is the short-term memory that your computer is working with.

When you install a piece of software it "lives" on your hard disk, when you start it up and begin working with it, however, your processor will transfer the relevant information needed to run the software to the RAM, which is composed of

a series of chips mounted on a printed circuit board known as a DIMM. RAM operates much faster, but at much lower capacity, than the large spinning Hard Disk, and can feed information to the processor at higher speed.

A common mistake among novice computer users is to confuse the two types of memory, meaning that an inexperienced user, when told that his machine does not have enough memory to execute a command, will attempt to "free up"

some memory by pointlessly removing items from the hard disk, rather than simply buying and fitting more RAM into the slots helpfully provided on most computers. (RAM is ludicrously cheap and fairly easy to fit – upgrading your memory won't necessitate another call to the bank manager.)

As a rough guide, when planning to use a computer to edit video, do not look at anything with less than 256MB RAM and possibly consider 512MB – you probably won't need that much, but it is better to have memory that you don't use than it is to sit there clicking through endless dialogue boxes laughing at you for trying to add half a dozen special effects to a clip when your computer is suffering from digital Alzheimers.

Similarly, when looking at the hard disk drive's capacity, keep in mind that video files are big, and will usually be measured in GigaBytes (Bits being the smallest piece of computer information, eight bits to a Byte, 1024 Bytes to a KiloByte, 1024 KB to a MegaByte, 1024 MB to a GigaByte).

Even if you plan to limit yourself to only having a single video project on your computer at a time, you will still find that it takes up a lot of room – a half-hour finished project will take up over 8GB and that project itself will probably have been put together from a couple of hours worth of footage. Separate, external hard drives can be plugged into your computer to provide additional storage space, but that is an extra expense. It is better to look for a machine with a high capacity drive to start with – start at 20GB and go higher if you can.

Left:
Many older PCs will require you to fit a DV capture card. Don't panic – it is easy to do.

One last point to remember is not to take software manufacturers at face value – not that we would suggest that they would ever lie to you, but the truth can be open to interpretation. When looking at the side of a software box and reading the minimum system requirements, keep in mind that they want your money – if it says it will run on Windows 98 with a Pentium II processor and 128MB RAM then it will, but probably in a slow and unreliable fashion. Do not choose a computer based on the minimum requirements of the software you plan to run on it, and do not believe that a piece of software will definitely work well on your system when it may, in fact, only just limp along.

This all may sound like a daunting shopping expedition, but in truth you can look at the basic specs of any Mac or PC and, as long as you bear in mind the information above, have a pretty good idea of whether it will do what you want it to. Do not be put off by the expense either – your computer will be useful for more than just video editing.

BUYING THE RIGHT ACCESSORIES

To capture the best images and audio you need more than just a camcorder, you need accessories! Chosen and used wisely these can help to add professional touches to your videos and they also help to make you a more proficient and organized producer. The miniaturization of technology attendant to digital video has seen many videomakers discard what are otherwise essential tools. Never assume that the tiny dimensions of your camcorder, and the quality of digital video don't need a helping hand from time to time. There's a wide array of accessories on offer, and though you don't necessarily need

Right:
Get yourself some support! A tripod is a videomaking necessity.

to possess all of them, it will be beneficial to have a selection.

Camcorder Supports

A tripod is the most important accessory you can have. It will enable you to shoot from a wide variety of angles and heights, and from a stable platform, and for these reasons it is essential. Prices range from very cheap to staggeringly expensive. Tripods aimed at semi-professional and professional users are incredibly stable, but weigh a prodigious amount. Depending on the cost of the tripod these set-ups can be sold separately, so you purchase a video head and a set of tripod legs that you then combine. Remember in professional productions there's always someone to cart the gear around, whereas in your productions it could well just be you!

If you are going to be shooting regularly you

will need a durable tripod that offers aluminium and/or graphite construction, a spirit level – either on the tripod head or legs – to ensure your shots are even, and a quick-release platform. This allows you to slide the camcorder on and off the tripod without having to unscrew the bolt that attaches the camcorder to the quick release platform. This is most beneficial when you are moving around a location and setting up new shots.

There are other forms of camcorder support,

such as a monopod, which is a single leg version of the tripod. Naturally it does not provide as much stability but is useful in locations where space is at a premium. It is also lighter, and invariably cheaper than a tripod. A chest pod can also be used to brace the camcorder against you for stability. Finally it's also worth mentioning Steadicam systems.

Created during the making of Stanley Kubrick's *The Shining*, Steadicam is a support that has no contact with the floor. Instead it uses a system of weights and counterweights below the camcorder to keep it level. It allows

the camcorder operator to move freely with the camcorder and shoot smooth footage, as well as allowing you to get closer to the action. Professional systems are prohibitively expensive for most amateur productions but there are cut-down, budget systems available which offer many of the same benefits.

Camcorder Protectors

Received wisdom says you don't get your camcorder wet – as it will not work! However, there are occasions where you might be shooting footage around, near or even in water, and, yep, it can also start raining. So, what can you do? Inexpensive rainjackets are available to cover the camcorder in light rain, and more substantial protection is on offer from some of the accessory companies in the back of this book. Underwater housing for many DV camcorders is also available. A number of manufacturers can tailor make a housing for you, but both camcorder makers and accessory firms supply one-size-fits-all options.

Left:
The Shining, directed by Stanley Kubrick, used the innovative Steadicam system.

Below:
Cover star. Your camcorder is precious so keep it protected from the elements.

Filters

Material placed in front of the camcorder lens to modify the light entering it. Used for creating a special effects. The range of filters on offer is incredibly diverse and include filters that merely protect the camcorder lens itself (Skylight filter) to graduated filters that can gradually change colour from clear at the bottom to a colour at the top.

Filters

Other filters include:

Neutral Density: for reducing the threat of underexposure in bright conditions, and for reducing depth of field.

Colour Correcting: change the overall hue of the whole frame.

Polarizing: for eliminating reflections, such as those from mirrors or water. Your camcorder lens has a filter diameter (i.e. 43mm, 37mm) and this helps you select the right size to fit your model. However, it's also possible to buy a Matte box, which clips around your camcorder's lens and allows you to slot in any type of filter.

Lens Converters

Very useful for grabbing detailed shots, with a difference. Lens converters fall into two categories, teleconverters and wideangle converters. Teleconverters increase the focal length of your camcorder's lens, while wideangle converters do the opposite. Take, for example Sony's DCR-PC9 digital camcorder, with its 3.3-33mm focal length. This gives it a 10x optical zoom. Adding a 2x teleconverter lens would increase its maximum focal length to 66mm – and enable you to get closer to a subject without anymore zooming.

Right:
Using filters opens you up to some intriguing effects.

As with filters, lens converters fit onto the end of the camcorder lens, and for the more ambitious videomaker there are special converters, such as a fish-eye, which is an ultra wide conversion lens.

Lights

You have two options: lights that are on the camcorder (either built-in or ones you attach), or external lights. Lights can be used simply to lift the gloom of a shot, so you can ensure you get detail in the picture. However, they can also be used to add atmosphere. Lighting an interview subject a certain way can increase tension and intrigue. Likewise in fiction you can evoke the right mood of horror, comedy or drama.

On camcorder lights have a limited value, so it's better to plump for a small lighting kit, if you are intent on producing high quality results. Accessory companies offer starter kits, which usually include three "redhead" lights – the most generally useful type of light – and perhaps a stand and reflector. The more ambitious your project the more specialist lights you will need. Check our useful addresses section for lighting suppliers.

Below, Left to Right:
Lights come in many
shapes and sizes –
on-camera, stand-
mounted or hand-held.

Right:
Sound advice: Use
the right microphone
for the right situation.

Microphone

The purchase of an external mic (make sure your DV cam has an external mic socket) frees you from the shackles of the in-built mic. Two types are available: dynamic and electret. The first requires no battery. A coil attached to its diaphragm is moved by sound waves and vibrates between the poles of a magnet to produce an electronic signal. Ideal for quiet locations, as the mic itself generates little noise, such as interviews and narration. Electret mics need a battery to power a built-in pre-amplifier that consequently boosts the signal. They are powerful and also more sensitive than dynamic mics. Overly loud audio can overload them, and they produce some noise themselves. Within these two types of mic there are several pick up patterns, which show the mic's angle of sound acceptance: Omnidirectional – picking up sound equally from all directions Cardioid – sound picked up from the direction the mic is pointing Super-cardioid, Hypercardioid – more directional than cardioid, these often reject sounds coming from behind or the side.

Below:
Heads up: Make sure
you hear what is being
recorded on tape.

Headphones

Essential for monitoring the sound you are recording. The ear is a sophisticated piece of technology that can filter out the sounds you don't want to hear (insert sexist nagging joke here!). Even expensive mics can't always do this. Make sure you know what's going down on tape. Ensure your camcorder has an external headphone jack before purchase though.

Tapes and Batteries

Small enough to forget yet you'd be lost without them. A supply of tapes, and a selection of charged batteries is essential for any production, whether it be holiday, birthday, fiction or

documentary. DV tape is affordable, more so when bought in bulk. Batteries are more expensive but you should invest in a separate charger and at least one extra battery.

Camcorder Cases and Bags

Think of your camcorder as a vulnerable possession – and make its home a pleasant one. Twee, we know, but it's easy to get blasé and forget just how much your camcorder cost you. Bags should be heavily padded and have space for plenty of tapes, batteries and accessories. The less ostentatious your carrier, the less likely it is to find itself in a bag marked swag.

Dollies, cranes and track

Bonjour Monsieur Professional! Dollies and cranes offer videomakers the chance to get incredible footage. However, it comes at a cost. You need to ensure you have a use for these expensive goodies. Dollies are "vehicles" that can be pushed along a plastic or metal track in order to follow action – hence the phrase tracking shot. But dollies don't need to be pro set-ups they can be any wheeled platform that allow the camcorder and its operator to keep up with the subject. Unless you're intent on recreating the crowd scenes from *Gladiator,* it might be worth keeping cranes to your bigger productions. Excellent for sweeping ground to air shots, or shots from extreme angles, these are costly and need a team of operators, plus an external monitor to view what you're shooting.

Above:
Stay secure. Protect your camcorder when it is not in use.

Left:
Supports such as dollies provide interesting shots as in Gladiator *(2000).*

2

The Basics

THE BASICS

BASIC CAMCORDER FUNCTIONS

Despite the prolific number of camcorder designs available to consumers, there are many key functions which are incorporated (to varying degrees) on all models. Here we have listed the most common buttons and controls you will find your fingers heading towards, along with a description of what they do and whether they are any good or not!

Automatic Settings

All digital camcorders, whether they are expensive or cheap, include automatic functions, which are activated as soon as you turn the camcorder's power on. This is where the term **point and shoot** comes from, as these auto settings take control over focus, exposure levels, white balance and shutter speeds. The video-maker therefore has nothing to do but point the camcorder in the direction of the action, and press the big red record button!

While the sophistication of automatic systems has increased, the level of performance can fluctuate, and relying totally on auto pilot often results in footage which, though acceptable, could be so much better. In many cases, the automatic systems simply cannot reproduce the shot you are after. Examples of this include shooting in low light conditions, starting to shoot indoors and then moving outdoors, as well as pull focus shots.

In low light the digital camcorder's circuitry boosts the DV signal in order to add detail to the picture. Therefore, when it is dark or gloomy, the camcorder tries to increase the light. This is often

Far Right:
Automatic white balance becomes a problem when mixing light sources.

Right:
The camcorder will automatically focus on subjects closer to it.

referred to as **gain,** or **gain-up.** Unfortunately, when it is trying to increase detail, the camcorder only promotes picture noise (grain) and the quality of the image degrades.

Capturing the right kind of light is very difficult. Our eyes are sophisticated at reading colour, camcorders are not, and can easily be tripped up by changes in colour. Most of what we see is a result of reflected light, ie not many objects generate their own light (the sun and artificial light being the main "sources"), and therefore the colour of an object is dependent on the colour of the light source and its own physical properties. Indoor artificial lights have a yellow/orange cast, while natural light is blue. Moving from one to the other using a camcorder's auto white balance setting will result in the colour of objects not always being true, as the camcorder boosts the intensity of colours to compensate for the changes in light.

Auto focus systems can also be hindered by rapid movement. If the camcorder does not have a speedy auto focus, then you will be left waiting a fraction of a second longer than necessary for objects to come into focus – this is commonly known as **hunting.** Using auto focus can also create problems when the subject of your shot is not at the front of the frame. Camcorders will generally concentrate focus on the first substantial object they see, leaving the background of the shot out of focus. In most situations, the auto setting will offer a large depth of field, whereby most of the frame is in focus. However, if, for example, you were shooting with railings or a fence in the foreground then it could prove difficult keeping what is in the background of the shot in focus if you relied totally on the auto focus system.

Pull focus is a common technique used in film and video production. It essentially sees the focus change from one object to another within a sequence of footage. It helps concentrate the audience's attention on what is important, and helps to convey a point without recourse to dialogue. Imagine a wine glass in focus at the front of a shot, gradually the glass goes out of focus and the background comes into focus, revealing a character opening a bottle of wine. It would be impossible to create this shot using auto focus.

Manual Focus, Exposure, White Balance and Shutter Speeds

Manual systems allow you to tell the camcorder what you want to see. Initially this might lead to images that are not exactly what you would expect, but once you become au fait with exposure, shutter speeds and white balance, it is possible to get very creative.

Very few digital camcorders lack any manual functions, though many budget models will only include manual focus. Selecting manual focus is usually done by pressing a button on the exterior of the camcorder to engage the mode. The user will then control focus by rotating a manual

Above:
Using auto focus can result in your camera "hunting" for an object to come into focus.

to as the aperture, and is a round hole behind the lens. To restrict light entering the lens when the conditions are too bright it needs to be closed. If the light is too low, then this aperture needs to be opened to make the most of what light there is. The size of the aperture/iris is measured in numbers known as **f stops.**

Domestic DV camcorders will generally have a wide selection of f stops controlled automatically and manually on entry-level and enthusiast models. Having control over these yourself provides much more flexibility for the user.

focus ring around the lens barrel, or a small thumbwheel on the left side, or back, of the camcorder. Manual focus rings are the best system for controlling focus as they are larger and easier to use than thumbwheels, make less noise (which can often be picked up by the camcorder's microphone) and are more sensitive. Unfortunately, it is rare to find focus rings on budget camcorders, they seem to be the preserve of true enthusiast machines. The reasons for using manual focus have been well highlighted in the Automatic Settings section.

Seizing control of white balance, exposure and shutter speeds is predominantly done via a DV camcorder's menu system, though a thumbwheel, or selector dial, is used to control the exposure or shutter speed rate.

Using manual exposure and white balance settings allows the user to compensate for light or dark shooting conditions, and, in the case of white balance, to record colour accurately. To make the best of these features, the user needs to control the amount of light entering the lens. Too much light and the picture will be over exposed, too little and it will be under exposed. The camcorder's iris and shutter speeds are essential to this control. The iris is often referred

As for the shutter, well that is a term picked up from stills photography. The shutter itself is actually an electronically controlled device on camcorders, situated behind the aperture. It opens for a split second to let light through and then closes to block it out. The speed at which it does this is known as **shutter speed.** On domestic DV camcorders the standard shutter speed is 1/50th of a second, but this can be changed with a manual function to speeds in excess of 1/800oth of a second. The benefit of being able to change shutter speeds is seen when you move away from shooting "standard" footage.

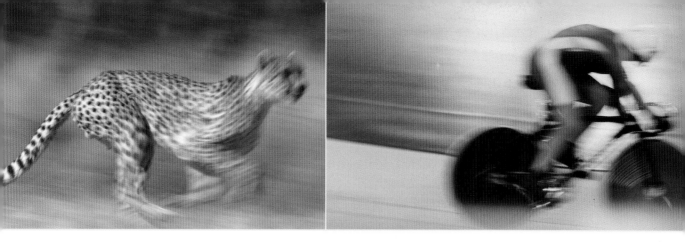

Variable shutter speeds are a must for capturing fast-moving action such as motor sport or football. Using a standard 1/50th shutter speed here will result in blurred footage, still sharp, but blurred.

There is a downside to using higher shutter speeds though. You have altered the amount of light coming through the lens and so you need to be in brightly lit conditions to see the best of it. There is also the problem of jerky footage, as sports footage is often slowed for slow motion replays or blur-free frame-by-frame analysis. Hence camcorder manuals' fondness for pointing out how great high shutter speeds are for improving your tennis serve or golf swing!

Manual white balance might also mean you have to carry a selection of coloured card around with you! Setting white balance manually involves placing the camcorder in the right mode via the menu system, pointing the camcorder at a piece of white card or paper and setting the white balance level. This tells the camcorder what is white -and it then relates the setting of colours to this. However, in order to be more creative, you can "trick" the camcorder by using different shades and colours.

Program AE Modes

Program AE modes are included on all digital camcorders. They are pre-configured auto exposure settings designed to cover the most obvious shooting conditions, such as sports, portrait, landscape, low light, spotlight, sunset, ski and snow.

An easy fix, should your digital camcorder not have too many manual functions, they are either hidden away in the camcorder's menu system or incorporated on a dial on the back, or side, of the camcorder.

Above:
The AE menu provides sports mode to capture fast-moving action.

Below:
On sand or snow, beaches and skis, AE modes help to compensate for extremely bright light.

Thumbwheels, Dial and Selectors

Every camcorder manufacturer has different design criteria, but all make use of thumbwheels, dial and selector switches. The miniaturization of digital technology has meant these controls are smaller than ever before, and can be frustrating to use. Thumbwheels, etc, usually control the selection of program AE modes, focus, exposure and digital picture effects.

TIMECODE

Hidden away in the maze of DV camcorders and their menu systems, writing timecode to your footage is vital for editing purposes because it enables every recorded frame of video to be numbered. A number representing hours, minutes, seconds and frames is recorded to tape. Camcorders record 25 frames per second, so, for example, one frame of video will be timecoded as 00:15:46:02 and the next frame will be 00:15:46:03.

Zoom

Optical and digital zooms are included on all DV camcorders. Optical systems can run up to 25x magnification, while digital can exceed 700x, but the latter will result in image degradation. Zoom controls are always on the exterior of the camcorder and usually take the form of a lever or a rocker, moved to the left or right (in and out).

It is advisable for the zoom to be used sparingly as it does not look attractive or professional in videos. It is better to zoom in on your subject before pressing record.

Right:
To make the best use of the zoom feature zoom in before press the record button.

Recording Button

Usually the big red button on the back of the camcorder and too obvious to miss. Some camcorders have a protective flap across the record button which needs to be flicked back before the camcorder can be switched on and recording can take place. Other models will have a switch or dial that needs to be moved to "On" before the recording button can be pressed.

Image Stabilization

Two systems are available, optical and digital (see Buying the Right Camcorder) and both offer a convenient way of steadying camera shake when you do not have access to a tripod – though this remains the most professional way of achieving smooth footage. Image stabilization can make footage appear jerky. It is located in the camcorder menu system.

Digital and Picture Effects

Competition within the camcorder market has led to an increasing number of digital effects being included on even the most basic digital camcorders. Essentially, these are gimmicky features which are cheap to include and look enticing, but which have limited practical use.

Typical digital effects include: sepia, negative, classic film, strobe, gain-up, trail, solarize, black and white and mosaic. The effect is selected before shooting and then applied to the footage, ie. sepia will add a brownish, old fashioned tinge to the video, negative will reverse colours, solarize enhance colours to give the look of a poster, while mosaic does exactly what it says – and consequently is not used that much!

Hidden away in the menu system, digital picture effects can also include more useful settings such as scene transitions. Fades and wipes can be selected and therefore a scene can be faded in from black or white. Wipes can see the scene start by sliding in from the left, right, top or bottom of the frame.

More advanced digital camcorders in the entry-level and enthusiast sectors allow users to apply digital effects on recorded footage.

Left:
Adding picture effects, such as negative or mosaic, can give your images a completely different spin.

Digital Still Snapshot

Incorporated onto all digital camcorders this is a way of storing still images. A photoshot button is situated on the exterior of the camcorder and when pressed will record a digital snapshot onto either a tape or a multimedia card, if the camcorder supports it. Recording to tape limits the quality to 640 x 480 pixels resolution (VGA quality) and usually sees the snap recorded for around six seconds, with accompanying sound if there is any. Recording to multimedia card can mean improved quality, with more sophisticated enthusiast camcorders offering megapixel picture quality, which is closer to the standard of traditional 35mm film.

It is possible to transfer these image onto a computer via RS232 or USB connections, and again, many camcorders include image manipulation software to "play" with the images once they have been transferred onto a computer. PC software is more readily supplied than Mac software.

Night-shooting Features

Aside from your DV camcorder's ability to shoot in low light conditions, it might also incorporate a near-darkness shooting mode. Sony's system is called NightShot, JVC's NightScope and Panasonic's NightView. Essentially, they all offer the same; recording in very low light conditions. This is beneficial if you are intending to video nocturnal wildlife, use your camcorder as a motion sensor in a security situation, or if you want to get a shot of your child sleeping peacefully at the end of a hectic birthday! Sony and Panasonic's system will provide slightly ghoulish, greenish images, with a white effect on the subject's pupils, but they are generally smooth. JVC's system will provide colour images, but, due to a long exposure time, any movement within the shot will appear blurred.

Below:
Because low light conditions add grain to your images, night shooting features can come to your aid.

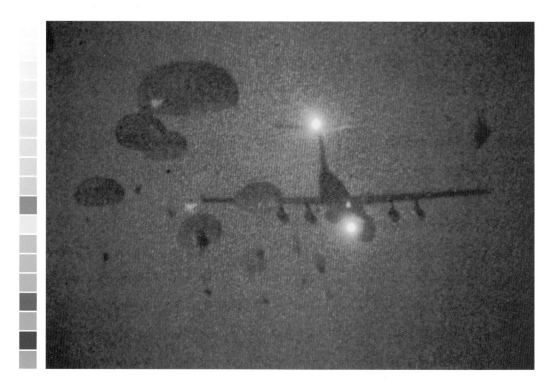

Progressive Scan

Only available on a limited number of camcorders, Progressive Scan offers a way of capturing sharp, blur-free moving and still images. The fields and frames that make up a single camcorder image are de-interlaced. The resulting image is ideal for analysis in a frame-by-frame manner, though moving Progressive Scan footage does exhibit jerky movement. Both Canon and Panasonic make use of Progressive Scan on their digital camcorders.

Basic Camcorder Maintenance

Although you might want this to be the longest section in this book, we *are* sorry to say it is going to be one of the shortest! Camcorders are intricately engineered and we cannot recommend that you attempt any maintenance yourself.

Mini DV camcorders are even more sophisticated than their analogue counterparts, so we would suggest you always seek the advice of a qualified engineer if your camcorder starts to malfunction. There are simply so many things which can go wrong on a digital camcorder it is not worth giving yourself sleepless nights over them. The majority of retailers and dealers will offer some kind of repair service, as will all the camcorder manufacturers, if you contact them directly, while there are also independent engineers you can find through the *Yellow Pages*. It is also useful to remember that the Internet, through newsgroups and message boards, is an excellent resource, and allows you to converse with like-minded individuals. Remember also that tinkering with your DV camcorder invariably invalidates its warranty, so if you do decide to have just a bit of a fiddle, think about the cost of having to buy a new digital camcorder, as opposed to the cost of having one repaired!

Take Precautions

Although tinkering with your DV cam is not recommended, there are several precautions you can take to limit what might go wrong. These range from the obvious to the still-fairly-obvious-but-very-easy-to-forget!

Despite claims that your tiny DV camcorder can fit into your shirt pocket, this is not always the best place for it! Try to ensure you have a heavily padded pouch or case for your camcorder to protect it from bumps and knocks while you are travelling with it. Buy either a lens cloth, or brush, from a camera manufacturer to remove small dust and dirt particles from the lens. The lens is one of the most important parts of your camcorder: help to preserve it.

Above:
A padded bag is a secure way of transporting your valuable equipment.

Left:
Carrying out simple maintenance, such as cleaning the lens, will be allowed in the warranty, but do not tinker with the insides!

If you have been shooting in the rain, even with a rain jacket covering the camcorder, make sure you leave the camcorder to "dry out" at home, before recording or playing back footage. Condensation has proved to be the cause of a large number of faults.

Reading the technical specifications of your digital camcorder (as you do!), you will often see details concerning the camcorder's operating temperature. Manufacturers, to cover themselves, suggest that camcorders should not be used in extreme conditions: hot, cold or damp. However, it is possible to use digital camcorders in these conditions, provided you are careful with them. Make sure you take protective covers and rain jackets where necessary, and try to avoid going quickly from one extreme situation to another.

Perhaps the best precaution you can take with your digital camcorder is to have it insured. Check with your home contents insurance provider to see if your camcorder is covered, needs adding, or requires a separate policy. As with many insurance policies, make sure you read the small print to ensure your camcorder is covered for trips abroad, as well as at home.

A FEW WORDS ABOUT WLDESCREEN

About ten years ago you probably noticed that an increasing number of films were being released on video with a choice of two formats – ordinary or widescreen. Now, despite having become more and more popular over the years, there are still people who, the moment you begin playing a widescreen video, will say: "I hate those black bars on the screen."

Even with the spread of widescreen format televisions, it is still not uncommon to find people who dislike the widescreen look. They may own a widescreen television, but the distinction between pan-and-scan and 16:9 is a stranger to them, and even the first hint of a

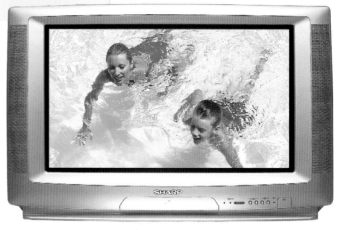

Above and Right: Widening the horizons. New technology in television means that widescreen will soon become the normal viewing medium.

letterbox effect onscreen will provoke a grumpy tirade.

It is incredibly easy to talk people out of this viewpoint, especially with the appropriate visual aids (two TVs, two VCRs, side by side, showing both a widescreen and an ordinary pan-and-scan version of the same film) and quite often you will find that they become fanatical converts to the world of widescreen. First, however, you have to explain what those black bars are, why they are there, and what effect they have on your videomaking.

A Potted History of Widescreen

The trouble all started back in the early days of cinema when the film stock used to make movies had a width to height ratio that made it approximately square. Over the years this aspect ratio changed to more rectangular choices of 2.35:1, 1.85:1 and 1.66:1 ratios that became popular among filmmakers for the extra width in framing it allowed and the consequent "epic" look it enabled. The popularity of these wider ratios (we'll just use 1.85:1 as an example) soon sounded a death knell for the older, narrower Academy ratio, although a few notable films were made in the older ratio even after its

decline had begun (*Seven Samurai,* for example, displays some of the best image composition in cinema history, despite using the narrower Academy format that was already near enough defunct by the time of its 1954 release in Western cinemas).

Meanwhile, as film ratios were widening, another development was in progress – the TV, or idiot box. By fluke of circumstance the mechanics of the cathode ray tube and its electron gun reached a very similar aspect ratio as the squareish academy format. The limitation on the distance from which the electron beam could "paint" its pictures on a television screen meant that a 4:3 aspect ratio became the default for screen ratios on TV sets.

Above and Below: Seven Samurai (above) and Lawrence of Arabia are often praised for their epic scale and brilliant composition, despite their very different Aspect Ratios (1.37:1 and 2.20:1, respectively).

RECEIVING BAND V SIGNALS

Practical Television 1/3
AND TELEVISION TIMES

JULY:1958 EDITOR:F.J.CAMM

Contents
HEATER-CATHODE TUBE SHORTS
ITV IN DIFFICULT AREAS
UNIVERSAL ALIGNMENT METHOD
A 600 Mc/s OSCILLATOR
A CUBICAL AERIAL FOR TV

Modern Television Receiver Design

Consequently, images shot on the wider 1.85:1 ratio of film have had to be panned and scanned in order to bring the most important parts of the cinematic image to the four units high by three units wide television screen.

The pan-and-scan process takes place using a process similar to the telecine process that transfers film to video – an operator pans around the film image to find the most important part of the image and then scans that, creating a 4:3 image and discarding the rest. This has the effect of either losing elements of the original picture composition or forcing multiple pan-and-scans of different areas of the image to be used consecutively, giving a scene that was originally a single shot take the appearance of being composed of several different shots.

This leads to three very annoying side effects – firstly, both a widescreen and a pan-and-scan version of the same film have to be separately assessed by a certification body, causing an extra expense which is invariably passed on to video purchasers; secondly, the intentions of the director and cinematographer *are* lost, as someone separate from the original filmmaking process reframes the shots; and thirdly, it creates people so used to seeing pan-and-scan movies that when the addition of black bars to the TV screen is made in order to recreate the original wider ratio they promptly turn into whingeing ninnies who demand a full screen picture, despite the fact that they will lose a chunk of the film that they are trying to watch.

The black bars that cut down the height of the visible screen area are often referred to as being part of the widescreen aspect ratio, although to be perfectly honest they *are* actually in a ratio, usually, of 16:9, which is a close, but not completely accurate, approximation of the cinema 1.85:1 ratio. Do not knock it, it is so close that it makes no odds, and, in any case, it is miles better than pan-and-scan. (When purchasing videos marked widescreen its often worth checking the aspect ratio on the back – they will often be in 16:9 format, but if you're really lucky many wide-screen videos will actually increase the black bars even further to give you an accurate 1.85:1 ratio.)

Additionally, many broadcasters show their programming in a 14:9 ratio that strikes a balance between the width of the image and the amount of black barring used to letterbox the screen into a wider ratio. Most of these broadcasters will only accept footage in a 16:9 ratio, so be warned that 4:3 footage will either require much post-production work or risk being considered redundant.

WIDESCREEN VIDEOMAKERS

So where does this mess of ratios leave video-makers who are working with camcorders that default to a 4:3 ratio despite the encroachment of widescreen TVs into the market? Not in too bad a position, actually. There are several ways of tackling the issue, all of which have their pros and cons that can provoke a stimulated debate between fans of one process or another. It is simply a question of deciding how you wish to go about things.

Should you decide to shoot in 4:3 then no problem, you are ready to go. Should you want to use 4:3 but *are* worried that you might want 16:9 later, take heart, as long as you frame your shots with the 16:9 ratio in mind it is possible to ARC (aspect ratio convert) your footage later, either at a post-production house who will do it for you, or by searching out and downloading an ARC plug in for your computer's Non Linear Editing software and then letting your poor computer spend several hours rendering the footage into a new format.

The problem of covering your back in this way is that around 25 per cent of your footage is being thrown way in post production as your image is scaled to a wider, less tall format. This means not only having to run the risk that a slight error in framing may render your footage useless, but also, according to some, that it will suffer a drop in quality by wasting the image processing resources of your camcorder on footage that will be discarded rather than by applying the full bandwidth to the important stuff.

There are, of course, other options available to those who want to achieve 16:9 footage. Starting with the camcorder itself, look at the instruction manual and look for either 16:9 or Cinema Mode under the list of digital effects.

The image chip (or chips) in most digital camcorders is already 4:3, but the digital effects can go some way towards creating a 16:9 appearance.

Below:
A wider presentation can help your storytelling; big pictures often speak for themselves.

Unfortunately, there is no standardization for the names of digital effects, which means that you will have to read through the manual in order to discover whether your camcorder's "Cinema" effect is a widescreen shooting tool or simply an imitator.

Cinema usually refers to an effect that places black bars on your footage in order to create a 16:9 look. This is the poor man's widescreen and, although interesting, is of no real benefit to someone interested in true 16:9.

Should your cam actually have a true 16:9 function, it will take one of two forms. The first is an inbuilt ARC capability that will adjust your 4:3 footage to 16:9. If your cam has this function it should also provide you with some sort of visual guide to aid your widescreen framing within a square viewfinder. If it does not then a pair of carefully placed strips of gaffer tape and a lot of cautious composition should be applied.

The other 16:9 option sometimes found on camcorders involves the actual de-activation of pixels at the top and bottom of the CCD in order to create a 16:9 ratio in the remaining pixels. This is both a blessing and a curse – on the positive side you will be capturing a 16:9 image, on the negative side you will be starting with a lower pixel count and consequently running the risk of losing detail.

The final practical option for obtaining 16:9 images is the anamorphic lens. If you look at the front of your camcorder you will notice a thread on the inside of the lens barrel – this can be used for many things, including the matte boxes, slide adapters and, most importantly for this chapter, an anamorphic lens (sometimes an anamorphic lens will require the addition of a supporting bracket, or a stepping ring, to overcome disparate thread diameters between the lens and the lens barrel). This is probably the most expen-

Above: An anamorphic lens, which can be attached to your camcorder.

sive method of capturing a shot in 16:9 (short of actually buying a broadcast camcorder equipped with widescreen image sensors), but it is also the one which provokes the least debate.

The only real drawback to using an anamorphic lens is that it will slightly cut down the zoom and focus ranges of your camcorder. Seeing as how zooms during shooting tend to be distracting and hideously amateurish, this is not too much of a problem: you will only be using the zoom for pre-shot framing and the old rule will apply – if your subject is too far away then move the camera closer. The same thing applies to focus: you will have taken care of it before starting your shot and will have worked around any minor problems using methods to be explained later in this section. Put simply, the drawbacks of an anamorphic lens will only catch you out if you let them; pre-planning will mean that they are not a problem at all.

Any problems that do occur will be at the widest angle setting, so a minor zoom should solve the problem and remove the possibility of the anamorphic lens cutting off (vignetting) part of the image. Vignetting also tends to occur more

with larger depths of field, so a little playing with your cam settings may solve the problem – depth of field can be reduced by increasing the aperture size and adjusting the shutter speed to compensate for the increased amount of light hitting the CCD.

The anamorphic lens (A-Lens) is similar to a traditional wide angle lens, but with one important difference: whereas a wide-angle lens will both widen and heighten your view (and transfer both width and height back to the CCD) an A-Lens only increases the viewing width, expanding the width ratio without affecting the picture height. These new, wider images are then squeezed onto the CCD of the cam ready for later viewing.

Most widescreen television sets, and many VCRs, will happily deal with the anamorphic lens recordings automatically, and although some 4:3 sets will produce a distorted image when trying to deal with anamorphic footage, many modern ones will have a setting that adjusts the available picture area of the screen in order to deal with the new footage.

Some compatibility issues may arise when sending anamorphic footage to an NLE system, but many of the more advanced systems, although unable to recognize the difference between 4:3 and anamorphic automatically, will have a selectable project setting intended for dealing with exactly this type of footage. Once again, there are always third-party plug-ins available should your NLE system need a helping hand.

Widescreen footage is both visually impressive and, in many cases, a prerequisite for being broadcastable. Daunting though it may be for videomakers to try adjusting their 4:3 consumer cams to the 16:9 ratio, it is always worth the effort. Play around with a few of the different options available and we guarantee that you will be pleased with the wider look.

Anamorphic lenses can overcome the narrow Aspect Ratio of a camcorder's image chip.

3

Skills

SKILLS

COMPOSITION

Proper composition is an invaluable aid to videomaking, and should be regarded as much a tool as a tripod or video light.

Careful thought about the layout of your shot, what will be in it and where it will be, can make an incredible difference both to the look of your film and to the feelings your images convey.

If composition was not vital, then Orson Welles would never have ripped up the floorboards to get a worm's eye camera angle on Charles Kane, communicating the man's imposing presence in a way that renders dialogue unnecessary.

As if composition was not important enough as a storytelling tool, then it is worth remembering that badly composed shots can ruin a good film – it may seem like a good joke to position

someone so that the trees in the back-ground appear to be sprouting from your subject's scalp, but in fact it is little more than a bad pun, at best a distraction and at worst an amateurish mistake.

Fortunately, there are rules and guidelines you can follow in order to create well-composed shots. For a dramatic videographer telling a fictional story, there will be time to plan shots with these rules in mind, for a documentary maker capturing video on-the-fly, good composition will not always be possible. The rules, however, will become second nature very quickly, and even if pushed a good videographer will be able to apply them instinctively. Of course, once you have this much grasp of the rules you can begin trying creatively to break them!

Think Ahead

Early planning is helpful both for avoiding common composition mistakes and for getting the best out of your location – it is vital to know what you want to shoot in order to make sure you shoot it correctly. Having established a list of things you wish to commit to tape, you can work out where you will position the cam for a "safety" or master shot and figure out what other shots you will need and what they are supposed to accomplish.

Knowing what your shot is intended to convey will

Below:
Good composition is one of the many reasons why Citizen Kane is hailed as one of the greatest and most influential films ever made.

help you plan its composition – there is no point having a shot in your finished work that is simply there because you had it on tape. Knowing that the subject of a shot needs to appear menacing, or dynamic, or serene will help you work out how the shot must be composed.

When you get to your location, try to see the shot the way your camcorder will: look for unlit objects, size discrepancies, obstructive items of scenery, things that are eyecatchingly bright and just about anything that will call unwanted attention to itself. Items like this are an inconvenience only if they go unnoticed until you have already shot. If you check things out beforehand you can turn annoyances into advantages – the obstructive branch right in the middle of the frame can be turned into useful foreground interest with a quick repositioning of the camcorder.

Rule of Thirds

Having disposed of, utilized or worked around potential trouble-spots, you can begin compos-

ing the shot with the camera. The most important guideline in composition is the rule of thirds, a guide that constantly comes in handy by making your shots look well balanced via the odd method of deliberately putting them together along unbalanced lines.

The most important item in any shot does not necessarily have to be at the centre of the frame, in fact, short of attempting to dominate an entire shot, it is generally best to avoid placing your subject dead centre as it will prevent your viewer from being able to relate anything else in the shot to the actual subject.

Imagine a shot of a landscape with the horizon falling dead centre across the screen -are you supposed to be paying attention to the land or to the sky? Instead, try to allocate two thirds of a frame to one part of the shot and the other third to the remainder. Imagine the screen divided into thirds across the horizontal and vertical in a grid – the intersections of these gridlines are usually the best place to position your subject.

Using the rule of thirds, composition will provide a natural-looking asymmetry to your footage rather than a staged and arranged look. Additionally, it serves to draw the viewers attention to where it needs to be whilst allowing the subject, foreground and background to complement, rather than compete with, each other.

Perspective and Points of View

Another point to keep in mind when filming is the nature of the medium – there is no point filming the three-dimensional real world and expecting it to have depth when played back on your 2D TV screen – you have to create the depth yourself.

Perspective problems can easily be solved with a little thought about camera placement. Extra depth or better perspective can be added to a shot simply by engineering it so as to avoid common pitfalls and make use of the available space.

Think of a tall skyscraper – a common mistake is to film it head on. It is an understandable error: filling the screen with the subject seems like a good way of conveying the building's scale and presence. Unfortunately, you will find that, rather than dominating the shot, the undynamic presentation of the building will make it appear little more imposing than a pile of bricks.

To make the scale of the building more apparent you should drag your camera to one of its corners and shoot from there – automatically adding a vanishing point to your shot as the facade of the building recedes into the distance and allowing other items into the shot to give a sense of relative sizes.

Another trick using the example of a building is to place your camera near the foot of the building and shoot upwards. The change of angle will allow the building to loom overhead and with careful framing you will get a natural border of sky which will start off narrow and

Right and Opposite: A dramatic camera angle and a bit of foreground interest make these shots much more dramatic than a simple head-on perspective could.

widen as distance "shrinks" the building – the dwindling upper floors of the building combined with the expanding frame of sky will impart the size of the building effectively, and the more dramatic the effect the more visual representation of size you will get.

Looming buildings are just an example, of course. These rules can be applied to pretty much anything. People, however, may object to having their double chins in shot as you crouch at their feet shooting upwards, and shooting from the side may make them uncomfortable, especially in drama, where actors have to appear ignorant of the camera's presence -they know you are there, they know you are doing something, but they are not allowed to look. Not knowing what is going may cause self-conscious subjects to cast sidelong glances at your cam. That is not to say you cannot shoot people using these methods, but it may be better to experiment with other methods, especially if your sub-

jects are saying or doing things that will not be picked up from low or diagonal angles.

Adding foreground interest is a good way of adding perspective to a picture where clever camera angles cannot be used. Simply relocate the camera to incorporate a naturally occurring object in the foreground or add a prop to accomplish the same effect. This has the added advantage of allowing you, if necessary, to drag the viewer's attention from object to subject by opening up the depth of field or doing a quick focus pull.

If you can't find a suitable foreground object for some reason (say there is nothing, or what is available would be too distracting) then try moving your subject to somewhere that provides a naturally occurring frame. This way you can add interest and a sense of scale to your shot without having any distractions in the foreground. Doorways, bridges, a corridor of trees, all of these will naturally frame your subject, drawing attention to the relevant part of the image in a pleasing, but non-distracting, way.

The naturally occurring frame has another bonus to it should you want to play cute with your footage – it allows you to manipulate contrast levels within the picture. An internal shot of a doorway can provide a dark border to a sun-lit street, whilst an external shot through a doorway into a darkened interior can add a touch of menace to an image.

Natural frames also provide another way of messing with your audience's perceptions, albeit in a risky fashion. Say, for example, you have a distant building and you frame it through the legs of a stone seat – with careful planning the shot can look as if it has been taken through a massive archway rather than through a narrow space – meaning that objects appearing in the mid-ground between frame and subject will appear to be out of proportion with their surroundings. This sort of gimmick can add novelty value to your shots but should be handled carefully – the line between amusing trick and terribly misjudged shot is a thin one, and one that is easily crossed.

Speaking of crossing lines, do not. This is another rule as fundamental as the rule of thirds. Say for example you have two people talking to each other, one on the left of the screen, the other on the right. Imagine a line drawn between them – should you shoot from one side of the line and then shoot from the opposite side your subjects will appear to have swapped sides despite not having moved. This will be noticed by your audience and will instantly shatter their illusions. Either pick a side and stick to it, shoot the conversation using "over-the-shoulder" shots or carefully combine the two using the shot of both subjects as a safety and over-the-shoulder shots as inserts.

Not crossing the line in a simple, two-person shot is fairly simple, but becomes more complicated when extra people are added. Think of the diner scene in *Reservoir Dogs,* or the post-trial pub gathering in *Trainspotting*. Both scenes are fairly minor in terms of their importance to the overall story, but try watching those films with a

Left:
When filming a conversation, make sure you don't "cross the line".

people will speak their lines and where your camera will be placed for the very first shot. That is the point where the first of many "lines" will be established and the place you have to build the rest of the scene from. Draw a diagram of the scene to plan things out. If you are filming from the head of a table and are starting with a conversation between two people opposite each other before

Above:
The risk of "crossing the line" is greatly increased during crowded conversation scenes.

gaggle of film buffs and those scenes will invariably draw comment for the way they handle conversations between large groups of people without accidentally crossing the line in an attempt to get the relevant speakers in shot.

Careful planning of group shots can be a subtle way of drawing appreciative comment from savvy fans, but it is also a minefield for the unwary and requires meticulous planning to get it right. Think about where your speakers and addressees are sitting, the order in which different

moving on to a conversation between people side by side, you will have to move your camera to the opposite side of the table, to avoid having one subject obscured by another. This is where you might cross the line. There is no way around these risks apart from painstaking shot planning. Even with pre-planning make sure you have a safety take and inserts ready so that any disaster with your bravura crowd scene can be rescued in the edit suite by substituting a more conventional approach to group conversations.

Right:
Working out a shot diagram based on the order of dialogue in your script can help avoid mistakes.

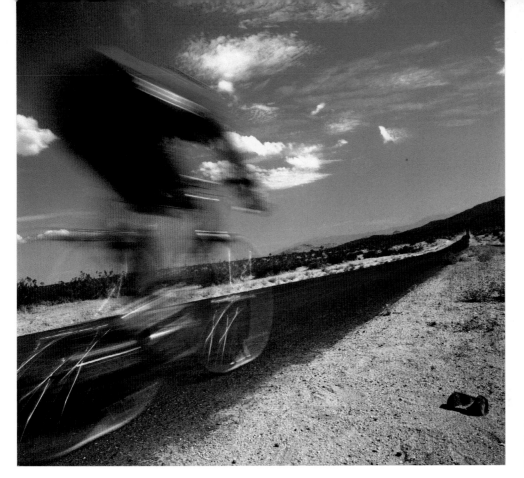

Left:
Moving subjects
will need space to
move into.

Movement

Moving objects also require careful composition, mainly to avoid glaring mistakes that will upset your audiences ability to immerse themselves in your drama or distract them from the points you are trying to make in a documentary.

Always allow for both moving and looking room within your shots – we have all been annoyed by a bad mime act doing a naff "walking-against-the-wind" performance. That is the effect you will achieve if you don't allow room in your shots for events to happen. If you are panning or dollying alongside a walking person or moving car then allow them room to move into. A car moving from left to right across the screen should be framed with space to its right and this space should be kept until the point when the camera movement stops, allowing the car to move naturally out of shot. Should you fail to allow enough room the car will run into the edge of the screen and the sideways movement of the camera will look as if it is being "pushed" by the car. Rule of thirds can be used to great effect here – line up a right-moving object on the left-hand thirds and you will avoid the push effect and will not appear as though you are struggling to keep pace with the subject.

Try to avoid too many cuts in a shot featuring moving subjects – allowing a subject to progress partway across the screen and then cutting to a later shot where the movement is even more advanced will provide a noticeable and annoying jump in the action, a jump cut. Should a movement be taking too long to complete try fading slowly between cuts to truncate the shot in a much more artistic and less jarring fashion.

Moving room also applies to slower shots such as someone walking toward the camera –

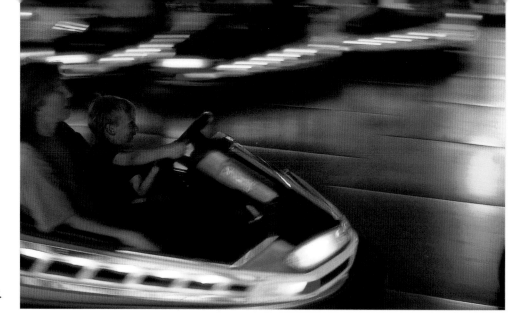

if you fail to allow space between their feet and the bottom of the screen they will appear to be walking on thin air – make sure they have some foreground to walk into.

Slower movements require even more careful composition. A simple left to right framing of a moving object is fine for conveying that object's speed, but something that moves more slowly will lack dynamism as it moves flatly across the scene without any change in perspective. Try using a diagonal composition – a person enters a room at the top left and moves diagonally to exit bottom right, allowing them to grow in stature as they approach the camera and giving your audience the chance to examine the subject head on.

Unnecessary Amputations

Speaking of heads, remember to allow headroom for people in shots. Be it an immaculate £300 haircut or the mullet from hell you have no business cutting off people's hair. Frame headshots with a noticeable gap between the top of someone's head and the top of the image to avoid an amateurish mistake. Alternatively, should you be going for a big close up on a subject's face that makes some loss of the subject inevitable, then try to cut off a significant amount, making the close up much larger and ensuring that any loss of the subject is clearly deliberate.

The rule of thirds makes itself useful here yet again – the most important part of any headshot is usually the eyes – place them on the uppermost line of your rule of thirds grid and you will have a well-balanced and natural-looking image without chopping off the head or the other alternative of leaving too much headroom and causing your subject to look pint-sized.

Similarly, try to avoid shots that cut people off across naturally occurring joints, a person framed with the bottom of the image cutting off across their waist will look like they have had a nasty accident. Try to make the edges of your image fall across limbs partway between joints - cut off at mid-thigh rather than at the knees, for example.

Weightings are another important part of composition, and a very subtle part at that. All items and locations have different effects on the eye, and these effects can be assessed and exploited. Warm colours, such as red and orange, will attract the viewer's eye more effectively than colder blues and whites. The placing

of objects also carries a certain weight – pick up an advertising directory and check out the most expensive areas of a page you can buy – you will soon notice that top right-hand spots are the most coveted and highly priced because the eye naturally tends to fall in that location. This rule is less true with a moving screen image than a static page, but it still applies to a certain extent, and should be kept in mind.

Most rules of composition are there for one of two reasons – to add a dramatic visual element to your story, or to avoid a visual trick that will disrupt your audience's ability to suspend disbelief. Like all rules in videomaking, there are times when the rules can be broken to good effect, but it takes an experienced eye to know when to do so. In general, it is better to be safe than sorry, so if you are going to break the rules then make sure you know what rules you are breaking and why before you risk throwing away a perfectly good scene for the sake of some experimental framing that may not pay off. Imitation is good, but you are better safe than shoddy!

Above:
This toddler my be very upset at his parent's recent decapitation! Frame your shots carefully.

Colour can affect the "warmth" of a shot and the feeling it conveys to the viewer. Compare the warm reds in a desert (above) and cold blues and whites in this glacial scene (right).

Shooting

It is odd to think that when creating a film, a visual story, that your visuals are, to a certain extent, subordinate to a separate part of the process, but it is true. Everything you shoot should have the edit in mind.

That is not to say that what you record on tape is just raw material for the editor. Far from it, getting good shots is what camerawork is all about. There are many elements that constitute a good shot and sometimes even an experienced camera operator will forget, in the heat of composition and framing, that one of those elements is editing.

The footage you pass to your editor should not only provide the excellent visuals needed to tell your story, they should also provide the editor with the elements he or she needs to practise their craft artistically. Your script only outlines the plot and dialogue, your storyboard only establishes certain shots. The gaps missed by the script and storyboard are where the editor works his or her magic with the footage you provide. Watch any scene in a film and you will see that it is composed of numerous shots, from numerous angles, with various cutaways or inserts to cover them. Work out the average shot length for a scene and you will see how many short shots a scene is composed from.

A skilled editor will put this collection of shots together in such a subtle fashion that the audience will not notice them as the scene unfolds. It is your job as camera operator to provide the raw materials for this.

On a simple level, this means that the bundles of tapes you hand over should contain more than just the shots marked out in the storyboard. If you are using expensive film it can be extremely nerve wracking trying to balance the cost against the amount of coverage you think you will need, but this is DV, and it is

Left:
Warning: cigarettes can seriously damage your continuity. Drifting smoke and changing cigarette lengths can be the bane of editing.

cheap. If you want to make sure your editor has options then use more tape. As long as you exercise enough self control, do not deluge your editor or force your cast and crew through millions of unnecessary takes, you cannot go wrong. Try to keep in mind three things:

1: Get a master shot. Say you have a conversation that is going to unfold through various two shots of the actors and a selection of cutaways. You could just do the various camera setups needed to capture the elements of the scenes, but this would be very short sighted.

Anything that goes wrong with the lighting, the continuity or the tape could render vital footage unusable. If you have a master take of the whole scene either as a long or medium, depending on how much framing is needed, then your editor always has something to fall back on. If the worst comes to the worst, it is even possible to use the entire master with some generic cutaways. Having a master shot covers your back.

2: Motivation. Your editor is not cutting blindly, randomly deciding to curtail shot 1 here and go to shot 2 there. In general, every shot change needs to have a motivation in order to look natural. We are not necessarily talking about a big dramatic moment or movement, we are talking about a simple thing. Imagine that a character is shown in medium profile and you wish to cut to a close up of his face. You could just get the two shots and let your editor to cut them together, but that would merely be two rather static shots joined together. Instead, try to capture the images up to a point that provides a logical reason to cut from one shot to the next. It could be a simple as a flicker of the eyes, a noise from offscreen or something more

elaborate such as the lighting of a cigarette. In any case you need some moment that will not overpower the content of the shot, but will be noticeable enough to provide a reason to cut.

3: Advancement. Advancement is simple. In the same way that each scene of your film advances the plot or adds subtle shadings to characterization, each shot should offer the same advancement to the scene it is contained within. You are not simply adding shots in order to keep the scene from being static and boring, you are adding them in order to enhance the scene itself. If you have a character smoking a cigarette, are they taking deep satisfying drags or short, quick nervous ones? Do they neatly tap their ash into the ashtray or are they insolently staining the carpet? You do not want to use shots so blatantly that they telegraph their meaning, but at the same time think about the way in which each shot is telling the miniature story of that scene. Think how the person in shot is to be portrayed and make sure that the shots you take capture the essence of this so that your editor can visually build the scene from a natural start to a natural finish in accordance with the overt meanings of the screenplay.

Shot Types

As a film/documentary maker you are already a visual person and can see pictures in your head of how you want things to look. You will have used these pictures to create your storyboard and amend your script. This is all very well when you are merely clarifying things for yourself, but sooner or later you have to explain what you want to the crew, so it is important to get an idea of the definitions of the shots and the forms they take so that you are not saying: "Two guys head to head, we cannot see below their

The distance and framing of a shot can be the difference between an image that sets a scene, such as those on the far left, and an image that provides important detail, such as those on the near left.

necks, but their faces are really angry and we are over here not over there" when what you actually want to be saying is: "A big close up profile two shot."

There are various terms used to describe the type, angle and content of the shot and you can combine them in any number of ways, for example H/A XLS, which would be a high angle extra long shot. Terms can also be combined with movements of your pan and tilt head or dolly. Below is an outline of the most commonly used shot types, their meaning and their abbreviations used in shot planning, storyboard and shooting script. We will assume, for the sake of simplicity, that the subject of all these shots is a person and that the compositional rules for head and foot room have been properly taken into account.

Extreme Long Shot (ELS): The person is so far in the distance that they are only just recognizable as a figure, with no discernible detail.

Very Long Shot (VLS): The subject is now close enough to take up approximately half the height of the screen from head to toe. You can probably make out a few more details such as clothes and gender and maybe, if the subject is familiar, identity.

Long Shot (LS): From head to toe the person now takes up almost the full height of the screen with the exception of the head and foot room that is left available as part of the composition.

Medium Long Shot (MLS): The subject is now framed so that they are cut off just below the knees. They are recognizable and their activities are discernible.

Medium Shot (MS): Now framed from just below the waist upward, the person is close enough to fully convey moods and the fine details of activity without having to "play to the balcony".

Extreme Long Shot (ELS)

Very Long Shot (VLS)

Long Shot (LS)

aMedium Long Shot (MLS)

Medium Shot (MS)

aaMedium Close Up (MCU)

Close Up (CU)

Big Close Up (BCU)

Extreme Close Up (ECU)

¾ Profile

Profile 2 Shot, Close (P2SC)

SHOT TYPES

Medium Close Up (MCU): Framed from the chest up, the actions carried out by the character are most likely lost out of shot, but their expression is fully readable and they have begun to dominate the shot.

Close Up (CU): Framed from the tops of the shoulder upwards, the audience is now on very intimate terms with the subject, picking up a massive range of facial expression and possibly feeling intimidated, attracted etc, according to the portrayal of the character.

Big Close Up (BCU): The subject is now totally dominating the screen, framed from chin to hairline. Simple movements and expressions now begin to seem exaggerated and the effect is good for conveying powerful emotions.

Extreme Close Up (ECU): Now framed from just below the nose to just above the eyebrows. This shot should only be used in carefully selected circumstances as the slightest flicker of the eyes is incredibly exaggerated. Can powerfully convey emotions or simple dominance of surroundings, but is equally likely to descend into unwanted parody.

Profile: This is a shot taken from the side of the subject rather than head on.

$^3/_4$ Profile: This a very naturalistic shot taken from a point approximately three-quarters of the way around the 90 degree angle between head on and profile. Especially useful for conveying depth or creating the impression that the subject is paying attention to something unseen offscreen.

The Two Shot (2S): This implies that there are two people in the frame and is used in three different ways. The most common is the over-the-shoulder-2s which is used in conversation, usually with a roughly three-quarter profile to take in the back and side of the nearer person facing away from the cam with the other person next to them but further away. The other variations are the profile two shot, which features the two people

directly facing each other, and the camera off at the side capturing a profile. Remember not to cross the line when using this. Finally there is the to-camera-two-shot, used if you have to people speaking directly to camera placed side by side and shot head on. Remember that variations in height and... ahem... weight can make these types of shots look comedic if composed improperly. If all else fails, bite the bullet and get the shorter person to stand on a box.

Lastly you have your multitude of camera angles, all of which can essentially be reduced to variations of extremity on the following:

High Angle (H/A): Looking down from just above head height.

Low Angle (L/A): Looking up from just below shoulder height.

Bird's Eye: Looking straight down from above.

Worm's Eye: Looking up from floor level.

You do not really need to quote an angle if the shot takes place at a level approximating that which you get from your own eyeballs, but it is worth remembering subtle variations such as **Point Of View** (POV) shots, which are from a normal height, but generally include movement and rhythm to create the illusion that they are views from a character's eye rather than the camera, and fly-on-the-wall, which is really a term for an overall style, but is occasionally used to imply a high angle wide shot from just below ceiling level.

Profile 2 shots can be used to show people in their surroundings (above) or, conversely, isolate them (left).

The movies *Se7en* (1995, Right). *Vanilla Sky* (2001, Below), and *Black Narcissus* (1947, Below Right), all make dramatic and innovative use of lighting.

LIGHTING

It is so easy to forget, amid all the technical innovation of digital, that light is one of a video-maker's most powerful tools. Used with care and consideration it can raise the quality of a video production.

Light alters an audience's perception of a scene, whether that be in a fiction video, documentary or an interview situation. Even in holiday or wedding videos, light can be used to suggest different moods and feelings.

Learning about light and lighting is worth a book in itself. That is why any self-respecting TV or film features a lighting cameraman in its credits, whose sole job it is to create the mood and lighting effects the director wants. On large productions you will often see the term **Director of Photography** (DoP) or **Cinematographer;** these are creative people who work with a director to shape the way a film or TV show looks. The best way to understand what a DoP does is to turn yourself into a part-time Media Studies student and just watch lots of movies and videos!

There are many famous DoPs and Cinematographers, among them Jack Cardiff *(Black Narcissus)*, Darius Khondji *(Se7en)*, Roger Deakins (Coen Brothers movies including *The Man Who Wasn' t There* and *Fargo)* and John Toll *(The Thin Red Line, Vanilla Sky)* who paint with light to help ensure the movies retain their silver screen magic. However, they also help

push the boundaries of what we see on film, as working with special effects teams they can create highly stylised environments for films such as *Blade Runner* or *Moulin Rouge,* or even *Saving Private Ryan* (where cinematographer Janusz Kaminski removed the protective coating

from the camera lens to help provide a bleached out, more realistic look for the film).

Lighting is not only the preserve of these masters of the art; lighting design can be achieved on the most modest of budgets and by the least experienced videomaker. What follows is a little taster of how . . .

Light Sources

As mentioned earlier in this book, there are only two forms of light source – natural and artificial. However, there are a myriad of choices for lighting within these two forms and getting the right one, or the correct blend of lighting, is where the skill part (or you could call it trial and error) comes in.

To achieve a realistic, well-balanced lighting design for your video, you first need to ensure your digital camcorder knows what colour light actually is, in order for it to assume that light is white. You do this by setting the white balance – sadly, for those of you without this feature on your DV camcorder, you will have to rely on the auto white balance system.

A knowledge of colour temperature is also handy when you are working with light, as you

Left:
Learn to use light and light sources for practical and artistic purposes.

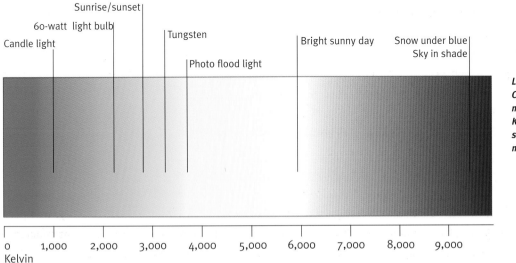

Left:
Colour temperature is measured in degrees Kelvin (°K). This diagram shows some typical measurements,

There are only two light sources: natural and artificial. Difficulties for videomakers occur when the two are mixed

will discover there is a natural order to the sources we use. Colour temperature is measured in degrees Kelvin (°K), and to give you an idea, a candle is measured at around 1,900°K, a light bulb at 2,500°K, normal daylight at 5,500°K and a bright sunlit sky at 10,000°K. Unfortunately for videomakers these sources do not keep to themselves and will often appear together within your camcorder's viewfinder, causing you production problems. Mixed lighting, as it is known, is apparent when you stand by a window in the office, while the office lighting is on. Therefore the "blue" state of natural light is being mixed with the orange/red of artificial light. Depending on how you have the camcorder's white balance set up, you will get a mixture of accurate and inaccurate colours. Having it set up for daylight will leave the outside light correctly balanced, but will leave the interior shots with over-saturated colours in the orange/red spectrum. Set up for indoor light, and though the office will be balanced correctly, any sign of the outside world will have a distinctly blue cast. Your options for relief here involve filter sheets. You can either cover the window with orange/red filtering sheets and balance the camcorder for artificial light, or perhaps choose to cover the artificial lights with a blue filter and go for a daylight white balance on your camcorder.

While colour temperature is measured in °K, and light output is measured in lumens, illumination is measured in lux. Another glance at your digital camcorder manual will highlight the minimum lux (illumination) figure your model will operate at. This is only a guide figure; be warned, the lower the illumination the more grain (noise) you will see on the picture – and hence one of the main reasons to use lighting.

One lux is actually the amount of light falling on an area, one metre square, one metre from the

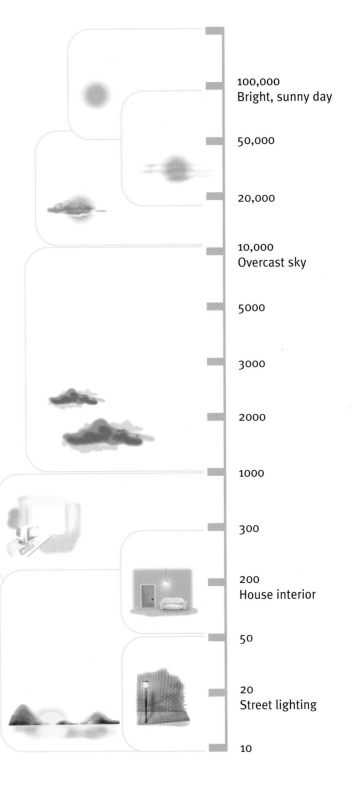

LUX LEVEL CHART

100,000
Bright, sunny day

50,000

20,000

10,000
Overcast sky

5000

3000

2000

1000

300

200
House interior

50

20
Street lighting

10

Above:
Barn doors around a light make its beam more directional.

corder's own battery pack. Either way these lights provide little flexibility and their output is harsh and lacks directionality.

Much better are the second and third options. Handheld lights are far more powerful, can be run from the mains or a battery system, and can be positioned wherever they are needed. Provided, of course, that you have an extra crew member on hand to hold them!

Stand mounted lights are invariably available in packs: a selection of two or three lights is offered, stands are included, and you might also get a diffuser or reflector for your troubles as well. Very similar to the lights used in professional productions, stand-mounted lights use mains power and offer the most versatility in lighting designs.

Within these second and third categories of lights we will find a diverse selection of illumination to cover all the most obvious lighting scenarios.

source of one lumen. In practice, the inside of a house is no more than 200 lux, an overcast sky no more than 10,000 lux, while a bright sunny day will register at around 100,000 lux.

Types of Light

So far we have only dealt with light sources around us, daylight and the artificial lights that surround us, office and home lights, street lights etc. The whole shooting match only gets more complicated as the videomaker introduces his or her own lighting system. Film and TV productions will usually employ a sophisticated array of lights, or **luminaires** as they are sometimes known, while the amateur videomaker realistically has three choices of light: on-camcorder; handheld; or stand mounted.

On-camcorder lights can either be built-in to the camcorder or attached via an accessory shoe. Power is supplied by a battery (in some cases) which fits into the light, or from the cam-

Floodlight, Spotlight and Soft Lights

Two terms have been devised to describe the width of the beam provided by lights: floodlight and spotlight. The first provides a wider angle, sometimes up to 90°, but generally around 60°. Spotlight is a far narrower beam, typically being around 20 to 30°.

In looking at these two terms, it is important to know the role that distance plays with light. Floodlights are usually placed closer to the subject

or area, because light intensity diminishes with distance. Spotlights, due to their narrower beam, can direct light over a greater distance.

By far the most common light is the focusing reflector, though you will more normally hear it referred to as a **redhead.** Redheads are powerful lights that can be used both as floodlights and spotlights, courtesy of their directional beam. Even with its capacity as a floodlight, the red-head is often used as a key light, the main ingredient in any set-up, as it provides shape and texture. This is to allow another type, a softlight, to be used. Softlights provide an overall level of light for a scene and also help to fill-in the shadows which are created by floodlights and spotlights.

Other specific types of light used in more professional situations, typically a studio set-up, include beam, sealed-beam and eye lights.

Single Point Lighting

For many amateur productions this is going to be the "norm" situation. Simply using one light to lift the gloom and illuminate the subject/ subjects. However, do not be fooled into thinking there is not any flexibility in this scenario because there is.

It has often been suggested that an ideal starting point for this system is for us to imagine where the light in the scene is coming from. Depending on what you are shooting, try and establish from where natural or artificial

Left:
Stand-mounted lights offer more power and versatility.

light would shine onto your subject. You have options here: it could come from above, or to the side of the subject, or it could even come from directly in front of them. What you have to decide is whether the shadows cast by the light look right or wrong. Study your subject, if you have a

Left:
Hand-held lights are useful when time is at a premium.

LIGHTING

Left: Two-point lighting: This will achieve a natural look.

Below:
Two examples of single point lighting with the main light source coming from a different angle, one behind the camera, and one to the left.

Above:
Three point lighting.

Left and Below:
Placing your main light
source at different heights
reduces or increases
the length of shadows.

monitor hooked up, look at it. Do you want the shadows to appear where they are? Feel free to move the light around, and if you have the capability, vary the beam to give less harsh shadows.

In lighting design the terms **hard light** and **soft light** are used to make the distinction between different types of shadow. If you can think that sunshine provides a harsh, abrasive light with very defined shadows, while a cloudy sky will provide shadows which are softer and more diffused. Decide which of the two suits your video the best and implement that one.

Two Point Lighting

With a second lamp in your set-up you do not have to pay as much attention to the harsh shadows that might be created by a single point shoot. Your first light can now be positioned to provide a hard light, or as it is now referred to, your **key light** and is adding both shape and texture. This new second light is known as a **fill light** and is now providing a softer tone to the scene.

With the key light only, the camcorder will not be able to make out any detail from the shaded parts of our scene, but once we have added the fill light, these areas will become illuminated. However, because fill light is soft light, we will not be contradicting the shadow thrown by the key light.

Although lighting has very few set rules, and precious little right or wrong approaches – this is art we are talking about here, if it works for you, then it is the right thing to do – it is generally accepted that a fill light will be placed on the opposite side to the key light.

Three Point Lighting

Making your lighting set-up a trio, means finding another name for this new light, and that is **back light.** It is placed behind the subject, and shines towards the camcorder, in

order that your subject stands out from the background. This is especially important if your subject is wearing dark colours against a dark background, as camcorders do not distinguish between shades of black!

It is possible to use either a hard or soft light, as a backlight as you should not see the shadows it creates.

Accessories

In their professional capacity, a lighting camera-man/woman will have a massive bag of tricks for subtly shading and emphasizing light. With all the accessories and apparel a videomaker already has, it is unlikely you will be able to match them. However, it is worth knowing a few bits and pieces.

Barn Doors

A frame of four metal flaps which fit around a light, barn doors can be fitted to spotlights or floodlights to restrict the beam size.

Gels and Filters

Just like digital camcorders, lights can use filters to change their colour. There is a wide range of coloured gels, as they are called, which come in rolls and are cut to fit into a frame that slots in front of the light. It is possible to get them in solid colours, or for more subtle shading and texture, pastel and graduated gels are available.

Scrims

A screen placed in front of the light to reduce its intensity, but without altering its colour temperature.

Snoots

These are like barn doors, only conical in shape rather than square. Snoots are only usually fit-ted to spotlights so that they can restrict the diameter of the beam. Snoots are available in a range of sizes, and allow the user to shine small circles of light toward a subject to highlight cer-tain areas.

Learn a few basic rules about light and shadow and you will be able to achieve the desired result whatever the scene you are shooting.

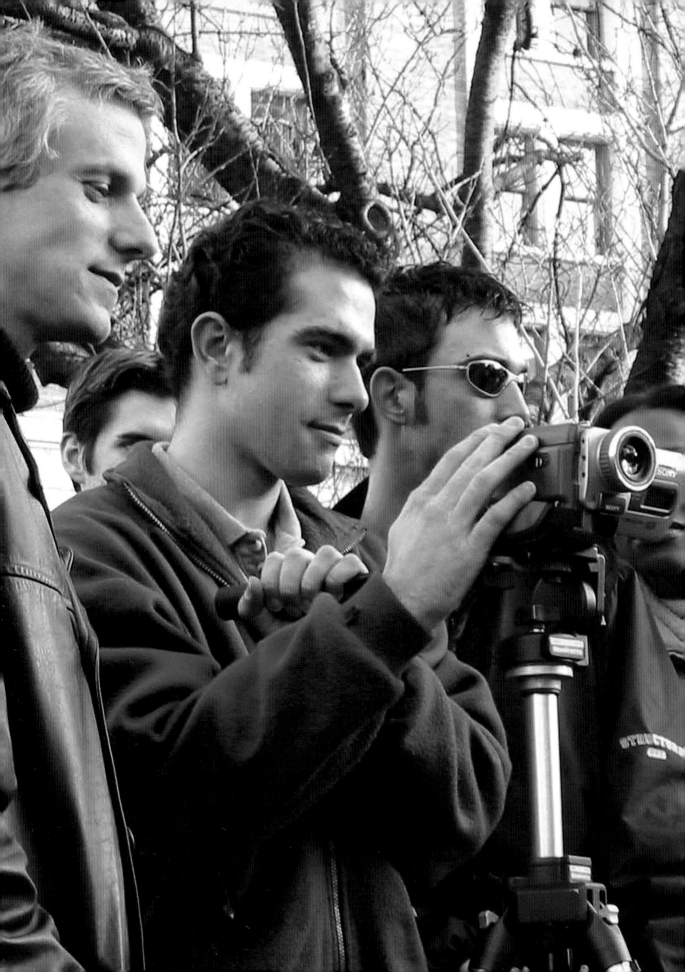

4

Production Time

Production Time

PUTTING A CREW TOGETHER

Ask any TV or production company what digital technology has done for them, and you will get a mixed response. While digital video has liberated videomakers to a point where the number of people needed to make a production can sometimes be just one, this naturally has caused "downsizing" within the media industry. News crews reporting on location can often consist of a cameraman and a reporter, or in some cases just a reporter who operates the camera by remote.

For videomakers this set of circumstances shows the power of digital videomaking over its analogue past, as it has reduced the division between "them and us", between the pros and the amateurs. Digital Video has also redefined the term **broadcast quality.** Having an entire production crew milling around a location, especially with documentaries and reality TV shows, often diminishes the responses of the protagonists. In fact, it is possible to record people even with the smallest digital camcorders without them registering that they are being recorded. Digital Video is good enough to be seen on TV (and increasingly cinema) screens, and now what matters most is the content and the context of the programme.

The image and sound quality of DV is as high as its ease of use factor. And, with the affordability of computer – based editing it is possible to complete the picture by cutting your video, and then distributing it on digital video tape, VHS, DVD, Video CD or via the Internet.

Not surprisingly, this has caused many video-makers to turn into one man bands, working on their own to produce a variety of video content. However, to think that you have to work "on your tod" as a digital videomaker is missing both the point and the benefit of working with a crew. As we have mentioned, context is everything and if you are planning to shoot any complicated production, such as a fiction film (heck, even if you are shooting a wedding) it is nice to

Right:
The boom in
reality television is due,
at least in part, to
the quality of modern
digital video camcorders.

have someone checking you are actually recording the sound while you are concentrating on the visuals. However, crew members can also be a contradiction, so remember that while it is helpful to have extra eyes, ears and hands, it is also other people to manage . . . and feed! Try to tailor the number of crew you need to the scale of the production. Crew members do not have to do just one job.

You're the boss

Since you are the one reading this book, we are going to assume that you are the head honcho, top banana, so to speak, and it is your little baby we are filming. You become the director and, unless you really want someone else to do the lens work, you are the camera operator as well. It is easy to get caught up with just the images, so you want a member of crew to look after sound. OK, meet your sound recordist. It is their job to monitor the sound levels, to check that the sound is not booming away from the microphone and distorting the audio. They need to ensure that dialogue is recorded cleanly, because it is unlikely on an amateur production that you will get a shot at dialogue replacement – even with the sophistication of computer editing. You can simply allocate the sound recordist a set of headphones, plug them into the camcorder, and ask them to check the sound, or you can double up, and, if you are using a microphone on a boom, ask them to hold the boom. This ensures they are more involved and can actually have an effect on the sound being laid down.

Next up, and getting a little more professional here, we have the lighting technician (or assistant). As you might have seen in the previous chapter, lighting can be a complicated business and a lighting tech can lift that burden from you. They will be in charge of positioning the

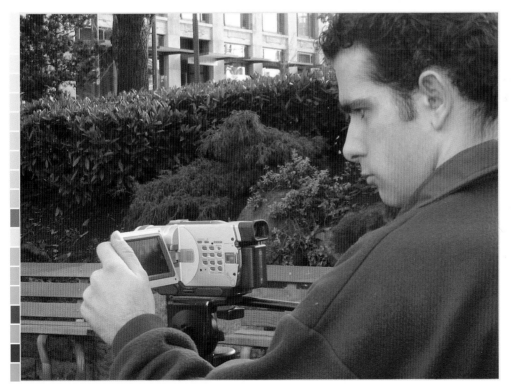

Left:
It helps to ensure that all you need is in place before you start to shoot a scene.

lights as well as suggesting what gels it might be useful to use. A lighting tech also has a responsibility for safety. Lights can get very, very hot, and also have an alarming tendency to explode, and no inexperienced crew members should be allowed to move or touch them without the lighting tech's say-so.

Continuity might sound like a luxury from a film set, but it is a useful function and if performed correctly can save you having to re-shoot scenes, or entire sequences. Essentially, continuity ensures an actor is wearing the correct clothes for each shot, that their hairstyle has not changed, that their make-up remains consistent and that the cigarette they *are* smoking in the scene does not get longer and shorter as you do new takes or shots! With so much going on it is easy to forget that your lead actor was wearing jeans in the scene you shot yesterday, but today is wearing suit trousers. The two scenes, shot on separate days, can easily be meant to be next to each other in your edit. Little things like cigarettes,

or the eating of food might cause nightmares in post production as you spot the differences in scenes. Continuity should also check the actors *are* speaking the right parts of dialogue and can prevent you from "crossing the line" by shooting a sequence from the wrong side.

For some of your crew you will have to be creative in supplying titles. Production Assistant sounds so much more professional than gopher, though essentially that is what this role is. You might want them to use the clapperboard – they will like that – but they *are* also useful for supplying sustenance. Having a crew means having

to feed people, and good work does not often come from a malnourished crew. You will probably be working long hours and you want everyone with you, not against you.

For the bigger, and finer, things in life you might want to employ a Producer. Although in most low-budget DV productions the "videomaker" would probably take this role, if you can find someone to produce, it can free the "artist" in you to concentrate purely on the creative side. A Producer ensures budgets are met, assuming that there is a budget to start with. They can liaise with other crew members and can diffuse tricky situations, can smooth the use of a location with "the authorities" whilst also being on hand at a later date to take some of the credit for your successful production!

Crew Checklist

Meet your crew, and find out what they do!

Producer: often "The Big Cheese" but, more appropriately on low-budget productions, finds cash, actors, food, equipment and solves problems.

Director: shouts "Action!", bosses everyone around. Remember, it is their vision you are re-creating.

Camcorder Operator: helps set up shots, tells Director if take is a good one, provides vision.

Sound Recordist/Monitor: checks sound levels and quality of recorded sound, wears headphones, can be deafened very easily.

Lighting Assistant: helps create mood of video with lighting design, turns on and positions lights!

Continuity: checks if you are crossing the line, ensures actors are wearing the right apparel and speaking the right lines, location is free from period clashes, takes photos.

Production Assistant: real title = gopher; gets tape, batteries and tea, on occasion gets to hold clapperboard.

Left:
Being prepared for the filming location is vital.

PLAN AHEAD

Embarking on a shoot is a risky business. It is the point in your production when you become irrevocably committed to spending serious money and time on your video, and you do not want things to start going wrong. You need to have dealt with every possible problem before going on a shoot, because once you are kitted up and on location, or in a studio, you are spending money every second you are there and do not want to be wasting time on anything that is not vital.

Sorting out a checklist before starting the shoot is the best way of avoiding time consuming mistakes, and it also helps you decide which people you can delegate jobs to. Equipment, for example, should be the priority of its respective departments. Camera operators and sound crews should know that they are expected to provide batteries, tapes, DATs etc, albeit at your expense. Production assistants or runners should be dealing with the elements of the shoot that are there to keep people happy and safe, as opposed to ending up on screen: food, first aid kits, etc.

Before you delegate anything, however, you need to be aware of what tasks and requirements you have, as well as working out things that are necessary for the shoot. Below is a selection of common pitfalls and handy hints that will help things go smoothly.

Make sure you have permission to shoot in your particular locations and make sure it is not just permission from some chap who happened to be passing through at the time. If you are shooting at a factory, for example, it may not be enough simply to have permission from the owner. The shift manager may have concerns about the potential workflow disruption you may cause; the security staff may be worried about having so many strangers on site; the health and safety officer may not be keen on having cables gaffer-taped all over the place. All these people can throw a perfectly justifiable

Right:
Shooting on location is great, but make sure you are safe, legal and well prepared.

spanner in the works. If you cannot get in touch with all of them, at least make sure that whoever you have spoken to has checked things with them and get copies of your permission in writing to prove you are allowed to shoot where you say you *are*.

When doing your reconnoitre do not just be thinking about the actual composition of your shots, make sure you keep an eye out for practical details as well. Are the power points conveniently located and suitable for your equipment or will you be running cables all over the place? If so, take gaffer tape to secure cables to the floor. (In fact, take gaffer tape everywhere, it is incredibly useful stuff.) Is there any annoying background noise that will mess up your soundtrack? Are certain areas particularly busy and likely to pose continuity problems? Forewarned is forearmed.

Think about your shooting ratio and adjust it according to specific situations. There is no point planning a 6:1 ratio (six minutes of shooting for every minute that reaches the screen) for easily controllable studio shots, and you definitely do not want to allow yourself a 3:1 ratio for a location shoot where any number of unscheduled occurrences can take you over the number of tapes you had planned to shoot. This is a digital video, its cheap, so burn tape as much as you like when in the field and make up for any extravagances by being more conservative with your safer shots – inserts, studio shoots, etc.

Plan your shots and setups carefully. Never be chronological with your shooting order and setups unless that is the most practical method, which it rarely is. If scene one is in a dining room, scene two in a bedroom and scene three back in the dining room, then film scenes one and three back-to-back before moving all your kit. Similarly, if a scene is composed of several

Left: Top to Bottom: Stately homes and railway stations will have safety and security concerns, and you should show consideration whenever you are shooting in public.

shots from different angles, take the similarly angled shots back-to-back rather than constantly lugging tripods and camcorders backwards and forwards across the set.

Draw a storyboard from your script that shows the action as it will be onscreen, then draw a bird's eye diagram of each set or location and mark out where you will need to set up to get the shots on your storyboard. Then go through the script, with the diagram to hand, noting scene and shot numbers next to their respective shot locations until you have clusters of numbers scattered around your diagram. This way you can break the whole thing down into fewer repeated setups and also check to make sure you will not be crossing the line with certain shots.

If you are doing this, you will find that the contents of your DV tapes are hopelessly garbled and in totally the wrong order, but that is OK, clapperboards are for more than just synchronizing sound. If you are recording a separate, off camera soundtrack (and we hope you are – it gives much better results) then you will already have a clapperboard that will allow you to sync the audio from mini disc or DAT to the video. On this clapper board, log the scene, shot and take number and when it comes to editing time, you will find that your unsequential recordings are no more inconvenient to work with than those shot in linear fashion.

Having worked out your shot list, move on to a call list. If you are shooting scenes 2, 8 and 15, for example, at a certain location on a certain

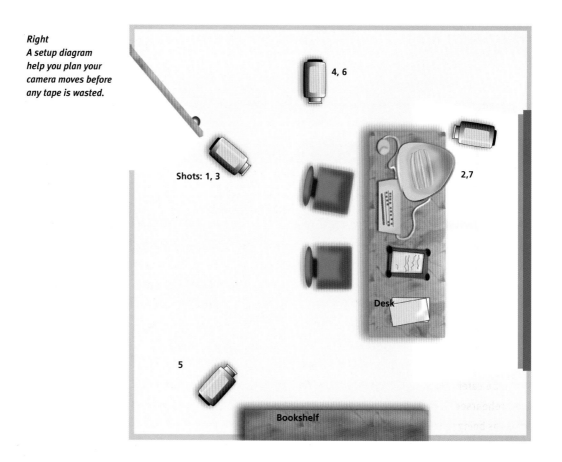

Right
A setup diagram help you plan your camera moves before any tape is wasted.

day, then make sure everyone who needs to be there will be and no one who need not be there ends up wasting a day on site. List the scenes, the locations and addresses, the cast and crew members required to be there, the equipment needed (there is no point dragging 20 feet of dolly track to a location that will only feature in static shots), etc. Distribute this list to all cast and crew and make sure they know when and where they are supposed to be and how to get there. Add an appendix to this list showing alternate locations for certain days in case it rains at one of your external locations and you want to avoid downtime by substituting an alternative.

When timetabling your shoot consult with those in the know. If your gaffer says it will take two hours to set up the lights for a specific shot then there is no point planning to finish that shot and move on in one hour. Remember to schedule in a little leeway for errors, consultations, discussions and such-like (but not too much leeway – you have to stay in control of the time and money being spent on the shoot).

Another thing to allow for in the schedule are last-minute onset rehearsals, be it for nervous interview subjects or amnesiac actors. Again, be careful how much time you allow. An over rehearsed interview subject will come across as being too practised and boring, and an actor can lose the vibrant edge of their perform-

ance if they have been through it too many times. Equally, do not be to stingy with rehearsal times – no one should have to appear on camera if they feel totally uncomfortable doing so. It is a question of getting to know your people and figuring out when they need the practice and when they are just nervously procrastinating.

Remember to allocate time for lunch. Most of your cast and crew are probably working cheap or for free and it is not a lot to ask that they at least be fed. Even if your budget is too tight to run to onsite catering, make (or get the runner to make) a couple of big flasks of tea and coffee and a selection of sandwiches and snacks.

Lastly, bring cash and cheque books. You may think you have everything you need, but you never know when you will need to improvise. On one shoot, several years ago, we had the embarrassing experience of having to use all our petty cash to bribe away local urchins – too young to be given a fat lip, but old enough to carry out their threats of pinching a few cameras. The only solution, in this particular case, was bribery, which worked a treat.

We are not suggesting that you specifically budget for backhanders, but it illustrates the point that you never know what might crop up during a shoot.

Act like a boy scout – be prepared.

*Left:
Storyboarding lets you plan your images in advance.*

5

Shooting Situations

Shooting Situations

There are a million and one reasons why you'll find yourself pressing the big red record button but of those, the main situations are likely to be: fiction, documentary, interviews, weddings and holidays. Many of the same shooting principles apply to these scenarios but there are techniques within each discipline which are useful to know.

Below:
Holidays are often the first shooting situation you will find yourself in.

Everyone armed with a camcorder can make holiday videos, because it's the easiest form of videomaking – virtually everyone takes at least one holiday a year and it ostensibly requires you just to point and shoot – to record your holiday memories. However, if you want to get the best out of digital video then every time you press the record button you need to have thought about what and how you are shooting. Even if you just want to make a record of your holiday, giving some consideration to the images you take will ensure you have a video more than one or two of you will want to watch!

Fiction Finding

We thought we'd start with the most ambitious project videomakers can tackle – the fiction video. This can be in short form (under 15-20 minutes) or a full-on feature-length production, but the same basic rules apply.

You might ask, "Why would I want to make a fiction video? surely my digital camcorder's just for recording the odd event?" They are good questions. The answers are that by dealing in fiction you are doing something different and having to think about video in a multitude of ways. It will involve working with actors, directing action, working with a script- and perhaps best of all means you can shout "Action!" . . . and mean it.

Getting Prepared

If you decide to embark on shooting a fiction video you will need to be organized. So where to start? Well as we've looked at scripting and storyboards in a previous chapters we'll head there first. Before you shoot a single sequence

you need to have an idea, and then you need to have a story. You then need to map out what you need to shoot this story, in terms of equipment, crew and actors. It's simply no use starting a project without a list of everything you are going to use.

Questions you need to ask are:

• **Do I need more than one camcorder?** A second camcorder gives you options for recording the same scene from different angles which might prove useful when editing. You also need to consider what accessories you will need: tripod, micro-

phone, headphones, tapes, batteries, charger, rainjacket/camcorder protection?

• **How many crew members do I need, and where can I get them?**

• **Do I want trained actors or will my friends do it for a laugh?** Tricky one this as your friends might not be able to act, might not be capable of meeting your demands, and might not be your friends after the shoot!

• **Will I need lighting?** If you do then what sort: on camera, handheld or stand mounted?

• **Which locations will I be using?** And have I got permission to film there?

• **What costumes and props do I need?** Where will I get them, and, if this is a period piece what do I need to remember to remove from view? Digital watches, television aerials, cars and planes were not that evident in Victorian Britain!

• **How will I shoot any action sequences I want?** And who will be doing the stunts?

Answering these questions will give you an insight into how complicated (or not) your production is going to be.

Left:
Using more than one camcorder will help you to cover action scenes comprehensively, as in 1955's Rebel Without a Cause.

Don't Lose the Plot

Once you've assembled your equipment, script and actors it's best to embark on a period of rehearsal. Doing this enables the actors to familiarize themselves with the character they are playing. Hopefully they will have done some research into how they (or you) want them to play the role, but you could also ask them to think of a "back story" for the person they are playing. This is information not in the script, and not necessarily relating to the story, but it enables the actors to understand where their character comes from, and why they react the way they do to certain situations. It can include where they come from, what their family background is, what jobs they have done and what relationships they have had. In acting terms this is often known as the method approach, and while many actors simply want to turn up and say their lines, it's useful encouraging them to think just a little about the person they are playing.

Rehearsal also helps actors familiarize themselves with their lines. This might seem a little trite, but it's surprising how many performers turn up on location barely on nodding terms with what they *are* supposed to say. If you choose to use your friends in your video then this might easily be the case. There is a way around the problem of not knowing your lines – and no we don't mean firing the actor – and it's known as an idiot board. You simply write down the lines in big text on a piece of card and have someone hold the card out of sight of the camcorder but close enough for the actors to refer to!

The low cost of digital tape, and the unobtrusive design of digital camcorders should also allow you to record the rehearsals. This will give you an opportunity to see if the dialogue that's been written works, and sounds realistic, when

Right:
Professional touches, using a clapperboard and numbering your scenes and takes, will help in post-production.

Left:
*Rehearsing scenes
shows you what does
and does not work.*

spoken. It also gives videomakers the opportunity to block out sequence, such as where an actor stands and then moves to, within a scene, along with giving the videomaker a chance to try out different shot angles.

With rehearsal over, and any adjustments to the scripts and storyboards made, it's time to move to the "in production" stage of your video. You should have a shot list ready along with your shooting schedule. You should have checked the actors and crew can make the times you've stipulated. Try to ensure you don't have to zip back and forth between locations, shooting scenes out of sequence but which need to be shot in the same location, and try to be realistic about how many scenes and how much footage you can shoot each day. Professional productions often have very long shooting days, often from 5.00 am to after 9.00 or 10.00 pm, but if you are not paying your crew or actors, or even if you're using

your friends try not to subject them to Kubrick and Hitchcock-esque demands. Get to a location early, and along with your crew set up so that everything is prepared before the actors arrive. Check sound levels, light levels and make sure you're not getting in anybody's way, and most important of all, definitely, most absolutely, make sure everyone involved in the production gets some food.

Recording Contract

One of the real secrets to success in making a fiction video is to think ahead. When you're shooting you should also be thinking about editing. So, don't just yell, "Action!" and start recording. Take a few tips from the professionals, it will mean recording more footage than you'll use but will cut down the amount of time spent in the edit suite, while also ensuring you don't go prematurely grey or lose your hair! In film pro-

duction, cameras take time to come up to speed, starting the action before the camera achieves "speed" could mean you don't get the shot you want. This is a good policy to adopt. Start the camcorder recording, the director shouts "Rolling!", get the clapperboard holder to mark the scene (calling out, "Scene one, Take one," etc), then shout, "Action!", have someone count down – five, four, three, two, one – using their fingers to indicate to the actors. Five to three should be spoken as well, to give the sound recordist an idea of sound levels, while two and one should be silent and indicated by fingers only. Each scene should be allowed to overrun for around five seconds before the Director calls, "Cut!" Using this checklist you not only know what scene and take you've recorded and are looking at when in the edit suite, but also you provide correct sound levels and give the actors the opportunity to do something unexpected at the end of a scene, that you might want to keep. At the end of a day's shooting try to look at what you've recorded. In film speak these are known as rushes. Digital video has an advantage

Right:
Action scenes are the
centrepiece of many
movies, but they can
seriously damage the
budget if something
went badly wrong.

even just be shooting a sequence in a quiet park, yet you can still intrude on the public.

Action sequences serve several purposes, they make your video more dramatic, increase its tension, atmosphere and pace. The secret here is coverage. In a film or video events don't have to take place in real time – a 10-minute race doesn't need 10 minutes on screen. A mixture of shots will serve your purpose better and make it easier for you to edit a sequence together. Change camera positions regularly, and make sure each shot is significantly different to the previous one. A good tip is to change shot size, starting with a. master shot to establish the situation and then move from mid range shots to close ups and occasionally back to a master shot so the viewer doesn't lose track of what is going on.

Professional productions will employ a stunt man or stunt team to carry out the complicated action sequences, but it's unlikely a low budget amateur production will be able to afford their services. The safety of your entire crew should be paramount so any action sequences should be well choreographed and rehearsed. Again, the range of camera angles can provide the dynamics for you.

Car chases are going to be pretty much out of the question on low budget videos because of the danger involved, but they are possible if you have permission to film in deserted locations well away from main roads and thoroughfares. Accessories manufacturers have a selection of car clamps and suction mounts that will allow you to fasten your (very expensive) digital camcorder to a vehicle, allowing you to get fast moving action, as well as close ups and interior shots.

over film here, in that film has to be processed before the rushes can be viewed, but digital video footage can be viewed immediately. If you want, a scene can be checked as soon as it has been recorded.

Action Stations

Finally it's worth mentioning action sequences. Even the most pedestrian of stories will require action at some point. It could just be a character running down the street, or falling to the ground after a punch-up. Be wary of anything that could go wrong and injure the actor, the crew or anybody on or near the location. This is especially pertinent if you've adopted the guerilla video-making tactic of not gaining permission to shoot on location, and simply turn up and try to get everything on tape before you're moved on. Imagine you decide to get some shots of a character running down London's Oxford Street. The number of people affected by your presence could run into thousands. Be careful. You could

INTERVIEWS

In the commercial world, the interview is proba-
bly the most common set-up a jobbing camera
operator is likely to experience. It doesn't matter
if it's a current affairs show, documentary for
broadcast, an image film, or product demo. The
chances are that somewhere you'll have a
talking head. As an amateur, an interview can
convey information "straight from the horse's
mouth", and is sometimes the only way to
explain a subject without resorting to expensive
travel, graphics or stock footage. Interviews fall
into two categories, single camera and multi-
camera shoots.

Let's start with the most basic, single camera
interview. It is possible to conduct the interview,
operate the camera and adjust the sound all at
the same time, but something will be lacking. I
guarantee it. Either the technical side will be
less than perfect or the subject will notice that
they're not getting your full and undivided
attention and will not perform their best in front
of the camera. Make no mistake, what you're
doing here is recording a performance, albeit an
unscripted one and your "talent" needs as much
attention as the most demanding actor. If you're
the director then sit down in position and talk to
the interviewee whilst the camera operator sets
the lights and the sound recordist fumbles with
cables and microphones. If you're the camera
person then give the interviewee a warning
before zapping them with 800 watts of light. Oh
and don't say "I'm going to switch this light on",

Right:
The "standard portrait"
lighting set up is
the basis of nearly
every situation.

as you turn on the juice because it's guaranteed that phrase will get the talent looking straight at the unit and consequently blinded for the next five minutes! A good phrase is "Cover your eyes . . . light coming on".

Single Life

For the majority of single camera interviews, a lighting set-up known as "standard portrait" or three-point lighting will provide more than satisfactory results. It's the basis of just about every lighting occasion and once you know how to set it, you can start adjusting and playing with it, expanding your possibilities, secure in the knowledge that if it all goes pear shaped you can quickly bung up a portrait rig without any problem.

If you've got a light meter then use it! Especially in studio or indoor situations where you've got to balance different sources. You might be able to see the features of someone sitting in front of a window and your viewfinder might even seem to show that it's within acceptable limits but beware. The viewfinder shows what the camera chip sees, not what levels the tape records and there can be quite a difference between the two. A good light meter will dispel any doubts you might have and make you look like you really know what you're doing.

A couple of hints about interviews. Firstly, make sure that the camcorder can see both of the "victim's" eyes. Profiles tend to lack intimacy and give the impression that the subject is talking to someone way off on the sidelines. If the interviewee keeps turning away from the camera then get the reporter close (and I mean close) to the lens axis. The other annoyance is an interviewee who keeps looking at the camera. This is easily sorted by placing a "reporter light" on top of the camera lens such that it blinds the subject if he looks at it. Cruel, I know, but at least it stops them looking down the tube.

Wherever possible have the camera lens on the same level as the subject's eyes. Place the camera above their eye level and they tend to look weak and vulnerable, below their eye level implies arrogance and dominance. Some subjects have deep set eyes or heavy eyebrows which throw a shadow onto the eyeballs. Eyes which don't have any highlights or reflections look "dead" and need a bit of help to bring them to life. We've mentioned using an on-camera light to stop subjects looking at the lens, well this is also the cure for pothole eyes. Sometimes the talent will have greasy skin, sweat slightly or simply have the sort of complexion which bounces light like a bowling ball. There are two solutions, one involves small, barely noticeable adjustments to the lights. The other way is to buy a powder compact. A bit of powder on a sweaty brow saves ages messing around with lights and reflectors.

There's a broadcasting mantra which goes "Zoom during the question, not the answer"

Left:
An example of the "over-the-shoulder 2 shot".

Above:
Two cameras are useful when the interviewer and interviewee are of different heights.

which is worthy of noting. Like all advice, it's not written in stone and a slow zoom in during a long answer can look really good, especially if the zoom creeps in with a barely perceptible movement. Don't overuse this effect though. Save it for a poignant answer. If it doesn't fit, then save it for another occasion.

Trick and Treat

You can "trick" a single camera set up into a multi-camera shoot by recording the reporter's questions separately and then adding them in the editing. It's best to record these after the interview because (a) the reporter knows the questions he or she has actually asked; and (b) the interviewee is already on tape and can't prepare or rehearse answers.

At this stage the main errors to avoid *are,* the reporter looking in the same direction as the interviewee and the eyelines conflicting. If the subject is recorded looking towards frame left, then the questioner should look frame right

(and vice versa). Be careful with this technique, it can very easily go wrong and look awful and obviously fake.

Occasionally you'll be asked to record an interview or meeting with more than one camera. This is the sort of challenge which video-makers should be searching high and low for. It's a great opportunity to put a team together and attempt a more complex job. Allow plenty of time to prepare the location and light the set. The same portrait lighting can be deployed on each subject and, with a bit of thought, some lights can be used for more than one purpose. If you're recording a discussion on a stage or hall with a public present, be aware that if you want shots of the public, you'll need to light them as well, without blinding them such that they can't see those taking part!

When directing a multi-camera interview try and get the cameras to vary their shots between close ups, mid shots and long shots with the emphasis on the close ups. Also try to make use

of the "over shoulder 2 shot" to show both the subjects in relationship to each other. If you are using more than two cameras, then it's a good policy to keep one camera just for the presenter so that you've always got a shot you can cut to. Finally, when you are editing, follow your feelings rather than the rules. If the cut looks and feels wrong, it is wrong. Try to avoid cutting long shot to long shot and – whatever you do –maintain a sense of humour. Multi-camera jobs are all about teamwork and co-operation.

HOLIDAYS

Without doubt the most common use for a camcorder, aside from "home movies" (we're not being tasteless it's actually true) is to record a document of your annual holiday. Now there is one big problem associated with this, and we're sure almost everyone has experienced it. The daunting invite to just pop round and see a friend's holiday video has seen the demise of more than a few friendships! Sitting through a

Below:
Holidays are without doubt the most popular videos shot by camcorder owners.

Above and Below: Make holiday videos more visually interesting by looking for some striking images.

TWO TRIBES

There *are* two distinct approaches to shooting a holiday video. One is a relaxed, carefree style, grabbing a few choice images but not taking your digital camcorder with you everywhere. The second is a full on, "this is a trip of a lifetime, not to be missed, pack everything" approach. And which one you pick depends on the trip you take.

You can, unquestionably, bring back a decent holiday record by just taking your camcorder and the odd accessory with you. On the other hand if you don't view videomaking as a chore, and see it as an integral part of your expedition, then you can choose to take a careful requisitioned amount of equipment.

Let's start with the first option. Before you travel group together all your equipment and then piece by piece discard the stuff you know in your heart of hearts you won't use. You should be left with a digital camcorder, a couple of tapes, a spare battery, a mains charger (with the appropriate adaptor for the country you're travelling to) and maybe a couple of filters. Two tapes, probably around two hours' worth,

couple of hours of badly shot, boring holiday video is more than any reasonable person should have to bear, and what's so frustrating is that it doesn't have to be this way.

The ideal holiday video should be a taster, illustrating the outstanding moments from what was a relaxing or invigorating trip. Every shot has to earn its right in your production and only then will you be able to invite the neighbours round.

should be more than enough raw material for any two-week vacation, because you're going to be shooting wisely. Filters aren't essential, so weigh up the practicalities of taking them. However, a plain skylight filter might be useful as it protects the lens from potential problems such as sand and grit.

So what you're leaving behind is a tripod, because you can use walls, posts, fences, anything as a form of stabilization, headphones – remember it's a holiday video not a film set, and believe us you don't want the unnecessary attention, lights and a microphone. You can do all that you need with the basics and some imagination.

Be Creative

Unless something jaw-droppingly exciting is happening, never press the record button until you've thought of an idea. Ideas are the saviour for holiday videomakers – and the poor souls you inflict your video on – as they can transform a dull situation into a truly entertaining specta-

cle. As you travel to your destination try and note down some ideas of what you'd really like to capture, and when it's feasible to actually go and video it. A travel guide book is useful here, allowing you to pinpoint tourist attractions and the off-the-beaten-track locations you might want to capture.

Don't start filming as soon as you get to your location, instead spend time getting a feel for your destination. If there's any chance of revisiting the location before your return journey, then go back once you've worked out what to do. Friends and family can go and enjoy a relaxing coffee or unexpected shopping expedition, while you quickly nab the shots you've been pondering over for the last couple of days. They'll thank you more for that than for keeping them somewhere longer than necessary, while you dash around hoping you've got enough material.

Not everywhere you venture will have a laissez-faire attitude to filming so find out where and when you can film. For example the streets

Right:
If filming familiar sights,
at least try to look for
interesting angles.

Opposite:
Lens glare is usually to
be avoided, but, in the
right circumstances,
can add texture to
your shots.

of New York and Los Angeles might seem like a permanent film set but you might be asked by police to stop filming, purely because you don't have a permit. Strange, but true. It's not only foreign outdoor locations that could create filming problems, museums and galleries can have strict anti-video/photography policy, so be careful here as well.

Short and sweet

The most common videomaking mistake, especially on holiday videos, is the length of time each shot lasts. You don't have to stay on the same shot for several minutes to take everything in. The human eye processes information very quickly and your viewers want to be entertained, not bored. Keep shot lengths short, anything more than five or six seconds for a shot, when nobody is talking, is too long. Also be keen to embrace a variety of angles. Don't just put the camcorder to your eye and press record, that way all your shots will invariably be at the same height. Try mixing low and high angle shots, as well as including a variety of long, medium and close up shots. And remember if you want to be closer to a subject, move closer to it, don't hit that zoom button during recording. You can use the zoom for close-ups, of course, just make sure you do it before you start recording. Ensure you also find the time to shoot some cutaways to use as fill between shots and sequences. When it comes to editing, cutaways can be an absolute godsend in covering up mistakes or shots that don't last as long as you want them to.

Travelling light also lets the videomaker make use of the beauty of digital camcorders –their size. Digital camcorders provide an opportunity for unobtrusive filming. You can take them along to most locations and shoot away without the public realizing what you're doing.

Right:
Sunsets can be dramatic subjects and need no explanations.

Light and Shade

Below:
The camcorder can bring back holiday memories more vividly than photos.

If you are on a sun-kissed holiday then there are a couple of situations you should take into consideration. Light is very different all over the world, but wherever you get harsh sunshine your camcorder is not going to like it. If you can move to manual exposure and stop down to reduce the amount of light entering the lens, otherwise you'll have a holiday video that looks more bleached than your hair. If you don't have manual exposure try and move to a program AE settings, such as sand and snow specifically designed for bright light, and if you don't have that, then try an AE setting which reduces the exposure to at least some degree. Natural light reflects and this in itself can cause a problem with lens glare, you don't want natural sunlight rebounding into the lens, as it can damage the camcorders lens and circuitry.

Images as beautiful as they might be require a decent soundtrack to complement them, so be sure to think about whether you want to add music or narration at a later date. If you do then you'll have to put the camcorder in its 12-bit PCM stereo mode, so you can audio dub at a later date. If you don't intend to add anything then put the camcorder in its 16-bit PCM stereo mode to ensure the sound you record is the best it can be.

And once you are back home again, please give some serious thought to editing your holiday video. Even if you have been judicious with the amount of footage you've shot, you will still have more than you need (or should have!). Spending some time separating the wheat from the chaff will make for a truly watchable video.

Finally remember to take a break from your camcorder . . . it's a holiday after all!

Excess Baggage

Alright so much for the easy option what about the videomaker who wants everything. Well, you'll be pleased to know that although you'll be taking more equipment the advice is more to the point than option one!

The same rules on shot lengths, angles, permission, exposure, sound and editing still apply but the planning stage is a little more involved. If you have decided to make shooting a video a central theme of your holiday then you first need to decide what to take and you'll also need to decide how you will be transporting your valuable equipment. Along with your camcorder, you'll be stowing away a tripod, headphones, a microphone, maybe a light, extra lenses, filters – essentially all the stuff you've left behind in option one. With all this extra equipment you will need a durable and large

holdall or even a camcorder rucksack. There are many on the market, but you might be surprised at quite how expensive they are. Still, compared to the expense of your digital camcorder and all the accessories, the investment is worth it.

Planning is even more important if you're taking this seriously and you should look into gaining permission in advance if you're considering visiting any out of the way, or extreme places. A good tip for creating a fully-rounded holiday video is to capture footage of maps, trails, visitor passes and still photos of the places you've visited, and perhaps music that's indigenous to the region, so that you can incorporate them into your completed production.

Another thing to bear in mind, should you be travelling alone, is not to forget to put yourself in the video from time to time. It's often the case that a videomaker returns from a trip, exhibits their work, only for people to ask where were you then!

Above:
Holiday videos can be a permanent reminder of a special time.

Right::
Variety is the key to successful documentaries. Different shot sizes, cutaways, using maps, signs, and a multitude of settings all help to create an interesting atmosphere.

DOCUMENTARIES

There is a richness and diversity to shooting documentaries that can probably only be equalled by the creativity involved in shooting a fiction video. As far as documentaries go, the world is your oyster. You can pick any subject life has to offer and turn it into a short or long form video of note. Fortuitously documentary making offers the videomaker a chance to break away from the constriction of shooting a scripted fiction video, or the formulaic nature of weddings and interviews. This is possible because a lot of the time the videomaker has no control over what happens. Good documentaries come from good observation and a key to this is getting access to situations and making the subjects feel natural and relaxed, rather than trying to dictate what happens and when.

Shot lengths will be much longer in documentary making as you simply have to keep rolling and wait for "life" to happen. This means that editing is the key to success. You will undoubtedly shoot more footage in a short documentary than a short film or interview. It is once you have the footage that you will see how the documentary will develop, and for this reason it's worth being open minded about what direction the video takes. Because you have no preordained shooting script, your initial theme might change, your central character might not be the most interesting aspect of your material in the end, and you might end up disproving any point you had intended to make.

Right:
Consider your audio options. Will all your dialogue be written in advance and delivered to camera, or will you add narration later, or will you have a blend of voice-over and interviews.

Right, Top to Bottom: Mix shot sizes, but don't cross the line in a sequence – as in the second image here.

Access All Areas

As well prepared as you might be for documentary shooting, it's likely that you will run with the bare essentials most of the time: a camcorder, basic microphone and lighting. Audiences don't expect intricate tracking shots or smooth Steadicam work in documentaries, they are increasingly media literate and understand context, and you can take comfort from the fact they won't expect *Lawrence of Arabia* standard cinematography!

The success of fly-on-the-wall and reality TV shows is that they get close to their subjects, warts'n'all, if you like. And digital video has played an enormous part in achieving this. Digital camcorders *are* small enough to be unobtrusive, and their image and sound quality is capable of rendering a sound recordist and lighting assistant surplus to requirements most of the time. Imagine this scenario: you are trailing the Managing Director of a small publishing affair as he is implementing potentially unpopular changes on his staff. He is far more likely to be candid with you as you interview him, or video him with staff members, if there is just one person with a digital camcorder. Re-jig the scenario and follow him with a team of three of four people and you'll no doubt see some impressive clamming up.

Again audiences don't expect gloriously lit scenes, or moody and intense situations courtesy of intrepid lighting design. They expect the odd grainy moment, the odd dark corridor, the odd incorrectly white balanced moment – context is everything, and if what you're showing them is entertaining or fascinating they'll follow you. The same goes for sound – just make sure you pick up what you need, nobody is expecting dynamic stereo switching and sound effects-just the juicy titbits of gossip!

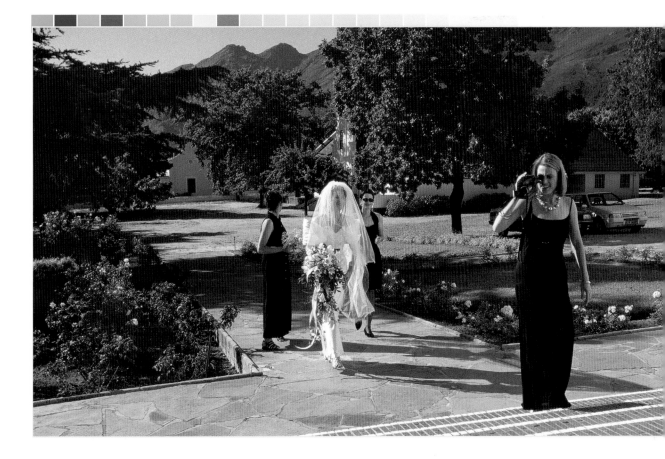

WEDDINGS

Ding dong indeed! Weddings are fraught, intense, exhausting affairs, and not just for the bride and groom. Weddings are the most traumatic occasions for a videomaker, they do not offer you the chance of a re-shoot, you are at the mercy of the weather, the relevant authorities and all the arrangements that rise above "the video" as a priority on the big day. By relevant authorities, we are talking about the service itself, the venue and the conductor, be it a religious or a civil affair.

You can plan until you're blue in the face with weddings, but it's worth nothing, unless you are quick to react on the wedding day. And that is how you succeed at wedding videography – you act and react fast. Still, videoing weddings can be a worthy and fruitful occupation – more than a

few serious videomakers use it as a regular earner – and there is a lot of satisfaction in making what could be viewed as a boring situation into a visual spectacle that will bear replaying.

The first rule of Fight Club is . . . sorry, of wedding videos is give the client your best. It's their big day and an important moment for family and friends. Speak to the couple about what sort of video they'd like, and always remember to speak to the relevant authority about permission to video and whether any fee is payable to them. You should also check about copyright for music, as well as performing rights licenses for the choir and organists.

Research your location, think about where you want to place the camcorder. And then remember to ask the authority whether it's OK to place your equipment there. For lighting

Above:
At weddings the temptation is to try and capture everything on video but try to avoid filming somebody who is also filming at the same time.

Right and Below:
Recce your location:
Check out the best and
least obstructive
locations for your
camera and mic, but
most important, get
permission to film.

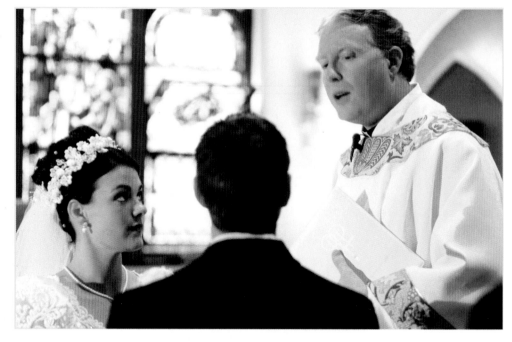

in a long period for editing you might want the extra footage a second camcorder can provide. If possible try to rehearse the sound recording, as churches can boom and echo away. Try and get to a rehearsal, if there is one, and make sure you have a selection of microphones to choose from – even if you have

requirements discuss what's feasible – could the church increase the light, or dim it, can you bring any stand mounted lights in, etc. You might have to make do with available light, which could alter where you need to place the camcorder.

Decide whether you want this to be a one-or two-camera shoot, and if so, who will be your second camera operator. Most productions can get by with one camcorder, but if you've factored

to hire them. You might want to record ambient and background sounds on a separate audio only recorder, while using a directional mic, close to the couple and priest, to pick up the ceremony. A microphone designed to give a general sound recording, such as the one usually built into your DV camcorder, will leave you with variable sound quality.

It's up to the bride and groom how in-depth you go with the video, not everyone wants to be

videoed getting ready for the big day. But whatever you present the happy couple with at the end of the day, make sure it's edited tightly, and compresses some wonderful memories into a tidy, efficient watchable package that family and friends won't feel they have to endure rather than enjoy. Titles are a necessity for rounding out the package, and be tasteful with the music soundtrack, should you wish to include any.

A Woe Free Wedding

Your location list might go a little something like this:

- Research location
- Speak to relevant authorities and gain permissions where necessary
- Arrive early on wedding day!
- Footage of bride and groom getting ready
- Guests arriving at the venue
- Groom and best man awaiting fate!
- Outside the venue as bride arrives
- Bride enters venue, walks up aisle if in a church
- Ceremony
- Confetti, celebration, depart for reception
- Arrive Reception
- Speeches and Toasts
- Evening "Do"

6

Editing

Editing

BASIC EDITING

Aha! It is time to get serious. Having amassed all the footage and audio necessary to create your fiction, holiday, interview, documentary or wedding video, editing gives you the opportunity to manipulate it. In many respects this can be the most creative part of the videomaking process. Editing is really all about telling a story, and it is where you get to decide how you want to tell it. As with many aspects of videomaking there are no hard-and-fast rules, simply guidelines to help you along. Sure there are conventional approaches which will enable you to get an idea of what the "norm" is, but remember this is your video and, ultimately, it is whatever works for you.

You will undoubtedly find that you spend more time editing your video than you do filming it. But though this fact tends to put off many amateur videomakers, editing is an absolute necessity if you are to create fully realized productions. Not every shot you have taken will work, and sequences you thought worthless might reveal themselves to be the very pieces that make your video "tick".

The very basics

At its very core, editing is choosing what to include and what to lose, and then splicing the remaining bits together. However, there are a myriad of permutations in how you reach a final cut. As you will discover later in this chapter, computer-based non-linear editing (NLE) systems are by far and away the most popular and versatile forms of editing in the 21st century. The arrival of digital video heralded a new dawn for editing, with powerful software and hardware packages available for decreasing amounts of cash. DV camcorders are particularly friendly with computers because of their digital signals and connections. Digital Video, with its improvements in picture and sound quality, also enables higher quality edited videos to be made.

Below:
Editing at its most basic is deciding what you what and what you don't want in your video.

Above:
It's possible to edit out "unnecessary" scenes and still
have a sequence that works.

The reason – there is no loss in quality. If you transfer digital images and sound to a computer; the footage remains digital while on the computer, when you output back to DV tape or create DVDs or Video CDs, the transfer signal is still digital, and when played back on either of these formats the image is still of digital quality.

If you are still troubled by the prospect of editing, let us lay it bare for you. All video editing involves copying images and sound (dubbing) from a player (camcorder or VCR) to a recorder (DV camcorder with DV-in connection, computer or VCR). The player plays back the original camcorder footage in the sequence you

Shot	Tape	TC In	TC Out	Description	Take	Comments
1	3	00:00:14:02	00:00:24:06	WS fans outside venue	1	Pics and audio OK
2	3	00:00:36:20	00:00:53:14	WS fans inside venue	2	Good
3	3	00:02:12:00	00:04:40:04	MS interview: singer	5	Too Slow
4	3	00:05:25:12	00:38:50:24	WS band performing	1	OK
5	3	00:40:38:10	00:41:11:17	CU fan interview	2	Audio NG (no good)
6	3	00:41:20:13	00:44:19:21	CU fan interview	1	Good

select, while the recorder records it. Et voila, you have dubbed a tape.

The simplest way of doing this is to hook your camcorder up to a VCR, via Scart or AV cables, press play on the camcorder, and record on the VCR. Seeing as this is done in one fell swoop, without changing the order of the scenes or sequences, this is referred to as linear editing. Every scene is followed by the one you shot next, and there can be no swapping around of sequences. Non-linear editing allows you to move a shot or sequence from one part of the video and place it somewhere else – i.e. a dramatic moment taken at the mid-way point of your tape, can be moved to the end of the video to provide a fitting conclusion.

Below we have identified the more basic types of linear editing you can attempt without recourse to a computer. Though, it has to be said, to get the best out of digital video you

*Left:
Audiodub on your
camcorder allows
you to add new
dialogue or music.*

have. As laborious as it might sound, you should log every shot you have taken. Play your material back and write down each new scene. So you might write:

Scene One: Jamie in the garden playing football

Scene Two: Jamie kicks ball over fence and breaks his neighbours kitchen window

Scene Three: Irate neighbour confronts Jamie about his conduct.

This system will allow you to build up a picture (on paper) of what footage you have. For a more detailed list, or **logging sheet** as it is often referred to, you can add timecode information which indicates the number of hours, minutes, seconds and frames each shot lasts. You can use this list to create what is known as a paper edit: simply an outline of your edited video written down. This can save hours in front of a monitor or VCR spooling back and forth through your footage as you desperately try to track down a shot. This system is often referred to as **off-line editing.**

Even at a basic level you ought to be thinking about adding sound to your edited footage. A short burst of music over a landscape shot can indicate a mood, while narration can often help to clarify a point not particularly well explained by your subject. It is all about widening the scope of a video to encompass as much information as possible, and to provide the viewer with a rounded product.

It is possible to add narration and music to an edited piece fairly easily. To ensure you can include additional soundtrack material you need to have set your camcorder to its 12-bit PCM audio mode – having a piece of footage recorded in 12-bit next to a sequence in 16-bit is going to cause you problems, as you simply will not be able to dub over it. Determine the length

really should consider computer-based packages.

In-camera editing

You simply shoot the footage you need in sequence, without the need for transitions or effects. Every shot you have is as long as you want and you do not want to add any extra audio. Complete your shooting list and dub it all straight to a recorder.

Assemble Edit

This involves using the player to transfer the footage you want to a recorder, but you can decide what sequences to send and in which order. Using this system you can rearrange your video and use shortened clips.

Still feeling a bit muddled about where to start, well try this example out for size. In order to start editing you need to know what footage you

Above:
Editing can take its toll!
But long hours in the
dark can pay dividends.

of the section to which you want to add a new soundtrack and then write the narration or choose the music to fit this gap. Tickled by how it sounds and looks? Well, you are getting the editing bug.

ADVANCED EDITING

For amateur productions, the basics of editing are likely to be enough to lead to the creation of a competent final cut. Yet, as we have mentioned, editing is about shaping your story, and once you feel confident enough with the building blocks, then it is worthwhile journeying onwards to more complex waters: where your bolder vision lurks, where your longer-form video hides and where you might find someone called a client, who wants to pay you for your work!

For a start, if your work is going to appear outside your living room, you need to record a few seconds intro of dead/black footage at the start of your master tape, or alternatively, you could record colour bars. This prevents your edited video from beginning with a jolt at the start of a tape – when the picture from VCRs can be unstable.

Insert Editing

More professional productions utilize a system called **insert editing** rather than assemble editing. To understand this concept you need to know what a control track is. Every digital camcorder creates a control track, pulses, one per frame, along the edge of a tape which helps the camcorder maintain a consistent speed. In assemble editing, the control track is transferred with the images and audio as one package; in insert editing it is not.

Insert editing involves recording new video

and audio over existing recorded material and you can only do this on a tape which has a control track already in place. Therefore, you will need to find the tape onto which your video will be dubbed and give it a control track. You do this by "blacking up a tape", essentially laying down recorded material for the tape's duration. Black is favoured to prevent any colour bleed from previous colours. You now have a continuous control track to lay your footage onto. When new footage is added, the existing control track and timecode recorded on the tape are left undisturbed. This reduces the chance of glitches in edits/cuts, such as visual disturbances.

Amateurs tend to make use of insert and assemble editing together, as they will "black" the copy-tape with their assembled footage, giving it a continuous control track, and then insert shots, such as cutaways, over them, erasing the original footage underneath.

EDITING PRACTICES

If you are intending to edit in a conventional way then you will need to satisfy the viewers' expectations with regard to what they see. Conventional technique maintains that editing should not distract the viewer, i.e. you do not

notice good editing. To achieve this it is necessary to ensure there is a consistency in the images the eye sees. Similar shots placed adjacent to each other are easy for the brain to assimilate, and for it to understand what is going on. Moving between different shot sizes requires a little time for the brain to process the new information. However, having too many

Above:
Think about how shots work next to each other, in terms of size, angle and lighting.

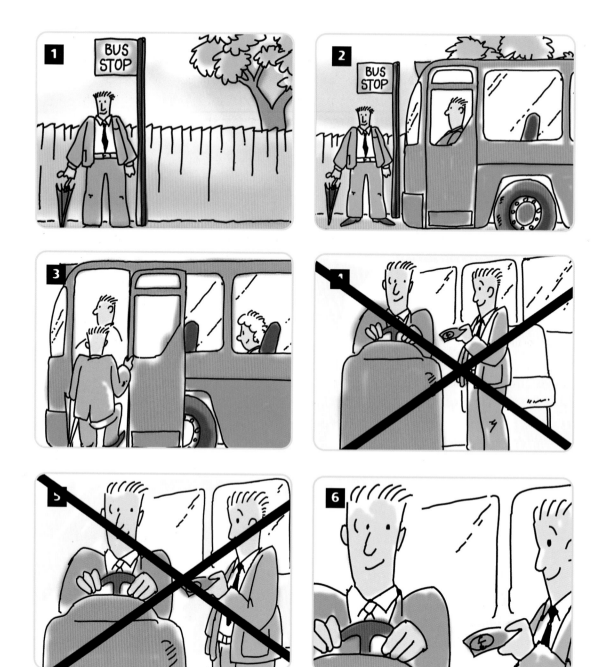

Above:
Editing is about telling your audience a story.
Make it interesting visually as well as in terms
of content. Avoid using the same type of shots,
it makes for blandness and slows the pace.

similar shots, from the same height and angle, will lead to a production which is lifeless and predictable. It is perfectly acceptable to make a significant change in shot size and angle when you are cutting on the same subject or when there is a major shift in the content of your video. For example, you can easily move from a wide angle shot of a man waiting for a bus to a close up of him exchanging money and ticket with the bus driver. If you had a medium shot of the man waiting, followed by another medium shot of the bus coming into view, and then a medium shot of the man boarding the bus, the overall effect would be very bland.

One part of editing that can confuse a novice is the comings and goings on the screen. By that we mean entrances and exits, not technically through doors (or windows), but into and out of the frame. Convention dictates that you cut when the subject has nearly left the frame, and in so doing you make sure the viewer does not have an empty frame to look at. The same is not always true of entrances, you can leave a frame empty before the entrance of your subject as it enables the viewer to figure out the location. You can then have your subject appear into shot, whether it is walking into a room or along a corridor.

As you become more comfortable with editing a sequence or video together, you will learn that you can add pace and tension to a video by altering its rhythm. Faster cuts naturally increase the pace, while adding an almost frenetic feeling. Shots left to run for longer provide a languid feel. You can further alter the pace of your video by adding a music soundtrack and cutting specifically to this. This is blindingly apparent in a music video promo, but think about action sequences in your favourite

Left:
Powerful NLE software,
such as Adobe Premiere,
allows you to trim clips
and add titles and effects.

NON-LINEAR EDITING

Having covered the basic types and conventions of editing, you are ready to think in more depth about non-linear editing. As mentioned above, this is the process of using a specialized computer editing program to trim and rearrange your shots. Not only does this method keep your footage in a digital form throughout the process, avoiding any loss of quality, it also allows you to edit non destructively – the footage you have shot on tape is captured to your computer. It is this captured footage you work with rather than the original footage on your tapes, meaning that no matter how much you hack and slash your way through a scene, you always have the original to fall back on should things go horribly wrong. Non-linear editing systems generally come in various configurations – software only, software and hardware bundles (usually in the form of a DV capture card for installing in a PC that does not have existing DV inputs) and real time capable software/hardware bundles. (Real time bundles feature additional processors on the capture card that augment your PC's existing processor so that complex video effects can be previewed instantly rather than waiting for your PC to render pixel by pixel the changes wrought upon your video by the use of a special effect.)

The process of non-linear editing is easily broken into three parts: capture, edit and output. Capture is the process of getting footage from your digital camcorder onto your computer's hard disk drive. When we talked about computers earlier we mentioned IEEE1394 cable, sometimes known as **Firewire** or **iLink.** This cable allows the huge volume of information contained in video to be transferred to your computer, but it has another trick

movies, car chases are a good example. The music will have been chosen for its compatibility with the images, but you might need to edit shots and sequences so they appear in time with the music. It is useful to understand music and its structure to use it compellingly, but this usually involves learning to count how many beats are in a bar of music. You can then make sure you cut on the beat, rather than off it.

up its sleeve. Thanks to a standard known as **OHCI** (Open Host Controller Interface), many combinations of hardware and software fit into a predictable set of parameters that allow differing manufacturers to predict how their equipment will work with that of others. The upshot of this is that the software capture facility on your computer can communicate with your DV camcorder. This is known as device control, and it makes the process of capturing video to computer an easy task.

When you begin capturing you simply tell the computer what sort of digital device is attached to the 1394 cable (or let the software figure it out for itself) and tell it that you wish to capture from that device. Then, without having to press a single button on your camcorder, you can begin controlling the tape within it from the computer, moving it to the points it needs to be at.

Capture is usually carried out in one of two ways. You can play the tape from the start and hit a record control in the software interface to capture footage as it appears. This method is great for shorter productions, but for times when you wish to capture a large number of scenes from different spots on the tape, you may wish to use **batch capture** if it is available on your software. Batch capture is a method whereby you speedily shuttle through your tape logging in and out points for your footage. This

Above the Timeline image:

Timeline — Video 2 — wild wanderings | Opening Title | wild wanderings — Globe.psd
Video 1 — Bald Eagle — Ocean Waves — Woods — Whaler
Channel Mixer — Transform — Basic 3D
Audio 1 — Voiceover — Voiceover — Voiceover — voiceov
Audio 2 — Eagle Calls — Ocean Waves — Whaler's Cove
Audio 3 — Sound Track — Sound Track
10 Seconds

log is then used by the computer which, for example, knows that it has to capture from 00:32:21:20 through to 00:34:07:14 before fast forwarding and capturing 01:12:09:00 to 01:14:07:09. While it charges around your tapes grabbing what you have asked it to, you can wander off and have a cup of tea.

Captured footage is stored in **bins,** a term which relates to the old days of film editing where film was stored in sacks known as bins. Before capturing, you will have set up a project area with these bins within it. Your project area will define certain things depending on the complexity of your software. Chances are it will know that the Project has a name, is using DV as

its source material, at either 24 or 25 frames per second and in either PAL, NTSC or SECAM. The bins allocated within this project area will probably involve one overall bin that holds all the raw footage with other bins designated according to your organizational preferences. We would suggest a bin for trimmed footage, a bin for inserts and cutaway shots, a bin for audio tracks and a bin containing any title sequences or captions that will arise.

Having captured and arranged your footage, it is time to begin editing. The layout and operating method of different editing programs vary wildly, but at the very least you will have a window displaying your bin and its contents,

Above:
Timeline interfaces are more complicated but also more versatile, especially when putting together complex edits.

Left:
The capture window allows you to control your camcorder from your computer.

Above:
You can manipulate the dialogue from one scene to be heard over another during the editing process.

another listing the effects and transitions you can apply, a monitor window for playing back clips, and either a timeline or a storyboard.

Timeline and storyboard editing are two different ways of keeping track of your projects, with storyboard being by far the simpler, but also the less versatile. In either case you are dragging video clips from your bin, adjusting their duration, adding effects and then placing them in your actual project. The timeline or storyboard is where you see the progression of your project as multiple clips joined together rather than just individual clips in your bin.

With storyboard editing you will see a sequence of single frames laid out sequentially from left to right across the screen. Each of these frames represents a different scene. When you have adjusted a scene you drag it to the point in the storyboard that you wish to place it and let it go. Gaps between the different pictures allow

you to place transitions, such as wipes or dissolves, between consecutive clips. Storyboard editing is as simple and intuitive as it gets, which is why it is the standard method on most of the sub-£100 entry level editing programs.

Timeline editing is more complex to start with, but once you have learned the basics, it actually allows for more complicated types of edit to be performed much more quickly than would be the case with storyboard editing. In timeline editing you have multiple tracks or channels for audio and video, arranged hierarchically. Many systems allow a staggering number of these tracks, but to keep things simple we will assume you have just five tracks. Video 1 and audio 1, video 2 and audio 2 and a transitions track between the two video tracks. Working on the basis that the uppermost track receives priority (if you have a minute of video on track one, parallel to a minute of video on

track two, the uppermost will play in the monitor window and the lower will not), it is easy to see the convenient creative possibilities offered by timeline editing.

For example, say you have two clips side by side on the same video channel, but the cut between them does not work, or is an unwanted jumpcut. You can easily cover the cut with an insert simply by trimming one of your cutaway shots to the right length and placing it on a higher video channel in a position that overlaps the cut between the end of one clip and the beginning of the next. As your video plays along the lower channel, it will play your existing footage until it encounters the cutaway on the higher channel, play through it and jump back down to the lower channel to carry on with the video beneath, bypassing the bad join via the insert shot.

This method is similarly applicable for inserting transitions on the transitions track. The ability to have the audio on a separate channel is also useful in a similar fashion. Say you wish to cut away from a scene involving a conversation in order to show the subject of that conversation, but wish to retain the audio so that the dialogue from the conversation scene can be heard over the cutaway. Simply manipulate the audio channels in the same way as you have manipulated the video, in this case by discarding the audio channel that goes with your cutaway and leaving the audio that goes with your scene in the uppermost channel.

The wealth of options, techniques and special effects available with most mid-to high-end NLE packages is huge, and worthy of a book in itself. Editing should be regarded as much a part

of your storytelling skills as screenwriting or camera work. It will take a long time to master your NLE system, but it is a vital area not to be scrimped on – you are using digital video and should aim to take advantage of the masses of creative possibilities that this medium entails.

Output is the final stage of non-linear editing. You now have a completed film on your hard drive, but unless you wish to invite your audience to sit around your PC, then you have to get it back out into the real world. At this point you generally have three options: you can export as a computer video file (usually Quicktime, Realplayer or Windows Media); you can export the film to any incorporated DVD creation software you may have; or you can put it back out to tape. We will be looking at the computer media formats and DVD creation in seperate chapters, so for this section, we will simply concentrate on output back to tape. In this case the video goes back out the same way as it came in, via an IEEE1394 cable. As long as you have not made any major changes to the format of your work, this is usually a simple case

Above:
A fairly typical NLE layout, showing bins, storyboard and a viewing window.

Quick Editing Glossary

Cut: when one image is replaced by another image. The simplest switch between shots.

Cutaway: literally a shot which cuts away from the main action or subject of a scene. It can be used to illustrate or confirm a point being made, or as a reaction to an event.

Dissolve: the incoming shot emerges from the outgoing shot.

Fade: an image either fades in from a blank/black screen or dissolves out to a blank/black screen.

Wipe: an edge moves across the screen between the outgoing image and the incoming one.

Editing Etiquette

Try to consider:

- Titles and credits.
- Fades and transitions between shots and sequences, rather than hard cuts.
- Narration.
- Music.
- Cutaways: can reinforce a point, or can disguise the fact you did not get the shot you wanted.

of rendering all your special effects and hitting a button marked export. Easy peasy.

Computer editing involves a large learning curve, but also one that you can work through at your own pace, easily creating simple edits long before you embark on getting to grips with the more flashy and complicated capabilities of your system. Additionally, editing is fun and will invariably open up a videomaker's eyes to the multitude of possibilities for presenting footage. Do not be surprised if your plan to simply trim a few shots to size and join them together is quickly swept aside by a tidal wave of creativity. It means that your project may take longer to complete than you had planned, but it also means it will be a better finished product and you will have had a lot of fun making it.

BURNING AMBITION – CREATING DVDS

Format wars are as much of a pain in the neck today as they were back in the early days of consumer VCRs. Back then you had a choice of VHS, Betamax or V2000, and the choice you made would eventually be responsible for much sniggering if, by the mid-80s, your friends came round for a visit and happened to see the diminutive shape of a Betamax cassette sitting next to the walnut-panelled bulk of your VCR. There was only ever going to be one winner in the videotape format war and oddly enough it was the one that was probably the least satisfying.

Fast forward to now and you have another format war developing, this time over DVDs. This whole book is about digital videomaking, so it would be remiss of us not to have a brief look at Digital Versatile Discs.

People are naturally sceptical of new formats. After the embarrassment of every Beta buyer of the 1980s, new forms for home visual entertainment such as laserdisc and CDTV were sure to be greeted sneeringly by those who had already had to change VCR at least once (or three times in the case of my family, who picked up first a Beta machine, then a VHS machine helpfully supplied by the traditional bloke in the

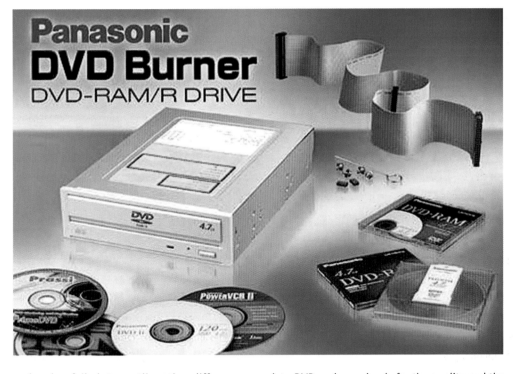

Right:
An example of
a DVD burner.

pub who failed to outline the differences between PAL and NTSC, before finally settling with a VHS deck which, wonder of wonders, actually worked with British TV). It is no great surprise that people who have to risk lashing their money on an obsolete format often adopt a wait-and-see approach to new technology.

Unlike laserdisc, however, DVD is not going to go away. It has got the backing of the major manufacturers and moviemakers and it delivers noticeable benefits. It can push even a bog-standard TV to its quality limits thanks to its ability to display 625 lines, as opposed to VHS which has approximately 240, the wealth of storage space that allows extras such as "making of" documentaries, commentary and even multiple camera angles to add value to a DVD movie, and the simple lack of quality degradation that comes from reading os and 1s with a laser as opposed to dragging metal speckled tape backward and forward over VCR heads.

Many people, especially movie buffs, dived into DVD early on simply for the quality and the extras, but others have chosen a more cautious stance, believing that DVD would not be a viable replacement for VHS until it was recordable.

Well, these days it is recordable, and even re-recordable, in much the same way that you have CD R and CD RW, so problem solved, right? Wrong. You now have a new format war between DVD RAM, DVD-R/RW and DVD+R/RW, and those little plusses or minuses can represent the difference between being able to transfer your digital video to a disc that all your friends can watch, or to a disc that can only be used as a very shiny drinks coaster.

The way in which a DVD Writer burns information to a disk essentially involves large volumes of information stored in grooves, smaller volumes stored in pits on the "land" between the grooves, and in some cases additional information stored on the land itself. Put simply, the way in which a DVD has information burnt affects the ability of a DVD player to read that information.

play in anyone else's player, you may be the sort of person that is willing to take that gamble and get in on the ground floor.

DVDs (and their little brother, VCDs, which, as their name suggests, use CD as a recording medium,) are essentially video signals, compressed to a manageable size and stored on a reflective disc that will be read by a laser beam.

The compression type is something you will have heard of – MPEG. MPEG2 in the case of DVD, and MPEG1 for VCD. MPEG stands for Motion Picture Experts Group and refers to a set of algorithms used by a computer or DVD player to work out what information has been removed or reduced in a signal to bring it down to a more manageable size. Using MPEG compression it is possible to store only the information that relates to vital frames of video whilst keeping track of only the changes, rather than the repeated information between one frame and another.

The process of creating DVDs is far too complex to go into here, but it is essentially three separate procedures – encoding a video file, authoring/designing a disc and burning the information. However, we can offer you a few hints on which method to choose when it comes to learning about, and finally implementing, the creation of your discs.

This new format war is daunting, and unfortunately it is still way too early to predict which format will eventually win, but that is no reason not to consider joining the party. DVD writers are dropping in price, with the major models available for a reasonable price. The actual media too is becoming cheaper, having nearly halved in price. Every company that has anything to do with recordable DVD has a compatibility list somewhere, usually on their website, showing what hardware, and to a lesser extent, software, their products will work with, and while there is the risk that one day your DVDs will be unable to

If you wish to create DVDs or VCDs, it is not enough simply to have an edited video project on your Hard Drive and a DVD writer installed. You need to create a video file in the MPEG format of choice (MPEG1 being of approximate quality to VHS, MPEG2 being of significantly better quality than VHS.) This can be done in two main ways, either through hardware (an encoder built into the chips of a card to be installed or attached as a peripheral to your computer) or the option we would recommend – through software.

The reason why we would recommend software encoding is simple: it is becoming the standard method. Many editing packages already have a utility included for the purpose, and separate, stand-alone DVD creation software is also available. Many CD burning programs already contain an option for creating VCDs, making it possible to put movies on to CD-R discs at a fraction of the cost of creating full-quality DVDs. In addition to this, the variables involved in creating MPEG files for disc are so numerous that software provides the perfect solution, allowing you to work slowly and carefully through dialogue boxes and "wizards" – step-by-step guides that, metaphorically, hold your hand throughout the process.

Buying a dedicated software package or using a utility also avoids the problem of having to use separate encoding, authoring and burning software (one to create the video file one to design the disc layout and information patterns and combine them with the video file, and one to actually burn all this information to disc). Most DVD creation software contains the encoding, authoring and burning programs in one package, simplifying the process and removing the possibility that your burner may not be able to handle the information rate you have chosen, or other such compatibility issues.

It is a complicated procedure, but you are getting in reasonably near the ground floor, and best of all you are keeping your digital video in the digital domain.

Below:
imovie is a simple, but effective NLE programme supplied by Apple. It can't burn DVDs but is capable of encoding your projects ready for burning.

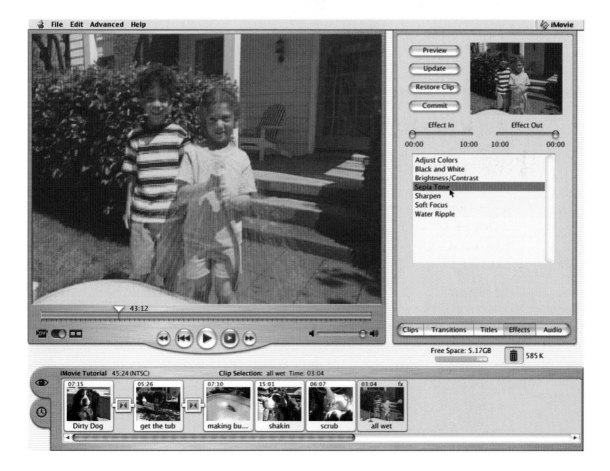

7

Distribution

Distribution

WHY STAY WITH DIGITAL?

There is a tendency for digital video-makers to feel obliged, at the final stage of their production, to move from video to film. Those videomakers with big screen ambitions are frustratingly told that they should transfer their completed masterpiece to the glory of film, because that is the only way it can be viewed. They might also be told that it is the only way they are going to be taken seriously as a producer.

This is nonsense. Most amateur videomakers may only show their video from the comfort of their living room, while those with a bigger appetite have, as we will demonstrate later, a multitude of avenues to investigate. Camcorder clubs, festivals and Internet sites all have the ability to host video.

The beauty of digital video, as we must have said a hundred times in this book, is its quality. It puts the tools needed to make affordable productions that look good into the hands of amateurs and semi-professionals. If you shoot on DV, edit on a computer and output back to DV tape or DVD, then you have a complete digital signal, and will suffer very little loss in image and audio quality, if any at all. You also have a piece of work that can be viewed by plenty of people. Record onto CD or DVD and you have a video that a vast percentage of your possible audience can watch on a DVD player or computer. Record onto VHS tape, and though you will lose some picture and sound quality, you will still have a high performance product, capable of being distributed easily. Should your video find its way onto the Internet, then you have a potential audience of millions, along with a way of seeing other videomakers' work, and the opportunity to contact them and talk about videomaking and its attendant thrills and spills.

The Transfer System

Some DV feature films have been transferred to film, such as *The Last Broadcast* and *The Blair Witch Project*. However, transferring to film is prohibitively expensive (we are talking upwards of £10,000) for an amateur videomaker, and the above films only managed it when they were "picked up" by a production company, or studio, who were willing to pay for the transfer, and then promote the film. The need for a film transfer is to enable cinemas to show the film,

Below:
The Blair Witch Project (1999) was a success story for Digital Video.

but at the risk of upsetting your outlandish ambitions of being the next Scorsese or Soderbergh, it is unlikely to happen. The number of videos picked up and invested in by production companies for cinema release is minuscule. It is far better to stick with your DV format and use the distribution and communications means at your disposal (and budget) to get your video seen. As you will see from a glance at the number of Internet sites listed at the back of this book, there is a wide variety that will allow you to submit your work. Some simply host a multitude of short films and videos, while others run competitions that you can enter. Bearing in mind that if you have edited with a PC or Mac then your digital video will already exist on your computer, then it should be a straightforward process of submitting your work.

GETTING YOUR WORK SCREENED

Shyness is a trait videomakers should banish from their personality. If you have made a video, you should want people to watch it and comment on it! It is very easy to sit in the comfort of your living room, and show your video to a select group of friends who will say "that's very good" or "that's nice". What you want is input from experienced videomakers who can tell you what worked in your video and what did not, plus, more importantly, why it did not work, and how you can put it right. Always remember that digital video is a visual art and it therefore involves an audience being able to see it, and naturally, wanting to comment on it. There is a dazzling array of video-making festivals that you can submit your work to – and we have provided a list at the back of the book – but not everyone wants to start that way, preferring to build up their videomaking skills slowly before putting them under the microscope of competition.

The club experience

Joining a videomaking or camcorder club is a quick and easy way of meeting fellow videomakers. It is also a wonderful way of gleaning information about the subject. Camcorder clubs do have a "strange" reputation in the UK, as

they seem to be predominantly made up of the more "mature" videomaker.

Camcorder clubs, like any community or hobby group, *are* also a social outlet for people, and do not be surprised if you spend more time gassing over a cup of tea and a hobnob than making videos. However, amidst the fish and chip supper mentality of many clubs lurks an enthusiastic heart. Many of the club members you will meet will have years of experience in making their own films and videos, and yes, shooting on cine film is included in this. Learn as much as you can from them as they have valuable info to impart – usually from having found out the hard way.

Clubs tend to make productions together, as well as allowing members to work independently, and they are often involved in community projects, such as creating promotional videos for tourist authorities or training videos for local businesses. These are useful as they provide a means of getting involved without taking on the responsibility of making the whole video. It will give you experience of doing different jobs within the production crew and will allow you access to equipment you might not have at home. Though clubs tend to spend most of their time foraging for funds, many are now seeing the benefit of arts funding, gaining improved projection facilities and computers for editing, as well as new digital camcorders.

Another benefit of club membership involves the inter and intra club competitions you will be exposed to. As well as fighting it out against fellow club members with your production, you might also find your effort representing the club in a dogfight between two or three other clubs from the region, or in a national event. Experienced judges are used

to oversee these competitions and while they are honest and constructive, they are usually well practised in not damaging the sensitive disposition of amateur videomakers. This is a useful forum for getting feedback without harsh criticism so you can improve your video-making technique.

FESTIVALS

The short film is increasingly seen as a valid form of expression and audiences often realize that as much work has gone into a short film as a full-on feature. This is especially true, given the number of crew involved!

The UK has a very active festival circuit, catering for live action, documentary, animation and avant garde videos. Whatever form of digital video you create, there will be a festival out there for you to subscribe to. Naturally the selection process for these festivals is stricter than for camcorder clubs, and they can often have in-competition sections where you might end up actually competing alongside entries not just from Britain, but from Europe and also from the rest of the world.

There are also an incredible number of short film and video festivals the world over, and they usually take submissions (provided your video

Above:
The adrenalin rush from seeing your work screened makes the effort worthwhile.

KinoFilm 2001

20TH - 28TH OCTOBER

SHORTS: THE FINAL FRONTIER

6TH MANCHESTER INTERNATIONAL SHORT FILM & VIDEO FESTIVAL

400 short films

60 screenings

9 days

infoline (0161) 288 2494

INTERNATIONAL PANORAMA
BRITISH NEW WAVE
KINO CHAOS: NEW UNDERGROUND CINEMA
BLUEFIRE - BLACK AND ASIAN FILM FOCUS
QUEER CINEMA
NEW DIGITAL MEDIA
EDUCATION PROGRAMMES
INDUSTRY EVENTS

VENUES

thefilmworks

cornerhouse

green room

www.kinofilm.org.uk

meets the theme) from whoever wants to submit their work.

Meet the criteria

Every festival has different procedures for accepting entries. Read their entrance criteria carefully, there are usually so many entries for these festivals that you do not want to give anyone an excuse to file yours in the bin! Check which format the festival wants to receive its videos in: this can be VHS or Mini DV, or it could be Video CD or DVD. Remember what the festival organizers need to see is a whole package. You might think your video is absolutely fantastic, but you want to make sure the judges feel

the same way. To do this they have to see the video, and if it is in a blank case with no details or publicity blurb then they might not get that enthusiastic. You have probably spent an immense amount of time and effort on making your video; do not fall short by not promoting it properly. Make sure your video catches people's eye. Try and fashion a cover for it and if possible include information about the story/subject, cast and crew on there as well. It is fairly straightforward to create titles for your video when you are using a non-linear editing package and if you have a printer with your computer then you could even print out a still from your video as a cover image.

Opposite and Above: Most countries have a thriving short film and video festival circuit.

darklight 4 ²⁰⁰²

call for enteries 2002
join the bulletin
darklight archive
Straylight art exhibition
about darklight
contact us

Call for entries 2002

News 13/2/02 Darklight Digital film Festival 2002 call for entries

Darklight encourages the creation of contemporary film and art works that demonstrate and explore the creative potential of digital technologies. Darklight provides a unique platform for both newcomers and established artists and filmmakers from many diverse backgrounds to exhibit their work.

The ENTRY FORM, CONDITIONS and INSTRUCTIONS are now available on the site click here.The DEADLINE FOR SUBMISSIONS is MONDAY 15th APRIL 2002

Download
Call for enteries poster

straylight ⁰¹⁻⁰²
exhibition

featuring the work of
Claude Closky , Conor Mc Garragle , David Sherriff, Peter Lunning , Sean Hillen , Shirin Kouladjie, David Phillips and Paul Rowley , Desperate Optimists , Euan Sutherland, Glorious Ninth , Starlab, Stanza V.Mizin

Above:
The internet offers an invaluable way of getting your videos distributed and seen.

Press the flesh

If you can, try and get along to the festival. Most of the bigger events have opening and closing shows, as well as talks, seminars and workshops during the event. This is useful, as it allows you to meet the organizers, along with fellow videomakers.

If you are seen around you can promote your video, and as a result you get a bigger audience for your screening. Having made this breakthrough and are seen as an interested videomaker there is no end to the contacts you can make.

Even if you do not have a video entered into a festival, they are great events to attend. You get the chance to see what your competitors are up to, and to check out the latest, cutting-edge techniques. As has already been mentioned, there are also workshops and seminars at many festivals. Even if you cannot get enrolled during the festival, the organizers often have training courses running all year round that keen filmmakers can join. Raindance, perhaps the UK's biggest independent film and video festival, is a good case in point. It runs courses all year round covering the basics and the advanced techniques of film and video production, from scriptwriting and storyboarding, to the different DV formats, lighting and computer-based editing.

It is also worth keeping an eye out for what camcorder manufacturers are up to. JVC sponsors its own videomaking competition in Japan (Tokyo Video Festival), but entrants come from all over the world. Amateurs from the UK have a strong record in the event, and though the general quality is very high, you are not always competing with videos that cost thousands of pounds.

Sony has been keen to promote the work of young videomakers, and in the past has run day-long seminars with pop promo directors and videomakers who use digital technology in their TV shows.

COPYRIGHT

Although it constitutes a book in its own right–a legal one – all videomakers keen to broadcast their own work should be aware of the issue of copyright. In the confines of your living room, you are usually safe to replay video and audio work without any fear of prosecution, but once you start looking towards an audience, there are rules you must be prepared to observe. These include using images from other films (such as a clip or still from a famous movie) and using copyrighted music (such as that from professionally produced CDs or DVDs).

Copyright can be a bit of a minefield, but here are a few of the basics. Any UK venue which exhibits your video – whether it is a community centre, village hall, exhibition centre, cinema or arena (ho ho!) – should already have a connection to, or licence with, the Performing Rights Society (PRS).

This means the venue pays a fee for the right to play music, whether that be the radio or a CD, and the PRS then sees that its members (songwriters, performers, producers, etc) get a percentage for the broadcast of the piece. You do not need to concern yourself with this,

Below:
Royalty-free music is
an affordable solution
to copyright issues.

unless the venue does not have PRS connections. It will then be up to you to contact the PRS (address at the back of the book) and cement a deal with them.

The cost of copyright

What should concern you is that virtually all film and video festivals require you to clear copyright on your entries. This can simply mean writing to the copyright holder: film company, estate, music or publishing company and asking for permission to use the music, photo or video clip in your production. They can simply write back – and say yes or no! If they say yes, then there are a further two options. If the use of the copyright material is fleeting or negligible, then organizations will say yes, and usually not charge a fee. However, they can say yes and then charge a fee, in order for you to get clearance. Film and TV companies invariably have a member of staff whose sole job it is to gain copyright clearance for music and film clips. Fees are usually very high in this area, as the audience can run to millions, and a few seconds of a familiar tune (even if it is in the background) can cost a production company thousands of pounds. Companies and the estates who look after writers' and performers' rights, tend to be less harsh with amateur videomakers, though it is worth noting that the higher up the production scale your video goes, the more you will end up being charged!

As regards your own work, you need to know that there is no copyright on ideas, so you can only howl with frustration if someone comes up with a similar video to yours. That is unless you can prove that they have stolen the idea from you in the first place! However, the good news is that you own the copyright of any original footage you shoot – unless you specifically assign that to someone else. This can be the case if you are shooting a video for a client and they express a desire to hold the copyright, or they include it in the contract you sign.

In any case, we would advise you to contact a recognized videomaking organization – such as the Institute of Amateur Cinematographers (IAC) – which can help you resolve any copyright issues. These organizations have often arranged their own deals for members with the PRS, MCPS (Mechanical Copyright Protection Society), PPL (Phonographic Performance Limited) or BPI (British Phonographic Industry).

Copyright

- You cannot copyright ideas.
- You own the copyright to the material you shoot, unless otherwise agreed.
- Any other material you use will be covered by copyright (music, CD covers, photos, paintings, statues, books – written material, book covers, advertisements and packaging).
- Film and video festivals invariably require copyright clearance.
- Videomaking organizations have arrangements in place to help with copyright issues.
- Consider copyright- or royalty-free music. You pay a small fee and are then entitled to use the music in your video. It is also possible to purchase copyright/royalty free video which is useful for creating backgrounds and titles. A list of companies offering copyright – and royalty – free material is included at the back of this book.

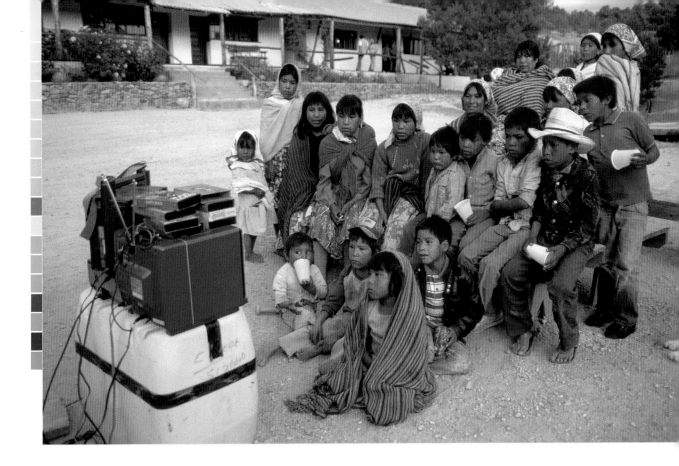

OPENING NIGHT – ONLINE

The Internet is fast becoming the place to pre-
miere your film, with innumerable sites providing
hosting services for films that fit in with their
audience demographic.

The whole point of the Internet is that there
is something for everyone out there. From the
pensioner wishing to find MP3 files of Billie
Holiday songs to the sweaty-palmed business-
man planning his trip to Thailand, every taste, no
matter how mundane or how bizarre, can be
catered for on the Internet, and that adds to the
potential audience for your film.

Go to any search engine and type in "Internet
Films" and you will be presented with an incred-
ible range of sites specializing in providing
online movies for people to watch. Some special-
ize in animation, others in social satire, or come-
dy, or video activism or . . . ahem . . . slightly more
stimulating content.

Most, in fact, divide themselves into several
sections and subsections in order to provide a
niche for every genre of film. There are so many
film sites now that many search engines, Yahoo!,
for example, now have a specific directory for
them, and as the broadband buzz continues to
build, more and more people will have high-
speed access to online films.

Of course, the potential audience for your
film may not be enough for you to overcome
certain reservations you may have for putting
your film online. Maybe you are thinking of an
Oscar nomination – which is a shame, because
films that make their debut on the Internet are
not eligible for those little gold statues. Maybe
you are concerned that compressing your film
down to a few megabytes will do irreparable
damage to its quality, maybe you just cannot be
bothered to go through the process of encoding
your film into a Quicktime movie or Realplayer

Above:
Thanks to the
internet, your
video can reach a
global audience.

Above:
Every genre of film is catered for online.

file. If you do not want to put your film online, there is no reason why you should, and if your film is not suitable for web viewing (lots of camera movement, special effects, fast editing, etc, will suffer badly during compression) then there may be no point in doing it.

But maybe your film is just right for the medium, and maybe the idea of having it watched by people from locations as diverse as Kinshasa and Caracas really floats your boat. In that case, what do you need to do?

Well, it is remarkably simple. Once again, the advantages of digital video make themselves known. The chances are that your NLE system already has what it takes to create an online movie, all you have to decide is how you are going to put it to use.

The simple option is to allow a specialist filmsite to host your DV movie. This usually entails little more than sending them a DV cassette with the film on it, which they will encode and post for you. If you wish to place the film on your own site, or send it to out to multiple sites already encoded (to save on posting dozens of DV tapes), then you have to decide on a few other things first.

Download or Streaming

The difference between downloading and streaming is simple. A progressive download film is a one big file that the audience can transfer from the host site to their PC in much the same way as software upgrades are transferred. You hit the download button and wait until the entire file has been transferred to your machine before playing back.

The advantages of this method is that once you have the file you can play it back from beginning to end in one go and don't run the risk that elements of the file have been lost in transit.

The disadvantages are simple – if you are on a 56K modem attached to an ordinary phone line, then – in all likelihood – your computer can probably only receive around about 48 Kilobytes per second (even if your modem claims to be able to receive 56kbps, there is a limit to what your telephone line can actually deliver). Considering that most Internet films run into several megabytes at least, there is every possibility that you will be old and grey by the time

Media players, such as Quicktime, tend to look similar, but have very different capabilities.

the whole file has downloaded (not to mention the risk that someone will pick up the phone and try to call dial-a-pizza halfway through the download).

Streaming a film, on the other hand, allows you to begin watching à film as it downloads. As long as it does not download slower than it plays back (given a well-specced computer and a broadband, or good dial-up connection, you should be OK) you will be able to sit through the whole thing as it plays, discarding what you have already watched to make room for the incoming stuff that is yet to make it to the screen.

The advantage of this method is that you can begin watching the film significantly quicker, having only to wait until a reasonable amount has downloaded before beginning playback.

The disadvantage is that you are cutting out the chunk of your audience who are not suffi-ciently well-specced enough to receive streamed video and taking the risk that frames of video will arrive out of sequence, or not at all, resulting in a playback that is even more distorted and jerky than compressed video normally is.

To choose which method you will use, watch several streamed and downloaded movies to get a feel for the issues of time and quality. Keep in mind that you do not have to stick to one method either, many sites offer the same film as download or a stream, in a choice of Quicktime or Real Player. If you have the time and inclina-tion to encode your film in a variety of formats then you can offer this variety as well.

Having decided whether to make your film available as a stream or as a download you should think about the type of player you want it to be compatible with. Once again, you are not limited to choosing one and leaving the rest,

you can make your film available on as many players as you like.

Comparing Computer Video Players

The big three video players are **Quicktime, RealPlayer** and **Windows Media Player.**

• **Quicktime** was the first of the media players to surface and often suffers from the fact that it originated from Apple computers. As has been mentioned earlier, Apple Macintosh computers have only a tiny share of the market compared to Windows-based PCs, and despite the fact that Quicktime is available for both operating systems, it has suffered due to the clannish nature of many computer users to the

point where Apple are rumoured to have considered making Quicktime a separate company in an attempt to get past anti-Apple bias. It is a shame that Quicktime has suffered this way, as it has the least jittery, glitchy playback of the big three and features a simple and intuitive interface.

• **RealPlayer** is an offshoot of an audio player and its best feature is the ease and quality with which it handles streamed video, which has made it the most common format, in our experience, for streaming video. On the downside, the interface is a mess and it does have a strange habit of occasionally making your web browser behave oddly.

Left:
RealPlayer is another of the most popular browsers.

• Finally the **Windows Media Player,** which is the mixed bag of the bunch. On the positive side it can, under the right circumstances, produce the best image quality of the big three. On the downside, it is ugly and non-intuitive. There is nothing you can do about the lack of user friendliness, but it does come with a selection of "skins" that allow you to choose its particular style of ugliness.

Codecs

All these players use **codecs** (COmpress/ DECompress) for compressing and decompressing video. Compression is the key to Internet movies, and images on computer, in general. MPEG, which we have mentioned in several places throughout this book, is a form of compression, and the same goes for JPEG photographs.

Put simply, compression is a system of ignoring certain less important elements of an image in order to save space and then reconstituting that image based on the knowledge of what information has been left out. The codec is the method by which this compression is achieved, usually in the form of assumptions based on the changes between frames.

To explain this further, if frame one shows a blue vase and frame five shows a blue vase, and frames two three and four all show a blue vase, why not ask the computer just to remember that there are five identical frames rather than remembering five separate frames all showing the same thing.

Having decided which type of player your video will be aimed at, you have a couple of options. Most of these players are available as free downloads, but as players only. If you wish to use them to create content, you will need to pay out for them and download the more advanced versions from the manufacturers websites or install them from disks.

We do not recommend this option, or the option of downloading a codec – such as Sorenson – and figuring it out for yourself. What we recommend is this – use whatever output capabilities your NLE system has. Even the cheapest entry level systems have some form of web output tool built in that you can use, and many feature an excellent program called Terran Media Cleaner (which can also be bought separately).

Why do we recommend using the utilities to hand? Simply because you have already learned how to be a videomaker – believe us, you do not want the extra task of learning to be a webmaster, AV content producer and server technician as well.

Most of these tools will offer you a range of options and will hold your hand as you work through them, from codec, to colour depth to optimizing for any number of bandwidths from 33K modem to ADSL. Terran Media Cleaner, for example, offers access to the different codecs used by the different players, so there is no chance of you deciding to use the MPEG4 codec from Windows Media only to find that the version of Quicktime you downloaded (without a licence) from your mate Freddy does not provide this. Using a tool for creating media for players is better than using players to create media for players. You do not ask Michael Schumacher to build his Ferrari.

It is this simple: try to do it on your own and you are in for a long, slow and disheartening learning curve. Use what is built into your existing software and you will be emailing the URL for your movie within a few hours.

Don't take our word for it. . . .

"Just as cinema of the 20th century was created on celluloid, so will the cinema of the 21st be defined by the digital image. DV represents the ultimate democracy in story-telling: you can shoot cheap, edit cheap and create gold. It will encourage a thousand people to make films – some good, some bad, but they will be made. The future is already here. What are you waiting for?"

Tom Bainton,

Writer/Director/DV Producer, *Cool Hill Films.*

"There is something very intimate about video. It makes working in a direct, personal way easier to do. The portable nature of camcorders means footage can be taken secretly and quietly, its less inhibiting. You can capture moments of reality rather than having to contrive the content."

Carolyn Black, Artist

The reason I use digital video equipment is very simple – when we are out there, we see things people could live a lifetime and never see. To be there without the kind of camera equipment that can record it would be heartbreaking. It is not a very hospitable environment and it is very salt laden, yet we have never had any problems with our equipment. We are thrilled with it."

Colin Speedie,

Head of The Wildlife Trust's *Basking Shark Project.*

"The dramatic latitude the cameras afford is awesome. For example, there is one shot where I was able to stand on a chair and hold the camera up against the ceiling, framing with the LCD screen, to get a full length shot of a bath. The result was a shot not possible with either 16 or 35mm, unless you are on a set and can move the ceiling. With DV we were able to work hard, shoot fast and not worry about stock."

Dominick Reyntiens,

Director of *Inside Outside Lydia's Head.*

"The cost of actually shooting in 35mm is instantly prohibitive. With DV you can see what you have got straight away, it is cheap for what it is and it is of a quality that is broadcastable."

Cashall Horgan,

Animator/Director of *Paddy.*

"*Kingdom* has 175 CG shots in it – if we had tried to do that on film we would have racked up a serious budget. Shooting on DV meant we could afford to play around with different ideas, and if an actor needed to do ten takes the cost was insignificant. The flexibility that DV gave was brilliant. Technology has become a great enabler."

Kenneth Barker,

Writer/Producer/Director of *Kingdom.*

Glossary

A

ACADEMY: In this instance, the older format of film stock with an approximately square aspect ratio, later superseded by stocks with wider aspect ratios, such as 2.35:1 or 1.85:1.

ALGORITHM: A standardized set of rules or procedures for repeated calculations, in this case, for compressing and decompressing video with as little quality loss as possible.

ANAMORPHIC LENS: A lens similar to a wide angle lens except it only enhances the width not the height creating a widescreen aspect ratio.

ARC: Aspect Ratio Convert, the process of taking 4:3 footage and converting it to a wider 16:9 ratio, sort of a reverse pan-and-scan.

ASPECT RATIO: The width to height ratio of the screen.

ASSEMBLE EDITING: Editing whereby material is joined on the end of existing footage, without any changes at the edit point.

AUDIO DUB: The recording, or re-recording, of an audio track on a video, which leaves the existing audio untouched.

B

BACKLIGHT: Light coming from behind the camcorder which highlights the subject's outline.

BROADBAND: Information delivery over a wide range of frequencies allowing for a very high information capacity. In this case used to refer to a permanently connected high capacity internet service as opposed to slower "Dial Up" services using ordinary domestic phonelines.

C

CAPTURE CARD: A device that adds DV sockets to computers not already equipped with them, often subscribing to the OHCI (Open Host Controller Interface) standard.

CARDIOID MIC: Partly directional microphone with a heart-shaped response field.

CAST: The actors in your film.

CCD: Charge Coupled Device, the image sensor that receives light from your camcorder lens and converts it into a video signal by assigning different values of electrical charge to represent the information contained by each pixel.

CHROMINANCE: The video signal which defines colour.

CODEC: A software or hardware item that applies algorithms to **CO**mpress and **DEC**ompress your video signal.

COMPRESSION: The process of taking the huge amount of information contained in a video signal and compressing it to allow smaller and more easily transferred files.

CONTINUITY: The method by which consistency and accuracy of costume, action, dialogue, etc, are maintained in film and video productions.

CRASH: When your computer gives up the ghost in the middle of a task, displaying the notorious "Blue Screen Of Death" and resetting itself – usually sending your current projects to digital heaven in the process.

CREW: The people who carry out tasks behind the camera – camera operators, gaffers, grips, etc.

CUTAWAY: Shot used as a break or link between principal shots in a film or video.

D

DEPTH OF FIELD: The range of object distances from a camera within which objects will be reproduced with sharpness and clarity.

DISSOLVE: Transition between two scenes where the first gradually disappears to be replaced by the latter.

DOWNLOAD: The act of importing a file from a remote computer to your own.

DVD: Digital Versatile Disc (sometimes referred to as Digital Video Disc) a disc similar to a CD that stores video information in MPEG2 format. Capable of higher quality then VHS video tapes.

E

EXPOSURE: Exposure of the CCD to the correct amount of light, which is controlled by the aperture and shutter speed.

F

FILTER: Glass, gel or plastic disc which fits over the lens to create special optical effects.

FIREWIRE: (aka IEEE-1394 or i.LINK) A high-capacity method of transferring digital video to other devices – such as a computer – and allowing those other devices to control the playback device.

FRAMING: The act of composing your shot and placing the elements of your composition in their required positions within the "frame" of viewable screen area.

FREEZE: When your computer locks and refuses to respond to inputs from the mouse, keyboard or other devices.

G

GAFFER TAPE: Vital stuff – holds cables to the floor, repairs broken objects, marks actors positions on the floor, etc.

H

HARD DISK DRIVE: The "long term memory" of your computer where software and projects are stored.

HARDWARE: The actual "physical" components of your computer-processor, monitor, etc.

HUNTING: Slow response from the camcorder's auto focus system as it takes time to bring a frame into focus.

I

IEEE-1394: (aka i.Link or Firewire) A data transfer protocol for moving audio and video footage, which also offers device control over VCRs and camcorders.

J

JPEG: A photograph converted into a computer file according to the standards of the Joint Photographic Experts Group.

JUMP CUT: An edit in which the perspective or framing or subject position between the two shots changes noticeably causing items on screen to appear to jump out of position, creating a jump in continuity. Sometime used as a stylish dramatic device, more often just a stupid mistake.

L

LINE, THE: In composition, an imaginary line drawn between parallel objects – if you begin shooting on one side of the line then move to the opposite side the two objects will appear to have swapped position.

LUMINANCE: The video signal which defines brightness (measured in lumens).

M

MASTER SHOT: Complete shot of a scene made in a single take in order to provide full coverage, usually used as a safety or backup should anything go wrong with other shots. Master shots are not always practically obtainable, but if you can get one its a good idea to.

MEDIA PLAYER: A program for playing back media files – such as video or music – on a computer. The major ones are Quicktime, Real Player and Windows Media Player.

MPEG: Motion (sometimes Moving) Picture Experts Group, a standard for compressing moving images into smaller file sizes.

O

OPERATING SYSTEM: The interface between yourself and various bits of computer hardware. Prominent operating systems include the various versions of Windows, Mac OS, Linux and Unix.

OHCI: Open Host Controller Interface, an agreement that allows various manufacturers to standardize their equipment for compatibility.

OMNIDIRECTIONAL MIC: A microphone that is equally sensitive in all directions.

P

PAN-AND-SCAN: The process of transferring a wider cinema image to a narrower television screen by panning around the frame and scanning the important elements, discarding the rest.

PIXEL: The smallest element of a picture-PIcture ELement.

PROCESSOR: The brain of your computer that essentially reduces tasks and problems into millions of "yes", "no", "and" "or" questions.

R

RAM: Random Access Memory, the "short term memory" of your computer which stores things that are currently in use and passes information to the processor.

S

SHOOTING RATIO: The ratio between footage recorded and footage required. A shooting ratio of 3:1 would imply that three minutes of video are shot for every one minute that makes the screen. Used by Producers and Directors as a rough guide for planning how much tape is

required, used by accountants to bemoan the amount of money spent.

SHOTGUN MIC: Highly directional microphone which can be aimed at its sound source.

SLIDE ADAPTOR: A device used for transferring still images from slides to video.

SOFTWARE: The programs used on a computer.

STEPPING RING: A device with screw threads of different diameter on either side, used when the threads on the lens barrel don't match those on the device you intend to screw into the lens barrel.

STREAMING: A method that allows a file to be played back as it downloads.

T

TELECINE: The process of transferring video to film stock, available in a variety of methods, of various quality at various prices.

TIMECODE: Coding system for audio and video for synchronization and editing. The timecode shows hours, minutes, seconds and frames, eg 01:12:58:02.

U

URL: Universal Resource Locator, otherwise known as a web address, such as http://www.diqitalvideo.com/.

UNIDIRECTIONAL MIC: Microphone that is sensitive in one direction only.

V

VIGNETTING: The loss of picture area that happens when using an Anamorphic Lens at its widest setting.

VCD: DVD's little brother, which uses MPEG1 compression on a CD; similar quality to VHS.

W

WIZARD: A software tool that takes you through a complicated process in a step-by-step fashion.

Contacts

Camcorders

Canon (UK)
0800 616417
www.canon.co.uk
worldwide: www.canon.com

Hitachi
08457 581455
www.hitachitv.com

JVC
020 8208 7654
www.jvc.co.uk
worldwide: www.jvc.com

Panasonic
08705 357357
www.panasonic.co.uk
worldwide: www.panasonic.com

Samsung
020 8391 0168
www.samsungelectronics.co.uk
worldwide: www.samsung.com

Sharp
0800 262958
www.sharp.co.uk
worldwide:
http://sharp-world.com

Sony (UK)
08705 111999
www.sony.co.uk
worldwide: www.sony.com

Thomson
01732 520920
www.thomson-europe.com

Videomaking Organizations

Institute of Videographers
020 8502 3817
www.iov.co.uk

Institute of Amateur Cinematographers
01372 739672
www.theiac.org.uk

New Producers, Alliance
020 7580 2480
www.newproducer.co.uk

The Guild of Professional Videographers
02476 272548
www.professional-videographers.co.uk

Useful Websites

Online Films And Animation
www.alwaysi.com
www.thebitscreen.com
www.atomfilms.com
www.ifilm.com
www.level13.net

Magazines
www.camuser.co.uk
www.computervideo.net
www.whatcamcorder.net

Information and Resources
www.bfi.org.uk
www.cyberfilmschool.com
www.filmfour.com
www.filmmaker.com
www.plugincinema.com
www.projector.demon.co.uk
www.raindance.co.uk
www.shootingpeople.org
www.simplydv.com
www.stuntmania.tv
www.whorepresents.com
www.widescreen.org

Scripts
www.howtowritescripts.com
www.scriptservices.com
www.shootingpeople.org
www.wordplayer.com

Index

Picture Credits

Original Illustrations by Geoff Fowler

The publishers would like to thank the following sources for their kind permission to reproduce the pictures in this book (all pictures on pages 1–187 are copyright Philip Andrews unless listed below):

Key: page no. (fig. no.)

Adobe® 72(15,16), 78(21,22) 79(23), 304b, 307, 311, 312–13, 314, 315t, 321, 336.

Advertising Archive 234, 198b

Agfa 49(30)

AMD 80(24)

Karen Andrews 35(5), 176(29), 21 (4,5), 95(42), 107(58), 130 (95,96), 131(97), 132(98), 133(99)

Courtesy of Philip Andrews 223.

Courtesy of Apple 83(27,28,29,30), 211, 212, 213, 335b, 335m, 335t, 337.

AtomShockwave 334 "© 2002 AtomShockwave Corp. and its licensors.All Rights Reserved. 'AtomFilms' and the Logo *are* trademarks of AtomShockwave Corp. and may be registered in one or more countries. Other trademarks are owned by AtomShockwave or its licensors."

Courtesy of Adrian Bentley226b, 248, 249, 290t, 291.

Birmingham Film and TV Festival 322.

Earl Bridger 14(8), 13(6)

Buzz Pictures 227b.

Canon 13(5), 28(16),29(17),50(32)

Canopus® 215.

Carlton Picture Library 224t, 231b, 254/55, 260tl, 261, 264/65, 270, 305, 310.

Cokin 218b.

Colab UK 59(45)

Coral 74(17,18)

Corbis 230/Theo Allots 231tl, Craig Aurness 259t, Bettmann 246b, 251, 284t, Anna Clopet 300b, Pablo Corral 245, CRD Photo 293, Richard Cummins 250t, Dennis Degnan 316, Duomo 227tr, Paul Edmondson 241, Randy Faris 224m, Mitchell Gerber 285, Kevin T.Gilbert 273, Rod Goldman 228, Philip Gould 253bl, 253br, Mark Hanauer 247, Walter Hodges 238, 244, Manuela Hofer 243, Jack Hollingsworth 325, Jeremy Homer 197, Lyn Hughes 301b, Dewitt Jones 253tl, 253tr, Ken Kaminesky 267b, Ed Kashi 222, Lawrence Manning 225, Darren Modricker 246, Marc Muench 284br, Charles O'Rear 290b, Joaquin Palting 224b, Caroline Penn 299, Picture Press 289, Paul Russell 292, Phil Schermeister 333, Paul A.Souders 294t, Chase Swift 250b, Ron Watts 191, 219t, 239, 242.

Tim Daly 58(41,42)

Darklight Digital Video Festival, Dublin 330.

Dell 214.

Edinburgh International

Epson 59(44)

Martin Evening 147(121,122)

Film Festival 329.

R. Follis Associates 218b.

FreeDrive 166(6)

Fuji 17(12), 43(21)

Getty Images/ Paul Avis 300t, 301, Cherie Steinberg Cote 276, 278–79, Antony Edwards 275t, Ghislain & Marie David de Lossy 206t, Patti McConville 275 2ⁿᵈfrom top.

Ronald Grant Archive 258br, 258t, 272b, 277, 217t, 233t, 281.

Patrick Hamilton 31, 45(24), 46(25)

Hitachi Home Electronics Ltd 200, 207, 208, 210t, 229, 235.

Imation 164(3)

Iomega 24(11), 163(2), 165(4), 166(5)

Jasc 76(19,20)

JVC UK Ltd 197, 198, 221tl, 231t.

Courtesy of Kobal Collection/
DreamWorks/Universal 221b, Twenty Century Fox 256, 257b, 257t, Cruise/Wagner 258bl, Artisan Pictures 279, 282, 323, 324b,Warner Brothers 284bl, Universal 327.

Kodak 12(4),25(12),26(13),27(14)

Manchester International Short Film and Video Festival 328.

Steve McAlpine 14(7), 133(100), 134(101)

MGI/ROXIO 66(9,10)

Microsoft 68(11,12)

The Moviestore Collection
233b, 240, 246t.

Nikon 49(31)

Courtesy of Kevin Nixon 190(2ndt), 194, 199tl, 199tm, 199tr, 206b, 216, 217b, 219bl, 219m, 219r, 220tl, 220tr, 221tm, 221tr, 223, 236, 237, 240t, 259b, 262, 263t, 263b; 276, 323, 324t, 331.

Stephen O'Kelly 260bl, 260b,
260tr, 267t.

Panasonic Consumer
Electronics UK Ltd 201, 204t,
209b, 209tr, 210b, 226t, 319, 320t.

PictureWorks 139(107)

Pinnacle Systems 303,
315b, 317.

Polaroid 59(43)

Popperfoto 287.

Queensland School of Printing and Graphic Arts 6(10)

Rex Features Ltd/ Timepix 272t.

Israel Rivera 92(38,39)

Sharp Electronics Ltd 232b, 232t, 304t.

SONY 188, 190t, 199b, 202, 204b,
207r, 209tl, 220b, 269.

Topham Picture Point 275t, 3rd, 288./Chapman
6,140, Photonews 275b.

Ulead 70(13,14)

Vancover Film School 270,
271, 274, 283, 302, 308, 320b.

Wacom 81(25)

We're So Happy Films (Steve Thomas) 286,
294b, 296, 297, 298.

Courtesy of Vega Herrera Family 189, 190b, 195, 196,
205, 280, 295, 306, 309b, 309t, 340.

Every effort has been made to acknowledge correctly and contact the source and/or copyright holder of each picture, and Carlton Books Limited apologises for any unintentional errors or omissions which will be corrected in future editions of this book.